THE PRE-RAPHAELITE LANDSCAPE

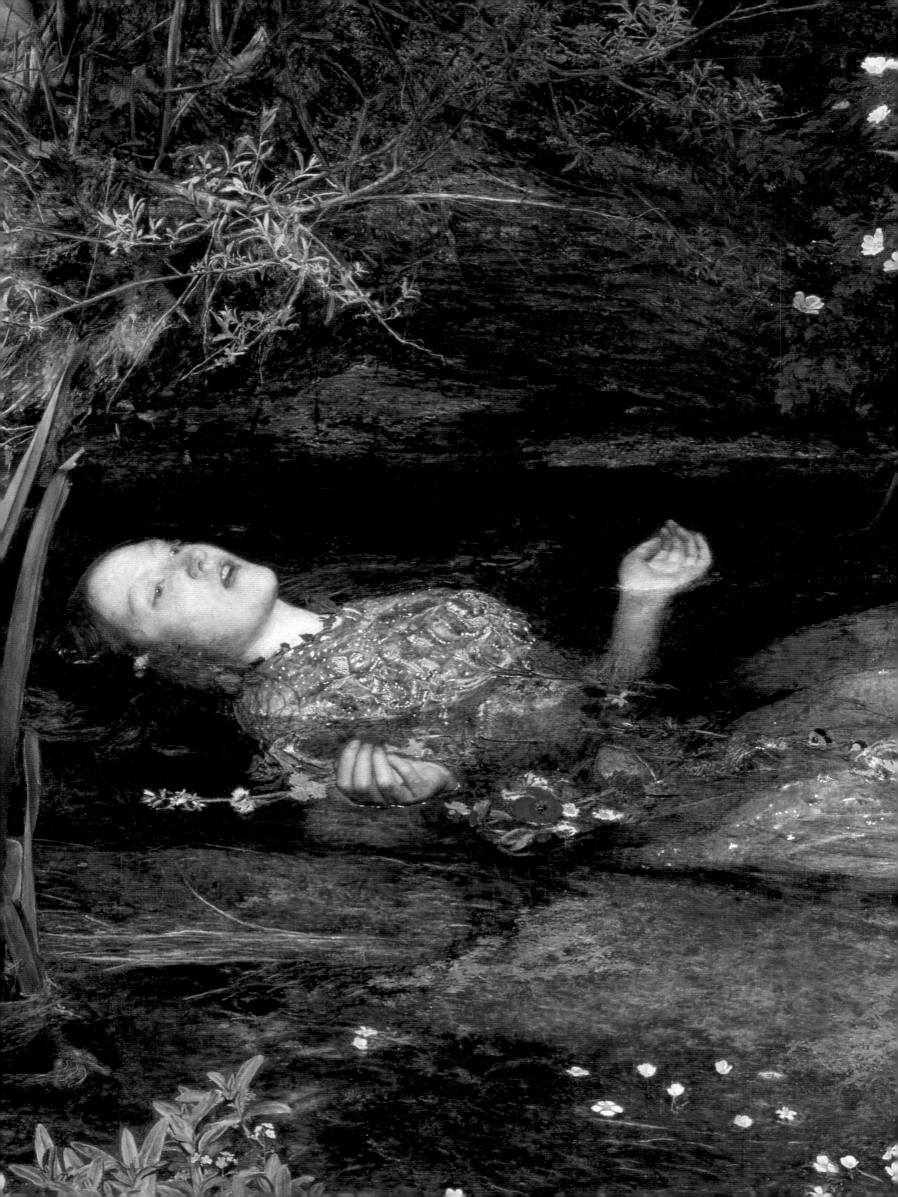

The Pre-Raphaelite Landscape

Allen Staley

Published for the Paul Mellon Centre for Studies in British Art
by Yale University Press New Haven and London

First edition © Oxford University Press 1973

This edition © Yale University Press 2001

Library of Congress Card Number: 00-110195

ISBN 0 300 08408 0

Designed by Kate Gallimore

Typeset by Best-set Typesetter Ltd., Hong Kong

Printed in Italy

Illustration on pages ii–iii: John Everett Millais, *Ophelia* (detail of Pl. 10).

Illustration on page vi: William Holman Hunt, *The Hireling Shepherd* (detail of Pl. 11).

Illustration on page viii: John Everett Millais, *The Blind Girl* (detail of Pl. 41).

TO

ETHELEEN, OLIVER, PETER, AND BRÓNAGH

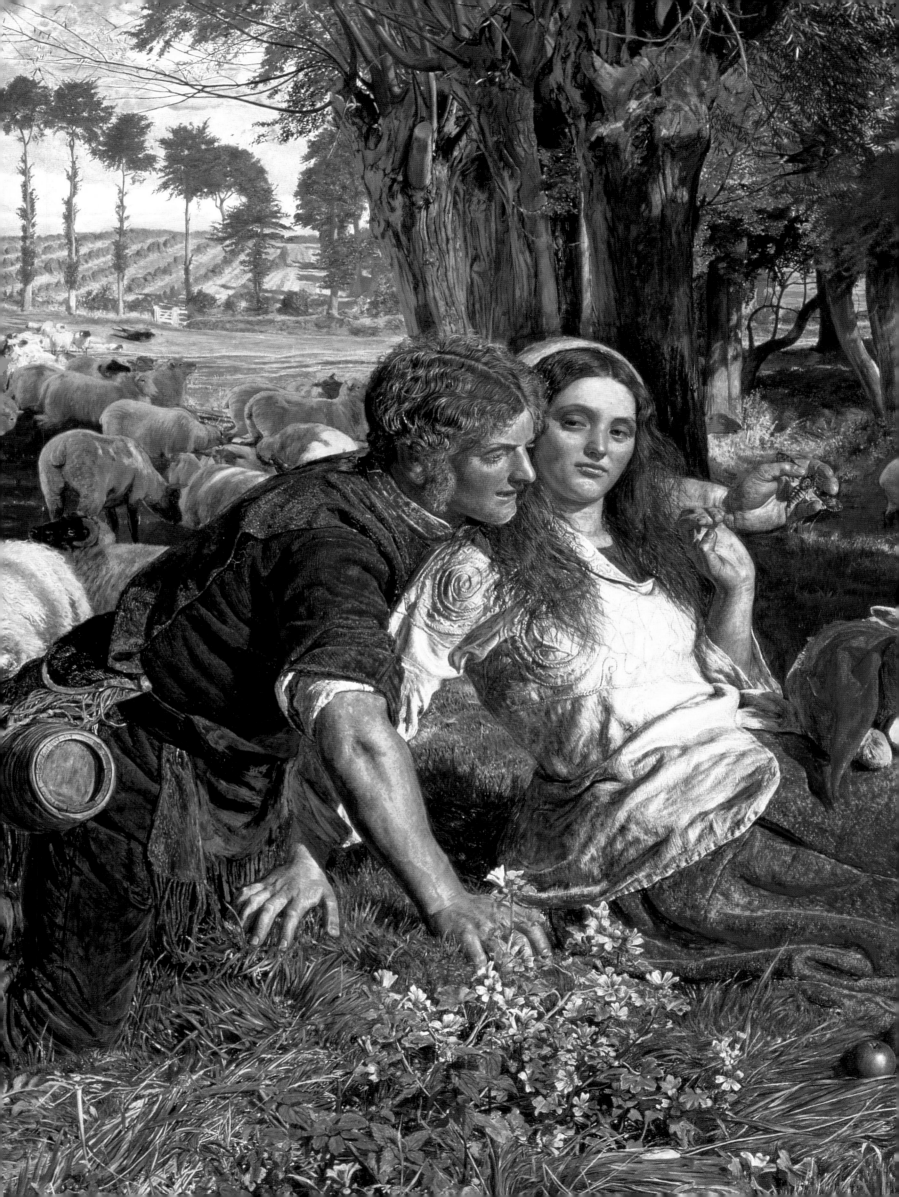

CONTENTS

This book was mainly written between 1960 and 1965 and was first published in 1973. Since those years, through the reappearance of paintings and drawings that had disappeared from sight, and through myriad publications and exhibitions, our knowledge of the art and artists discussed in the following pages has grown. In preparing this edition, I have tried to incorporate new information relevant to the subject and to discuss and illustrate numerous works that previously I had known of only from contemporary reviews and other written accounts, or had not known of at all. I have also added references to significant recent critical and interpretative comment about this art, but, with one slight exception, I have refrained from attempting to restructure my own arguments in response to such comment, or in response to the many new approaches to history and to art that since 1973 have affected the ways in with we think about nineteenth-century art. While I admire and have learnt from much that has been written in the past quarter century, I believe firmly in the value of the type of historical account that I set out to write in 1960 and that I offer here in updated but not radically different form. I hope that readers will find that account reliable, informative, and useful.

Neglect of women artists was, in my opinion, the greatest single shortcoming of this book when it first appeared, a shortcoming that can be explained, if not entirely excused, by the fact that when I started out no women artists loomed large in my perception of the subject, and feminism had not yet taught me (or anyone else) to ask why they did not, nor indeed to look for them. So, a modest attempt to say something about a very few female artists who have since surfaced is the one obvious acknowledgement of newer art historical interests and methodologies to appear in this new edition. The brief considerations of Anna Blunden, Barbara Bodichon, and Rosa Brett, which I have added, depend heavily upon the researches of Jan Marsh and Pamela Gerrish Nunn, to whom I am indebted for opening my eyes to this dimension of my subject, a dimension that still calls for much further investigation, as I am sure they would agree.

Exhibitions at the Tate Gallery in 1987 devoted to George Price Boyce and in Leeds in 1993 devoted to John William Inchbold have vastly expanded our knowledge of two artists who figure centrally in this book, and the exhibition catalogues, both written by Christopher Newall (the former jointly with Judy Egerton), are now the standard accounts of their lives. John Brett has yet to receive such comprehensive treatment, but he has been the subject of several important articles by Michael Hickox, with whom I also have had friendly and fruitful correspondence for some thirty years. Since 1984 our perception of Pre-Raphaelite art more generally has been shaped or reshaped by the great exhibition presented at the Tate Gallery in that year and by the accompanying catalogue. Its authors were scholars who had devoted – and have continued to devote – years of research to their subjects, and the entries by Mary Bennett for Ford Madox Brown, Judith Bronkhurst for William Holman Hunt, and Malcolm Warner for John Everett Millais are now the most authoritative sources of information relevant to and affecting my consideration of those artists' works. To all the authors cited above I am indebted for stimulating discussion and much personal assistance during a span of many years. I must also happily acknowledge all that I have learnt from my students at Columbia University, where I taught from 1969 to 2000. It would be invidious to try to single out individuals and impossible to name everyone who presented a paper or seminar report from which

I have profited, participated in a thought-provoking classroom discussion, or passed along a reference or piece of information, but my debts run deep.

In the preface to the first edition I acknowledged collectors, curators, dealers, and scholars to whom I was obliged for various forms of assistance. Needless to say, what I took from them remains equally a part of this new edition. Sadly, some members of that group are now deceased, but many others have remained friends from whom I have continued to draw stimulus and support. I also thank Martin Beisly, Kenneth Bendiner, Barbara Bryant, Julius Bryant, Susan Casteras, Richard Dorment, Simon Edsor, Hilarie Faberman, Charlotte Gere, Robin Hamlyn, Julian Hartnoll, Rupert Maas, Peter Nahum, Jenny Newall, Jason Rosenfeld, Peyton Skipwith, Simon Taylor, Clovis Whitfield, and Christopher Wood among the colleagues and friends who have given additional help and encouragement that is reflected in multifarious ways in this book. I should add a special word of acknowledgement to John Goelet and Christopher Newall, who, in different but overlapping ways, through their engaged enthusiasm for the art that constitutes the subject of this book led me to return to it. Christopher Newall has very generously assisted me in locating collectors and works that I had lost sight of over the years.

Finally, I wish to thank the Paul Mellon Centre for Studies in British Art and Yale University Press for making this new edition possible. At Yale University Press, John Nicoll has had a long-standing involvement with the undertaking. Sally Nicholls carried out the work of gathering the illustrations, and Kate Gallimore, as editor and designer, has done most everything else.

New York
September 2000

The best-known artists belonging to or associated with the Pre-Raphaelite Brotherhood were not primarily landscape painters, and their best-known pictures are not landscape paintings. This book is not a history of the movement, but a one-sided look at the work of some of these artists during the 1850s and 1860s, and the reader should bear in mind that there were other facets of the movement which are here ignored. The name of Dante Gabriel Rossetti is conspicuously absent from most of the following pages, and I have made no effort to discuss his central contribution to the history of the Pre-Raphaelite Brotherhood and to nineteenth-century art in general. On the other hand, I hope that the reader will be able to see the activities of these artists in a perspective not unlike that of the exhibition-going public of the 1850s, for whom Rossetti's work was unknown and Pre-Raphaelitism was what Ruskin said it was. The book is not just about Pre-Raphaelite landscape painting, but also about the Pre-Raphaelite approach to the natural world, which did lead eventually to the emergence of a school of landscape painting as an integral but distinctive part of the Pre-Raphaelite movement.

If Rossetti's name is missing, that of John Ruskin appears more frequently than that of any single artist, and this is how it should be. Ruskin dominated the contemporary art world of the 1850s. He provided the underlying ideas; he patronised the artists; he was their chosen advocate; and he remains the one mid-Victorian writer on art whose critical opinions are of more than documentary or curiosity value. Ruskin loomed large in the consciousness of most of the artists discussed in this book, and he must inevitably loom large in our awareness of their art. I have quoted and discussed his opinions abundantly, but I have tried to do so in a fashion that illuminates the pictures, rather than using the pictures to illustrate his ideas. Although I hope that this examination of activities with which he was involved in myriad ways will reflect some light, this is not a book about Ruskin.

I began this study in London in 1960 and submitted it in considerably different form as a doctoral dissertation at Yale University in 1965. I am indebted to Michael Kitson and to Robert Herbert, who gave me much assistance at the beginning of my investigations, and I owe a particular debt to George Heard Hamilton, who supervised the writing of my dissertation. Since 1965, the general reawakening of interest in Victorian art has brought to light large numbers of works by the less well-known artists, and our knowledge of the major figures has been considerably expanded, particularly by Mary Bennett's exhibitions of John Everett Millais and Holman Hunt, and by books on Millais, Hunt, and Rossetti by Mary Lutyens, Diana Holman-Hunt, and Virginia Surtees. Incorporating what I have learned since 1965 has meant writing what is essentially a new book. I am grateful to John Gere, who has given me advice and encouragement from the beginning; indeed, a footnote in his catalogue for the Phaidon Press *Pre-Raphaelite Painters* of 1948 was my initial point of departure. Mary Bennett has throughout generously shared the results of her investigations with me, and only she can know how deeply I am in her debt. In addition, the invariable hospitality and helpfulness of collectors, dealers, scholars, and museum officials have made my work easier and pleasanter than I ever deserved, and I can never properly acknowledge all the assistance I have received or my debts for suggestions and bits of information. However, I would like to record my gratitude to the following people: Keith Andrews, Patrick J. Brett, Charles Carter, James

Coats, Malcolm Cormack, Peter Fitzgerald, M. A. Ford, Mrs Robert Frank, Robin Gibson, the late Charles Handley-Read, M. S. Hickox, the Reverend Gerald Hollis, Nerys Johnson, Elizabeth Johnston, Dr Gilbert Leathart, Ian Lowe, Jeremy Maas, Hugh Macandrew, Ronald Marshall, Richard Morphet, Armide Oppé, Richard Ormond, Andrew McIntosh Patrick, William Plomer, Graham Reynolds, Ian Robertson, Robert Rosenblum, Miranda Strickland-Constable, Colin Thompson, Mrs Warwick Tompkin, William Vaughan, Mrs C. D. Wales, Ellis K. Waterhouse, Catherine Williams, and John Woodward. My employers since 1962, the Frick Collection, the Philadelphia Museum of Art, and Columbia University, have all been generous with time, facilities, and financial support; in 1970 I was the recipient of a grant from the Columbia University Council for Research in the Humanities. Finally, I am grateful to the staff of the Clarendon Press for proposing that I make this study into a book and for subsequent supervision of its production.

New York
October 1972

Dyce James Stirling Dyce, 'The Life, Correspondence, and Writings of William Dyce, R.A., 1806–64: Painter, Musician, and Scholar', unpublished typescript in the Aberdeen Art Gallery.

Hunt William Holman Hunt, *Pre-Raphaelitism and the Pre-Raphaelite Brotherhood*, 2 vols, 1905.

Millais John Guille Millais, *The Life and Letters of Sir John Everett Millais* 2 vols, 1899.

Ruskin *Works* *The Works of John Ruskin*, E. T. Cook and Alexander Wedderburn, eds, 39 vols, 1903–12.

Seddon [John Pollard Seddon], *Memoir and Letters of the Late Thomas Seddon, Artist, By His Brother*, 1858.

Tate 1984 Tate Gallery, London, *The Pre-Raphaelites* (exhibition catalogue), 1984.

All dimensions are in inches, height precedes width.

The Pre-Raphaelite Brotherhood from 1848 to 1851

When the Pre-Raphaelite Brotherhood was formed in the autumn of 1848, no manifesto was issued. Although the members of the Brotherhood and their immediate associates did make statements about the nature and purpose of art at various times, notably in the four issues of their short-lived periodical *The Germ*, none of these statements can be taken as a clear-cut assertion of the beliefs of the group at the moment of their decision to join together in a Brotherhood. Probably, even at the moment of their greatest unity, they never agreed entirely upon a common purpose. That is certainly implied in Holman Hunt's memoirs, *Pre-Raphaelitism and the Pre-Raphaelite Brotherhood*, published in 1905, where he describes his laborious efforts to educate his friend Dante Gabriel Rossetti as to the true meaning of their movement.[1]

The youth of all the figures involved is perhaps the most important single factor to remember when trying to assess what the artists were attempting when they chose to form their group. In the autumn of 1848, William Holman Hunt was twenty-one years old; Dante Gabriel Rossetti was twenty; John Everett Millais was only nineteen. Of their four associates in the Brotherhood, William Michael Rossetti, Frederick George Stephens, Thomas Woolner, and James Collinson, none was older than twenty-three. Whatever they may have been, or wanted to be, in 1848, all of them were to change considerably in the next few years. It is with Pre-Raphaelitism as it took shape in the 1850s – or with one aspect of the movement which only came to the forefront in 1851 – that this study is concerned. Nonetheless, the movement was born in the 1840s, and some attention must be paid to its formative years.

Beyond the bonds of youthful conviviality and fellowship, which were of substantial importance, the members of the Brotherhood were probably most strongly united in their dislike of the conventionality and insipidity of most of the painting they saw being produced and exhibited around them. Holman Hunt's account of the movement's formation describes their 'determination ever to do battle against the frivolous art of the day, which had for its ambition "Monkeyana" ideas, "Books of Beauty", Chorister Boys, whose forms were those of melted wax with drapery of no tangible texture'.[2] In particular, the Pre-Raphaelites disliked the rising young associate members of the Royal Academy, whose pictures Dante Gabriel Rossetti described in 1850 as 'so closely resembling each other (though from different hands) as hardly to establish a separate recollection'.[3] In the review in which this comment appeared, Rossetti specifically cited William Powell Frith, Frederick Goodall, and Frank Stone; later, in 1865, William Michael Rossetti wrote 'Praeraphaelitism aimed at suppressing such styles of painting as were exemplified by Messrs. Elmore, Goodall, and Stone, at the time of its starting; and it did suppress them.'[4] But, if the Pre-Raphaelites were reacting against what they considered the low state of some of the art around them, the form their reaction took depended heavily on other developments in English painting during the 1840s. The most obvious sign of this dependence is the name that the young artists chose to give to their movement.

The name 'Pre-Raphaelite Brotherhood' suggests a conscious emulation of early Italian art, and even before the meaning of the initials 'PRB' was made public in the spring of 1850, the first exhibited products of the Pre-Raphaelite Brotherhood were seen as imitations of early art. The first picture to be exhibited bearing the initials 'PRB' was

Facing page: Charles Allston Collins, *Convent Thoughts* (detail of Pl. 9).

Rossetti's *Girlhood of Mary Virgin* (Tate Gallery, London), which he sent to an exhibition in Hyde Park in the spring of 1849. In May 1849, the *Art Journal* described Rossetti's picture as 'the most successful as a pure imitation of early Florentine art that we have seen in this country', and in his brief mention the reviewer managed to suggest similarities with the Giotteschi, Piero della Francesca, and Paolo Uccello.[5] In the following month, when the *Art Journal* reviewed the Royal Academy exhibition, Millais's *Isabella* (Walker Art Gallery, Liverpool) and Holman Hunt's *Rienzi* (Pl. 4) were described similarly. The Millais was 'a pure aspiration in the feeling of the early Florentine school', while Hunt's picture provoked the comment, 'We have this year seen more essays in the manner of early Art than we have ever before remarked in the country within so short a period.'[6]

The Pre-Raphaelites' attachment to early Italian art, which the movement's name implied, and which the pictures demonstrated to contemporary viewers, was a product of growing awareness of early art in England during the 1840s. This growth of interest is manifested by the number of books that appeared during the decade. Charles Eastlake's translation of Franz Kugler's *Handbook of the History of Painting* appeared in 1842. It was followed by Mary Philadelphia Merrifield's translation of Cennino Cennini in 1844, Anna Jameson's *Memoirs of the Early Italian Painters, and of the Progress of Painting in Italy: From Cimabue to Bassano* in 1845, the second volume of Ruskin's *Modern Painters* in 1846, and Lord Lindsay's *Sketches of the History of Christian Art* in 1847. The extraordinary redirection of English taste which these works reflect is most evident in the early writing of John Ruskin. In 1843, in the first volume of *Modern Painters*, the seventeenth century provided the sole standard by which Ruskin set out to prove the superiority of Turner and other nineteenth-century landscape painters. In the second volume, published three years later, even Turner was set aside for eloquent passages describing Giotto, Fra Angelico, and Tintoretto.[7] The growth of an art historical interest in quattrocento and earlier Italian painting went hand-in-hand with actual developments in English art during the decade, and this was what at least some of the writers wanted. For example, in 1847 Lord Lindsay concluded his two volumes with an exhortation to English painters to study Italian art before Raphael and Michelangelo.[8] But at the centre of the new developments in painting was also the practical need of decorating the new Palace of Westminster, Sir Charles Barry's great building, which replaced the Houses of Parliament destroyed by fire in 1834. In 1841 a commission, headed by Prince Albert, was appointed by Parliament to supervise the decoration of the new building. It decided that the interior should be decorated with monumental frescoes, an undertaking without precedent in England, and sponsored a series of competitions to select the artists. The project was partly inspired by the example of the frescoes painted in Rome and Munich by the German artists known as the Nazarenes, who earlier in the century had undertaken their own revival of early Italian art. Two German painters, Peter Cornelius and Julius Schnorr von Carolsfeld, gave advice, and at various times the commissioners considered actually employing German artists.[9] In addition to following the German lead, the English also took a practical interest in early Italian fresco painting. The government sent abroad several representatives, including Mrs Merrifield, Charles Eastlake, and William Dyce to study techniques. Eastlake's *Materials for a History of Oil Painting*, published in 1847, and Mrs Merrifield's *Original Treatises, dating from the XIIth to XVIIIth Centuries on the Arts of Painting*, published in 1849, both resulted from this officially sponsored research. Dyce's report appeared as an appendix to the *Sixth Report of the Commissioners on the Fine Arts* in 1846.

This activity naturally led to a greater general awareness of early art among English artists. It also brought into prominence a number of artists who had some background of continental experience or training, the most important of them being William Dyce. Born in Aberdeen in 1806, Dyce visited Rome twice during the 1820s. On his second visit, in 1827–8, he came into contact with the Nazarene group, forming a friendship with Friedrich Overbeck which he maintained over the following twenty years.[10] To what extent his painting of the 1820s was influenced either by the Nazarenes or by early Italian art is unclear. His work done in Italy, notably a *Madonna and Child*, which the Germans were said to have taken up a subscription to purchase, has all disappeared, and after he returned to Scotland, he turned to painting portraits in a fairly conventional style reminiscent of Raeburn and Lawrence. In 1837 he was appointed Master of the Trustee's Academy in Edinburgh, the chief art school in Scotland, and in the same year he travelled abroad on behalf of the newly formed Schools of Design in London to study methods of education in France and Germany. In 1838 he was appointed Superintendent of the Schools of Design, a position which he held until 1843.

Dyce's appointment as a teacher seems to have ended his activity as a professional portrait painter and to have allowed him to follow a more adventurous path. At the Royal Academy in 1838 he exhibited a *Madonna and Child*; this was possibly a painting now in the Tate Gallery, which recalls both early Italian and Nazarene prototypes.[11] In the following year he exhibited *St Dunstan Separating Edwy and Elgiva* with the accompanying explanation in the catalogue: 'Design for the façade of a Chapel, in the style practised by the scholars of Giotto in upper Italy, intended to illustrate the polychromatic decoration of the end of the fourteenth century.' Reviewing the Royal Academy exhibition of 1839, the *Art Union* called Dyce's ideas 'peculiarly his own' and declared 'his course is not a wise one'.[12] Nevertheless, in the following few years, Dyce's position was to shift rapidly from that of an educator with eccentric ideas to one of prominence among English artists. In 1841 he was one of the first witnesses to appear before the committee responsible for the Parliament decorations. In 1845 he received the first actual commission for a fresco in the new House of Lords, and in the following winter he was sent abroad on behalf of the government. He was elected an associate member of the Royal Academy in 1844 and a full member in 1848. He received several commissions from Prince Albert during the 1840s, and, following the completion of his fresco in the House of Lords, he received in 1847 an additional commission for the Palace of Westminster: to paint a cycle of frescoes in the Queen's Robing Room, a project that was to occupy him for the rest of his life.

Dyce was the most eminent, but he was only one among several artists brought into prominence by the new activities and interests of the 1840s. One of the most significant results of the Parliament competitions was that, in addition to causing artists to look abroad and to the past for models of fresco painting, they also attracted back to England a number of artists who had been trained or had lived on the continent. Among these artists was one figure who was to play a central role in the Pre-Raphaelite movement: Ford Madox Brown. Born in Calais of English parents, Brown studied painting first in Belgium; then from 1840 to 1844 he lived in Paris. In 1844 he submitted two cartoons for frescoes to the competitions for the Houses of Parliament; he also came to London to live. The style Brown brought with him, as represented by his cartoon of *The Body of Harold Brought before William the Conqueror* (South London Gallery), echoes contemporary French painting, specifically a work he would have seen exhibited in the Salon of 1841, Delacroix's *Crusaders Entering Constantinople* (Louvre, but painted for the historical galleries created by Louis-Philippe at Versailles, in their way a French prototype for the Parliament decorations).

Brown spent the winter of 1845–6 in Rome. There he visited the studios of Cornelius and Friedrich Overbeck and was much impressed by both artists.[13] He was also exposed to early art, both in Italy and *en route*. In a letter written twenty years later he listed among his strongest memories the Holbeins in the museum at Basel.[14] Among the pictures he painted after his return, he described one, a *Portrait of James Bamford* (location unknown) as 'a Holbein of the 19th Century'.[15] Another work, a cartoon of the Madonna and Christ child with attendant angels, *Oure Ladye of Good Children* (Tate Gallery), was 'little more than the pouring out of the emotions and remembrances still within me of Italian Art';[16] and Brown's larger pictures from this period, *Chaucer at the Court of Edward III*, begun in Rome in 1845 but finished only in 1851 (Pl. 1), and *Wycliffe Reading his Translation of the Bible to John of Gaunt*, painted in the winter of 1847–8 (City Art Gallery, Bradford), both show strong Nazarene influence.[17]

In March 1848, Dante Gabriel Rossetti wrote a letter to Ford Madox Brown introducing himself as a student in the Royal Academy schools, professing admiration for Brown's works, and asking to become his pupil.[18] Rossetti did work under Brown briefly, but, apparently because he found the kind of disciplined routine expected by Brown too irksome, he soon left and began to work instead in the studio of Holman Hunt. Nonetheless, Rossetti and Brown remained close friends for the rest of their lives, and Rossetti's *Girlhood of Mary Virgin*, although painted in Hunt's studio, shows a direct and heavy dependence on Brown's *Oure Ladye of Good Children*.[19] Either Brown was invited and declined to become a member of the Pre-Raphaelite Brotherhood, or an invitation to him was framed and never delivered.[20] In either case, although Holman Hunt later tried to minimise Brown's importance, he was intimately and significantly involved in the Brotherhood's formation and with most of its members' activities in the following years.

Hunt's attempt in *Pre-Raphaelitism and the Pre-Raphaelite Brotherhood* to belittle Brown's role in the formation of the Brotherhood was only part of a larger effort to deny Pre-

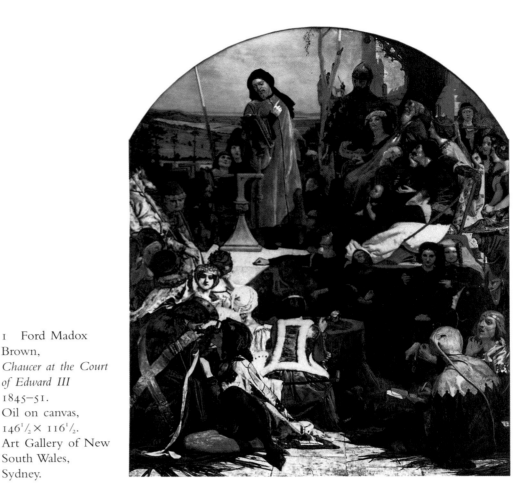

1 Ford Madox
Brown,
*Chaucer at the Court
of Edward III*
1845–51.
Oil on canvas,
146¹/₂ × 116¹/₂.
Art Gallery of New
South Wales,
Sydney.

Raphaelite emulation of either early Italian art or the German Nazarenes. According to
Hunt's account, the first principle of Pre-Raphaelitism from the beginning was 'a child-
like reversion from existing schools to Nature herself'.[21] Although what Hunt says must
be respected as the most cogent first-hand account of Pre-Raphaelitism that we possess,
the evidence of the name the artists chose to give to their Brotherhood, the critical reac-
tion to their first pictures, cited above, and the pictures themselves all suggest that Hunt's
arguments, published over half a century later, place a one-sided interpretation upon his
own and his colleagues' activities in 1848. Nonetheless, unless we take Hunt's memoirs
as total fabrications, which they certainly are not, truth to nature was an overriding con-
cern of Hunt's from well before the actual formation of the Pre-Raphaelite
Brotherhood.

Realism or naturalism of one sort or another were interests widespread throughout
Europe during the middle years of the nineteenth century, and it was perhaps inevitable
that a would-be revolutionary movement whose first works were contemporary with
The Stonebreakers by Gustave Courbet (Pl. 2) and *The Sower* by Jean-François Millet
would embody some of the same concerns. However, if we compare Courbet's
Stonebreakers with Rossetti's *Girlhood of Mary Virgin*, Millais's *Isabella*, or Hunt's *Rienzi*, it
is apparent that whatever naturalistic or realistic urges lay behind the first Pre-Raphaelite
pictures, they were not only very different from those present in Courbet's painting, but
also mixed with other, contradictory tendencies. The inherent contradictions in the first
Pre-Raphaelite pictures were soon reflected in a split between Rossetti on one hand and
Hunt and Millais on the other. Whereas the archaising and revivalist elements in
Rossetti's art remained and became more important, Hunt and Millais both moved
rapidly towards greater naturalism, divesting themselves of any obvious dependence on
early art.

The two most conspicuous components of Pre-Raphaelite naturalism, which were
present from the start, were minute detail and bright colour with a minimum of shad-
ow. The artists considered both to be more true and less conventional than breadth of
handling and organising the composition of a picture primarily by contrasts of light and
shade. For both their detailed handling and their bright colour, the Pre-Raphaelites had
numerous forerunners among English artists active in the 1830s and 1840s. Of most
obvious significance for them were probably William Mulready and the watercolourist
William Henry Hunt, both of whom, in addition to a finical delicacy in handling,

2 Gustave Courbet, *The Stonebreakers* 1849.
Oil on canvas, 63 × 102. Destroyed (formerly
Gemäldegalerie, Dresden).

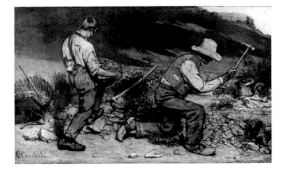

THE PRE-RAPHAELITE BROTHERHOOD FROM 1848 TO 1851

developed in their different media unprecedented brightness of colour by glazing transparent broken colours over a white ground.

But, of course, bright colours were not foreign to the artists who lived before Raphael. The English painters in 1848 saw in early art not only quaintness, grace, and charm, but also an honesty and a freedom from the conventions which these later artists were trying to escape. In this, they shared the attitudes of Ford Madox Brown and William Dyce, the painters whose interest in early art anticipated their own. The most significant single change in Brown's art following his trip to Italy in 1845–6 was a lightening of his palette. This can be seen, for example, in the difference between his *Prisoner of Chillon* of 1843 (City Art Gallery, Manchester) and the large *Chaucer at the Court of Edward III* (Pl. 1) begun in Rome in 1845. Brown later ascribed the change to the impact of Italy: 'During my sojourn, Italian art had made a deep, and as it proved, lasting impression on me, for I never afterwards returned to the sombre Rembrandtesque style, I had formerly worked in.'[22] Although Brown's change from Rembrandtesque to Italianate light and colour could be interpreted simply as the substitution of one set of conventions for another, he saw it as part of an attempt to gain more exact truth. He described the *Chaucer* as the first work in which he endeavoured to treat light and shade 'absolutely, as it exists at any one moment, instead of approximately, or in generalized style'.[23] It should be noted, however, that although Brown began the *Chaucer* in Rome in 1845, he only completed and exhibited it in 1851, three years after the formation of the Pre-Raphaelite Brotherhood. Holman Hunt claimed that in completing the picture Brown was influenced by the Pre-Raphaelites' example.[24] The work which Brown claimed gave 'first evidence of an entirely new direction of thought and feeling' was the *Portrait of James Bamford* of 1846. It is now lost, but we do have Brown's statement of what he was trying to do and how it contrasted with his earlier work:

> To those who value facile completeness and handling, above painstaking research into nature, the change must appear inexplicable and provoking. Even to myself at this distance of time [written in 1865], *this instinctive turning back to get round by another road*, seems remarkable. But in reality it was only the inevitable result of the want of principle, or rather confliction of many jarring principles under which the student had to begin in those days. Wishing to substitute simple imitation for *scenic effectiveness*, and purity of natural colour for scholastic depth of tone, I found no better way of doing so than to paint what I called a *Holbein of the 19th century*. I might, perhaps, have done so more effectively, but *stepping backwards* is stumbling work at best.[25]

No clearer statement exists of the link made by the Pre-Raphaelite group in the late 1840s between their aims toward a new naturalism free from inherited conventions and their awareness of early art. 'Simple imitation' and 'purity of natural colour' would become and remain essential ingredients of Pre-Raphaelite naturalism through the 1850s.

William Dyce's easel paintings of the 1840s, for example his *Madonna and Child* at Osborne House, painted for Prince Albert in 1845 (Pl. 3), are much more obviously Italianate than any of Brown's pictures or those of the Pre-Raphaelites, and they do not appear to be based on the same naturalistic urges which Brown and his younger friends asserted lay behind their works. Nevertheless Dyce was concerned with the naturalness of effect of the quattrocento works he admired. When he was in Italy in the winter of 1845–6 (at the same time as Ford Madox Brown), Dyce kept a notebook of his observations. This was the basis of his technical recommendations for fresco painting published in 1846 mentioned above, but the full notes, which have never been published, contain much more than the material of the report.[26] Dyce's greatest admiration was for Pinturicchio, who attracted him primarily because of his decorative richness; the Piccolomini Library in Siena was for Dyce 'a most magnificent piece of decorative art in which mere brilliancy and harmony of effect exceeds any other production I am acquainted with.' But Dyce also admired Pinturicchio for truth of local colour, and he was puzzled how Pinturicchio achieved his effects. He concluded that they depended on opposition of colour, rather than on chiaroscuro, but he remained at a loss to explain such methods as shading lake-coloured draperies with lake and nothing else:

> I suspect that we modern painters do not study nature enough in the open air, or in broad daylight, or we should be better able to understand how the old painters obtained truth by such apparently anomalous means. In sunlight, shadows partake largely of the local colour of the objects, and still more so in the shade, viz: seen by

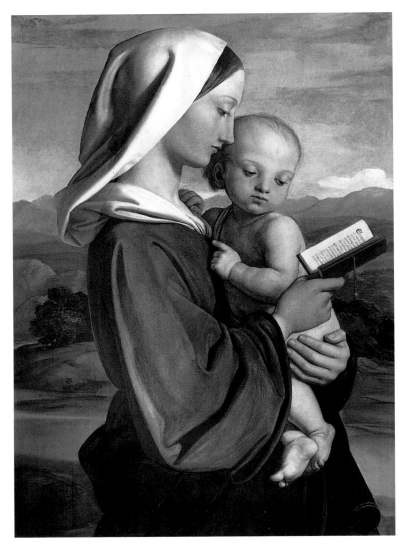

3 William Dyce,
Madonna and Child
1845. Oil on canvas,
31½ × 25.
Collection of Her
Majesty the Queen.

the diffused light of the sky; indeed in the open air I have observed that peculiar indef-
initeness of the shadows and darkening of the receding and undercut parts which is
so characteristic of the older painters, and which nobody doubts is more effective for
mural painting on a large scale than the sort of painter's studio shadowing, which from
habit and prejudice one can hardly nowadays avoid. The Germans such as Cornelius
attempt to follow the old painters in their method of darkening rather than shadow-
ing: but without success, simply because they learn the method from old art rather
than from nature. . . .

Of this I am quite convinced that no degree of study in the painting room with a
small confined light will ever enable one to make any approach to the kind of open
daylight reality obtained by the early painters.

Although Dyce was not as intimately involved with the Pre-Raphaelites as Ford
Madox Brown, during the 1840s he was known and admired by them. He seems to have
taken a special interest in Holman Hunt. According to Hunt's memoirs, they often talked
together when Hunt was a student in the Life School of the Royal Academy. Later, Dyce
commissioned Hunt to paint a copy of his *Meeting of Jacob and Rachel* exhibited at the
Royal Academy in 1850, found other work for him, and offered him a job as his studio
assistant. Hunt recorded one conversation in which they contrasted Dyce's art with the
'asphaltum indefiniteness' of the earlier nineteenth-century painters David Wilkie and
William Hilton.[27]

In addition to helping Holman Hunt, Dyce also gave the Pre-Raphaelites support in
one other way which was to have vast consequences: he made John Ruskin look at their
pictures. According to Ruskin, his introduction to the school came at the Royal
Academy in 1850, when Dyce dragged him up to Millais's *Christ in the House of His
Parents* (Tate Gallery), 'which I had passed disdainfully, and forced me to look for its mer-
its'.[28] Ruskin's editors cited this statement as proof that Ruskin did not inspire Pre-
Raphaelitism, and similar denials of Ruskin's importance for the origins of the
movement have also been made in many histories of Pre-Raphaelitism, notably in the

life of Millais by his son, John Guille Millais.[29] But the denials are misleading. Although Ruskin may not have been aware of the young artists until 1850, and although they had no personal contact for another year, the Pre-Raphaelites had certainly been exposed to Ruskin and to his ideas through his books. For Holman Hunt, Ruskin was of seminal importance; in the summer of 1847 a friend lent Hunt Ruskin's *Modern Painters*, of which by then the first two volumes had been published. Its impact was immediate: 'of all its readers none could have felt more strongly than myself that it was written express-ly for him. When it had gone, the echo of its words stayed with me, and they gained a further value and meaning whenever my more solemn feelings were touched.'[30]

The two volumes of *Modern Painters* which were available to Hunt embody an analo-gous combination of interests in nature and in Italian art to that which we have seen in Ford Madox Brown and William Dyce. In Ruskin's case, the link seems accidental, or rather the outgrowth of his evolving sensibility. *Modern Painters* began as a defence of Turner. The seeds lay as far back as 1836 when Ruskin, then seventeen years old, wrote a reply to *Blackwood's Magazine* protesting against its hostile criticism of Turner.[31] The reply was not published, and by 1843, when the first volume of *Modern Painters* appeared, the defence of Turner had grown into a projected three-volume treatise on landscape art. Ultimately *Modern Painters* was to consist of five volumes with chapters on almost every-thing under the sun, but in 1843 Turner was still very much to the fore. Ruskin origi-nally wanted to call the book 'Turner and the Ancients', but the publishers changed it to 'Modern Painters: Their Superiority in the Art of Landscape Painting to All the Ancient Masters: Proved by Examples of the True, the Beautiful, and the Intellectual, From the Works of Modern Artists, Especially from those of J. M. W. Turner, Esq. R. A.: By a Graduate of Oxford'. The three classes of the True, the Beautiful, and the Intellectual cited in the title were intended to be the subjects of the three separate vol-umes, and in the first Ruskin set out to prove Turner's superiority in truth to all other artists, both ancient and modern. Following a fairly involved theoretical preamble, Ruskin's method of argument was simple. By long descriptive passages he attempted to demonstrate the objective facts of nature; he then compared the work of all other artists unfavourably to his own descriptions and concluded by demonstrating how only Turner achieved the truth. Although truth was to be only one aspect of Ruskin's three-volume attack, he made abundantly clear that it was the most essential quality in art, and his fun-damental criterion of evaluation.

The second volume of *Modern Painters*, published in 1846, does not contradict the first, but it is a very different book. Not only is it about beauty rather than truth, as Ruskin had intended from the start, but it has a different cast of characters. In the first volume, the 'Ancient Masters' to whom Ruskin compared Turner were mainly the landscape and seascape painters of the seventeenth century. His frame of reference was limited to the picture collections available to him in London in the Dulwich Picture Gallery and the then young National Gallery. A trip to Italy in 1845 was for Ruskin a revelation. As a result, he turned his back on landscape painting and began to establish himself as England's most eloquent advocate of Italian art. In the subsequent volumes of *Modern Painters* he returned to the subject of landscape and to Turner, but as the third and fourth volumes appeared only in 1856, and the fifth in 1860, they were too late to have had any influence in shaping the initial goals of Pre-Raphaelitism.

For the formation of the Pre-Raphaelite Brotherhood in 1848, Ruskin's second vol-ume probably had the greater immediate importance, helping to nourish the urge that led the Brotherhood to call itself Pre-Raphaelite. But in 1851, when Ruskin published a pamphlet entitled *Pre-Raphaelitism*, he claimed in his preface that the Pre-Raphaelites were putting into practice what he had called for in the concluding pages of the first volume of *Modern Painters*. There Ruskin had turned the book's insistence upon Turner's truth to nature into an exhortation to the young artists of England:

> They . . . should go to Nature in all singleness of heart, and walk with her laborious-ly and trustingly, having no other thoughts but how best to penetrate her meaning, and remember her instruction; rejecting nothing, selecting nothing, and scorning nothing; believing all things to be right and good, and rejoicing always in the truth.[32]

This passage was assumed by many contemporary critics to be the basic dictate underlying the detailed naturalism of the Pre-Raphaelites. It was, however, only one eminently quotable bit lifted out of a long and involved book which argues con-sistently for the kind of painting that Pre-Raphaelite art was to become. Truth to nature, called for by Ruskin in 1843 and by Holman Hunt in 1848, was, of course, not a new

idea; concepts of natural truth have motivated so many artists, at so many times, painting in so many different manners, that the phrase is virtually meaningless. But Ruskin presented his demands in specific and idiosyncratic terms which define a very different path than that of, say, Constable (who set out to be a 'natural painter' and whom Ruskin detested). The most repeated of Ruskin's principles, and the one which most distinguishes him from most earlier English theorists, notably Reynolds, is his preference for particular truths over general ones, those which are the most informative about the individual qualities of a subject rather than about what the subject has in common with everything else.[33] Of particular truths, the most valuable are the most 'historical', those which 'tell us the most about the past and future states of the object to which they belong'.[34] For Ruskin truth of tone, as seen in a landscape by Claude, is of little value because it is characteristic only of a single moment, whereas the detailed delineation of a tree's branches tells us what the tree has been and what it will become.

These principles lead directly to another leitmotiv of the book: insistence upon detail and finish. This concern may seem out of place in a book about Turner, but Ruskin argued that Turner's breadth was based on a fine control over the details of nature, which the artist had developed in his earlier works. Thus Turner became a model for the young artist, who should only be allowed to indulge in broader effects after a faithfully minute study of natural forms.[35] In his concluding advice, Ruskin emphatically repeated his demand for detail. He criticised the public preference for brilliancy and rapidity of execution as a taste for glitter and claptrap. Artists should make and exhibit sketches, but these should be distinct from finished works. A picture should have the wholeness and effect of nature, but it would be incomplete unless it also contained 'the inexhaustible perfection of nature's details'. After satisfying himself on the first requirement, the painter should always ask himself: 'Can my details be added to? Is there a single space in the picture where I can crowd in another thought?'[36]

Despite its different focus, the second volume of *Modern Painters* repeats the emphasis on detail and finish. Now, instead of Turner's, it is the 'divine finish' of Perugino, the young Raphael, Fra Angelico, Pinturicchio, Giovanni Bellini, 'and all such serious and loving men', which is praised and contrasted to the coarse and slurred painting of Ribera, Salvator Rosa, and Murillo.[37] Ruskin praised the backgrounds of Perugino for their exquisite refinement of natural detail, but he did not urge their imitation: 'the only safe mode of following in such steps is to attain perfect knowledge of Nature herself'.[38]

The Pre-Raphaelites set out to follow this advice to the letter. In Holman Hunt's account, the real moment of genesis of Pre-Raphaelitism was a conversation between Hunt and Millais – or, more accurately, a lecture Hunt gave to Millais – that took place in February 1848.[39] After railing against the lack of discipline and lack of purpose among present-day artists, Hunt brought in *Modern Painters* as his chief weapon: 'By Jove! passages in it made my heart thrill. He feels the power and responsibility of art more than any author I have ever read.' Hunt described the book at some length to Millais because of the contrast of the men 'of such high purpose and vigour', which it described, to 'the uninspired men of today'. It demonstrated a need for young artists to consider what course to follow, and it helped one 'to see the difference between dead art and living art at a critical juncture'. Bursting with revolutionary enthusiasm, Hunt and Millais agreed to paint their next pictures according to new principles. Although in his harangue Hunt had described the second volume of *Modern Painters*, his resolution was more in accord with the advice which concluded volume one. He could not alter his present picture, *The Flight of Madeline and Porphyro* (Guildhall Art Gallery, London), which was an interior, night scene, but he declared: 'I purpose after this to paint an out-of-door picture, with a foreground and background, abjuring altogether brown foliage, smoky clouds, and dark corners, painting the whole out of doors, direct on the canvas itself; with every detail I can see, and with the sunlight brightness of the day itself.'

The next picture, in which Hunt put this resolution into practice, was *Rienzi Vowing to Obtain Justice for the Death of his Younger Brother Slain in a Skirmish between the Colonna and Orsini Factions* (Pl. 4). *The Flight of Madeline and Porphyro* had been most original in being based on a poem, 'The Eve of St Agnes', by Keats, who remained relatively little-known in 1848. Otherwise, it is not too unlike the theatrically staged and elaborately costumed scenes from history and literature being painted by those associate members of the Royal Academy of whom the Pre-Raphaelites so disapproved. *Rienzi* is still a painting of a literary subject in historical costume, but it is a much more individual, and indeed revolutionary work, as Hunt intended it to be. Based on the opening pages of

Edward Bulwer-Lytton's novel *Rienzi: The Last of the Roman Tribunes*, Hunt's picture manifests the new Pre-Raphaelite ambitions in several ways. It shows Cola di Rienzi swearing an oath over the body of his dead brother; Rienzi's fulfilment of that oath by leading a popular revolution, which overthrows the Roman nobility, forms the substance of the novel. In 1848 the novel had a timely message, which Bulwer-Lytton pointed out in the preface to a new edition published that year. Hunt also saw the message: 'Like most young men, I was stirred by the spirit of the passing revolutionary time. The appeal to Heaven against the tyranny exercised over the poor and helpless seemed well fitted for pictorial treatment'.[40] Hunt's embodiment of his subject in a lucid, four-square figural composition seems to relate the picture to a series of neo-classic depictions of fervent patriotic oaths, harking back to and beyond Jacques-Louis David's *Oath of the Horatii*. But the delicate drawing and bright colours, as well as Hunt's choice of a subject from fourteenth-century Italy, point to other sources. As we have seen, the *Art Journal* classified *Rienzi* as an essay 'in the manner of early art', and it described Hunt's picture as 'perhaps more austere in its denials than any of the others'.[41]

To put into practice his resolution of February, Hunt had begun his picture in the summer of 1848 by attempting to paint each part from nature. He took his canvas to Lambeth to paint a fig tree directly in the sunlight in the garden of F. G. Stephens's father. He also painted there a patch of grass and dandelions. He painted the background and trees at Hampstead. Later, for the shields and spears he took his canvas to the Tower of London, and he painted the figures in the studio during the following winter. His work from nature was done with what Hunt described as unprecedented exactness. He painted 'directly and frankly, not merely for the charm of minute finish, but as a means of studying more deeply Nature's principles of design, and to escape the conventional treatment of landscape backgrounds'.[42]

Unfortunately, an assessment of *Rienzi* must depend as much on Hunt's statement of what he did as on the picture itself. In 1886 he discovered that it had been covered with a heavy varnish, which was affecting the pigments. In removing this he found the back-

4 William Holman Hunt, *Rienzi Vowing to Obtain Justice for the Death of his Younger Brother Slain in a Skirmish between the Colonna and Orsini Factions* 1848–9. Oil on canvas, 32½ × 47½. Private Collection.

5 William Holman Hunt, *A Converted British Family Sheltering a Christian Missionary from the Persecution of the Druids* 1849–50. Oil on canvas, 43¾ × 52½. Ashmolean Museum, Oxford.

ground so severely damaged that he extensively repainted it.[43] The foreground parts were apparently not repainted, but their present condition suggests that they suffered from the scraping required to remove the varnish. As the picture now stands, the handling in the foreground is much thinner than that in Hunt's works of the following years, and the detail is less abundant. Hunt described the 'gravelly variations and pebbles, all diverse in tints and shapes as found in Nature', which he painted 'instead of the meaningless spread of whitey brown which usually served for the near ground',[44] but the variations and pebbles are now barely noticeable. Whether detail has actually disappeared is open to question. If we accept the probability that the picture no longer possesses its original appearance, we should also note that in their reviews neither the *Athenaeum* nor the *Art Journal* made any mention of the picture's natural detail when it appeared at the Royal Academy in 1849.[45] Despite Hunt's assertions to the contrary, it is perhaps appropriate to discern in his treatment of foreground details some of that archaising spirit which the contemporary reviewers saw as the picture's dominant quality. It is difficult not to see the charm of minute finish in the foreground dandelions and, behind it, a desire to emulate the foreground flowers of quattrocento paintings.

In his next two major pictures, exhibited at the Royal Academy in 1850 and 1851, *A Converted British Family Sheltering a Christian Missionary from the Persecution of the Druids* (Pl. 5), and *Valentine Rescuing Sylvia from Proteus* (Pl. 6), Hunt followed the path he laid down in *Rienzi*. Both pictures are elaborate compositions of several figures, and both are historical reconstructions. As in *Rienzi*, landscape elements are limited to subordinate parts of the pictures, but Hunt began each picture by painting those parts directly from nature. For the earlier picture he worked during August and early September 1849 on the Lea Marshes in Essex. He painted the background of the other in Knole Park in Kent

in the latter part of October and early November of 1850. Although the landscapes seem relatively insignificant in the overall compositions of the pictures, Hunt seems to have considered them of essential importance. He chose the subject of the *Druids* because it would allow him to compete in the Academy's Gold Medal contest, which required the illustration of 'An Act of Mercy'; however, as he worked out the composition he realised that the specified size of canvas for the competition would not leave 'a margin, most precious in my eyes', on which to paint a landscape setting. He included the landscape and did not enter the competition.[46]

In the *Druids* the chief figures are seen in a hut. The landscape setting consists of a strip of water to which the hut is open along the foreground, a view of a Stonehenge-like monument through an opening underneath the hut's roof, and a narrow strip of landscape running from bottom to top of the picture along its right side. Hunt had projected all these elements in a drawing dating from May 1849 which is reproduced in his memoirs as the 'First Design' for the picture (Johannesburg Art Gallery).[47] The landscape background contains figures – a mob of Druids pursuing a priest – which contribute to the picture's story, and on the right side is a cultivated garden which Hunt intended to symbolise the influence of Christianity. As specified by Shakespeare, the background of *Valentine Rescuing Sylvia*, which illustrates the final scene of *The Two Gentlemen of Verona*, is supposed to represent the Forest of Mantua, through which are seen approaching the Duke of Milan and his retinue.

In both pictures the elaboration of foreground detail is much more pronounced than in *Rienzi*, and, in both, separately delineated leaves and other botanical details are the chief elements thus elaborated. The distant parts of the pictures do not share this precision. The trees along the horizon of the *Druids* are quite fuzzy, in sharp contrast to the leaves along the top of the hut to which they are juxtaposed. In the painting from the following year, not only are the landscape elements of the background less precise and

6 William Holman Hunt, *Valentine Rescuing Sylvia from Proteus* 1850–1. Oil on canvas, 38³/₄ × 52¹/₂. Birmingham Museum and Art Gallery, .

elaborate than the foreground leaves and grass, but the group around the Duke of Milan appears to be unfinished. Although Hunt's account of his work on this picture describes his usual difficulties in having it ready in time for the Royal Academy exhibition, he does not say that he was forced to leave off before completing it.[48] As the background figures in the small oil sketch of the subject which he began earlier, but completed and sold as a replica in 1852 (private collection), show a similar treatment, it appears intentional, as if Hunt was avoiding carrying the sharp focus of his foreground into the depth of the picture, but had no better way of achieving breadth than to leave his work unfinished.

In *Valentine Rescuing Sylvia* Hunt for the first time made extensive use of a new technique, as did Millais in his pictures of the same year. This was painting over a wet white ground.[49] Previously, to gain brilliant colours they had painted over a white ground, following the lead of older artists such as William Mulready. They apparently developed independently the use of a wet ground applied fresh each day, probably by attempting to emulate in oil paint the methods of fresco painting. Thus, their practice, which would become a cornerstone of subsequent Pre-Raphaelite painting, was ultimately a product of the interest in early technical processes generated by the programme for decorating the new Palace of Westminster. Exactly when Hunt and Millais began to develop the technique is unrecorded. In his picture exhibited in 1851 Hunt used it for the heads and hands of Valentine and Proteus and for the brighter costumes. The result was much greater brilliance in colour, and this development in the work of both Hunt and Millais was noted by contemporary observers.[50]

In Hunt's account of his career, his pictures of 1850 and 1851 continued the study of nature which he had first put into practice in *Rienzi*. Both were painted 'with unprecedented care for their landscapes'.[51] This is the view taken also in the first substantial review of Hunt's early activities, a pamphlet, *William Holman Hunt and His Works*, published anonymously in 1860, but written by Frederick George Stephens. Stephens was an erstwhile pupil of Hunt's and one of the founding members of the Pre-Raphaelite Brotherhood, who gave up painting to become a critic. In his pamphlet Stephens defined Pre-Raphaelitism as basically concerned with minute truth to nature.[52] According to Stephens, *Rienzi* was 'anything but perfect' as a Pre-Raphaelite picture, but Hunt progressed in the *Druids* – 'Above all, this picture showed the partially successful representation of the natural effect of sunlight' – and he made in *Valentine Rescuing Sylvia* 'an enormous advance in execution, in potency, and fidelity of treatment'.[53] Most critics outside the immediate Pre-Raphaelite circle still saw Hunt's and his colleagues' pictures of 1850 and 1851 as imitations of early art, but now they had a reason other than the evidence of the pictures themselves. In the spring of 1850 the world learned the meaning of the initials 'PRB' which the artists had put on their pictures exhibited the year before. This information seems to have acted as a red rag, and, in place of the general approval which met the pictures exhibited in 1849, came an almost unanimous castigation of the return to 'all the objectionable peculiarities of the infancy of art'.[54] Largely as a result of such criticism Dante Gabriel Rossetti ceased to exhibit his work publicly in London after 1850. Millais continued to share with Hunt the critical vicissitudes, and his work achieved even greater notoriety.

Although Millais was the most naturally gifted member of the original Pre-Raphaelite group, who rapidly attracted the most attention to his works, he was less important in shaping its outlook than either Hunt or Rossetti. As the youngest member of the Brotherhood, intellectually he was a disciple of Hunt's. He was the companion to whom Hunt expressed his resolution in February 1848 to paint his out-of-door picture, and a year later than Hunt he also put the resolution into practice. Millais's first Pre-Raphaelite picture, *Isabella*, begun in 1848 and exhibited in 1849, shows, like Hunt's picture of the preceding year, a subject from Keats in an interior setting. But in 1850 Millais exhibited three pictures at the Royal Academy, one of which, *Ferdinand Lured by Ariel* (Pl. 7), is set in the open air. This is a small picture, only $25\frac{1}{2} \times 20$ inches, and it consists essentially of a standing figure before a foliate background. This background rises directly behind the figure of Ferdinand to approximately four-fifths of the height of the painting; there is no depth of space. The entire background, except for the open sky at the top, is delineated with a thoroughness comparable to – or even surpassing – that of the foreground foliage in Hunt's *Druids* of the same year. Because of the suppression of space, of the sheer variety of plant forms delineated, and of Millais's extreme minuteness of handling, this natural detail did receive attention from contemporary critics. The *Art Journal*, which still took no notice of any naturalistic elements in the *Druids*, described *Ferdinand Lured by Ariel* as 'quattro-cento' and eccentric, but it also saw something else:

7 (Facing page) John Everett Millais, *Ferdinand Lured by Ariel* 1849–50. Oil on panel, $25\frac{1}{2} \times 20$. The Makins Collection.

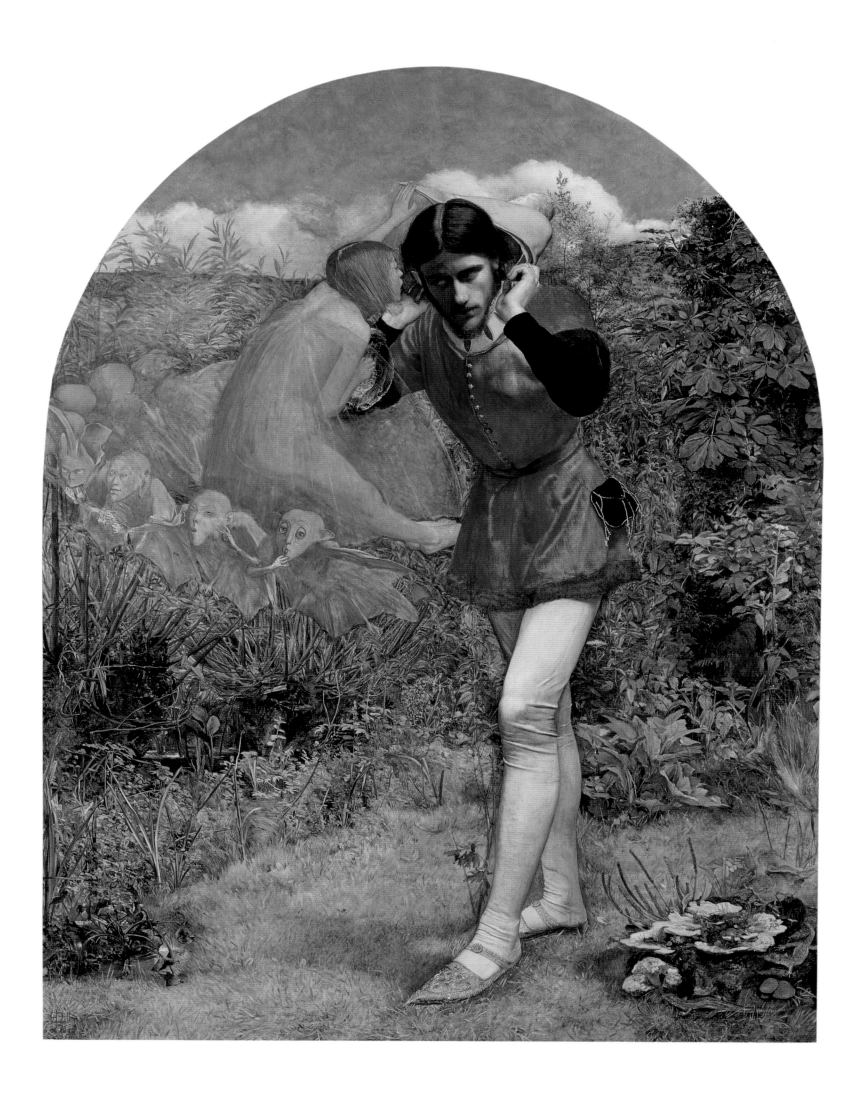

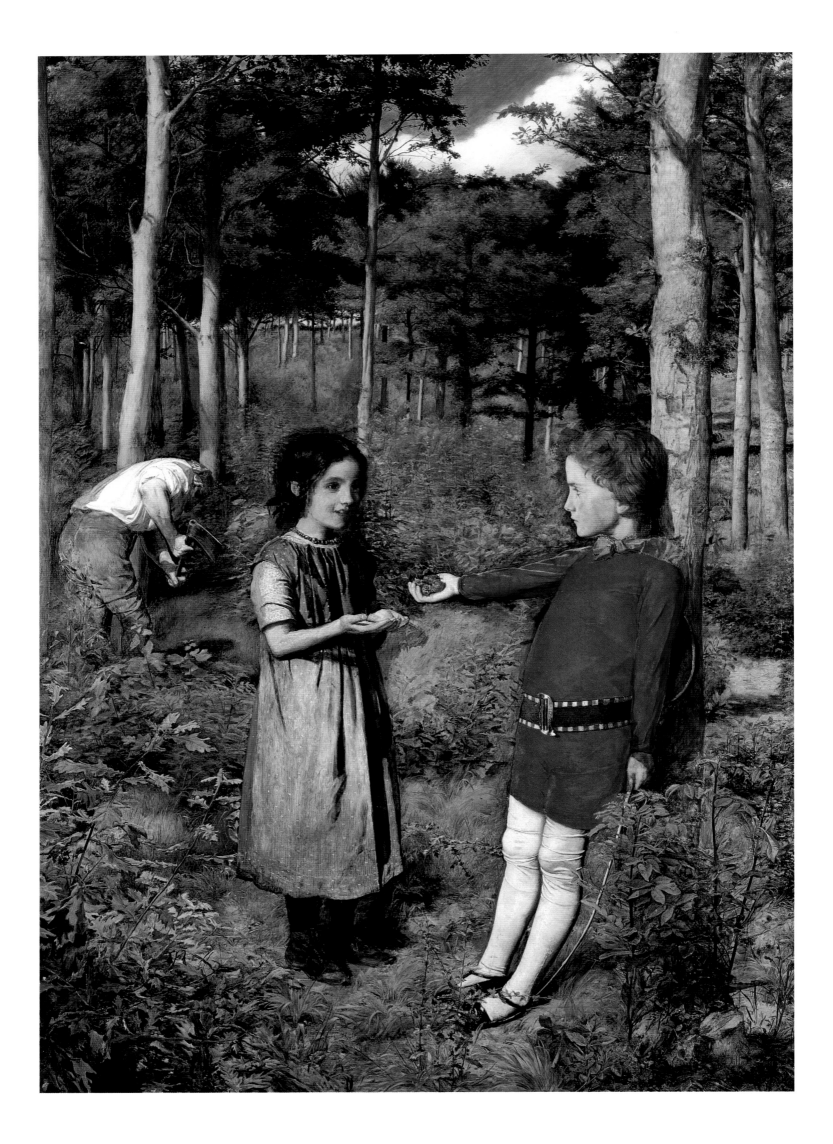

The emphasis of the picture is in its botany, which is made out with a microscopic elaboration, insomuch as to seem to have been painted from a collection of grasses, since we recognize upwards of twenty varieties; there may be more; and such is the minute description of even one leaf; that the ravages of an insect are observable upon it.[55]

This microscopic natural detail appears at the expense of space, atmosphere, or any feeling of light and shade. It fills a substantial part of the picture, but allied to the fairy subject from Shakespeare's *Tempest*, it seems to belong to a world of dreams and enchantment rather than to the world as we normally know it. The hyper-real clarity of delineation does not contradict, but enhances the sense of fantasy.

In 1851 Millais again exhibited three pictures at the Royal Academy, one of which was of an outdoor subject. This was *The Woodman's Daughter* (Pl. 8), based on Coventry Patmore's poem of the same name. It shows two children, Maud and a rich squire's son, in the immediate foreground, Maud's father at work slightly beyond them, and a wooded landscape stretching into the distance. Millais painted the background near Oxford in the summer of 1850. As the figures are of a smaller scale than those in Millais's and Hunt's previous pictures, the background is proportionately the most extensive of any Pre-Raphaelite picture to date. The foreground grass and leaves are painted with the same precision as the botanical detail in *Ferdinand Lured by Ariel*, but the microscopic treatment does not extend into the depth of the picture much beyond the figures. As in Hunt's *Valentine Rescuing Sylvia from Proteus*, the distant forest is painted with relative breadth. Unlike the autumnal colours of Hunt's picture, which indeed was begun in late October, Millais's are of a startling green, which is maintained with little diminution throughout the landscape.

The points of view in both Hunt's *Valentine Rescuing Sylvia from Proteus* and Millais's *Woodman's Daughter* are from slightly above the figures, and consequently the background spaces rise sharply. The arched top of Hunt's picture slices through the trunks of the distant trees, and there is no open sky. In Millais's, although the horizon is well above the heads of the figures, the trees in the distance are seen in their entire height, and there is an area of open sky above them. We can also see underneath the foliage, between the trunks of the trees, to open sky along the horizon in the distance. The effect of recession through the tree trunks, marshalled in an almost one-point-perspective arrangement, seems the antithesis of the two-dimensionality of *Ferdinand Lured by Ariel* and indeed of the increasing flatness of most subsequent Pre-Raphaelite painting. The view through the trees does, however, recall the background of a fifteenth-century painting in the Ashmolean Museum, the *Hunt in a Forest* by Paolo Uccello, and the similarity may not be coincidental; the Uccello was presented to the University Galleries in Oxford in 1850, the year that Millais painted the background of his picture while staying in the city.[56] So, *The Woodman's Daughter* may be an example of early Pre-Raphaelite attention to nature given distinctive form by the example of quattrocento painting. According to the critic for the *Art Journal*, it not only displayed, but exaggerated 'every infirmity of early art'. This same critic singled out the high horizons and, by implication, faulty perspective in both Millais's and Hunt's pictures as particularly offensive.[57]

Although Rossetti ceased to exhibit his work after 1850, following the first critical attacks upon Pre-Raphaelitism, by 1851 Hunt and Millais had gained other allies. Ford Madox Brown completed and exhibited his *Chaucer at the Court of Edward III* in 1851. As we have seen, Holman Hunt thought that in its completed state it showed Pre-Raphaelite influence. Most critics in 1851 still did not class Brown among the Pre-Raphaelites, although he suspected that they had begun 'to smell a rat'.[58] An artist whom the critics did look upon as another Pre-Raphaelite, and whom they attacked as mercilessly as either Hunt or Millais, was Charles Allston Collins, the son of the painter William Collins and brother of the writer Wilkie Collins. As a painter Charles Collins did little more than imitate Millais. His *Berengaria's Alarm for the Safety of Her Husband Richard Coeur de Lion* (City Art Gallery, Manchester), exhibited at the Royal Academy in 1850, is a weak reflection of Millais's *Isabella* of 1849. His *Convent Thoughts* (Pl. 9) of 1851 seems equally dependent on *Ferdinand Lured by Ariel*, which it also followed by a year. The composition is essentially the same as Millais's, but the mass of greenery in *Ferdinand Lured by Ariel* has been separated into an ivy-covered wall in the background and a lily pond and two beds of flowers in the foreground (see detail, p. xiv). Millais's tangle of vegetation has become a row of flowers, each rigidly distinct upon its own stalk. Lacking his model's gifts as a draughtsman, Collins could not forge the elements of his picture into a comparable synthesis; the painting remains both dry and awkward. It also seems very

8 (Facing page) John Everett Millais, *The Woodman's Daughter* 1850–1. Oil on canvas 35 × 25½. Guildhall Art Gallery, Corporation of London.

much a product of its time. The subject, a nun in an enclosed convent garden, reflects mid-Victorian obsessions, whether pro or con, with Roman Catholicism;[59] the style is palpably a product of the related growth of interest in the quattrocento during the previous decade. *Convent Thoughts* is hardly auspicious as an omen of anything. Yet, Collins's nun has turned aside from her missal to examine a withered blossom; she has gone directly to nature. Exhibited with a quotation from Psalms, 'I meditate on all Thy works; I muse on the work of Thy hands', this modest painting by a minor figure epitomises what was to be the dominant interest in progressive English painting for the next decade.

9 (Facing page) Charles Allston Collins, *Convent Thoughts* 1851. Oil on canvas 33 × 23¼. Ashmolean Museum, Oxford.

1851

From a practical point of view, the most noteworthy achievement of the Pre-Raphaelites in the first three years of their Brotherhood's existence was their success in turning almost the entire critical establishment in England against them. The reasons for this were complex and not entirely related to the stylistic qualities of the Pre-Raphaelite pictures. The religious subjects of Rossetti's *Ecce Ancilla Domini!* (Tate Gallery), Hunt's *Druids*, and particularly Millais's *Christ in the House of his Parents*, all exhibited in 1850, provoked anti-Tractarian and anti-Catholic sentiments which were further outraged in 1851 by Collins's *Convent Thoughts*. The name Pre-Raphaelite Brotherhood also had in itself a capacity to arouse ire; in addition to keeping alive a firm belief that the pictures were painted in imitation of early art, it seems to have raised the spectre of the Roman Catholic and monastic inclinations of the German Nazarenes. In the extremely hostile comments in *The Times* in 1851, the Pre-Raphaelite pictures were called 'monkish follies'. *The Times* also noted the pictures' minute natural detail, but saw this as part of the 'mere servile imitation of the cramped style, false perspective, and crude colour of remote antiquity'.[1]

The near unanimity of the hostile criticism in 1851, following that of 1850, led the Brothers to take steps. Millais asked Coventry Patmore to seek the aid of Ruskin. Patmore approached Ruskin, and Ruskin complied with the request by writing a letter that appeared in *The Times* of 13 May 1851. He followed it with a second letter in the issue of 30 May and a pamphlet entitled *Pre-Raphaelitism*, published in August.[2]

Ruskin announced in his first letter that he had no acquaintance with the artists and 'very imperfect sympathy with them'. He carefully disassociated himself from their 'Romanist and Tractarian tendencies', and he deplored the cloistered sympathies of Collins's nun. 'But', he added about *Convent Thoughts*:

> I happen to have a special acquaintance with the water plant, *Alisma Plantago* . . . and as I never saw it so thoroughly or so well drawn, I must take leave to remonstrate with you, when you say sweepingly that these men 'sacrifice *truth* as well as feeling to eccentricity.' For as a mere botanical study of the water lily and *Alisma*, as well as of the common lily and several other garden flowers, this picture would be invaluable to me, and I heartily wish it were mine.

He denied *The Times*'s allegations of false perspective, with one small exception, and for that he offered to show worse errors in any twelve pictures containing architecture, chosen at random from the Royal Academy exhibition.

The most positive part of the letter had to do with the movement's name. Ruskin criticised the artists' lack of common sense in choosing to call themselves Pre-Raphaelites, but, nonetheless, he set out to say why they did so. Their paintings did not resemble ancient works, and critics who accused the Pre-Raphaelites of imitating early art were only revealing their own ignorance.

> As far as I can judge of their aim – for, as I said, I do not know the men themselves – the Pre-Raphaelites intend to surrender no advantage which the knowledge or inventions of the present time can afford to their art. They intend to return to early days in this one point only – that, as far as in them lies, they will draw either what they see, or what they suppose might have been the actual facts of the scene they

Facing page: Ford Madox Brown, *The Pretty Baa-Lambs* (detail of Pl. 13).

desire to represent, irrespective of any conventional rules of picture-making; and they have chosen their unfortunate though not inaccurate name because all artists did this before Raphael's time, and after Raphael's time did *not* this, but sought to paint fair pictures, rather than represent stern facts; of which the consequence has been that, from Raphael's time to this day, historical art has been in acknowledged decadence.

Thus asserting that the purpose of Pre-Raphaelitism was a return not to 'archaic art', but to 'archaic honesty', Ruskin claimed the painters deserved respect simply for the indisputable labour and fidelity to a certain kind of truth displayed in their pictures. He concluded with the pronouncement 'there has been nothing in art so earnest or so complete as these pictures since the days of Albert Durer', and promised a second letter devoted to more special criticism.

What Ruskin originally intended his special criticism to be, we do not know, for under his father's advice he rewrote the second letter.[3] Even as it appeared it was critical enough. Half of it was spent deprecating the homeliness of the Pre-Raphaelite figures. Ruskin then complained about defects in the colouring of flesh; Millais's flesh tints were 'wrought out of crude purples and dusky yellows', which Ruskin thought possibly came from attempting to gain too much transparency. He suggested that close study of minor detail was incompatible with flesh painting, and he noticed a similar weakness in the watercolour exhibited the preceding year by John Frederick Lewis,[4] who in treatment of detail, Ruskin claimed, should be classed with the Pre-Raphaelites. But the fault which Ruskin thought most offended the public was an apparent want of shade. Here he took the offensive and laid the blame upon the other pictures at the Academy. Although he admitted some weaknesses, such as Hunt's tendency to exaggerate reflected lights, he wrote 'for the most part the pictures are rashly condemned because the only light which we are accustomed to see represented is that which falls on the artist's model in his dim painting-room, not that of sunshine in the fields'. Collins's nun suffered under a few more witticisms, although Ruskin said he had been informed that he was wrong in accusing the painters of Romanising tendencies. Finally, the letter ended with another glowing conclusion: the Pre-Raphaelites 'may, as they gain experience, lay in our England the foundations of a school of art nobler than the world has seen for three hundred years.'

To the content of the two letters, the pamphlet, *Pre-Raphaelitism*, although much longer, added little about the movement. Beginning with generalities about the nature of work, Ruskin defined the proper work of the artist as, 'the faithful representation of all objects of historical interest, or of natural beauty existent at the period'.[5] However, modern artists were occupying themselves instead with 'drawing dances of naked women from academy models, or idealities of chivalry fitted out with Wardour Street armour, or eternal scenes from *Gil Blas*, *Don Quixote*, and the *Vicar of Wakefield*, or mountain sceneries with young idiots of Londoners wearing Highland bonnets and brandishing rifles in the foregrounds'. This 'inexpressible imbecility' Ruskin implicitly suggested was the result of the false and harmful teaching of the Royal Academy. He caricatured its 'Raphaelesque rules' – a principal light and shade of set proportions, an elaborate variety of poses, and the highest ideal beauty, consisting 'partly in Greek outline of nose, partly in proportions expressible in decimal fractions between the lip and chin; but mostly in that degree of improvement which the youth of sixteen is to bestow upon God's work in general' – whose purpose was 'the pursuit of beauty at the expense of manliness and truth'. This was what the Pre-Raphaelites were opposing. Their pictures, 'painted in a temper of resistance', by young men 'with little natural perception of beauty' were hardly likely to win the viewer from works 'enriched by plagiarism, polished by convention, invested with all the attractiveness of artificial grace, and recommended to our respect by established authority'.[6] Still, Ruskin found the violence of the attacks and the absence of support for the pictures strange. He again defended their perspective. Then, he launched into a comparison of Turner and Millais. This led to a discussion of several other contemporary artists and ultimately to the meat of the pamphlet, a description of the Turners in the celebrated Fawkes collection at Farnley Hall in Yorkshire, which Ruskin had visited the previous April.[7]

Ruskin's justification for a publication primarily about Turner under the name *Pre-Raphaelitism* was that it would allay accusations of inconsistency between his defence of the younger artists and his previous writings.[8] In his comparison of Millais and Turner, he tried to reconcile their differences, and ascribed to them a common defiance of false teaching.[9] He claimed that Turner's greatness lay in 'his taking possession of everything that he sees, – on his forgetting himself, and forgetting nothing else', and that all greatness in any artist lay in an intense sense of fact.

And thus Pre-Raphaelitism and Raphaelitism, and Turnerism, are all one and the same, so far as education can influence them. They are different in their choice, different in their faculties, but all the same in this, that Raphael himself, as far as he was great, and all who preceded or followed him who ever were great, became so by painting the truths around them as they appeared to each man's own mind, not as he had been taught to see them, except by the God who made both him and them.[10]

Into the pages on Turner Ruskin inserted an aside that the Pre-Raphaelites were overworking their pictures, a criticism which both Ruskin and the painters seem to have forgotten in the next few years, but one that would resurface in his criticisms of the followers of the movement at the end of the decade.[11] For the rest, the Pre-Raphaelites had to be content with a footnote, where Ruskin again rebutted their critics and elaborated the defence of their light which had appeared in his second letter: 'their system of light and shade is exactly the same as the Sun's; which is, I believe, likely to outlast that of the Renaissance, however brilliant'. He repeated his hopes of their founding a new and noble school, but added qualifications; it depended upon their painting nature, 'as it is around them, with the help of modern science', and if they were led into Romanism or mediaevalism they would come to nothing.[12]

In addition to his direct defence of the Pre-Raphaelites in the two letters and the pamphlet, Ruskin also inserted remarks about Hunt and Millais into the fifth edition of the first volume of *Modern Painters*, which appeared in September 1851. Then his militancy seemed to abate. Ten days before the publication of the pamphlet, he set off for Italy to work on *The Stones of Venice*. Returning to London only in July of 1852, Ruskin missed the critical storms of that year's exhibitions. His next public utterance about the Pre-Raphaelites was a defence of the aerial perspective in Millais's *Huguenot* (Pl. 35) in the third volume of *The Stones of Venice*, published in October 1853.[13]

In May 1851 Ruskin was thirty-two years old. He had published two volumes of *Modern Painters*, *The Seven Lamps of Architecture*, and one volume of *The Stones of Venice*. His defence of Pre-Raphaelitism did not turn the tide of hostile criticism; in fact, it broadened the target for the attackers. But it was a godsend to the young painters. Praise by a writer of Ruskin's stature forced the critics to take them seriously. Still, in the next round of criticism, the pictures tended again to be lost sight of as the attackers levelled on Ruskin's theories. This meant that from 1851 through 1859 Pre-Raphaelitism was seen by most contemporary observers almost solely within the naturalistic parameters proclaimed by Ruskin. His differentiation between 'archaic art' and 'archaic honesty', coinciding with the disappearance of Rossetti's works from public exhibition, seemed to settle the conflict within the movement between the goals of revivalism and naturalism definitely on the side of the latter.

Why did the Pre-Raphaelites turn to Ruskin in 1851? He had not seen the exhibitions of 1849, where the first Pre-Raphaelite pictures were exhibited, and, as we have seen, he only took notice of the Pre-Raphaelite pictures in 1850 when forced to by William Dyce, but the artists seem to have expected that he would respond favourably to their work. In 1850 when an anonymous article praising them appeared in *The Guardian* they erroneously thought that it might have been written by Ruskin.[14] In 1851 they had considered writing to him themselves. When Patmore reported that Ruskin was interested in buying Millais's *Return of the Dove to the Ark* (Ashmolean Museum, Oxford), William Michael Rossetti wrote that it was evident from this that Ruskin admired the Brotherhood, adding parenthetically 'were it from nothing else'.[15] This ambiguous 'nothing else' may have meant no more than that the artists, believing themselves to be working along lines recommended by Ruskin, thought that he should recognise this community of interest and that he should approve of and defend their work.

If Ruskin initially did see a relation between the activities of the young artists and what he had preached in *Modern Painters*, he kept it masked. Only after he had met and spent some time with Millais (and had prepared new editions of the first two volumes of *Modern Painters*) did he publicly acknowledge what they had in common, which suggests that it may have been pointed out to him by Millais. Whatever the cause, the 'no acquaintance' and 'very imperfect sympathy' with the artists, professed in the first letter to *The Times* in May, were superseded by the preface to his pamphlet, *Pre-Raphaelitism*, in August:

Eight years ago, in the close of the first volume of *Modern Painters*, I ventured to give the following advice to the young artists of England:

'They should go to nature in all singleness of heart, and walk with her laboriously and trustingly, having no other thought but how best to penetrate her meaning; rejecting nothing, selecting nothing, and scorning nothing.' Advice which, whether bad or good, involved infinite labour and humiliation in the following it, and was therefore, for the most part, rejected.

It has, however, at last been carried out, to the very letter, by a group of men who, for their reward, have been assailed with the most scurrilous abuse which I ever recollect seeing issue from the public press. I have, therefore, thought it due to them to contradict the directly false statements which have been made respecting their works; and to point out the kind of merit which, however deficient in some respects, those works possess beyond the possibility of dispute.[16]

This preface was not to go unquestioned. William Michael Rossetti immediately wrote in the *Spectator* that he did not think 'strict non-selection' was either desirable or possible, but he did not deny the implied genesis of Pre-Raphaelitism out of Ruskin's earlier writing.[17] Ruskin himself was not to remain entirely faithful to the dogma of 'rejecting nothing, selecting nothing', but for the rest of the 1850s his attitude towards the Pre-Raphaelites was to be that of an involved associate rather than of a detached observer, as it had been in May 1851.

Following the appearance of Ruskin's second letter in *The Times*, Hunt and Millais wrote him a letter of appreciation. Ruskin then drove to Millais's studio and introduced himself. Holman Hunt wrote that Ruskin carried Millais off for a week's stay at his home at Denmark Hill,[18] but no other source mentions such a visit. Nonetheless, Ruskin and Millais did commence a friendship. On 2 July 1851, Millais wrote to his friend and patron in Oxford, Mrs Thomas Combe: 'I have dined and taken breakfast with Ruskin, and we are such good friends that he wishes me to accompany him to Switzerland this summer. We are as yet singularly at variance in our opinions upon Art.' As an example of this variance, Millais cited their different opinions of Turner.[19] Ruskin's didactic inclinations – most recently made evident in his letters to *The Times* – must also have guaranteed that Millais heard plenty about his own art and what it should become.

Millais's letter to Mrs Combe was written from Kingston upon Thames in Surrey, where he and Hunt had gone to paint the landscape backgrounds of their next paintings. These paintings were Millais's *Ophelia* (Pl. 10) and Hunt's *Hireling Shepherd* (Pl. 11), and they display far more radically than any of the artists' previous works that careful attention to the appearance of nature which henceforth would be regarded as the essential Pre-Raphaelite quality. Along with Ford Madox Brown's *Pretty Baa-Lambs* (Pl. 13), which was begun separately during the same summer, they would establish the path which Pre-Raphaelitism would follow through the rest of the 1850s. As Ruskin had done in print, Hunt, Millais, and Brown settled in practice, in their work of this summer, the chief contradictions contained in their pictures from the previous three years. Hunt, assessing Millais's career in his memoirs, declared the seminal significance of *Ophelia*:

> The landscape of *The Woodman's Daughter*, painted in 1850, might not be so conclusive in the testimony it offers of a new *evangel*, but the charm throughout the background of the *Ophelia*, and the pathetic grace of the lovewrapt maiden, are enough to proclaim that not in one feature alone, but in the whole picture, a new art was born.[20]

The outdoor paintings of the Pre-Raphaelite circle from 1851 and subsequent years indeed do constitute a 'new art'; and claims can be made for Brown and Hunt, as well as Millais, as its parents.

In subject, *Ophelia* is still a picture derived from a literary source. It does not, however, show an event that actually takes place in *Hamlet*, and it does not show a reconstructed scene as if it might be taking place on the stage. Millais's picture departs from the usual *tableau-vivant* appearance of most earlier and contemporary English paintings of Shakespearean subjects, even those of his friends, such as Ford Madox Brown's *Lear and Cordelia* of 1849 (Tate Gallery) or Holman Hunt's *Valentine Rescuing Sylvia from Proteus*. What is most distinctive in *Ophelia* is the degree to which everything theatrical is subordinated to the depiction of the natural world. The picture is based on Gertrude's description of Ophelia's death in the fourth act of *Hamlet*:

> There is a willow grows aslant the brook
> That shows his hoar leaves in the glassy stream;

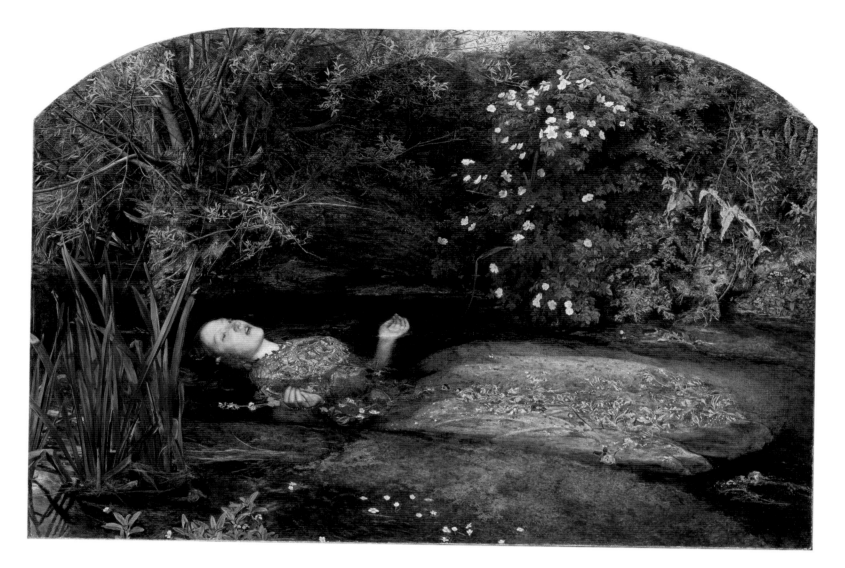

Therewith fantastic garlands did she make
Of crowflowers, nettles, daisies, and long purples
That liberal shepherds give a grosser name,

10 John Everett Millais, *Ophelia* 1851–2. Oil on canvas, 30 × 44. Tate Gallery, London.

Ophelia is shown floating in the stream, buoyed up by her clothes spread wide, and still singing snatches of old songs. Above and around her are the willow aslant the brook and the flowers enumerated in Gertrude's description.

The Hireling Shepherd also has a Shakespearean dimension. Hunt exhibited the painting at the Royal Academy in 1852 accompanied in the catalogue with the following quotation from one of Edgar's songs in *King Lear*:

Sleepest or wakest thou, jolly shepherd?
Thy sheep be in the corn;
And, for one blast of thy minikin mouth,
Thy sheep shall take no harm.

However, Hunt's picture does not illustrate *Lear* in the way that Millais's does illustrate lines from *Hamlet*. It shows a scene of rustic dalliance in which the figures are not in recognisable period costume but seem to belong to the contemporary agricultural world. The central incident of a shepherd neglecting his flock to show his shepherdess companion a death's head moth seems to be entirely of Hunt's invention. If we must ascribe a literary source to the picture it should be biblical rather than Shakespearean. The ancestry of Hunt's shepherd and sheep is in the parables of the New Testament and in Christian symbolism of the pastoral flock. When the Manchester City Art Gallery acquired *The Hireling Shepherd* in 1897, Hunt wrote a letter describing Shakespeare's shepherd as 'a type of other muddle-headed pastors, who, instead of performing their services to the flock – which is in constant peril – discuss vain questions of no value to any human soul.'[21] In his letter Hunt pointed out the foolishness of his shepherd's concern with the death's head moth, while his sheep are doomed to destruction from eating wheat and the lamb on the shepherdess's lap is being poisoned with sour apples.

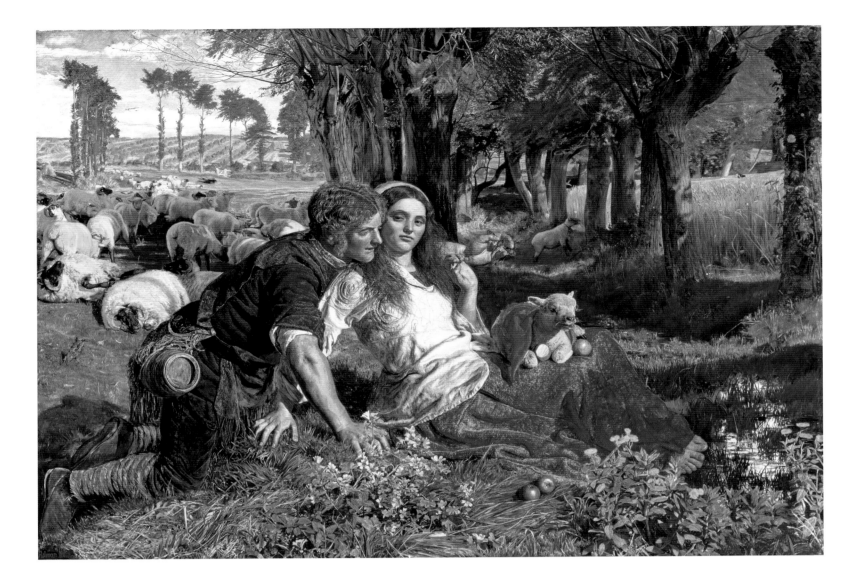

11 William Holman Hunt, *The Hireling Shepherd* 1851–2. Oil on canvas, 30¹/₈ × 43¹/₈. Manchester City Art Gallery.

For his pastoral symbolism Hunt had both artistic and literary precedents. In 1850 Sir Edwin Landseer exhibited at the Royal Academy a painting of a shepherd carrying a sheep in the snow entitled *The Lost Sheep* and accompanied in the catalogue with a quotation from Luke xv. 22. In March 1851, Ruskin published a pamphlet on church organisation which he called *Notes on the Construction of Sheepfolds*. To this, William Dyce, who was an active high-church man, replied with another pamphlet, *Notes on Shepherds and Sheep*. Hunt read both while in Surrey in the summer of 1851.[22]

Thus, there is abundant evidence that Hunt intended the picture to have a symbolic, moralising message. In recent years, *The Hireling Shepherd* has been looked upon as a forerunner of Hunt's later religious pictures packed with symbolism. On the other hand, we should remember that Hunt wrote his letter to Manchester explaining the picture forty-five years after he painted it, and after he had secured his reputation on the basis of his later religious works. Even then, in his letter of 1897, Hunt wrote:

I did not wish to force the moral, and I never explained it till now. For this meaning was only in reserve for those who might be led to work it out. My first object as an artist was to paint, not Dresden china *bergers*, but a real shepherd, and a real shepherdess, and a landscape in full sunlight, with all the colour of luscious summer, without the faintest fear of the precedents of any landscape painters who had rendered Nature before.

In a fragmentary manuscript in the John Rylands Library in Manchester, possibly a first draft for the letter of 1897, Hunt made a similar statement but one in which he denied that he had originally intended the picture to have any religious message:

The Hireling Shepherd was not painted with any distinctly symbolic and allegorical view altho' I can understand how the work as it stands may be regarded as such. . . . It may of course bear application to religious as to other pursuits. And I am grateful to have it so solemnly used, but I must confess that [by] doing it my first object was to portray a real [Shepherd] and Shepherdess . . .[23]

When *The Hireling Shepherd* was exhibited in 1852, none of the critics seemed interested in delving into its deeper symbolic meaning. Even a friend who would have known Hunt's intentions first-hand, William Michael Rossetti, writing in the *Spectator*, only mentioned the 'moral suggestiveness' of the subject and declared that the most striking quality of the work was 'its peculiar manliness, and spirit of healthful enjoyment'.[24] The anonymous author of a long and thoughtful article about the Pre-Raphaelites which appeared in the *British Quarterly Review* wrote that there might be some allusion to the scriptural idea of a hireling shepherd,

> but on the whole, the picture is a piece of broad rural reality, with none of the fantastic circumstance implied in the lines quoted, and with no attempt to bring out the scriptural allusion, if it exists, by deviating from what is English and modern. . . . There is certainly no attempt at poetry here; for a fellow more capable than the shepherd of drinking a great quantity of beer, or a more sunburnt slut than the shepherdess, we never saw in a picture.[25]

A less sympathetic critic, the reviewer for the *Athenaeum*, described the picture similarly: 'Mr. Hunt . . . carries anti-eclecticism to the absurd. Like Swift, he revels in the repulsive. These rustics are of the coarsest breed, – ill favoured, ill fed, ill washed. Not to dwell on cutaneous and other minutiae, – they are literal transcripts of stout, sunburnt, out-of-door labourers.'[26] In his pamphlet of 1860, F. G. Stephens, whose perspective was affected by close personal ties as well as knowledge of Hunt's subsequent paintings of religious subjects, *The Light of the World* (Pl. 50), *The Scapegoat* (Pl. 55), and *The Finding of the Saviour in the Temple* (City Art Gallery, Birmingham), still made no mention of any allegorical reference to the pastoral flock, but described the picture as a naturalistically rendered rural scene in which the moral interest went no further than the unfortunate fate of the neglected sheep.[27]

The general composition of *The Hireling Shepherd* – a couple embracing in the foreground, sheep in the background – recalls representations of an Old-Testament pastoral world, particularly scenes of the meeting of Jacob and Rachel. Of the renderings of that subject, which Hunt was likely to have known, the closest in composition to his picture is a Spanish seventeenth-century painting in the Dulwich Picture Gallery, which Hunt says he haunted as a youth.[28] This painting shows the couple kneeling and embracing before a flock of sheep in a wide landscape. On the right, one sheep is partly hidden by a tree, a motif that possibly suggested the sheep emerging from behind the trees in the centre of Hunt's picture. Closer in time, he also knew *The Meeting of Jacob and Rachel* by William Dyce, of which he had painted a commissioned copy of the version exhibited at the Royal Academy in 1850.[29] Hunt's composition is closer to that of the Dulwich picture than it is to Dyce's, which depicted three-quarter-length standing figures in biblical costume before a biblical landscape. But the manner in which Hunt's shepherd reaches around the shepherdess echoes the gesture of Dyce's Jacob putting his hand around the neck of a reticent Rachel. Some smaller details such as Hunt's shepherd's beer keg and the wine flask of Dyce's Jacob also seem related.[30]

Hunt's comments about the picture quoted above indicate his awareness of other earlier depictions of pastoral scenes. His phrase 'Dresden china *bergers*' has an eighteenth-century sound, suggesting Boucher's rural confections or Gainsborough's fancy pictures. However, those words also suggest consciousness of the older Victorian artist William Mulready, as they anticipate a passage in *Pre-Raphaelitism and the Pre-Raphaelite Brotherhood* in which Hunt criticised Mulready's 'taste for Dresden-china prettiness'.[31] There are several rural amatory scenes by Mulready to which *The Hireling Shepherd* might be compared: *The Sonnet* (Victoria and Albert Museum, London), and *Open Your Mouth and Shut Your Eyes* (Pl. 12), both exhibited at the Royal Academy in 1839 and also included in an exhibition of Mulready's work at the Society of Arts in 1848, and *Burchell and Sophia in the Hayfield*, exhibited in 1847 (private collection). This latter picture, based on one of Mulready's illustrations to *The Vicar of Wakefield* published in 1843, depicts Burchell reaching around Sophia on the pretext of assisting her with her work. Like *The Hireling Shepherd* it shows a kind of non-embrace, and there is in both works a similar closeness of the figures without any feeling of real physical contact between them.

Dyce and Mulready were probably the two older, established artists most admired by Hunt at the beginning of his career. We have already discussed Hunt's relations with Dyce. His remark about Mulready's taste for prettiness was a qualification in a discussion in which he declared Mulready the most appropriate model for the young artist to follow in the 1840s. Mulready did provide not only a lead for the Pre-Raphaelites' bright

12 William Mulready, *Open Your Mouth and Shut Your Eyes* exhibited 1839. Oil on panel, 12½ × 12. Victoria and Albert Museum, London.

colours but also compositional hints; Millais borrowed from Mulready's *Vicar of Wakefield* illustrations on at least two occasions: in *Isabella*, exhibited in 1849, and in *The Rescue* of 1855 (National Gallery of Victoria, Melbourne).[32] Hence it is plausible to see both Dyce's and Mulready's pictures behind *The Hireling Shepherd*. Yet, if we compare the works, the differences are more striking than the similarities. The Italianate, Raphaelesque manner of Dyce, and the refined prettiness of Mulready have given way to a more robust concern with actuality, which appears both in Hunt's unidealised figures and in their setting. The critical response to the picture cited above shows that contemporary observers could no longer respond within a frame of reference established by Dyce, as they had for Hunt's pictures of the previous years. If the comparison which was made in the first chapter between Hunt's *Rienzi*, or the other Pre-Raphaelite pictures exhibited in 1849, and Courbet's *Stonebreakers* (Pl. 2) seems almost laughable because of the pictures' manifest dissimilarities, it is transformed if we substitute *The Hireling Shepherd* for *Rienzi*. There are still important differences, but now there are equally important elements in common. Visiting Paris in 1849, Hunt had found paintings of the 'new Realistic school . . . coarse and ugly'.[33] Three years later the critic for the *Athenaeum* used the adjectives 'coarsest' and 'repulsive' for Hunt's picture. During these years, Hunt's art, as well as Millais's, had changed more profoundly than he admits in *Pre-Raphaelitism and the Pre-Raphaelite Brotherhood*. It is now time to examine the manifestation of this change in the landscape elements of the pictures.

Hunt and Millais painted their landscape backgrounds near the village of Ewell, between Kingston upon Thames and Epsom in Surrey, some fourteen miles from Charing Cross. Both artists knew the area from visits to relatives and family friends during the 1840s. Late in June 1851 they took lodgings in a cottage on Surbiton Hill in Kingston; later in the summer they moved to Worcester Park Farm, a seventeenth-century hunting lodge near Cheam, where they remained until December. They painted every day except Sunday, and their normal painting day lasted from eight o'clock in the morning until seven in the evening. Eleven hours a day, six days a week, for twenty-three weeks amounts to more than 1,500 hours of work apiece. Even after that figure is reduced substantially to allow for breaks, bad weather, and miscellaneous distractions, the two painters still spent a staggering amount of time painting landscape backgrounds. During this period each started a second work. Hunt began the background of *The Light of the World* (Pl. 50) at the beginning of November, and he worked on it at night while continuing to paint the sheep in *The Hireling Shepherd* by day. Millais painted the background of *A Huguenot, on St Bartholomew's Day, Refusing to Shield Himself from Danger by Wearing the Roman Catholic Badge* (Pl. 35). For all these pictures Hunt and Millais painted only the landscape settings in the country; the figural parts remained to be done after they returned to their London studios. As the deadline for submitting pictures for the Royal Academy exhibition was the first of April, the amount of time (under four months) which Hunt and Millais allowed for the figures was substantially less than that (over five) which they devoted to the landscapes. Three of the four pictures did appear at the Royal Academy in 1852; the exception was *The Light of the World*, which Hunt completed in 1853 and exhibited in 1854.[34]

Each of the landscape backgrounds was apparently painted from a single location. Millais worked on the banks of the Hogsmill River; Hunt in a field two miles away. Each picture appears to be a faithful transcript of the appearance of the place at a certain time. However, the specific conditions of a certain time do not remain constant over a period involving hundreds of hours and running from June to November or December. The effects of light, weather, and foliage, could not all have been copied directly from what was before the artists' eyes. During those long hours of working directly from nature, Hunt and Millais must constantly have had to adjust what they saw to accord with what they had already represented in their paintings. In *Ophelia* Millais had the lesser problem. By taking a myopic view of his subject, he bypassed temporal and meteorological concerns. There are shadows in the depth of the greenery, but they do not suggest the fall of light at a specific time. Questions of atmosphere or weather do not exist; Millais ignored them to concentrate his energies upon botanical fact. On the other hand, Hunt set out to paint his landscape 'in full sunlight, with all the colour of luscious summer'. He thus had to cope with more complications of changing conditions than Millais. Still, the conditions shown are those of a typical summer day. The sun shines and cumulus clouds drift across the sky. The mood is of the ripeness of full summer when days are long and time moves slowly. The shepherd and shepherdess are idling away the hours. Some sheep drift towards the corn, but most stand placidly in the shade or lie dozing in

the sun. The time is specific, but it is hardly an Impressionist 'fleeting moment' which must be seized rapidly before it passes.

The most obvious result of the many hours that Millais and Hunt spent painting directly from nature is the sheer quantity of detail that their pictures contain. Although natural detail had been an increasingly prominent element in Hunt's previous pictures, the advance from the foreground of *Valentine Rescuing Sylvia* to the abundance of the grass and flowers in *The Hireling Shepherd* is still substantial. A comparison of that grass and those flowers with the dandelions in *Rienzi* shows that an attempt by the artist to encompass the infinite complexity and multiplicity of nature has replaced the delineation of separate and isolated natural details (see detail, p. vi). In *Ophelia* the abundance of plant life is even more striking than in *The Hireling Shepherd*. Millais had established a precedent in *Ferdinand Lured by Ariel* of treating nature as botanic detail and little else, but the foliate detail in *Ophelia* is still more prominent. It now rises to the top of the picture, and, instead of being distinctly behind the figure as in *Ferdinand Lured by Ariel*, it remains on the surface of the canvas. The brook appears wide enough to allow room for Ophelia, but the willows and the plants on the further bank bend over the stream so that the leaves and flowers at the top of the picture seem as near to us as those at the bottom. Perspective space has been abandoned for a direct, even primitive insistence on literal botanic detail (see detail, pp. ii–iii). Background has become foreground covered inch by inch with microscopically observed detail in which the critic for the *Athenaeum* saw 'the botanical study of a Linnaeus'.[35]

In *The Hireling Shepherd*, foreground detail is combined with a spacious landscape background, one much more extensive and important in the composition of the picture than any that Hunt had previously painted. It includes sheep, a field of wheat into which their leaders are straying, and beyond the sheep distant rows of trees and fields. The elaboration of the immediate foreground is not maintained throughout the entire picture, but there is not as conspicuous a difference between the handling of the foreground and distance as in *The Druids* or *Valentine Rescuing Sylvia from Proteus*. In the wheatfield, which is well back from the foreground figures, separate stalks are still clearly delineated one by one. However, what is most remarkable about the background, and what contemporary observers praised, was not its quantity of detail but its truth, or at least its novelty of effect. William Michael Rossetti wrote 'there is a feeling of the country – its sunny shadow-varied openness – such as we do not remember to have seen ever before so completely expressed.'[36] In 1860, F. G. Stephens declared that the representation of sunlight was 'an entirely new thing in art', and he explained:

> For the painter first put into practice, in an historical picture, based upon his own observations, the scientific elucidation of that peculiar effect which, having been hinted at by Leonardo da Vinci, in one of his wonderful world-guesses, was partly explained by Newton, and fully developed by Davy and Brewster. He was absolutely the first figure-painter who gave the true colour to sun-shadows, made them partake of the tint of the object on which they were cast, and deepened such shadows to pure blue where he found them to be so, painted trees like trees, and far-off hedgerows standing clearly in pure summer air.[37]

This explanation may provide a rather muddled assessment of the place of Hunt's picture in the histories of science and art, but it does indicate what a contemporary and friend saw as revolutionary in Hunt's work: in two words, coloured shadows.

Hunt was not concerned with recording changing atmospheric effects; indeed, by his method of working, he was not prepared to record them. But, as we have seen, he expressed as early as 1848 his intention of painting 'the sunlight brightness of the day itself'.[38] To do this, he had to free himself from conventional schemata of light and shade, the 'brown foliage, smoky clouds, and dark corners' against which he had directed his resolution of 1848. What this meant was that the relation of light and dark areas, which had provided the main organisational structure of a picture from Claude through Constable ('I was always determined that my pictures should have chiaroscuro, if they had nothing else'[39]), would be replaced by the relation of colours, without the tonal range of earlier works. Of course, Hunt was not the first artist to be interested in this redirection, nor was *The Hireling Shepherd* the first picture to show it. We can see behind Hunt's painting the spectrum of interests and activities discussed in the first chapter, and, as we have seen, Ruskin defended the Pre-Raphaelite pictures exhibited in 1851 against the criticism that they lacked shade. But it was the sunlight in *The Hireling Shepherd* which Stephens declared 'an entirely new thing in art'.

Despite all that has happened in art since *The Hireling Shepherd* was painted, its impact is still startling. Hunt freed himself from what he considered conventional to such a degree that to eyes accustomed to Claude or Constable his greens still seem raw and garish. But these presumably were the colours which he saw before him while working in the country and which he recorded directly without allowing considerations of pictorial values to intervene. As Stephens observed, the colours are primarily the local colours, both in sunlight and shadow. Stephens also wrote that Hunt deepened the shadows 'to pure blue where he found them to be so'. The blue in the shadows is the reflected colour of the sky. Although Hunt's use of blue is not as marked as in some of his later works or as Brown's in *The Pretty Baa-Lambs* of the same year. It can be seen in the shadows under the distant hedgerow, for example, and, more prominently and perhaps less explicably, in the bare branches on the upper left which are drawn in pure blue at their further extremities. More complex reflections are seen in the clouds and in the stippled flesh tones of the figures. The brightness of *The Hireling Shepherd*, however, is not due to reflected colours, but to the primacy of local colours and to Hunt's refusal to modify them for the sake of tonal harmony.

Hunt's and Millais's technical methods also contributed to the brightness. Hunt stated that in the country he and Millais used the wet white ground mainly for the blossoms of flowers.[40] They did not use it throughout their pictures, but as the areas in which they used the wet ground could not be retouched, the only way they could bring other parts of a picture into harmony with them would be to heighten their colours correspondingly. In *Valentine Rescuing Sylvia* the brightly coloured costumes, painted over a wet white ground, stand out from the relatively subdued colours of the forest beyond, but in *The Hireling Shepherd* a new luminosity is evident throughout the landscape, not only in the figures and flowers.

The technique of the wet white ground required an entirely fresh start, beginning with laying the ground, for each day's work. It thus forced concentration upon the local colour at the expense of consideration of the picture as a whole. Even where Hunt and Millais were not using this technique, their method seems to have been to work on a single area at a time, finishing it in detail while other parts of the canvas were still bare. Later, when painting his portrait of Ruskin (Pl. 36), Millais described a day's work as about the size of a five-shilling piece.[41] Despite any overall conceptions of the picture that the artists may initially have had, in working from nature they observed and recorded in terms of local colour and specific detail.

If their working methods precluded the traditional organisation of a picture, behind the methods lay a widespread dissatisfaction with that kind of organisation, a dissatisfaction reflected, for example, in Ruskin's criticisms of Claude as well as in Hunt's determination to escape convention.[42] Truth to nature was to be paramount, and whatever stood in its way could be sacrificed. Therefore, that the pictures would lack traditional harmonies was inevitable as well as intentional. That they have any formal coherence at all is perhaps more surprising. But a new kind of organisation, based on relationships of colour and a consistency of handling over the entire surface, is beginning to appear, replacing the traditional relationship of light and dark and the subordination of parts in an illusion of three-dimensional space. In Millais's *Ophelia*, where there is no spatial depth, the emergence of two-dimensional relationships is most obvious. It is worth noting that the *Athenaeum*, which disapproved of the 'misdirected observation and imitation of everything', nonetheless did see a kind of harmony in the *Ophelia* and advised its readers: 'Rightly to appreciate the general chromatic effect, this picture should be looked at from a little distance – when it becomes quite luminous.'[43] At a distance, the natural details lose interest as observed details and become part of an overall surface design. In *The Hireling Shepherd* there is still an extensive landscape background, but we need only recall the spaciousness of pictures by Claude or Constable to see how, in contrast, everything in Hunt's picture crowds towards the surface. This is not only the result of the effect of the bright colours upon the landscape space. The figures are not conceived in depth but in a thin triangular silhouette on the surface of the picture. If we contrast them with Mulready's figures in a landscape in *Open Your Mouth and Shut Your Eyes* (Pl. 12), their two-dimensionality is evident.

Another result of Hunt's and Millais's working method was that they tended to think of their figures separately from the rest of the pictures. The pictures were made up of parts which the artists could worry about at different times. Millais did not decide upon the subject of his second picture, the *Huguenot*, until well after he had set to work on its background. When Charles Collins joined Hunt and Millais at Worcester Park Farm,

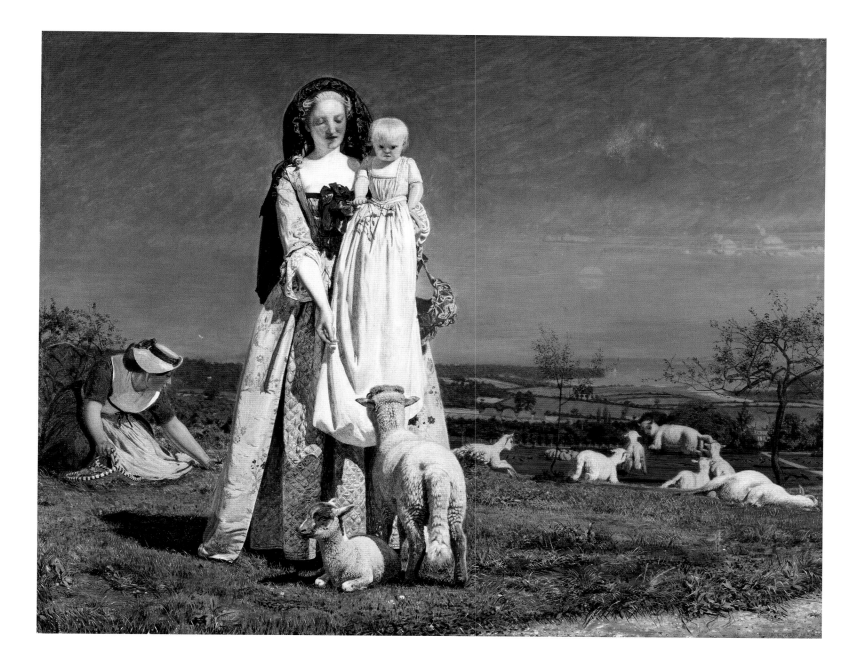

he laboured away at a background of a broken-down shed, while constantly changing his mind about what he should put in it.[44] For *The Hireling Shepherd* and *Ophelia*, Hunt and Millais apparently had fairly complete conceptions from the start, but their canvases still contained areas of white canvas for the figures when they took them back to London.

Elizabeth Siddal, Rossetti's future wife, posed in Millais's studio in a bathtub filled with tinted water for *Ophelia*. It is, therefore, not surprising that the water does not have the same convincing verisimilitude as the surrounding greenery. William Michael Rossetti wrote, 'Of the water we are not so certain as of the other points of rendering: its colour is a dusky purple – we will not venture to say untruthful, but scarcely familiar to the eye, and the flow is so slight as hardly to enhance the appearance of liquidity.'[45] Hunt also painted his figures in the studio and imported a country girl to pose as the shepherdess. He had evident difficulties in fitting the figures into their space, most obviously in the lower right corner, where the feet of the shepherdess dangle precariously over a ditch. In contrast to his work out of doors on the background, Hunt's figure painting followed a more conventional pattern, beginning with making studies of the models posed in the nude. The flesh tones have a livid coppery redness, apparently the result of Hunt's attempt to impart to them the outdoor, sunlight effect of the rest of the picture. At least, that is how William Michael Rossetti explained their complexions. To the *Athenaeum*'s critic they looked as though they had drunk too much beer.

The figures have a more integral importance in the third revolutionary Pre-Raphaelite picture begun in 1851, Ford Madox Brown's *Pretty Baa-Lambs* (Pl. 13). In April, Brown, Hunt, and Henry Mark Anthony, a landscape painter and friend of Brown's, took a three-day trip to the Isle of Wight. After their return Brown, at his home

13 Ford Madox Brown, *The Pretty Baa-Lambs* 1851–9. Oil on panel, 24 × 30. Birmingham Museum and Art Gallery.

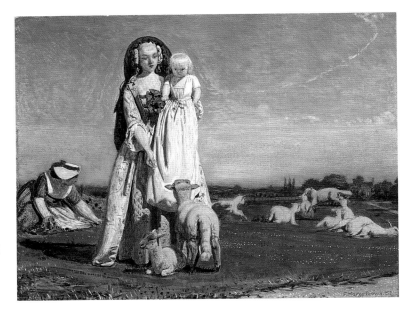

14 Ford Madox Brown, *The Pretty Baa-Lambs* 1852. Oil on panel, $7^3/_4 \times$ 10. Ashmolean Museum, Oxford.

in the south London suburb of Stockwell, began to paint *The Pretty Baa-Lambs*. According to an entry in his diary written three years later, in 1854, the painting occupied him for five months during the summer of 1851.[46] He completed it by the end of September. If Brown's memory was accurate, he began the painting before the first of May – two months before Hunt and Millais went off to Ewell to begin their pictures, and even before Ruskin wrote his letters in defence of the Pre-Raphaelites. This is Brown's description of his work, from his diary entry of 1854:

> The baa lamb picture was painted almost entirely in sunlight, which twice gave me a fever while painting. I used to take the lay figure out every morning & bring it in at night or if it rained. My painting-room being on a level with the garden, Emma [Brown's companion and wife-to-be; they married in 1853] sat for the lady & Kate [their daughter, born the previous November] for the child. The Lambs & sheep used to be brought every morning from Clappam Common in a truck. One of them eat [*sic*] up all the flowers one morning in the garden where they used to behave very ill. The background was painted on the Common. The medium I used was Robersons undrying copal (Flake White).[47]

Brown had admired the brilliance of Hunt's and Millais's pictures exhibited at the Royal Academy in 1851, and in May he wrote to Lowes Dickinson in Rome advising him to adopt the pure white ground at once, in emulation.[48] However, his use of the undrying medium does not mean that he was employing Hunt's and Millais's technique of the *wet* white ground. He did visit them in Surrey during the summer of 1851 and learned the secret of the technique from Millais, but in Brown's diary the first reference to his use of the wet white ground is for the flesh tones of his *Christ Washing Peter's Feet* (Tate Gallery), which he began in the following winter.[49]

Brown continued to work on *The Pretty Baa-Lambs* after the summer of 1851. He altered the head of the woman in the spring of 1852 before sending the picture to the Royal Academy. He worked on it further in the autumn of 1852 and in the spring of 1853 before sending it to an exhibition in Glasgow. In 1852 he made a small copy (Pl. 14), which he sold in 1854. The larger picture remained unsold until 1859, when Brown worked on it once again before it was finally bought by his patron James Leathart of Newcastle. This later work resulted in the addition of a panoramic landscape background. According to Holman Hunt's description,[50] and according to the evidence of the copy made in 1852, the picture originally had a low horizon. The background painted on Clapham Common stopped at the cottage and trees on the fringe of the open land where the figures stand. Brown apparently added the further landscape to lessen the stark contrast between the vertical figures and the low horizontal landscape. The distant wide estuary seems loosely related to two views of the estuary of the Thames painted by Brown in the 1840s, *Southend*, begun in 1846 (Pl. 17), and *The Medway Seen from Shorn Ridgway, Kent*, begun in 1849 (Pl. 15), but it is not copied directly from either of them.[51]

The meaning of *The Pretty Baa Lambs* is as problematic as that of *The Hireling Shepherd*. When the picture was exhibited at the Royal Academy in 1852, it seems to have puzzled most of the reviewers who took any notice of it. William Michael Rossetti

described it as an eighteenth-century subject showing a pretty touch of domestic sentiment.[52] Some critics suspected a religious meaning, and the *Art Journal* concluded that it was a 'facetious experiment upon the public intelligence'.[53] In 1865 Brown acknowledged the confusion when he wrote a catalogue of virtually all his work to date, and he included a statement trying to set things straight:

This picture was painted in 1851, and exhibited the following year, at a time when discussion was very rife on certain ideas and principles in art, very much in harmony with my own, but more sedulously promulgated by friends of mine. Hung in a false light, and viewed through the medium of extraneous ideas, the painting was, I think, much misunderstood. I was told that it was impossible to make out what *meaning* I had in the picture. At the present moment, few people I trust will seek for any meaning beyond the obvious one, that is – a lady, a baby, two lambs, a servant maid and some grass. In all cases pictures must be judged first as pictures – a deep philosophical intention will not make a fine picture, such being rather given in excess of the bargain; and though all epic works of art have this excess, yet I should be much inclined to doubt the genuineness of that artist's ideas, who never painted from love of the mere look of things, whose mind was always on the stretch for a moral. This picture was painted out in the sunlight; the only intention being to render that effect as well as my powers in a first attempt of this kind would allow.[54]

The denial of any meaning except the obvious one seems slightly disingenuous. Brown's *œuvre* of the 1840s and 1850s contains a number of other pictures of mothers or nurses with children: *Oure Ladye of Good Children* (Tate Gallery), *Out of Town* (City Art Gallery, Manchester), *Waiting* (private collection), *The Last of England* (Birmingham Museum and Art Gallery), and *Take Your Son, Sir!* (Tate Gallery). The first of these is a picture of the Virgin with the infant Christ, and in all the others, as in *The Pretty Baa-Lambs*, there are strong reminiscences of images of the Madonna. Also, the sheep, which Brown went to the trouble and expense of importing from Clapham Common, are not unlike those in *The Hireling Shepherd*, which Hunt later allowed to bear a weighty load of symbolism. Although Brown may not have intended his sheep as a pastoral flock, it is understandable that contemporary viewers expected them to have some meaning. It is ironic, however, that the critics were more ready to search for a hidden meaning in Brown's work than in Hunt's. Brown's assertion of the purely visual motivation of his work provides a significant antidote to the usual view of Pre-Raphaelitism as an excessively literary phenomenon. His statement also points to the importance which the study of nature directly out of doors had for the Pre-Raphaelites at this time. The friends Brown refers to are certainly the members of the Pre-Raphaelite Brotherhood. In the context of a statement about a picture in which the 'only intention' was to render the effect of sunlight, the 'certain ideas and principles in art' being sedulously promulgated by those friends could only be the ideas and principles lying behind the outdoor study of natural appearances, to which Brown, Hunt, and Millais all devoted themselves in the summer of 1851.

15 Ford Madox Brown, *The Medway Seen from Shorn Ridgway, Kent* 1849–51. Oil on board, 8 × 12. National Museum of Wales, Cardiff.

The landscape in *The Pretty Baa-Lambs*, especially as it originally stood, is less elaborate than the landscape in *The Hireling Shepherd*. If we compare areas of the foreground grass in the two pictures (see details, pp. vi and 18), we can see that Brown's delineation is less precisely detailed. His picture does not display an exploration of the botanical world com-parable to that of Hunt's, much less to that of Millais's in *Ophelia* (see detail, pp. ii–iii). What is of greater importance in Brown's work is his attention to the figures, which he, unlike Hunt and Millais, painted out of doors in the sunlight. The figures are seen under the same light as the landscape surrounding them, and thus, unlike Hunt's figures, they belong to the landscape and are part of it. The result is not only that the picture, painted as more of a piece, has a greater unity than *The Hireling Shepherd*, but also that Brown's study of outdoor light on the human figure produced a more precocious vision of light and shadow than that achieved by Hunt. Stephens praised the blue shadows in *The Hireling Shepherd*, but those in *The Pretty Baa-Lambs* are much more conspicuous. Where precise shadows are cast across a white background – the baby's garment or the maid's bodice – they are of a strong blue. In flesh areas, where the shadows are softer, they are more violet or purple, and on the grass, which has a strong colour of its own, the shadows show more darkening of the local colour without being noticeably bluer. The effect of the light on the modelling of the figures is also more pronounced in *The Pretty Baa-Lambs* than in *The Hireling Shepherd*. In Hunt's picture, despite the amount of colour in the flesh tones, the heads of the shepherd and shepherdess are modelled by subtle gradations from highlight to shadow. We still feel behind them the methods of modelling learned from drawing from casts and the controlled source of light of the painter's studio. In Brown's picture the contrast between highlight and shadow is harsher. Broad areas of flesh exposed to the full sunlight are blankly light, without modelling in light and shade. Intermediary gradations have begun to disappear, and with them the volumetric modelling of three-dimensional form.

The Pre-Raphaelites were not the first artists to paint out of doors. Painters had sketched directly from nature at least as early as the seventeenth century, and, although painting finished pictures out of doors was not as common as sketching, there are examples predating the Pre-Raphaelites. In English art, the best-known is Constable's *Boatbuilding Near Flatford Mill* (Victoria and Albert Museum), which according to C. R. Leslie's memoir of Constable was painted entirely in the open air. But, as Graham Reynolds and John Gage have pointed out, for Constable this was primarily an exercise in finishing out of doors, and to prepare for it he made a study of Claude Lorraine.[55] The picture is based on sketches, and in general effect it does not differ markedly from works painted in the studio. From written descriptions, a more unusual example of early out-of-door painting was the now lost *Christ Giving Sight to the Blind* painted in 1812 by the almost completely forgotten Henry Richter.[56] A contemporary complained of the bluish hue of Richter's draperies and of the 'alabaster transparency and copper-coloured surface' of the areas of flesh. Richter published in 1817 a pamphlet entitled *Day-light: A Recent Discovery in the Art of Painting*, in which he urged artists to paint and exhibit studies made directly out of doors, but he exhibited little, and his dicta on colour were mixed up with some rather odd metaphysics. He seems to have had little impact except possibly upon William Blake, who was a friend. Although studying nature out of doors was an important factor in the great achievements of English landscape painting in the first third of the nineteenth century, painting finished pictures out of doors was by and large not a concomitant. When it was practised by Constable it did not produce results different from what he was doing otherwise. Hunt, Millais, and Brown, on the other hand, did not paint studies from nature; they worked directly out of doors on pictures which they intended to exhibit. Their observations were not modified in the studio in the process of being transferred from the sketch to the finished picture. Although it can be said that each generation sees in nature what it wants to see, it can also be said that the Pre-Raphaelites' method encouraged a more immediate transformation of their art than the more pondered methods of their predecessors. Whether the transformation was achieved at too great a cost is still open to question.

The Pre-Raphaelites' painting out of doors, and in particular Ford Madox Brown's painting an entire figural picture in the sunlight anticipated interests of the French Impressionists in the 1860s. The stark lighting of Brown's figures and the coloured shadows have more in common with early examples of French *plein-aireism* such as Claude Monet's *Women in the Garden* of 1866–7 (Musée d'Orsay, Paris) than with previous English art. Although there seems to have been no historical link, at least one nineteenth-century critic proclaimed one. When R. A. M. Stevenson, who had studied in France and knew French painting, saw *The Pretty Baa-Lambs* in 1896, he exclaimed to Ford Madox

Hueffer with appealing overstatement: 'By God! the whole history of modern art begins with that picture. Corot, Manet, the Marises, all the Fontainebleau School, all the Impressionists, never did anything but imitate that picture.'[57]

What does all this owe to Ruskin? Certainly much: both directly and indirectly. Indirectly, we have seen in Brown's comments about *The Pretty Baa-Lambs* the implied importance of the 'ideas and principles' of his Pre-Raphaelite friends, and we know the importance that *Modern Painters* had for Holman Hunt in 1848, when he was formulating many of those ideas and principles. More immediately, Ruskin could have been of little or no importance for Brown. The two had no personal contact in 1851, and Brown began *The Pretty Baa-Lambs* before Ruskin wrote his two letters to *The Times*. On the other hand, Hunt and Millais had sought Ruskin's support. They probably would not even have started ambitious pictures in the summer of 1851 without his assertion of their right to respectful treatment. Ruskin's intervention came at a moment when Hunt was considering abandoning his career as an artist.[58] Hunt apparently did not meet Ruskin in 1851, when Millais did, but he was certainly re-exposed to Ruskin's influence through the medium of Millais. The two artists set off to the country at the end of June with Millais full of excitement about his new friendship with the famous man.[59] After meeting Millais, Ruskin wrote that the Pre-Raphaelites had carried out his advice to the young artists of England about going to nature 'in all singleness of heart . . . rejecting nothing, selecting nothing'. Meanwhile, Hunt and Millais were doing what he said they had done with a dedicated thoroughness unmatched in any of their previous work.

Ruskin, absent in Venice until July 1852, made no public comment about the Royal Academy exhibition of that year. He never publicly mentioned *The Pretty Baa-Lambs* or *The Hireling Shepherd*. Probably he considered both of them ugly because of their subjects, an opinion he expressed about Brown's later work. He did approve of Millais's *Ophelia*. When the Royal Academy exhibition opened in May, Ruskin's father sent a report, consisting largely of praise of the picture, to Ruskin and a report of that letter to Millais.[60] In Ruskin's acknowledgment of his father's account of the exhibition, he expressed possessive interest in the reception of *Ophelia*: 'I am *very* glad you like the *Ophelia* [as opposed to the press] – We will make the *Times* change its note, yet'.[61] Upon his return to London, he wrote to Millais calling both *Ophelia* and the *Huguenot* exquisite, but also giving criticism. The pictures were spoilt by the shadows, which 'are all chilled and want varnishing or something'. He disliked Millais's flesh painting, and he disapproved of Millais's and Hunt's choice of the Surrey landscape for their backgrounds: 'When you do paint nature why the mischief should you not paint pure nature and not that rascally wirefenced garden-rolled-nursery-maid's paradise?'[62] However, these remarks were for private consumption; in 1854, in his first public reference to *Ophelia*, Ruskin wondered how anyone could criticise this 'loveliest English landscape, haunted by sorrow'.[63]

Ophelia was not as immediately popular as the *Huguenot*, which Millais also exhibited in 1852, but since the 1850s it has been perhaps the most widely admired of all Pre-Raphaelite pictures. Nonetheless – and despite Ruskin – it has had its critics: the scholar A. P. Oppé claimed it fulfilled Constable's prophecy, made in 1822, that art would die in England in thirty years.[64] In the artist's own century, the most appropriate criticism came from Tennyson. According to William Allingham's diary entry for Saturday, 25 August 1888:

> While looking at a drawing with daffodils [by Mrs Allingham], T. said 'Millais put daffodils along with wild-roses in his *Ophelia* picture. I pointed this out to him. He said he had painted the rosebush from nature; and some time after when he was finishing he wanted a bit of yellow and sent to Covent Garden and got the daffodils. I told him it was quite wrong.'[65]

THREE

Ford Madox Brown

Ford Madox Brown's 'first though not very recognizable attempt at an out-door effect of light' was *Manfred on the Jungfrau* (City Art Gallery, Manchester), which he painted in Paris in 1840–1.[1] In later years, he did not think highly of the depiction of the natural world in the picture, 'glaciers not having formed part of my scheme of study in those days'. He retouched the painting in 1861, and, according to his own account, he obliterated the original scheme of colour. As the picture now stands it does have a lighter palette than other works from Brown's Paris period such as *The Prisoner of Chillon* of 1843 (City Art Gallery, Manchester).

We have seen that after his Italian trip in 1845–6 Brown attempted to reform his art along naturalistic lines, substituting 'simple imitation for scenic effectiveness, and purity of natural colour for scholastic depth of tone'.[2] In *Chaucer at the Court of Edward III* (Pl. 1), begun in 1845 and completed in 1851, he tried to treat the light and shade 'absolutely, as it exists at any one moment, instead of approximately or in generalized style'. He described the light as 'sunlight, not too bright, such as is pleasant to sit in out-of-doors'.[3] The effect of light was not the result of work out of doors, which Brown commenced only in the summer of 1851 with *The Pretty Baa-Lambs*. The size of *Chaucer* – 146½ × 116½ inches – would have made such direct work on it impossible. The bright colours of the costumes of the foreground figures were probably a result of Brown's admiration for the brilliance of Hunt's and Millais's early pictures.[4]

The landscape background of *Chaucer*, which forms a relatively small part of the painting, is mainly characterised by the linear pattern of the distant hedgerows. It is based on a study Brown painted in 1849, *The Medway Seen from Shorn Ridgway, Kent* (Pl. 15), which shows a view over the Kentish landscape and the estuaries of the Thames and Medway looking towards Essex in the far distance. Brown began the sketch on the spot in July 1849.[5] He completed it in the summer of 1851, after finishing *Chaucer*, and gave it to Thomas Seddon. In 1873 he bought it back from Seddon's widow and retouched it (it is signed and dated 1849–73 on the verso). The background of the large painting reproduces the study, but in reverse and with the colours somewhat heightened. Stylistically, *The Medway Seen from Shorn Ridgway* seems close to the work of a friend of Brown's, Henry Mark Anthony, a landscape painter who, like Brown, had spent several years working in France. *The Severn Valley* by Anthony (Pl. 16) shows a similar view from a high vantage-point over a landscape broken by hedgerows to a broad body of water. Both Brown's and Anthony's foregrounds consist of massive dark areas of foliage which provide a contrast to the lighter, patterned fields of the further landscapes, and both contain inconspicuous genre figures, a beggar and a boy in the lower left corner of Brown's picture. The foreground is rather clumsy, and it may have been added in 1873, when Brown retouched the study, in an effort to make what had initially been only a sketch for the distant landscape in *Chaucer* into a more complete and marketable picture. The handling throughout is broader than that of any of Brown's work of the 1850s. The colours stay within a range of subdued greens and yellowish browns with a marked tonal diminution to an almost monochrome horizon.

Another landscape commenced in the 1840s, also looking out over the estuary of the Thames, is *Southend* (Pl. 17). Brown lived at Southend-on-Sea in Essex, overlooking the mouth of the Thames, briefly in 1846,[6] and began the painting at that time. According

Facing page: Ford Madox Brown, *An English Autumn Afternoon* (detail of Pl. 23) .

16 Henry Mark Anthony, *The Severn Valley* c. 1850. Oil on canvas, 12 × 18. Private Collection.

17 Ford Madox Brown, *Southend* 1846–58. Oil on paper, 11³/₈ diameter. Collection of Lord Lloyd Webber.

to his own account, he finished it there in 1858.[7] According to his grandson he retouched it in 1861,[8] but it was sufficiently complete in 1859 to be included in the first exhibition of the Hogarth Club, and it was also shown in Liverpool in 1860. In 1865 Brown stated 'Southend is here represented as it was before the invasion of gas and rail-road', a remark suggesting that the picture shows the area as it was when he began the work in 1846. However, that remark also claims nostalgia for a pre-industrial landscape as part of the painting's subject, and it seems likely that Brown added the old-fashioned foreground details of a horse and buggy and a boy leading a cow during his later work on the painting to enhance the nostalgic appeal. The further landscape is painted with topographical precision and encompasses a vast distance, including the Isle of Sheppey, on the south side of the Thames, and the Nore light-ship. Like the distant view in *The Medway Seen from Shorn Ridgway*, it has little in common with Brown's more intimate landscapes of the 1850s, but the *tondo* shape does anticipate his break from conventional rectangularity in several of them.

Several versions exist of *Windermere*, or *Winandermere*, Brown's third landscape begun in the 1840s. The first version is an oil painting in the Lady Lever Art Gallery (Pl. 18). Brown began it in September 1848, while on a trip to the Lake District. He spent six days, four hours a day, painting from nature, the last day in the rain under an umbrella. Back in London he continued to work on the picture, and he also started another version.[9] He submitted one of these to the Royal Academy in 1849. It was rejected, but

18 Ford Madox Brown, *Windermere* 1848–55. Oil on canvas, 6⅞ × 18½. Lady Lever Art Gallery, Port Sunlight.

Brown did exhibit a *Windermere* the following year at the North London School of Design and in 1851 at the British Institution. The picture he exhibited was probably the second version, as in 1854 he wrote in his diary that he was 'making a picture' of the study of Windermere painted in the Lakes. At this time he cut down the sky of the study; as a result this version (Pl. 18) has an appearance and proportions quite different from the others.[10] The painted canvas is rectangular, but it is framed as a horizontal oval, a shape Brown used earlier in *An English Autumn Afternoon* (Pl. 23), which he began in 1852.

Another *Windermere*, or *Winandermere* as Brown distinguished it in 1865, is a smaller work in watercolour and heavy bodycolour formerly in the William Morris Gallery in Walthamstow (Pl. 19). In 1865 Brown dated this version 1859.[11] In composition it is practically identical to a lithograph made in the winter of 1853–4 (private collection) and to what is apparently another lithograph which Brown coloured in 1858 (City Art Gallery, Carlisle).[12] The only noteworthy visible difference between the Walthamstow and Carlisle versions is that the former has a small rainbow on the left. The earlier duplicate, which Brown began in 1848 and sold in 1854 (destroyed in World War II), he also called 'Winandermere', so it is probable that the Walthamstow picture and its mates were based on it. These pictures all have elaborate cloud effects which Brown eliminated in the Port Sunlight version.

All four known versions depict a straightforward view from the north end of Lake Windermere looking south, still easily recognisable today. As Brown mentioned in his diary that he spent the last day in the rain, the clouds in the Walthamstow version apparently reflect the weather he actually experienced. The Lake District subject and the meteorological interest bring Brown's view closer to the mainstream of English landscape painting than any of his other works. His composition, based on a dark foreground and lighter distances and framed by a series of *coulisses*, is also relatively conventional. Most of the elements of Brown's view are standard features in the watercolours of an older artist such as Copley Fielding; an example is Fielding's *Loch Lomond* of 1847 in the Manchester City Art Gallery.[13] Brown's view over a lake to distant mountains and clouds is also prefigured in a picture of 1845 by Brown's friend Henry Mark Anthony: *Killarney: the Lower Lake*, which was bought by Prince Albert (Pl. 20). As Brown's *Medway Seen from Shorn Ridgway* of 1849 seems related to Anthony, a connection here seems likely as well. Brown repeats Anthony's low vantage-point, so that the expanse of water is extremely foreshortened, and his firmly modelled distant clouds are also reminiscent of Anthony's.

Brown's clouds, however, are much more obtrusive than Anthony's. They dominate the picture, and they are so laboriously modelled that they seem as solid as the hills below them. Brown must have been doubtful of their success, for when he made his original study into a picture he altered it radically. He cut it down, thus raising the horizon; he eliminated the clouds except for a few wispy streaks; and he also eliminated a group of trees to the right whose foliage had balanced the stormy sky.[14] Brown was working on this picture in August 1854, a few days before he started his small landscapes, *The Brent at Hendon* and *Carrying Corn* (Pls 24 and 25), and the elimination of the exuberant sky is in accord with the style of these later works. His landscapes from the 1850s show his concern with the 'simple imitation' of the physical world, not with elaborate effects of atmosphere and weather. Nevertheless, atmosphere and weather are the main subjects of the other versions, and by eliminating them Brown eliminated the picture's *raison d'être*. But none of the versions is a real success. They constitute his most important attempts at landscape before coming into the Pre-Raphaelite milieu, and they show him working rather uncomfortably within a frame of fairly conventional ambitions.

Brown was a figural painter, who only painted landscapes on the side. But all his major paintings begun in the 1850s, with the exception of *Christ Washing Peter's Feet* (Tate

19 Ford Madox Brown, *Winandermere* 1859 (?). Watercolour and bodycolour, $5^1/_2 \times 11^1/_2$. Present location unknown (formerly William Morris Gallery, Walthamstow).

20 Henry Mark Anthony, *Killarney: The Lower Lake* exhibited 1845. Oil on canvas, $21^3/_8 \times 48^3/_8$. Collection of Her Majesty the Queen.

21 Ford Madox Brown, *Work* 1852–65. Oil on canvas, 54¹⁄₂ × 77¹⁄₈. Manchester City Art Gallery.

Gallery) have outdoor settings. We have already discussed *The Pretty Baa-Lambs*, begun in 1851 and painted entirely in the sunlight. In the following year Brown began three more paintings in which painting out of doors was of prime importance: *Work* (Pl. 21), *The Last of England* (City Art Gallery, Birmingham), and *An English Autumn Afternoon* (Pl. 23). In June 1852 Brown moved from Stockwell, where he had painted *The Pretty Baa-Lambs*, to Hampstead, where he immediately set to work in the main street. Writing in his diary two years later, Brown described his activity of 1852 (when he had neglected to keep up the diary): 'The first work I undertook at Hampstead was the designe for my picture of "work" still unfinished save the background . . . I began the background for "Work" in the streets of Hampstead painting there all day for two months having spent much time in inventing & making an apparatus.'¹⁵ Holman Hunt described the operation in greater detail:

> To follow our method more religiously he had taken a lodging near his chosen back-ground. For an easel he constructed a rack on the tray of a costermonger's barrow, above the canvas were rods with curtains suspended, which could be turned on a hinge, so that they shrouded the artist while painting. When all was prepared, Brown himself wheeled the barrow to the desired post; and forthwith worked the whole day, surrounded of course by a little mob of idlers and patient children, who wondered when the real performance was going to begin.¹⁶

From all evidence, Brown seems to have begun directly on the background of the large picture. Nonetheless, he also made a smaller study of the site. In his diary for 6 January 1855, we find: 'in the eveng copied in the background from the study at Hampstead in the designe of work so as to get all quite correct.'¹⁷ The 'study at Hampstead' is probably the small oil sketch with a single figure which Brown completed in December 1855 and gave to Thomas Woolner (Pl. 22); the 'design' may have been an earlier version of a watercolour sketch in Manchester which shows several variants in the figures. The finished painting is from a slightly lower point of view than the oil sketch. Both show the short rise of The Mount, just to the west of Heath Street, Hampstead's

22 Ford Madox Brown, *Study at Hampstead* 1852–5. Oil on canvas, 9 × 12. Manchester City Art Gallery.

main thoroughfare, which runs off on the right. The site today still looks almost exactly as it does in the pictures.

This is not the place to follow the history of the painting, which Brown only completed and exhibited in 1865.[18] Nevertheless, we should remember that before the figural composition was completely decided, Brown had painted an elaborate and rigorously literal landscape setting. The background was apparently completed by November 1856, when Thomas Plint saw it and commissioned Brown to finish the picture.[19] Although the figures dominate the picture, their positions were dictated by the landscape which Brown did not alter in any way to suit them.

Work is usually looked upon as an allegorical statement of social comment. Brown's long explanation of the picture and the sonnet which he wrote to go with it make clear that he intended it as such. Nevertheless, according to Brown's explanation, the allegory came later. His initial inspiration was the sight of actual labourers at work.

> At that time extensive excavations were going on in the neighbourhood, and seeing and studying daily as I did the British excavator, or *navvy*, as he designates himself, in the full swing of his activity (with his manly and picturesque costume, and with the rich glow of colour, which exercise under a hot sun will impart), it appeared to me that he was at least as worthy of the powers of an English painter, as the fisherman of the Adriatic, the peasant of the Campagna, or the Neapolitan lazzarone. Gradually this idea developed itself into that of *Work* as it now exists, with the British excavator for a central group, as the outward and visible type of *Work*.[20]

In the thirteen years between the picture's commencement and its exhibition in 1865 it became much more than a northern version of the picturesque paintings of Italian genre scenes to which Brown related his subject. It acquired an elaborately structured social message and an equally elaborately worked-out figural composition based on the rectangular opening of the excavation which provides the picture's focus. It also acquired a vast amount of observed detail, and, of course, the main part of the time Brown spent working on the picture was not devoted to developing its symbolism or its composition, but on the careful rendering of all the elements of the visible world.

Brown had previously spent several years working on his *Chaucer at the Court of Edward III*, which he completed a year before beginning *Work*. The difference in their subjects demonstrates the redirection of Brown's art resulting from his association with his Pre-Raphaelite friends. The seemingly realistic subject fraught with allegorical significance, which we might compare to that of Hunt's *Hireling Shepherd*, is accompanied by an analogous literalness both in details and in larger effect. Brown had attempted to show sunlight in *Chaucer*, but since completing it he had had the experience of painting *The Pretty Baa-Lambs* out of doors. He did not paint a picture of the size and complexity of *Work* entirely in the sunlight, but he did incorporate what he had learned about outdoor light. At the end of his statement explaining the picture Brown did not make claims for its social message; rather, he pointed to the light:

> I have only to observe in conclusion, that the effect of hot July sunlight attempted in this picture, has been introduced, because it seems peculiarly fitted to display *work* in all its severity, and not from any predilection for this kind of light over any other. Subjects, according to their nature, require different effects of light. Some years ago, when one of the critics was commenting on certain works then exhibiting, he used words to the effect that the system of light of those artists was precisely that of the sun itself — a system that would probably outlast, etc., etc. He might have added, aye, and not of the sun only, but of the moon, and of the stars, and, when necessary, of so lowly a domestic luminary as a tallow candle! . . .
>
> For the imperfections in these paintings I submit myself to our great master, the public, and its authorised interpreters, pleading only that first attempts are often incomplete. For though certainly not solitary, attempts of this kind have not yet been so frequent as to have arrived at being mapped out in academic plans. But in this country, at least, the thing is done, 'la cosa muove', and never again will the younger generation revert to the old system of making one kind of light serve for all the beautiful varieties under the heaven, no more than we shall light our streets with oil, or journey by stage-coach and sailing-packet.[21]

The critic commenting on certain works some years ago was Ruskin; the passage about the system of light being that of the sun itself appeared in his pamphlet *Pre-Raphaelitism*.[22]

Brown's additional remark that hot sunlight was only one kind of light, and that different subjects require different kinds of light is of pertinence not only to *Work*, but also to *The Last of England*, which he began four months after *Work*. This picture does not show sunlight, but Brown, nevertheless, painted it out of doors, and explained in 1865: 'To insure the peculiar look of *light all round*, which objects have on a dull day at sea, it was painted for the most part in the open air on dull days, and when the flesh was being painted, on cold days.'[23] The reason for painting flesh in the cold is explained by Brown's diary entry for 2 September 1855, when he was giving the finishing touches to the painting:

> to day fortune seemed to favour me. It has been intensely cold – no sun, no rain, high wind, but this seemed the sweetest weather possible, for it was the weather for my picture & made my hand look blue with the cold as I require it in the work, so I painted all day out in the garden & made the mans hand more what I want than it has looked yet.[24]

Most of the painting of flesh was done under similar conditions in the early months of 1853. 'Emma coming to sit to me in the most inhuman weather from Highgate. This work representing an out door scene without sun light, I painted at it chiefly out of doors when the snow was lieing on the ground.'[25] No more need be said on this score, but Brown's concluding sentences from his explanation of 1865 are also of interest:

> Absolutely without regard to the art of any period or country, I have tried to render this scene as it would appear. The minuteness of detail which would be visible under such conditions of broad daylight, I have thought necessary to imitate, as bringing the pathos of the subject home to the beholder.[26]

Thus, Brown's goal was an absolute realism, in which minute detail is appropriate both because it is what we would see, and also for psychological reasons. The psychological explanation was not uniquely Brown's; Ruskin had given a comparable explanation of the accessory details in Holman Hunt's *Awakening Conscience* in 1854.[27] John Gere has also pointed out that similar instances of heightened awareness in moments of stress are described in Tennyson's 'Maud' and Rossetti's poem 'The Woodspurge'.[28]

The third painting begun by Brown in 1852 was *An English Autumn Afternoon* (Pl. 23), the most ambitious of his landscapes. He worked on it for approximately a month during October 1852, again from 15 September to around 20 October in 1853, and for two months more between October 1853 and the following summer when he sold it at auction. In January 1855 Brown borrowed the painting back and worked on it again before sending it to the British Institution, where it was exhibited as 'English autumn afternoon, Hampstead-scenery in 1853'. When he sold the painting in 1854, he estimated that he had given it six months of work.[29] He received nine guineas, the frame having cost him four, and even then it was bought by a friend.

The picture is a view from the artist's landlady's bedroom window in Hampstead looking over the Heath (see detail, p. 34); Kenwood House and the spire of one of the churches in Highgate are visible in the distance.[30] This suburban view provoked Ruskin's one recorded comment about Brown's art. Coming upon the painter in Rossetti's studio in the summer of 1855, Ruskin asked Brown why he had chosen 'such a very ugly subject'. Brown, feeling that Ruskin had intended a deliberate insult, answered curtly, 'Because it lay out of a back window'.[31] But Ruskin's question is understandable, even if Brown suspected his motives. Why should so much labour have been spent in recording scenery which by Ruskin's standards was of so little interest, which lacked any elements of natural grandeur or natural beauty? It is a question that comes up again and again in Ruskin's criticism; we have seen it before in his comments on the background of Millais's *Ophelia*. Brown's reply was not meant to satisfy Ruskin, but it was to the point. The picture is the landscape of his own personal experience. It does not have the scenic interest which Ruskin wanted – and which we can see in Brown's earlier *Winandermere* – but shows an intimate, domestic view, full of signs of human activity and human presence. This is what the artist saw from his home, and this personal association sanctions the subject.

The human presence is most evident in the foreground, where a boy and girl are relaxing and enjoying the view. They give the painting a slightly sentimental air, but Brown did not want too much sentiment read into them, and in his remarks about the picture in 1865 he declared that they were not lovers, but mere 'boy and girl, neighbours and friends'.[32]

Foreground figures looking into a picture are a device for leading the viewer's eye into the landscape by associative means. Antecedents date back to Jan van Eyck. An English example, similar in feeling, is Constable's inclusion of the Bishop of Salisbury and his wife in the foreground of his *Salisbury Cathedral from the Bishop's Grounds* (versions in the Victoria and Albert Museum, Frick Collection, etc.). Other examples are in the work of Francis Danby, for whom Brown had high respect.[33] *The Painter's Holiday* by Danby (Yale Center for British Art, New Haven), which Brown would have seen when it was exhibited at the Royal Academy in 1844, shows a painter reclining on a high foreground, like Brown's, and watching the sun set over an extensive landscape.

Brown also used an age-old device, the so-called plateau landscape, which again dates back to Jan van Eyck, in placing the figures on a high foreground, above and separate from the rest of the landscape. As in fifteenth-century paintings, it provides a means of transition from large foreground figures to a distant expanse of landscape. While there are numerous earlier English examples of the plateau landscape, including *The Painter's Holiday* by Danby, it also appears in Brown's earlier historical compositions, *The Body of Harold Brought before William the Conqueror* and *Chaucer at the Court of Edward III*. In his first use of it in the cartoon of *Harold*, Brown was probably following the example of Delacroix's *Crusaders Entering Constantinople*. In the Delacroix and in Brown's two earlier pictures the plateau landscape is the device of a figural painter. We could consider *An English Autumn Afternoon* also as a figural picture with a separate landscape background, but it is one in which the relative importances of foreground and background have been reversed. Following Brown's lead, variations of the plateau landscape appear frequently in later landscapes of the Pre-Raphaelite circle, most frequently in those of Thomas Seddon (a disciple, whose brother owned *An English Autumn Afternoon*), John Brett, and Holman Hunt. For all of them it allowed a combination of close foreground detail with panoramic views, for which they, like Brown, were willing to sacrifice spatial continuity.

A result of the high vantage point of the plateau landscape is a high horizon. While in *Winandermere* the sky fills over two thirds of the composition, the sky accounts for less than one third of *An English Autumn Afternoon*. We have seen that the pictures with high horizons exhibited by Hunt and Millais in 1851 were denounced in *The Times* as part of the servile imitation of the false perspective of remote antiquity.[34] It is virtually an axiom of art history that high horizons belong to the earliest stages of landscape painting,[35] and in Brown's art this change and most of the other changes from *Winandermere* do seem to indicate a reversion to a more primitive style. In important respects, *An English Autumn Afternoon* has more apparent affinities stylistically with Jan van Eyck than with

23 Ford Madox Brown, *An English Autumn Afternoon* 1852–5. Oil on canvas, 28¼ × 53. Birmingham Museum and Art Gallery.

Claude Lorraine or Constable. In 1846, before he had any contact with the future members of the Pre-Raphaelite Brotherhood, Brown had painted a 'Holbein of the 19th Century' in which he wished 'to substitute simple imitation for scenic effectiveness, and purity of natural colour for scholastic depth of tone'.[36] *An English Autumn Afternoon* is a later product of the same process of seeking a more simple, direct truth, but the primitive qualities are no longer the result of consciously emulating early art as the way of achieving it. Brown had learned those lessons. In October 1852 he commenced two pictures: *The Last of England* and *An English Autumn Afternoon*. His assertion in 1865 of the freedom of one from any dependence upon the past – 'Absolutely without regard to the art of any period or country, I have tried to render this scene as it would appear' – is equally appropriate for the other. But, in *An English Autumn Afternoon* he rendered the scene not as it would appear, but as it did appear. He described the picture as 'a literal transcript of the scenery round London, as looked at from Hampstead'.

The scenery is viewed at a certain time and under the conditions of that time. Here is Brown's description:

> The smoke of London is seen rising half way above the fantastic shaped, small distant cumuli, which accompany particularly fine weather. The upper portion of the sky would be blue as seen reflected in the youth's hat; the grey mist of autumn only rising a certain height. The time is 3 P.M., when late in October the shadows already lie long, and the sun's rays (coming from behind in this work) are preternaturally glowing, as in rivalry of the foliage.[37]

That Brown should want to paint a literal transcript of the view is what we might expect. That he should provide a detailed explanation of the atmospheric and meteorological conditions is slightly surprising. The sky forms a small and relatively neutral part of the painting; the terrain, not the sky, is the primary interest. We see none of the dramatic clouds that dominate Constable's views on Hampstead Heath, or Brown's earlier *Winandermere*. Yet, Brown, like Constable, associates particular cloud formations with other conditions of the weather, and he points out four different aspects of the sky visible in his picture: rising smoke, grey mist of autumn, small distant cumuli, and a blue upper sky. The distant clouds are pink in the light of the late afternoon sun. The entire foreground is in shadow, and consequently in details such as the boy's hat we see the reflected blue of the upper sky. But the hat is so completely blue, while other foreground details such as the white bench are relatively unaffected, that it appears to be a blue hat. Despite Brown's working directly from nature, the effect seems eccentric, as if it were painted on the basis of theory rather than observation, and it brings to mind Henry Richter's bluish draperies of some forty years earlier.

As well as the reduced importance of the sky, *An English Autumn Afternoon* shows several other compositional changes from *Winandermere*. Although the foreground is in shadow, it is not as dark as the foreground of the earlier picture. Tonal contrast between foreground and distance has been radically reduced, and in its place comes overall strength of colour. Similarly the *repoussoir* clumps of trees and series of framing *coulisses* of the earlier composition have disappeared. Immediately beyond the foreground plateau a dense area of foliage runs across the picture like a wall. The eye is not led through open spaces into the distance but must jump across this compositional barrier. The foliage is treated neither as clearly delineated individual leaves, as by Hunt and Millais, nor in large masses, but in myriad small touches of colour. Where various planes of foliage are seen through, or juxtaposed to, one another, the separate touches tend to merge into one plane of colour. The result is a confusion of conventional illusionistic, spatial depth. As in the Pre-Raphaelite pictures of 1851, composition in two-dimensional relationships is replacing three-dimensional space.

Brown gives no indication in his diary or in the catalogue of 1865 that this flattening process was a result of conscious effort. Rather it seems to have been a result of his willingness to sacrifice any conventional means of organising or clarifying space in order to record exactly what he saw. Even the shape of the picture appears to be a product of his attempt to give as pure an approximation of the visual experience as possible. Following the lead of the German Nazarenes and numerous English artists, Brown started using shapes other than the normal rectangle for some of his pictures in the 1840s. In the earlier examples he adopted medieval or renaissance forms: *Chaucer at the Court of Edward III* was originally planned as a Gothic triptych.[38] *The Last of England* is still a Renaissance tondo, but there is no equally obvious source for the horizontal ovals which Brown gave to *An English Autumn Afternoon* and *Windermere*. There are seventeenth- and eighteenth-

24 Ford Madox Brown, *The Brent at Hendon* 1854. Oil on board, 8 × 9³/₄. Tate Gallery, London.

century precedents, which would have had little appeal for Brown, in the decorative shapes of overdoors, dictated by architecture, and in the shapes of engraved illustrations, conceived as embellishments of a printed page. In Brown's case the most likely reason for employing the shape was not its decorative appeal but its relation to actual experience: its correspondence with what we accept as the normal field of binocular vision.

Brown painted two small landscapes, *The Brent at Hendon* (Pl. 24) and *Carrying Corn* (Pl. 25), in 1854, and a third, *The Hayfield* (Pl. 26), in 1855. He painted these landscapes largely as a diversion, inspired by his enjoyment of the natural world. In 1854 and 1855 he made a number of excursions in the countryside with his wife from their home in Finchley, to which they had moved in September 1853, and his diary entries describing them record his love of landscape for its own sake, regardless of his requirements as a painter. For example, on 22 August 1854, he felt disgusted with everything and was unable to work, so they took a trip to St Albans, part of the way on the top of a bus: 'We should have thought more of the fields, no doubt, were we not so much used to them of late. However one field of turnips against the afternoon sky did surprise us into exclamation with its wonderful emerald tints.'[39] On 13 October they went for a walk: 'exquisite day, hedges all gold rubies & emeralds defying all white grounds to yield the like'.[40] Both these diary entries show Brown seeing with the eyes of a painter, but not looking for potential pictures. He is a tourist or stroller, enjoying his surroundings. At other times he did try to channel his enjoyment into pictures; a diary entry dated 21 July 1855, demonstrates his difficulties:

> Looked out for landscapes this eveng, but although all around one is lovely how little of it will work up in to a picture – that is without great additions & alterations which is a work of too much time to suit my purpose just now. I want little subjects that will paint off at once. How despairing it is to view the loveliness of nature towards sunset, and know the impossibility of imitating it, at least in a satisfactory manner as one could do would it only remain so long enough. Then one feels the want of a life study such as Turner devoted to landskape & even then what a botch is any attempt to render it. What wonderful effects I have seen this eveng in the hayfields, the warmth of the uncut grass, the greeny greyness of the unmade hay in furrows or tufts with lovely violet shadows & long shades of the trees thrown athwart all & melting away one tint into another imperceptibly, & one moment more & cloud passes & all the magic is gone. Begin tomorrow morning all is changed, the hay & the reapers are gone most likely, the sun too, or if not it is in quite the opposite quarter & all that *was* lovelyest is all that is tamest now, alas! it is better to be a poet – still better a mere lover of nature, one who never dreams of possession.[41]

This passage reveals two elements not entirely in harmony with one another: Brown's awareness of his limited capabilities, and, once again, his response to the beauty of the landscape. Essential to these paintings is the 'loveliness' of some natural effect. Brown looked for 'little subjects that will paint off at once', but he chose subjects that he admired and then found them impossibly difficult to paint.

25 Ford Madox Brown, *Carrying Corn* 1854.
Oil on panel, 7³/₄ × 10⁷/₈. Tate Gallery, London.

His purpose was to paint potboilers. At the time, Brown and his family were miser-
ably poor, and his painting excursions were interspersed with visits to the pawnbroker.
While many of his major paintings were dragging on for years (*Work* from 1852 to 1865,
The Last of England from 1852 to 1855), these landscapes were painted to produce an
immediate income. All considered, the undertaking was impractical. Brown could not
command high prices for his landscapes, and, from temperament and lack of experience,
he could not paint them off at once. He invariably bogged down in difficulties and put
in large amounts of time. As he concluded, 'altogether these little landscapes take up too
much time to be proffitable'.⁴² Doubts about his capabilities are a theme running
through his diary. To be a successful landscape painter requires a life's study. Lacking this,
Brown could not work with assurance; it 'requires all my energy & attention to master
the difficulties attending a style of work I have not been bred to'. Individual details
become insurmountable problems causing doubts and delays:

> to work at the corn field from ¹/₂ past 3 till ¹/₄ to 6, did next to nothing. It would seem
> that very small trees in the distance are very difficult objects to paint or else I am not
> suited to this sort of work for I can make nothing of this small screen of trees, though
> I have pottered over sufficient time to have painted a large landskape, the men of eng-
> lish schools would say.⁴³

These are not the comments of a master sure of himself and of his art. Brown's approach
to landscape is tentative and searching, and this is reflected in the finished pictures. There
is no consistent production; each picture is unique, an isolated object, the result of a fresh
attack upon fresh problems.

Although his first purpose was the literal depiction of natural scenery, Brown realised
that he could never achieve exact imitation. For one thing, he was aware that he could
not cope with nature's changeability, and that the effects he wished to paint would not
wait to be painted. Furthermore, no degree of copying in itself was adequate for the
complexities of even the more permanent aspects of nature: 'nature, that at first sight

appears so lovely is on consideration almost always incomplete, moreover there is no painting intertangled foliage without losing half its beauties. If imitated exactly, it can only be done as seen from one eye & quite flat & confused therefore.'[44]

Brown wrote this while looking for a spot to paint *The Brent at Hendon*, the first of the small landscapes of 1854–5 (Pl. 24). The problems of painting intertangled foliage were evidently real ones; the picture is quite flat and confused. In the crowded oval space, the effect of the foliage is further complicated by reflections in the stream. There is a conflict within the picture between Brown's technique of painstaking literalness and a subject that is essentially romantic. The subject is not the forest primeval, but it is a city-dweller's equivalent. In 1865 Brown described the Brent as 'a most romantic little river'. It was part of the surrounding outskirts of London which were disappearing before urban expansion, but at the time the picture was painted, 'once embowered in the wood-ed hollows of its banks the visitor might imagine himself a hundred miles away'.[45] The appeal is to nostalgia, as in *Southend* (Pl. 17) which he completed in 1858, and the mood is emphasised by the little figure of a woman reading a letter, which Brown added, then altered, to make the picture more sentimental.[46]

Brown began *The Brent at Hendon* on 2 September 1854. A few days later, he started a second landscape, *Carrying Corn* (Pl. 25), which he painted simultaneously. He worked on *The Brent* in the mornings until 26 September and on *Carrying Corn* in the evenings until 13 October. He sold both the following June for ten and twelve pounds respectively, and a month later, on 28 July 1855, he began a third landscape, *The Hayfield* (Pl. 26). This painting occupied him until late October, with additional work on the foreground and some repainting in December 1855. Brown sold it in the following August to William Morris for forty pounds.

Carrying Corn and *The Hayfield* both show harvest scenes, the former seen just before sunset, the latter just after, and in both a full moon is low in the sky. Like *The Brent* they depict a rural England still untouched by the modern city and the industrial revolution, and they share some of its nostalgic escapism. In both, farmworkers are carting off hay

26 Ford Madox Brown, *The Hayfield* 1855.
Oil on panel, 9 × 12½. Tate Gallery, London.

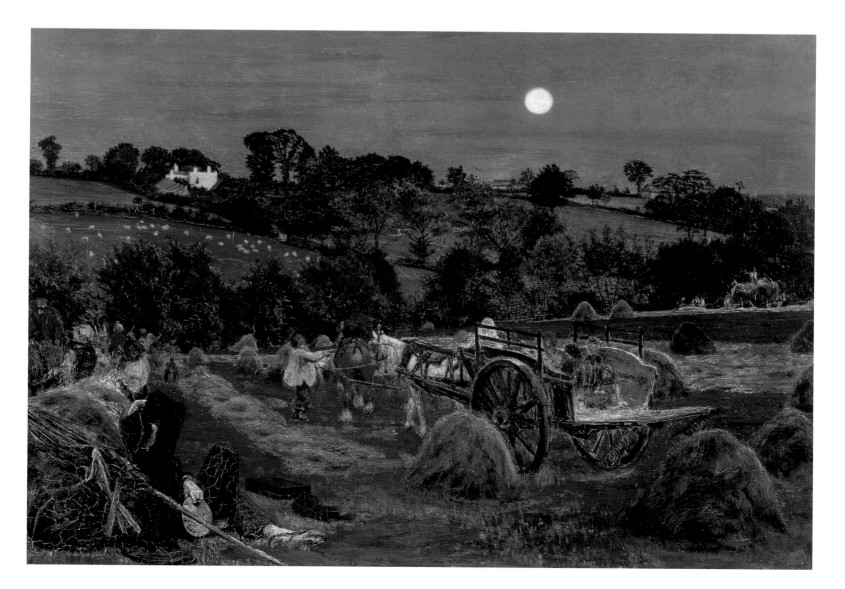

or wheat; in the foreground of *Carrying Corn* a woman is picking turnips, and in *The Hayfield* an artist, certainly Brown himself, watches the activity. Brown's diary records his choosing the site of *Carrying Corn*: 'About three out to a field, to begin the outline of a small landscape. Found it of surpassing loveliness. Cornshocks in long perspective form, hayricks, and steeple seen between them – foreground of turnips – blue sky and afternoon sun.'[47] The following year the site he chose for *The Hayfield* was 'a very lovely bit of scenery'. He did not describe the scene further in his diary, but in 1865 he identified the location as Hendon and went on:

> The stacking of the second crop of hay had been much delayed by rain, which heightened the green of the remaining grass, together with the brown of the hay. The consequence was an effect of unusual beauty of colour, making the hay by contrast with the green grass, positively red or pink, under the glow of twilight here represented.[48]

That last sentence about hay appearing red or pink because of the conditions under which it was seen reminds us of Claude Monet painting red and pink haystacks in the 1890s, but, whereas Monet's haystacks were vehicles for recording effects of light to the exclusion of other interests, Brown was less single-minded. The amount of detail that the pictures contain reflects his struggles at one site for a period of a month and a half and at the other for almost three months to depict accurately everything he saw. Yet, despite his hard work, the results do not seem very natural. They show the same tendency towards two-dimensionality that we have seen in *An English Autumn Afternoon*, but in these smaller pictures it is even more evident. Everything becomes woven into a surface pattern. Details which we might expect to stand out, such as the woman picking turnips in the foreground of *Carrying Corn* or children in a cart in *The Hayfield*, appear to be deliberately de-emphasised, even left unfinished, so as not to be more prominent than anything else. As in *An English Autumn Afternoon*, neglect or avoidance of space-creating compositional formulae leads to emphasis on the surface at the expense of illusionistic space. This is partly a result of Brown's limited competence; he had never learned the tricks of landscape painting. But his lack of experience allowed him to look at landscape with a remarkably fresh eye. He seems to have been oblivious of anything to be learned from previous painting which could help him slide over his problems, approaching his landscapes almost as if they were the first ever painted. The results have a freshness, an individuality, and a slight feeling of naivety more akin to the Limbourg brothers in the *Très Riches Heures of the Duc de Berri* and Jan van Eyck than to what we usually consider the mainstream of nineteenth-century naturalism, running from Constable to Monet.

It is difficult to accept Brown's landscapes as realistic pictures of the surroundings of Hampstead in the way that we readily accept Constable's views of the nearby Heath. Brown's pictures show too much too clearly; they are like wide-eyed visions of a world of pastoral harmony and tranquility. The twilight hour, the scenes of harvesting (rather than ploughing and planting), the relative importance and the placing of the figures, and the transformation of landsape space into surface pattern have little in common with Constable, but they do recall some of the harvest scenes painted by Samuel Palmer at Shoreham in Kent in the 1820s and early 1830s. In 1854–5 Palmer was still alive and active, but it seems unlikely that Brown was aware of his early works done in Shoreham over twenty years previously. As a young artist Palmer was a disciple of Blake. He scorned naturalism, and in the Shoreham paintings he deliberately tried to be visionary and spiritual. Brown, on the other hand, was ostensibly only trying to paint potboilers showing straightforward views of rural scenery. Both artists, however, lacked any interest in traditional landscape virtues; Palmer's admiration for the 'very ancient Italian and German masters' and his disapproval of what the moderns 'call their effects' anticipated Brown's later rejection of 'scenic effectiveness'. Palmer's descriptions of the strength and clarity of distant hills – 'we are not troubled with aerial perspective in the valley of vision'[49] – could well have been a statement by Brown, who seems to have been equally untroubled by aerial perspective when painting his *Hayfield*. In Palmer, visionary clarity verges on the hallucinatory, and in Brown there is a slight tendency to similar imbalance. In *Carrying Corn*, for example, there is something disturbing about the insistent scale of the foreground turnips. Brown painted these landscapes after his move to Hampstead, where he was 'most of the time intensely miserable very hard up & a little mad . . . broken in spirit and but a melancholy copy of what I once was'.[50] He wrote these words describing the previous two years in his diary in August 1854, just before beginning the first of the landscapes. His diary during the period of these paintings alternates widely between

depression and exaltation. The pleasure he was able to draw from nature provided a release from his problems, and his small, idyllic landscapes seem to have become vehicles into which he unknowingly projected an emotional load far transcending his original moneymaking goals.

After *The Hayfield*, Brown's next landscape was a small watercolour, *Hampstead from My Window*, which he painted from his studio almost two years later, in the spring of 1857 (Pl. 27). He included it in an exhibition of British pictures sent to America later in the same year, and it was sold in Philadelphia. It differs considerably from the group of paintings that preceded it. It is smaller and in a different medium. In subject it has few of the evocative overtones of the group of landscapes of 1854–5; rather it shows Brown's domestic environment, and in this respect, as in several others, it recalls *An English Autumn Afternoon*. The view in the watercolour is of Hampstead seen from Kentish Town, where Brown had moved in October 1855, rather than from Hampstead toward Highgate, but in both works we look over foliate foregrounds and across the Heath. As in *An English Autumn Afternoon* the foliage is treated as small touches of colour in an almost *pointilliste* fashion, and there are comparable confusions or ambiguities of planes. There is no foreground; we are above ground level and look out of the window through a screen of trees whose bottoms are cut off by the picture frame. As a result, the dots of foliage have no horizontal ground plane to situate them in depth. They are on the immediate surface of the watercolour, making it yet more strongly two-dimensional than any of Brown's earlier landscapes. We see through the foliage to diminutive figures on a street below, and over it to open space beyond, but the distant view forms only a small part of the composition.

The last of this series of Brown's landscapes from the 1850s is *Walton-on-the-Naze* (Pl. 28). Brown stopped keeping his diary early in 1858, so we cannot follow his day-by-day progress on the painting. *Walton-on-the-Naze* was begun in late August and early September 1859, but it was completed the following year and is signed and dated 1860.[51] It shows what Brown described in 1865 as 'a small watering place on the east coast of Essex lately of some repute'.[52] The rest of the entry in his catalogue mainly describes the scenery, but it also contains a brief mention of the figures: 'The lady and little girl, by their let-down hair, have been bathing – the gentleman descants learnedly on the beauty of the scene.' These figures, absorbed by the scenery before them, represent Brown,

27 Ford Madox Brown, *Hampstead from My Window* 1857, Watercolour, 5¹⁄₂ × 8¹⁄₂. Delaware Art Museum, Wilmington.

28　Ford Madox Brown, *Walton-on-the-Naze*
1859–60. Oil on canvas, 12½ × 16½.
Birmingham Museum and Art Gallery.

his wife, and his daughter, and the picture is, among other things, a souvenir of a family
holiday at the seaside.

From Brown's diary entries, we have seen his feeling for natural scenery. The strength
of that feeling seems to have undermined detachment. In Constable's paintings, the land-
scape is nature, something with a life of its own apart from the artist; in Brown's, his own
reaction to the landscape is inextricably present. The beauty of a place is important, but
the artist makes us as aware of his response as of the landscape. In two of Brown's land-
scapes, *An English Autumn Afternoon* and *Hampstead from My Window*, the subject is his
own landscape, the view he sees every day from his home. In two others, *The Hayfield*
and *Walton-on-the-Naze*, he includes figures who represent himself. These figures seen
from the rear are, like the young couple in *An English Autumn Afternoon*, compositional
crutches, devices to lead the viewer into the picture; they belong, likewise, to a long tra-
dition of figures looking into the distance of a picture. But whereas in much painting of
the earlier nineteenth century, that of the German artist Caspar David Friedrich pro-
viding the best-known examples, we feel that the figures embody a melancholy mood,
a desire for escape into the space they contemplate, or beyond, in Brown's landscapes
there is only contentment. The landscape is limited, the figures belong to it, and they
convey the artist's own happy relation with the scene. The artist makes clear his delight
in the world he depicts by showing himself there enjoying it.

The figures in *An English Autumn Afternoon* and *Walton-on-the-Naze* are of a dif-
ferent social class from those in most English landscape paintings from the first half
of the century. Instead of picturesque peasants and fishermen, we see people from the
middle-class world of the artist and his patrons enjoying their middle-class pleasures.
Brown's subject of a seaside holiday in *Walton-on-the-Naze* was, however, far from the first
of its kind. *Life at the Sea Side* (or *Ramsgate Sands*; Royal Collection) by William Powell
Frith was exhibited in 1854 with tremendous popular success, virtually establishing a new

genre of painting. For Frith the contemporary holiday scene provided an opportunity to paint a picture packed with amusing or sentimental anecdote. Brown's paintings are free (or almost free) of this narrative element, and he began painting scenes of middle-class leisure independently of Frith; *An English Autumn Afternoon,* boy and girl lolling in the foreground, was begun in 1852, two years before Frith exhibited *Life at the Sea Side.* Brown painted these subjects primarily from 'love of the mere look of things', and in this respect, while they differ considerably from Frith's works, they seem akin to the early Impressionist paintings by Monet and others from the following decade. As a subject, *Walton-on-the-Naze* is not unlike the well-known *Regatta at Sainte-Adresse* and *Terrace at Sainte-Adresse* (both Metropolitan Museum of Art, New York) painted by Monet in 1867 and showing similar scenes of middle-class relaxation at the edge of the sea.[53]

But the look of things for Brown was quite different from the look of them for the Impressionists. *Walton-on-the-Naze* gives an extraordinary amount of information about the place. Brown's look was not a rapid glance, but a steady gaze taking in the myriad features of the landscape. We are aware of those features in much the same way as the woman in the picture, whose companion points them out to her one by one. The figures examining the landscape give it a narrative unity. The corn shocks in perspective rows lead the eye into the picture, and the rainbow arching over the landscape provides an enclosing frame. But there is no single focus for the painting as a whole; there is a separate, precise focus for each object. Things lack the feeling of inevitable relationship that objects in a more traditionally composed and organised painting normally have, and the differing components of the landscape are not subordinated to a unifying effect of light and atmosphere as in an Impressionist picture. In looking at *Walton-on-the-Naze* we notice various details – a square-rigged ship on the horizon, a field mouse in the foreground, tiny figures at work in the middle distance – separately and unexpectedly. The picture shares the hyper-real clarity of vision of *The Hayfield* and *Carrying Corn,* but compared to those paintings *Walton-on-the-Naze* is less compact, less tautly composed. It is more spacious and leisurely, more like a dream than a vision. The antiquated ship on the horizon is like a ghost ship, and the rainbow and the moon, just faintly visible, enhance the feeling of dream-like unreality.

The white building at the centre of the picture recalls a detail of one of the best-known English watercolours, *The White House at Chelsea* by Thomas Girtin (Tate Gallery).[54] It is possible that Brown was aware of the Girtin, which had been engraved, when he made such a marked accent of the small building. There are also other points of similarity between the watercolour and Brown's painting: the windmills to the left of the buildings, the meandering interplay of land and water, the clouds low over the horizons, and the twilight or near twilight hours. In both there is a flat monotony about the scenery which is relatively rare in English landscape (and also rare in Girtin's work). There are also glaring differences; Brown's smallness of touch, his much greater profusion of detail, and the inclusion of foreground figures all contrast with Girtin's breadth and simplicity. Girtin's colours are cool greys and blues; Brown's are vibrant greens and purples. These differences demonstrate some of the transformation of English painting in the sixty years between the two works. But Brown's painting does have something of the almost magical stillness and serenity of mood of the earlier watercolour. While in some important respects Brown's landscapes seem to look more to the future than to tradition inherited from the past, they also can and should be seen as among the last masterpieces of the English landscape tradition.

Despite some differences, *Walton-on-the-Naze* is still basically in the same style as Brown's pictures from the mid-1850s, but it is his last work in which rigorous naturalism is of much importance. In 1861 he was a founding member of Morris, Marshall, Faulkner and Company, and in the early 1860s he spent much of his time designing furniture and stained glass for the firm. He also produced numerous designs for book illustration. This work seems to have had a substantial effect upon his later painting, almost all of which falls into curvilinear, two-dimensional patterns and is radically different from his art of the 1850s. Landscape elements appear throughout his paintings from after 1860, but they are relatively unambitious, and they reveal little of the scrupulous fidelity of his earlier works.

In one design commissioned for an illustrated Bible by the Dalziel brothers and in a later painting based on it, *The Coat of Many Colours* of 1866 (Pl. 29), Brown copied the background from an Eastern landscape by Thomas Seddon (Pl. 105).[55] This shows a concern for historical and geographical exactitude; however, at the same time, it shows an abandonment of that direct confrontation with nature which lay behind all

29 Ford Madox Brown, *The Coat of Many Colours* 1866. Oil on canvas, $42\frac{1}{2} \times 40\frac{5}{8}$. Walker Art Gallery, Liverpool.

of his art of the previous decade. Furthermore, although the derivation is obvious, Brown altered Seddon's view to emphasise the linear pattern of the paths on the distant hillsides. All Brown's landscape backgrounds of the 1860s and later are relatively linear and schematic; they are more like those in his painting of the 1840s than those of the 1850s. The background of *Byron's Dream* of 1874 (Pl. 30), also based on an illustration, recalls the pattern of fields in the background of *Chaucer at the Court of Edward III*. The same curvilinear schematisation is visible in the landscape passages in Brown's

30 Ford Madox Brown, *Byron's Dream* 1874. Oil on canvas, $28\frac{1}{4} \times 21\frac{3}{4}$. Manchester City Art Gallery.

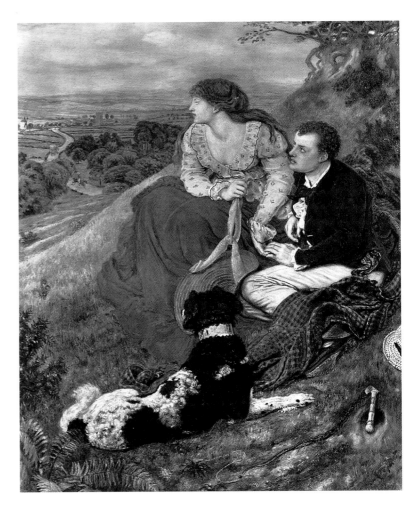

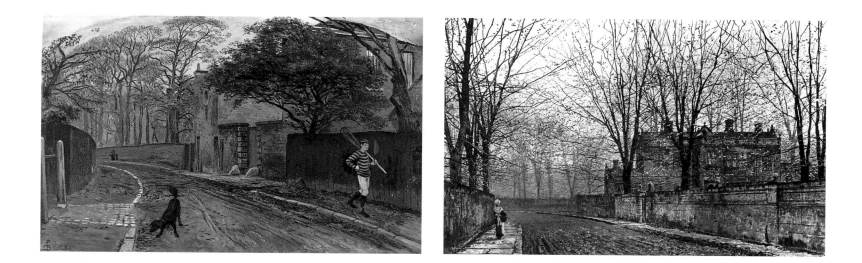

frescoes in Manchester Town Hall, which were the main occupation of the last fifteen years of his life.

Brown lived in Manchester for the sake of his frescoes from 1881 until 1887, and he painted one landscape there, *Platt Lane* (Pl. 31), which is dated October 1884. Although, according to Brown's grandson, he intended it as a study for his fresco *Chetham's Life Dream* in the Town Hall,[56] the fresco shows a different site, and there is only slight resemblance in the angular patterns made by the branches of trees. Brown painted *Platt Lane* directly on the spot, using a cab to protect himself from the weather. Despite this, it shows the same curvilinear stylisation as Brown's later figural works. The composition, dominated by the linear patterns of bare branches and of the curving lane, recalls and may have been inspired by pictures by the Leeds artist John Atkinson Grimshaw (Pl. 32).[57] The picture has an air of naive quaintness, which is appealing, but it has little in common with Brown's landscapes of the 1850s and shares little of the extraordinary freshness of vision which makes them such memorable works.

31 Ford Madox Brown, *Platt Lane* 1884. Oil on canvas, 10¼ × 15½. Tate Gallery, London.

32 Atkinson Grimshaw, *November Morning* 1883. Oil on canvas, 20 × 30. Shipley Art Gallery, Gateshead.

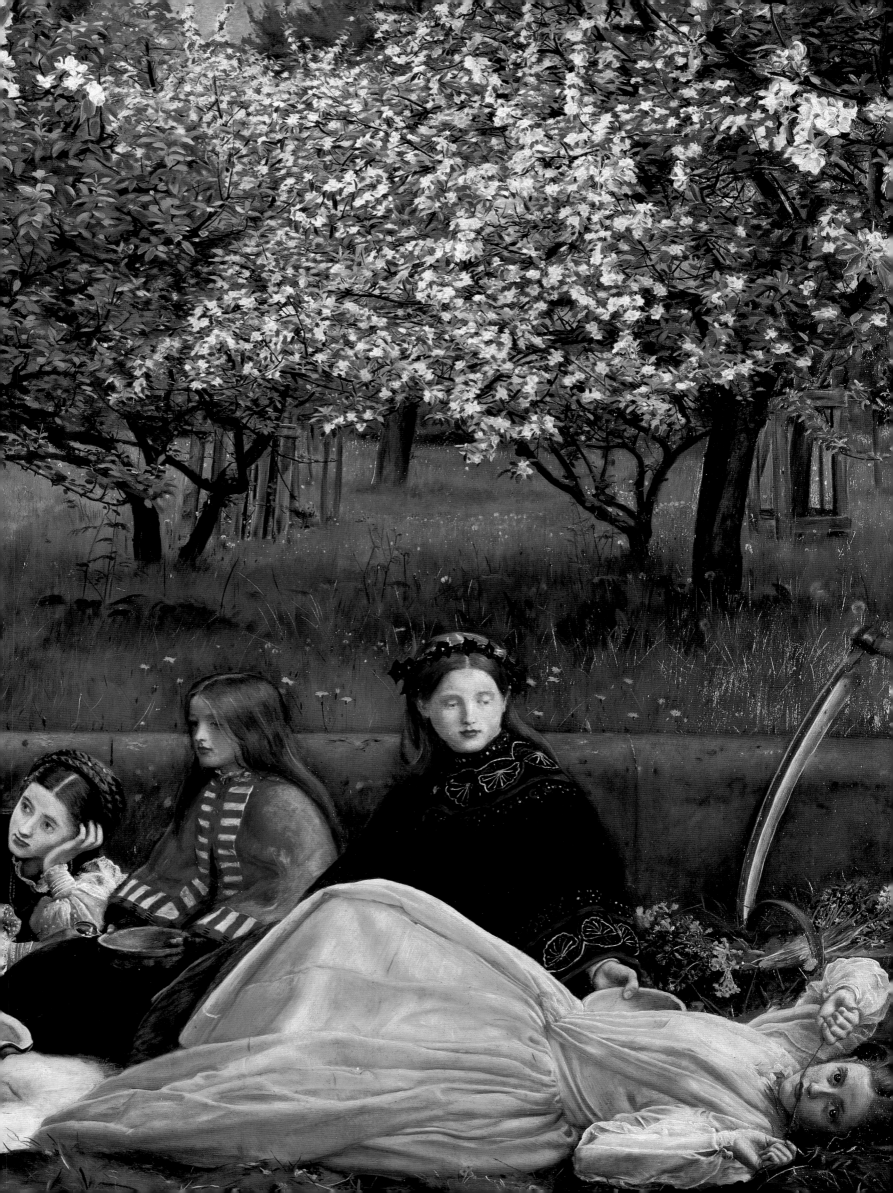

FOUR

John Everett Millais

Neither Holman Hunt nor John Everett Millais developed a feeling for landscape comparable to that of Ford Madox Brown. As painters of landscape neither stands on the same level. Nonetheless, landscape elements appear throughout their art both in figural compositions and in occasional pure landscapes.

The earliest extant landscape of any consequence by either artist is a watercolour by Millais, *The Gipsy* (Pl. 33). It is signed and dated 1846, that is, when Millais was seventeen years old, and two years before the foundation of the Pre-Raphaelite Brotherhood. The watercolour shows no hint of Millais's future Pre-Raphaelite style, but it does demonstrate the young artist's fluency in the vocabulary of the 1830s and 1840s. The composition contains framing trees, a road leading into the picture, alternating lights and shades, and a subdued tonality with one touch of bright colour on the foreground figure. It recalls works by William Collins, W. F. Witherington, and a host of contemporary watercolourists, and it is itself an example of the conventionally composed picture, with little or no fresh observation of nature, against which the Pre-Raphaelites were to rebel.

The small *Landscape, Hampstead* (Pl. 34) is not dated, but in a letter of 1878 Millais described it as 'a sketch from Nature done many years ago . . . I think I painted it from Hampstead or thereabouts.'[1] Millais had friends who moved to Hampstead in 1848, and during visits to them he is known to have painted landscapes in the vicinity. A *Hampstead Heath* (location unknown) was dated 1848 and described as 'an extremely elaborate and patient sketch' by M. H. Spielmann in his monograph on Millais published in 1898.[2] So that seems the likely date for the picture under discussion. It is a study of a group of farm buildings whose main interest lies in their picturesque dilapidation. It shows a warm palette of reds and browns, care and competence in the depiction of the buildings, and fairly broad handling in the foreground. As yet there is no hint of the minute details or brilliant colours of Pre-Raphaelitism. If the picture dates from the summer of 1848, it is mainly of interest in demonstrating that, just before the formation of the Pre-Raphaelite Brotherhood, the new winds blowing had had no apparent effect on Millais's treatment of the natural world. For Millais, as for everyone else, Pre-Raphaelitism was initially a figural art whose central impulse was archaising. However, by the next year this was beginning to change.

The Kingfisher's Haunt, a small oil sketch destroyed in the Second World War but of which a photograph exists (Pl. 49), was probably the product of an early attempt by Millais to make a Pre-Raphaelite study from nature. There is conflicting evidence about both its subject and its date. J. G. Millais, the artist's son, dated it 1856.[3] Ford Madox Brown described it in his diary in August 1854 and called it recent.[4] But there is a small painting by Holman Hunt, *The Haunted Manor* (Pl. 48), which shows the identical foreground. As even the plant life is the same in the two works, they must have been painted at the same time, and the Hunt is dated 1849.

When Millais's *Kingfisher's Haunt* was in a sale in 1858 it appeared in the catalogue with the subtitle 'A Study in Wimbledon Park'.[5] There is correspondence between Millais and Hunt from June 1849 about sketching at Wimbledon, and a number of further contemporary references to Hunt's *Haunted Manor* establish conclusively that it was painted, or, at least, begun at Wimbledon.[6] So it seems that the two artists began studies

Facing page: John Everett Millais, *Spring (Apple Blossoms)* (detail of Pl. 44).

33 John Everett Millais, *The Gipsy* 1846. Watercolour, 9³/₄ × 13⁷/₁₆. Birmingham Museum and Art Gallery.

34 John Everett Millais, *Landscape, Hampstead* c. 1848. Oil on panel, 9¹/₈ × 13¹/₄. Walker Art Gallery, Liverpool.

from nature together in 1849 in Wimbledon Park. As the backgrounds are not the same, it appears that they finished them separately at later dates. The picture Brown saw in 1854 and described as 'quite recent – a waterfall with a little lady and gent, and a child in the background' was surely *The Kingfisher's Haunt*. So that may be the date when Millais completed it; J. G. Millais's 1856 is apparently an error.

The Kingfisher's Haunt is primarily a study of foreground detail. The little waterfall and surrounding plants are the subject of the picture. The point of view is from above looking down on the immediate foreground, which fills the composition. The horizon is at the very top. Thus, the painting is not strictly comparable to the *Landscape, Hampstead*, which is a study of larger objects well within the depth of the picture. But the change from a relatively conventional landscape view to a closely focused study of detail in the immediate foreground parallels the change in Millais's larger figural pictures at the same time. The plants around the waterfall are painted with the same microscopic accuracy as those in *Ferdinand Lured by Ariel*, *The Woodman's Daughter*, and *Ophelia*. As in those pictures, rationally ordered space is sacrificed to concentration upon natural detail; this marks a reversal from the Hampstead picture, in which there is no such detail at all. For the picture's colour we must rely upon Ford Madox Brown's diary: 'The foliage and foreground icy cold and raw in colour; the greens unripe enough to cause indigestion.' These words indicate a substantial change from the innocuous browns of the earlier landscape in the direction of the shrill greens of *The Woodman's Daughter*.

As evidence that the background was added at a later date we have not only Brown's 'quite recent' but also the stylistic evidence of the figures, which recall the couples that appear in several of Millais's drawings of 1853 and 1854, for example the figures in *Rejected*, dated 1853 (Yale Center for British Art).[7] The view under the trees to the horizon is like that in the background of *The Woodman's Daughter*, but the handling seems looser and appears from a photograph to have been comparable to that in Millais's small painting of *Waiting* (Pl. 40), which is dated 1854. There is, however, a marked contrast between the generalised treatment of the foreground in *Waiting* and the leaf-by-leaf and stone-by-stone attention to detail which provides the main *raison d'être* of *The Kingfisher's Haunt*.

We have seen that Millais in *Ferdinand Lured by Ariel* treated the natural setting as botanic detail, with almost no concern for spatial depth. In *The Woodman's Daughter* he expanded the background to show a distant view through the woods, but the space seems artificially contrived, suggesting Paolo Uccello more than nature. In the summer of 1851, in *Ophelia*, he returned to a constricted space, filling the entire picture with closely studied foliage. In his second picture of 1851, *A Huguenot, on St Bartholomew's Day, Refusing to Shield himself from Danger by Wearing the Roman Catholic Badge* (Pl. 35), which he began painting in September or October, he restricted the space still more closely by painting the figures before an ivy-covered wall running to the top of the picture. The *Huguenot* shows botanic detail comparable to that in Millais's other paintings, but because much of the background consists of a brick wall, plant life plays a less dominant role than in *Ophelia*. On the other hand, the wall running across the picture forbids any penetration at all through the depths of foliage, as is still possible in *Ophelia*. Like Hunt's figures in *The Hireling Shepherd*, Millais's are on the surface of the picture. But unlike *The Hireling Shepherd*, in the *Huguenot* there is no space behind the figures. The result is a two-dimensional composition in which the figures appear inlaid into the flat background rather than standing before it.

When the *Huguenot* was exhibited at the Royal Academy in 1852 it was well received; in fact, it was Millais's first great popular success. Nevertheless, the *Art Journal* and some other periodicals criticised its flatness, blaming it on a lack of aerial perspective.[8] This criticism drew a scornful rebuttal in the unlikely vehicle of the third volume of *The Stones of Venice* from Ruskin, who argued that the conventional aerial perspective of most modern artists was a gross exaggeration; if we can see objects in clear weather at distances of miles, distances of a few feet or yards should have no visible effect.[9] In the *Huguenot*, if the figures were standing about three feet from the wall, the aerial perspective calculated by scientific principle would be 'less than the 15,000th part of the depth of any given colour'. Ruskin claimed that Millais's perspective was accurate and that perspective as usually shown was 'entirely conventional and ridiculous; a mere struggle on the part of the pretendedly well-informed, but really ignorant, artist, to express distances by mist which he cannot by drawing.' Whatever the merits of that argument, Ruskin did not assert that Millais's accurate perspective gave any suggestion of the three feet between the figures and the wall. His argument that the effect of aerial perspective on tone and colour is so slight as to be hardly noticeable except over vast distances is, nonetheless, of significance because of its claim of scientific truth for the overall evenness of tonality which had been appearing in Pre-Raphaelite pictures at the expense of traditional three-dimensional illusionistic space.

In March 1852 Millais wrote to his friend Thomas Combe that his next picture would not require much out-of-door work and that he hoped to enjoy the summer 'without a millstone of a picture hanging about my neck'. The picture he proposed painting would have 'nothing but a sheet of water and a few trees – a bit of flooded country, such as I have seen near you at Whitham.'[10] This was to have been the background of *The Eve of the Deluge*, a picture Millais had been contemplating since 1850, but which he never painted. Instead, he painted in time for the Royal Academy exhibition of 1853 two pictures of couples, repeating a formula which had made the *Huguenot* his first popular success. One, *The Order of Release, 1746* (Tate Gallery), which Millais began in December 1852, is of biographical interest because Effie Ruskin was the main model. The figures appear before a black background, and the consequent simplicity led the *Athenaeum* to declare that Millais had escaped so successfully from 'the trammels of the school which he founded' that it wondered why he consented to be fettered by them in his other work.[11]

The other work, *The Proscribed Royalist, 1651* (private collection), shows a Puritan girl visiting a Cavalier hidden in a hollow tree. Millais painted the background out of doors at Hayes, near Bromley in Kent. Despite his hope of avoiding work out of doors, he was in the country from June until November. The background consists almost entirely of plant life: leaves, ferns, and the roots and trunk of the tree in which the Royalist hides. This botanic detail makes *The Proscribed Royalist* seem closely comparable to *Ophelia*, but it showed an advance in attention to outdoor light and colour as well as botanical detail. Millais painted the picture in sunlight, and he took the Puritan's dress to Hayes to paint it out of doors on a lay figure. He painted the actual models in the studio, but Arthur Hughes, who posed for the Cavalier, reported that Millais moved from his regular studio to a small back room where direct sunlight could fall on the figures.[12]

In October 1852 Millais wrote again to Thomas Combe expressing his intention of painting *The Deluge*, this time in 1853.[13] It now would not require any outdoor painting, so Millais would be able to take a holiday abroad with the Combes. When the summer of 1853 came, he kept to part of this plan; he did not paint *The Deluge*, and he did not go abroad with the Combes, but neither did he begin another picture requiring a landscape background, and in June he set off for a holiday in Scotland. His companions were his brother William Millais, John Ruskin, and Ruskin's wife, Euphemia or Effie. The trip was Ruskin's idea, which Effie mentioned in a letter to her mother as early as March. Holman Hunt was also invited to accompany the group, but did not go because of a last-minute tooth-ache.[14]

The party arrived at Brig o'Turk in the Trossachs north of Glasgow on the first of July 1853. They remained there until the end of October. Ruskin left on 26 October to go to Edinburgh to lecture, and Millais followed a day or two later. During the stay an attachment developed between Millais and Effie Ruskin which led to her leaving Ruskin in the following year and marrying Millais in 1855. The emotional complications of the situation probably explain the low spirits and ill health displayed by Millais almost from the moment of their arrival. Ruskin wrote to his mother in October, 'Sometimes he is all excitement, sometimes depressed, sick and faint as a woman, always restless and unhappy. I think I never saw such a miserable person on the whole.'[15]

The trip was intended as a vacation. As Ruskin wrote to a friend in August: 'Both Millais and I came down here to rest; he having painted, and I corrected press, quite as much as was good for either of us; but', Ruskin added, 'he is painting a little among the rocks, and I am making some drawings which may be useful to me.'[16] Although everyone proclaimed Millais's need of a rest, almost as soon as they arrived at Brig o'Turk Millais and Ruskin began to plan a picture which was to become more of a burden to the artist than anything he had yet done. This was his portrait of Ruskin standing by the stream running through Glen Finglas (or Glenfinlas, as they generally referred to it) a short distance from their lodgings (Pl. 36). At the suggestion apparently of Ruskin's father, Millais planned a picture of Effie Ruskin at a window in Doune Castle, which he never painted, and a companion picture of her husband. They settled on a site for Ruskin's portrait by 4 July, but then had to wait until the end of the month for a canvas to come from London before Millais could begin to paint. During the interval Millais painted 'for practice' a small picture on millboard of Effie Ruskin sitting on the rocks by the stream (Pl. 37).[17] There is contradictory evidence about the exact date when Millais began the larger portrait of Ruskin, but it seems most likely to have been on 28 July, when Ruskin wrote to his father, 'you will be delighted to hear that my portrait is verily *begun* today and a most exquisite piece of leafage done already, close to the head'.

35 (facing page) John Everett Millais, *A Huguenot, on St Bartholomew's Day, Refusing to Shield himself from Danger by Wearing the Roman Catholic Badge* 1851–2. Oil on canvas 36⅞ × 25⅝. The Makins Collection.

37 John Everett Millais, *The Waterfall* 1853. Oil on board, 10½ × 12½. Delaware Art Museum, Wilmington.

Henry Acland, Ruskin's friend who was later to own the picture, was visiting the party at Brig o'Turk when the picture was begun, and Ruskin reported that 'he says it is in every way perfect both for me and Millais'.[18]

As work began, Ruskin kept in his diary a record of each week's progress:

Millais's picture of Glenfinlas was begun on Wednesday; outlined at once, Henry Acland holding the canvas, and a piece laid in that afternoon. More done on Thursday – about an hour's work on Friday – Saturday blank – Monday blank – Tuesday out at 6 in the morning painting till 9, and from 12 till 5 – Wednesday 11 to 6 – Thursday 11 to 6 – Friday 11 to 5 – Saturday 11 to 5 . . .[19]

Ruskin kept this record for ten weeks; the painting took longer. Millais was working on it in the middle of October, when, according to Ruskin, it was still not nearly done.[20] After the Ruskins left for Edinburgh on 26 October, Millais planned to stay on at Brig o'Turk, but inclement weather almost immediately put a halt to his labours. On 29 October he wrote to Hunt from Edinburgh, 'I have sent home the picture of Ruskin for the weather was terrible and would have killed me outright, so I intend coming for a week or so in March when it is dry, although colder than now.'[21]

When the spring came, Millais tried to avoid his return visit. On 8 April 1854, he called on George Price Boyce, who recorded in his diary, 'He wanted to finish the picture of Ruskin (looking on falling water) from some spot nearer than the Highlands. I recommended him the neighbourhood of Capel Curig.'[22] Millais planned to follow this advice and during April announced to friends his intention of going to Wales, but in May he decided to return to Scotland. Before leaving he wrote to Frederick Furnivall, a friend of Ruskin's, that he was going in order to finish the background properly: 'For a time I intended to finish the waterfall from Wales but Ruskin did not seem satisfied with this notion as the rocks are of quite a different Strata there.'[23] He was back at the New Trossachs Hotel at Glen Finglas by 24 May, and he worked on the painting there for another month. During both visits to Scotland he was plagued by rainy weather and various mishaps, so he spent by no means all his time on the picture. On the other hand, as with his other works, he left the figure painting to be done in the studio. Ruskin posed between January and April 1854, and his hands were not completed until the following autumn.

Effie, Ruskin's wife, left him in April 1854; in July their marriage was annulled. These events did not lessen Ruskin's enthusiasm for the picture, although completing it became an odious duty for Millais. He wanted to drop it as early as December 1853, but continued with it at Ruskin's insistence. When Ruskin finally had the painting in his possession he wrote to Millais expressing his delight with it and asking for Millais's proper address 'as I may often want to write to you, now'. To this, Millais replied insisting upon 'the necessity of abstaining from further intercourse' because of 'the barrier which cannot but be between us personally'.[24]

36 (facing page) John Everett Millais, *John Ruskin* 1853–4. Oil on canvas, 31 × 26¾. Private Collection.

Since 1851 Ruskin had taken a possessive interest in Millais. The portrait allowed him an opportunity of participating in Millais's work which he obviously relished – to the degree that the picture seems to have meant more to him than his wife. His description of the site to his father reveals his enthusiasm:

> Millais has fixed on his place – a lovely piece of worn rock, with foaming water and weeds and moss, and a noble overhanging bank of dark crag – and I am to be standing looking quietly down the stream – just the sort of thing I used to do for hours together – he is very happy at the idea of doing it and I think you will be proud of the picture – and we shall have the two most wonderful torrents in the world, Turner's *St. Gothard* – and Millais's *Glenfinlas.* He is going to take the utmost possible pains with it – and says he can paint rocks and water better than anything else – I am sure the foam of the torrent will be something quite new in art.[25]

His excitement continued throughout the summer. On 16 October, he wrote to Furnivall that Millais was painting 'a picture of a torrent among rocks, which will make a revolution in landscape painting'.[26]

In both these letters Ruskin described the picture primarily as a landscape painting. Its new or revolutionary qualities were to be not in portraiture but in the treatment of nature. This one-sided emphasis was partly due to the fact that Millais concentrated during his time in Scotland on the landscape detail, leaving the figure for his London studio. Hence, the details of rocks and water were the aspects of the picture receiving the most attention during the summer. Nonetheless, Ruskin's letter to his father was written before the daily routine of painting had begun. Later, when he had the completed picture in his possession, he wrote to Millais that he had to get reconciled to 'the figure's standing in the way'.[27] His attitude toward the picture reflected his basic interests and not just his preoccupation of the day. Since beginning *Modern Painters* Ruskin had consistently devoted more attention to landscape painting than to any other aspect of contemporary art. His early defence of the Pre-Raphaelites was based entirely on their treatment of natural detail, and in the pamphlet *Pre-Raphaelitism* he had drawn a hypothetical comparison between Millais and Turner. The two both set out to paint the same mountain valley. Turner has 'a memory which nothing escapes, an invention which never rests, and is comparatively near sighted'. Millais, in contrast,

> sees everything, small and large, with almost the same clearness; mountains and grasshoppers alike; the leaves on the branches, the veins on the pebbles, the bubbles in the stream; but he can remember nothing, and invent nothing. Patiently he sets himself to his mighty task; abandoning at once all thoughts of seizing transient effects, or giving general impressions of that which his eyes present to him in microscopical dissection, he chooses some small portion out of the infinite scene, and calculates with courage the number of weeks which must elapse before he can do justice to the intensity of his perceptions, or the fulness of matter in his subject.[28]

This is a presentiment of Millais's spending some fifteen weeks painting the veins on the pebbles and the bubbles in the stream of a small portion of a mountain valley in Scotland. In 1851, at approximately the time he was writing the pamphlet, Ruskin tried to get Millais to accompany him to Switzerland. In 1852 he complained about Millais's painting a 'rascally garden-rolled-nursery-maid's paradise' for background instead of pure nature.[29] Now, in 1853, he had Millais painting exactly what he approved of, and he worked to see that Millais painted it as he wanted it. In Ruskin's letters there are references to 'managing' Millais, and he explained to Furnivall in October,

> I have stopped all this time to keep Millais company – to keep him up to the Pre-Raphaelite degree of finish – which I have done with a vengeance, as he has taken three months to do half a background two feet over, and perhaps won't finish it now. But I have got maps of all the lichens on the rocks, and the *bubbles* painted in the foam.[30]

He kept a time-table of Millais's progress, he held an umbrella over him while he worked, and he made at least one large and careful drawing of the rocks in the background of the painting (Pl. 38).

Ruskin's role in the painting of his portrait was the first example of the sort of personal direction that he would later give to the landscape painters Inchbold and Brett, which will be discussed in chapters nine and ten, and it is more extensively documented than those later efforts. Nevertheless, despite Ruskin's participation, Millais's style in

38 John Ruskin, *Gneiss Rock in Glenfinlas* 1853. Pen and wash and bodycolour, $18^{3}/_{4} \times 12^{7}/_{8}$. Ashmolean Museum, Oxford.

the portrait is not radically different from that of preceding years. Ruskin's comments made in 1851 about Millais's inability to seize transient effects or to give general impressions are equally apposite to *The Woodman's Daughter* of that year, to *Ophelia* of the following, and to the *Portrait of Ruskin*. There is no space, no sky, no atmosphere; there is not even a hint of shadow linking the figure to his environment. Ruskin seems pasted on the surface of the picture. This is partly the result of Millais's painting the figure separately with Ruskin posed on a flight of steps. It also reflects Ruskin's argument in *Modern Painters* that specific and historic facts (such as the lichens and striations of the rocks) are more important than general and transitory ones (such as light and atmosphere) and that expression of the latter should not obscure the former. From the beginning, Millais planned that there would be no sun in the picture, which delighted Ruskin: 'Everett paints so brightly that he cannot possibly have too quiet a subject.'[31] Previously, Millais's *Ophelia* had had a quiet subject, and he excluded from the portrait the same things that he had excluded from the earlier picture. As Ruskin's remark to Furnivall about keeping Millais 'up to the Pre-Raphaelite degree of finish' indicates, his influence on Millais stylistically was to encourage him to stick to the paths he was already following. He did force Millais to struggle with new features of the landscape – gneiss rock, lichens, falling water – and these caused difficulties. 'Everett never having painted rock foreground before did not know how troublesome it was',[32] Ruskin wrote rather lightly in August. By October Millais was writing to Hunt: 'I so long to finish this background but I fear it will take me three weeks more at least and you know how dreadfully these out of doors affairs hang fire. This is a little writched [sic.] picture not larger than your sheep of last year [Hunt's *Strayed Sheep*, Pl. 52]. There is some falling water in it which is very perplexing.'[33]

During the stay at Brig o'Turk the whole group busied itself with painting and sketching, and there is a substantial body of additional works dating from the trip. Millais's small *Waterfall* (Pl. 37), showing Effie seated on the rocks, has already been mentioned. This

39 John Everett Millais, *Pre-Raphaelite sketching inconvenience in windy weather* 1853. Pen and sepia ink, 8 × 7¹/₂. Private Collection.

picture has usually been identified as a study for the background of the *Portrait of Ruskin*. Strictly speaking, this is incorrect. *The Waterfall* was begun earlier, but it does not show the same site. Millais painted the background of the portrait directly from nature, making no more elaborate studies for it than a slight pencil sketch in the Ashmolean Museum. Compared to the portrait, *The Waterfall* is a much slighter production. It is considerably smaller (10¹/₂ × 12¹/₂ inches), and the foreground rocks and water are less crisply detailed, displaying little of the compelling verisimilitude of those in the larger painting. The differences demonstrate that the vastly longer time which Millais spent on the portrait was employed to effect. The background of *The Waterfall* shows some distance and a bit of sky, but it is treated summarily and may have been added to complete and make saleable the original sketch.

Millais also made a number of humorous drawings, some of which show the hardships of working out of doors in the Scottish climate. His hat and umbrella are blown into the stream in one (Pl. 39), rain prevents the group from sketching in a second, and they are attacked by midges in a third. Another drawing, inscribed 'Two Masters and their Pupils', shows Millais seated on the rocks working at the portrait on a rustic easel while Effie Ruskin sits behind him reading.[34] The upper right corner of the drawing, which evidently showed Ruskin, has been cut away, and the 'two masters' of the inscription would seem to be Ruskin, who was teaching Millais, and Millais himself, who was giving Effie instruction in drawing and painting.

A small and amateurish painting of a waterfall may be by or partly by Effie,[35] and a more expansive view which includes a man fishing was painted by Millais's brother William during their Scottish sojourn (Pl. 166). Finally, there is Ruskin's drawing, mentioned above, of *Gneiss Rock in Glenfinlas* (Pl. 38). It appears to show part of the rocks on the left side of the background of Millais's portrait, but from a viewpoint that is lower and looking more downstream.[36] The linear patterns in the rock are emphatically defined, and we can easily visualise Ruskin's using the drawing to demonstrate to Millais the laws of rock formation. Because Ruskin's drawing is a close study of a limited area, it is in some respects a more successful work than the painting, which extends similar study over a wider area and combines it with a portrait to dissipate the effect. Ruskin had a point when he objected to 'the figure's standing in the way' in the painting.

Millais's break with Ruskin was accompanied by his withdrawal from Pre-Raphaelite circles. In the autumn of 1853 he was elected an associate member of the Royal Academy. While Rossetti, Ford Madox Brown, and their friends were becoming increasingly hostile to the Academy, Millais was becoming a staunch member of the establishment camp. The break was not absolute: Millais remained throughout his life a close friend of Holman Hunt, and he did exhibit in a Pre-Raphaelite-sponsored exhibition in Russell Place in 1857. On the other hand, he did not become a member of the Hogarth Club, the Pre-Raphaelite exhibiting society founded in 1858. Ruskin was a member of the Hogarth Club, and it is probable that Millais did not join in order to avoid contact with him, but that decision was symptomatic of his changed circumstances. After 1854 Ruskin became an ever more active figure in Pre-Raphaelite circles while Millais gradually dropped out. After his marriage to Effie in July 1855 they lived in Scotland until 1862.

As we have seen, Millais insisted that his contacts with Ruskin be broken off, but the ill will he held toward Ruskin was not reciprocated. In 1855 Ruskin started writing an annual review of the Royal Academy and other annual exhibitions in London, which is usually known as *Academy Notes*. Ruskin claimed '*entire* impartiality' for his *Notes*,[37] but, in fact, he used them to proselytise for his beliefs and for his Pre-Raphaelite friends. And in *Academy Notes*, at least in the first two years, Millais was the brightest star: the artist who in 1855 had painted 'the only *great* picture exhibited this year; but this is *very* great'; and whose pictures exhibited in 1856 would 'rank in future among the world's best masterpieces.'[38]

Ruskin eulogised Millais not only in the face of personal conflict but also in the face of changes in Millais's art. After 1853 Millais never painted with the same Pre-Raphaelite detail that we can see in the *Portrait of Ruskin* and in his earlier work. Ruskin noted the departure, and initially he approved of it. About *The Rescue* (National Gallery of Victoria, Melbourne), the '*great*' picture of 1855, in which Millais showed a fireman saving three children from a blazing home, Ruskin wrote: 'The execution of the picture is remarkably bold – in some respects imperfect. I have heard it was hastily finished; but, except in the face of the child kissing the mother, it could not be much bettered. For there is a true sympathy between the impetuousness of execution and the haste of the action'.[39]

40 John Everett Millais, *Waiting* 1854. Oil on panel, 12 × 9. Birmingham Museum and Art Gallery.

In outdoor subjects, we can see the start of the change in Millais's small *Waiting*, signed and dated 1854 (Pl. 40). In composition, this picture of a girl sitting at a stile does not show significant change from earlier works such as *The Woodman's Daughter* or *The Proscribed Royalist*. The background consists of trees running to the top of the picture. The greens are as bright as in Millais's earlier pictures. However, if we look at the foreground there are no longer separate blades of grass, but a general green area in which brush strokes suggest an occasional blade. The wall over which the stile is built is of a uniform texture and colour, with the individual stones summarily outlined in black. Their lack of detail makes one feel that, after painting the rocks and lichens of the Ruskin portrait, Millais decided that he had had enough. He did not exhibit the picture (he exhibited nothing at the Royal Academy in 1854), but a writer for the *Art Journal* saw it in a private collection in 1857 and noted, 'in the secondary material there is greater breadth of manipulation than is generally found in Millais's works'.[40]

In abandoning exact botanical and geological detail, Millais abandoned the most distinctive quality of his work of the previous few years, but he also gained from the change. There is, for once, an effective feeling of the fall of light in *Waiting*: evident both in the dappled effect of sunlight falling through the trees in the background and in the contrast of highlights and shadows upon the foreground grass. In addition, mood is not swamped by detail. The girl in *Waiting*, although much smaller relatively than Ophelia, dominates the picture as Millais's earlier heroine does not. The artist is no longer the

conscientious slave of what he sees, rejecting nothing, selecting nothing, but now uses the natural world for the sake of other ends.

The masterpieces of Millais's changed style are *The Blind Girl* (Pl. 41) and *Autumn Leaves* (Pl. 42), two of the five pictures that he exhibited at the Royal Academy in 1856. A third, *Peace Concluded, 1856* (Minneapolis Institute of Arts), elicited Ruskin's talk about 'the world's best masterpieces', but it shows an interior subject, whereas both *The Blind Girl* and *Autumn Leaves* show figures out of doors before landscape backgrounds.

Millais began the background of *The Blind Girl* at Winchelsea in Sussex in the autumn of 1854, but he did not paint the figures, middle distance, and foreground until 1856, when he was living in Scotland. There is no conspicuous break between the earlier and later portions of the painting. Nevertheless, by the standards of his earlier work, the foreground and middle distance are broadly painted. There are still individual flowers and blades of grass, but they are selected details which provide an illusion of high finish, more like the dandelions in Hunt's *Rienzi* than the painstaking thoroughness of Hunt's and Millais's subsequent works. When Ford Madox Brown saw *The Blind Girl* he praised it in his diary as a religious picture and 'a glorious one', but he added, 'a pity he has so scamped the execution'.[41] A comparison of Millais's treatment of detail in *Ophelia* with that in the later picture will explain why Brown tempered his praise, but, once again, we can see that Millais gained as well as lost by seeking broader handling, at the expense of detail.

There is nothing in Millais's earlier work to which we can compare the further background of *The Blind Girl*. It is a view of open, rising ground with the buildings of Winchelsea clearly recognisable on top of the rise. For the first time in Millais's art, space and distance are important. The background is still, however, not a conventional landscape setting. The hill behind the figures goes up more than it goes back. The horizon is almost at the top of the painting, and there is little tonal modification between foreground and distance. Spatial recession is established only by the smaller sizes of animals, trees, and buildings, and these provide uncertain measurement. It is difficult, for example, to estimate the pitch of the slope or the distance from the animals in the middle distance to the buildings on the horizon.

Above the horizon, the sky forms a significant part of the painting, likewise for the first time in Millais's art. Although the sky accounts for less than one fifth of the picture, the double rainbows set against lowering grey clouds give it a dramatic prominence. *The Blind Girl* comprises one of the first Pre-Raphaelite attempts to make weather other than open sunniness a significant part of the picture. To do this Millais had to abandon dependence upon direct observation. The double rainbows are a studio concoction whose colours he originally got wrong and later had to repaint. He had earlier copied the natural world objectively, for its own sake; here he manipulates nature as a pictorial element. Because of the high horizon, the dramatic sky, and the brilliant green of the fields, the landscape is full, active, and close to the surface of the painting. It is not a subordinate backdrop for the figures, but an essential part of the subject. The spectacle of rainbows and landscape, which the blind girl cannot see, provides the meaning of the picture. Nonetheless, if Millais manipulates nature, it is only within naturalistic limits; we must recognise the beauty which the girl will never see. The brilliant contrast of the green hill against the grey sky is convincing as a momentary effect just after a storm. And the distant background is a scrupulous view of the 'Ancient Town' of Winchelsea seen from the east. The strip of buildings and trees, at once objectively detailed and, because of the distance, seen in masses and as a whole, is one of the loveliest passages in Pre-Raphaelite painting. The buildings march in ordered rhythm across the horizon and are shown with a clarity and chastity which make us accept the honesty of the artist's vision and feel the joys inherent in the possibility of sight.

Millais painted *Autumn Leaves* in the autumn of 1855 in Scotland, at Annat Lodge, where he was living, near Perth. According to his wife's diary, he wanted it to be a picture 'full of beauty and without subject'.[42] In the eyes of Ford Madox Brown he came close to succeeding, but in Brown's opinion this was not an unmixed blessing: 'I have seen Millais' picture of this year the Autumn leave [*sic*], the finest in painting & colour he has yet done – but the subject somewhat without purpose & looking like pourtraits.'[43] The figures, four girls gathering leaves, pose in the foreground. Two of them gaze out of the picture in a manner that connects them more with the viewer than with each other or their two companions, who stare pensively into the pile of burning leaves. Behind them, we see autumnal woods and a sunset over purple hills. The subject is mellow – sunset, autumn, burning leaves – the day, the season, nature are at a languid end, not

41 (facing page) John Everett Millais, *The Blind Girl* 1854–6. Oil on canvas, 32 × 24½. Birmingham Museum and Art Gallery.

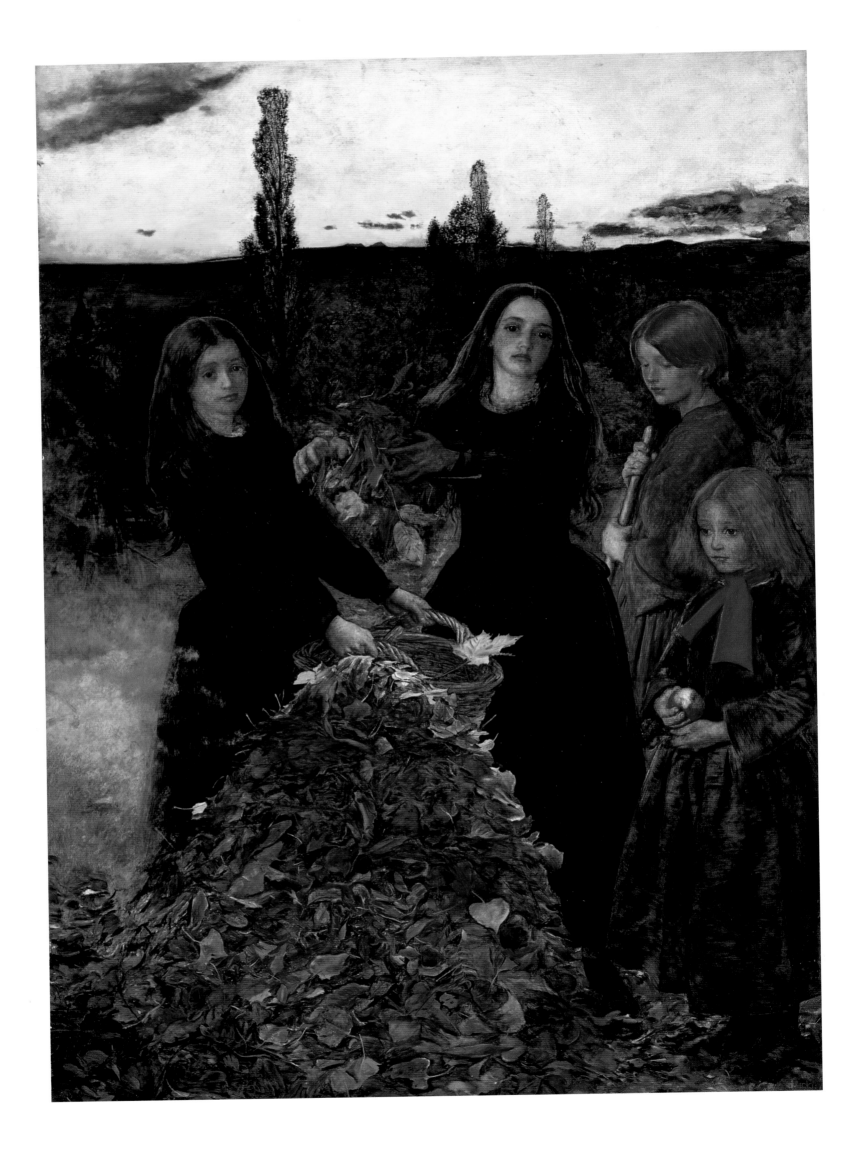

thriving and blossoming, as in *Ophelia*. A story is not told, but mood is evoked by the associative appeal of the imagery. The treatment of nature is like the subject: suggestive rather than precisely defined. The colours – red and gold in the foreground leaves, blue and purple in the distance, the sky gold over the horizon – are in themselves emotive and over-ripe. The pile of leaves at the centre of the picture seems elaborated, but it shows none of the fineness of observation of Millais's earlier works. Past the foreground figures there is no detail. On the left a man raking leaves is only a faintly suggested ghostly presence. The trees are a loosely brushed-in area of reddish browns. The town of Perth in the valley beyond is lost in the evening mist, and the distant hills are silhouettes against the sky.

In front of *Autumn Leaves* talk about the Pre-Raphaelites' 'childlike reversion from existing schools to Nature herself' no longer seems appropriate. Millais's goal was a picture 'full of beauty'. Although he certainly would have seen no conflict between truth and beauty, five years earlier truth had been the goal, and beauty happened as a consequence. Now, the order has been reversed. The kind of botanic truth shown by Millais in an earlier picture such as *Ophelia* depended on close personal observation and resulted in a view of nature of startling individuality and originality. *Autumn Leaves* still depended upon observation; Millais painted it from the view from his own garden. But autumnal colours and sunset skies were hardly a discovery of Millais's. Many older artists such as Francis Danby had made a speciality of sunset effects. To say that Millais turned to a tried-and-true formula is too strong, because the effects were unprecedented in his own work, but he had left the springtime of independent discovery.

Ruskin did not mention *The Blind Girl* in his *Academy Notes* of 1856, although much later he did write one of his most rapturous descriptive passages about it in *The Three Colours of Pre-Raphaelitism* published in 1878.[44] He did laud *Autumn Leaves* in *Academy Notes*, calling it 'by much the most poetical work the painter has yet conceived'; and he went on to describe the background as, 'as far as I know, the first instance of a perfectly painted twilight. It is as easy, as it is common, to give obscurity to twilight, but to give the glow within its darkness is another matter; and though Giorgione might have come near the glow, he never gave the valley mist.'[45] He had complained in the first volume of *Modern Painters* that he had never seen a clear twilight properly painted, 'that effect in which all details are lost, while intense clearness and light are still felt'. Even Turner had failed by making the effect appear too misty, 'but it remains to be shown that any closer approximation to the effect is possible.'[46] Now, Millais had at last done it, surpassing not Turner but Giorgione. In Ruskin's review of Millais's *Peace Concluded* he was even more extravagant with Venetian comparisons, declaring that 'Titian himself could hardly head him now', and he placed Millais on a pedestal, which he shared only with Turner among the artists of all time.[47]

If today Ruskin's enthusiasm seems excessive, perhaps in 1856, when he could look at *Autumn Leaves* with no knowledge of Millais's later art, it might have been possible to see the painting only as an omen of promising developments. However, other viewers noting the changes in Millais's art were more restrained. Ford Madox Brown was not the only person to have mixed feelings. The critic for *The Times*, for example, saw new weaknesses as well as new strengths:

> Millais contributes several works of very various merit. The best is *Autumn Leaves* – girls burning these leaves – and here may at once be seen the advance made in his style. Compare the leaves with the straw in the ark of several years ago [*The Return of the Dove to the Ark* (Ashmolean Museum, Oxford)]. There every straw was painted with a minuteness which it was painful to follow. Here the leaves are given with great truth and force, but the treatment is much more general and the work more vapid. Throughout all his works the same increasing insipidity of touch may be seen; but in all of them will not be seen colour as good as in this work or expression so true.[48]

Today, we can see that Millais never again achieved the heights that he reached in 1856 and preceding years, and that, in important respects, *Autumn Leaves* contained many of the seeds of what is usually judged as the deterioration of his later art.

A Dream of the Past: Sir Isumbras at the Ford (Pl. 43) was the chief picture that Millais exhibited at the Royal Academy in 1857. It depicts a medieval knight ferrying two children across a river on his charger. The children are wide-eyed cousins of those in *Autumn Leaves*, but while the children in the earlier picture either gaze provocatively at the viewer or have a moody remoteness, those in *Sir Isumbras* engage us with a too-easy sentimental appeal. Behind them is a twilight similar to the one in *Autumn Leaves*. There is

42 (facing page) John Everett Millais, *Autumn Leaves* 1855–6. Oil on canvas, 41 × 29⅛. Manchester City Art Gallery.

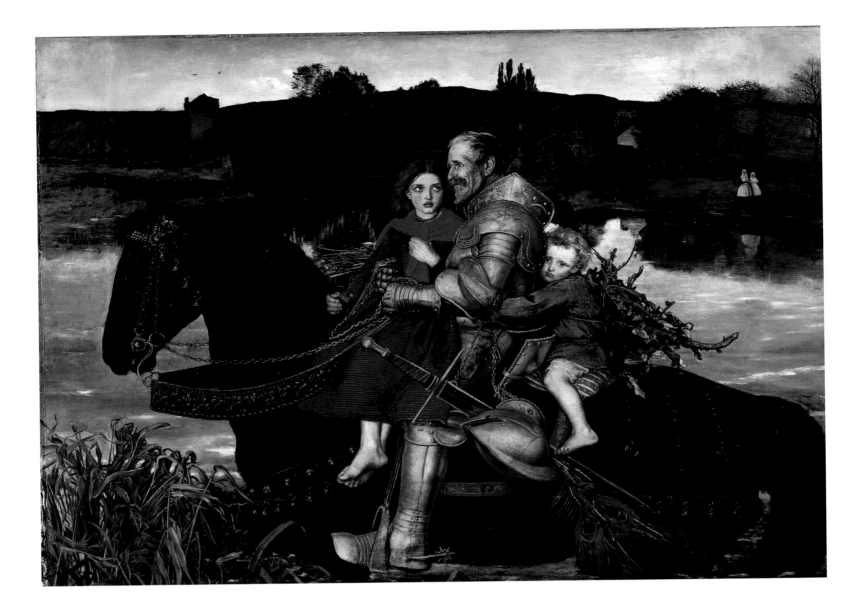

43 John Everett Millais, *A Dream of the Past:
Sir Isumbras at the Ford* 1856–7. Oil on canvas,
49 × 67. Lady Lever Art Gallery, Port
Sunlight.

still some detail in the foreground plants, but the treatment is increasingly broad or
coarse. Millais spent less than a fortnight painting the picture's background, although *Sir
Isumbras* was larger than any of his previous Pre-Raphaelite works. If we remember the
amount of time he spent on the backgrounds of *Ophelia* or the *Portrait of Ruskin*, much
of the difference between Millais's earlier and later art is explained. In 1859 Millais wrote
that his art was too broad for Ruskin to understand,[49] but, despite the loosening of tech-
nique, pictures like *Sir Isumbras* and others from the next few years are made out of hard
edges and sharp contrasts; they possess little more breadth of vision or feeling than
Millais's earlier works. And whatever breadth he achieved was probably more an inci-
dental product of changed working methods than a deliberately sought goal. Among the
reasons for the change was Millais's recognition of the impracticality of devoting as much
time and effort to painting backgrounds as his earlier approach had required. He need-
ed to achieve a speedier execution and consequently a larger production, in order to pro-
vide an income to support his wife and rapidly growing family. Spending the amount of
time he had devoted to *Ophelia* would henceforth be an impossible luxury.

Ruskin was as aghast at *Sir Isumbras* as he had been enthusiastic about *Autumn Leaves*.
He began his discussion of the picture by explaining his praise of the previous year's
works. They had promised to place Millais among the 'great Imaginative masters',
although there had been 'a slovenliness and imperfection in many portions' which
Ruskin had passed over as accidental. Now, however, the change from *Ophelia* 'is not
merely Fall – it is Catastrophe', and Ruskin saw no hope but 'in a return to quiet per-
fectness of work.'[50]

Millais did not return to quiet perfectness of work. He exhibited nothing at the Royal
Academy in 1858, but in 1859 he exhibited two large pictures of outdoor
subjects. Both have moody, ambiguous subjects which again depend on *Autumn Leaves*.
One, *The Vale of Rest* (Tate Gallery), which shows nuns digging a grave, has yet another
sunset. The other, *Spring* or *Apple Blossoms* (Pl. 44), is of a group of girls taking tea in an

orchard. It has a background of flowering trees which at first glance appears comparable to Millais's earlier foliate backgrounds, but the handling is closer to that in *Sir Isumbras* (see detail, p. 52). Ruskin wrote a long and troubled review of these pictures, in which he still found greatness, but greatness undermined by crudity.[51] Here is an excerpt from his comments about *Spring*:

> When we look at this fierce and rigid orchard – this angry blooming (petals, as it were, of japanned brass); and remember the lovely wild roses and flowers scattered on the stream in *Ophelia*; there is, I regret to say, no ground for any diminution of the doubt which I expressed two years since respecting the future career of a painter who can fall thus strangely beneath himself.

Ruskin concluded with the assertion that Millais still had greater powers than any other artist, but he was misusing them, or not using them. 'Here, we have a careless or insolent indication of things that might be; not the splendid promise of a grand impatience, but the scrabbled remnant of a scornfully abandoned aim.'

Ruskin's criticisms in 1857 and 1859 and a generally unsympathetic critical response otherwise must have made Millais feel that he was fighting on the wrong ground. For the following several years after 1859 none of his works were on as ambitious a scale or as provocative in content as *The Vale of Rest* or *Spring*. Also, significant landscape passages disappeared from his painting; almost all of his pictures from the early 1860s are of interior subjects. Much of Millais's activity in the next decade was devoted to book illustration, in particular to a memorable series of illustrations for the novels of Anthony Trollope. These illustrations occasionally have landscape settings, and one, the frontispiece to *Orley Farm*, published in 1862 (Pl. 45), is a full landscape composition. It shows a woman milking a cow in the foreground and a house, Orley Farm, on top of a slope behind her. The rising hillside and high horizon are faintly reminiscent of *The Blind Girl*, but in every respect the illustration is a slightwork, based, we can presume, not on independent observation but, appropriately enough, upon Trollope's description in the opening pages of the book.

Beginning in 1870 and continuing to the end of his life, Millais did regularly paint landscapes. These are often impressive and beautiful works in their own right, but they

44 John Everett Millais, *Spring (Apple Blossoms)* 1856–9. Oil on canvas, 43$\frac{1}{2}$ × 68. Lady Lever Art Gallery, Port Sunlight.

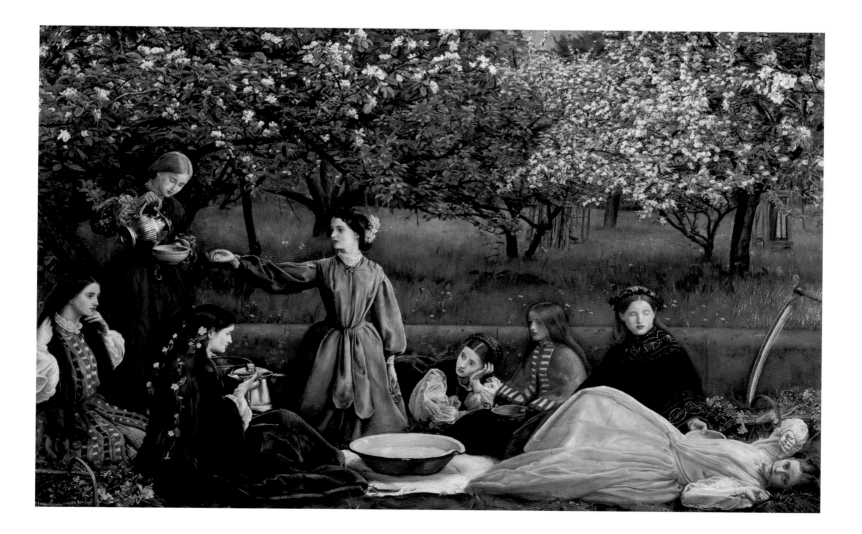

45 John Everett Millais, *Orley Farm* 1862. Wood engraving by the Brothers Dalziel, 6¹/₄ × 4¹/₈. Frontispiece to volume I of *Orley Farm* by Anthony Trollope, London, Chapman and Hall, 1862.

have nothing to do with Pre-Raphaelitism, and have no evident relation to the earlier works by the artist discussed in this chapter. They belong to the sphere of late Victorian popular painting that found its home in the Royal Academy, of which in 1896 Millais would become president. In style and content they are not far from the landscapes of

46 John Everett Millais, *Chill October* 1870. Oil on canvas, 55¹/₂ × 73¹/₂. Collection of Lord Lloyd Webber.

Benjamin Williams Leader and other popularly successful late Victorian landscape painters. The painter William Blake Richmond, a friend of Millais's, wrote that people interested the artist more than things, 'Even in his landscapes I think I can always detect a kind of human sentiment pervading them, a mood of Nature akin to a human mood which prompted them.'[52] While that remark may have been intended as praise, it points to what is troubling about the paintings. They illustrate moods or feelings, which, unfortunately, often seem trite. Millais's titles in themselves are suggestive of the banality of the ideas behind the pictures: 'Chill October', 'Flowing to the Sea', 'The Fringe of the Moor', 'The Moon is up and yet it is not Night', 'Lingering Autumn', 'Over the Hills and Far Away'. His explanation of *Chill October* (Pl. 46), the first of these later landscapes, is characteristic of the attitudes underlying all of them: 'I chose the subject for the sentiment it always conveyed to my mind, and I am happy to think that the transcript touched the public in a like manner.'[53] The inspiration came not from what the artist saw before him, but from a sentiment conveyed by the subject. Effectively, sentiment, rather than the landscape itself, became the subject in these later paintings, and it was sentiment that brought them their considerable public popularity.

FIVE

William Holman Hunt

In his memoirs, Holman Hunt describes an effort he made to paint a picture of a pool at Ewell in the summer of 1847: 'The difference between the scene as it was presented to my untutored sight, and any single landscape by the great painters that I knew, suggested the doubt, when I had begun the subject on my drawing-board, whether it was not one which a practical painter should avoid.' After a few days, he gave it up, 'blaming only my want of masterliness'.[1] This small incident is predictive of Hunt's entire career. If we recall Millais's watercolour of 1846, *The Gipsy*, or his small *Landscape, Hampstead* of 1848 (Pls 33 and 34), we can see some of the differences between the two men. In the 1840s Millais accepted the prevailing styles and worked comfortably within them. Hunt, on the other hand, had to abandon his picture because of the conflict between his own perception of nature and inherited ideas. This integrity runs all through Hunt's career, making him the most forceful proponent of Pre-Raphaelitism and giving to his late art an interest not shared by that of most of his colleagues. In contrast, Millais, except in his few Pre-Raphaelite years, followed the path of least resistance, and even his most Pre-Raphaelite art displays an ease and sureness denied to Hunt. As Hunt's book demonstrates, he conceived his role as a holy mission, and his life was a series of struggles where nothing came easily.

In the summer of 1848, when Dante Gabriel Rossetti was working in Hunt's studio, the two artists made a sketching excursion to Greenwich and Blackheath. An apparent product of this outing is a small oil painting by Hunt (Pl. 47), which bears on its back an inscription probably by the artist's widow: 'Love at First Sight: Study made in Blackheath Park for a picture he intended to paint / W. Holman Hunt / Sept. 1848'. In *Pre-Raphaelitism and the Pre-Raphaelite Brotherhood* Hunt placed the excursion just before he moved into a new painting room in August 1848 and before beginning work on the figures in *Rienzi* (Pl. 4).[2] The picture includes two figures and three deer. These were apparently added to enhance what was intended as a simple study for a background. They are small and rather slight, and Hunt seems to have had difficulty with them. The reproduction in *Pre-Raphaelitism and the Pre-Raphaelite Brotherhood* shows the man on the right in a different costume and position from those in the painting as it now exists, evidently because of repainting after the picture was photographed for the book.[3] In the picture, the man is smaller than the woman and appears proportionately too small for his place in the spatial depth of the composition. The legs of two of the deer in the foreground are cut by the picture frame, prefiguring or (depending upon when they were added) more likely echoing Hunt's frequent later practice of slicing his figures by the edge of the picture.

Although the label on the back implies that the picture is a study for a work that was never painted, Hunt did make use of it in *A Converted British Family Sheltering a Christian Priest from the Persecution of the Druids* (Pl. 5), begun a year later. The cluster of dead trees visible in the centre of the *Druids*'s background is based on a detail in *Love at First Sight*, and we can also recognise the pair of trunks on the left and the trees rising over the mass of foliage above and to the right. Hunt may also have used these same trees as the model for the tops of the trees seen above the heads of his figures and through a row of poplar trunks in *Rienzi*. The further trees in *Rienzi* have a similar outline, and Hunt was working on the picture at the time of and after his outing to Blackheath. However, as this is

Facing page: William Holman Hunt, *Strayed Sheep (Our English Coasts, 1852)* (detail of Pl. 52).

47 William Holman Hunt, *Love at First Sight* 1848. Oil on canvas, 9 × 11¼. The Makins Collection.

part of *Rienzi* that Hunt repainted in 1886, the evidence of its similarity or dissimilarity is not conclusive. What is of greater significance is the fact that while Hunt went to the Lea Marshes to paint 'the background and foreground' of the *Druids*, he did not paint all the background directly from nature but based it partly on an earlier sketch, made before he had conceived the subject of the picture. As we have noted, the distant background of the *Druids* does not share the precise detail of the foreground.[4] The trees in *Love at First Sight* are more carefully treated than the corresponding portion of the *Druids*, in which they have been reduced in size by about a third, but they are not painted with leaf-by-leaf precision. The foreground shows no detail at all. The colour, except in the figures, is rather heavy and dull, with little suggestion of the brilliant pitch that was soon to appear as a hallmark of Hunt's art.

In 1849 Hunt painted at least two landscape studies. On 19 August, William Michael Rossetti recorded in the *P.R.B. Journal*, which he kept intermittently, that Hunt had made a study in colour of a cornfield at Ewell.[5] This can probably be identified as a small painting on millboard acquired by the Tate Gallery in 1988, which was described when seen by George Price Boyce at Dante Gabriel Rossetti's home in 1854 as a 'lovely hasty rub in of a cornfield against a deep blue sky'.[6] It does not seem particularly Pre-Raphaelite, but how much detail should we expect to find in a 'hasty rub in'? Another small landscape which includes a cornfield was given by the artist's widow to Sir Kenneth R. Swan and lent by him to the Holman Hunt exhibition of 1969.[7] This painting has an unusual narrow vertical shape and is possibly a fragment. It is too elaborate to have been called a hasty rub in, although it does have a broadly brushed foreground. That foreground probably was a later addition to a view of fields and distant trees not unlike the background of the *Druids*.

The Haunted Manor (Pl. 48) is signed and dated 1849. This picture shows the same waterfall that was depicted in Millais's no longer extant *Kingfisher's Haunt* (Pl. 49). The two works must have been begun at the same time, in Wimbledon Park, in May or June 1849, but finished separately at later times.[8] Hunt first exhibited *The Haunted Manor* in 1856 at the Liverpool Academy, and it seems unlikely that he would have waited so long to exhibit it unless he had also waited to finish it. The background, full of golden light and blue shadows, has no similarity to the background of the *Druids*, which was begun in 1849, and seems impossibly precocious for the Hunt of 1849. On the other hand, the heightened colours do accord with his art of the middle and later 1850s, which will be discussed below.

Most of *The Haunted Manor* is close and scrupulous study of blocks of stone, plant life, and splashing water in a foreground which evidently remains more or less as Hunt painted it in 1849. None of Hunt's works painted before that year show much interest

48 William Holman Hunt, *The Haunted Manor* 1849–56. Oil on board, 9¹⁄₈ × 13¹⁄₄. Tate Gallery, London.

49 John Everett Millais, *The Kingfisher's Haunt* 1849–54. Oil on panel, 9⁵⁄₈ × 13¹⁄₄. Destroyed (formerly collection of Mrs Arthur E. Street).

in elaborate foreground detail. In *Rienzi* the detail consists of a few separate dandelions, and there is none in the foreground of *Love at First Sight*. Begun in 1849, Hunt's *Druids* and Millais's *Ferdinand Lured by Ariel* start to display the elaboration of botanic detail which would characterise much of both artists' work in subsequent years. What we see in *The Haunted Manor* and *The Kingfisher's Haunt* are two close studies of natural detail, which the artists apparently made working side by side in 1849 in anticipation of their larger paintings begun slightly later in the year. In both cases they finished their studies by adding backgrounds at a later date.

Although the backgrounds differ considerably, the centre sections of the pictures show the identical stones and plants. Yet, the differences between the two are striking. They reveal Hunt and Millais, within a year of the formation of the Pre-Raphaelite Brotherhood, as considerably farther apart than the Impressionists Claude Monet and Auguste Renoir in the pictures of *La Grenouillère* which they painted side-by-side in 1869.[9] The differences are in part due to the artists' different points of view: Hunt's low, close, and frontal; Millais's looking at the waterfall obliquely from above and from a greater distance. But the viewpoints themselves were determined by choices which reflect the personalities of the men: Hunt tending to be blunt and direct; Millais, more facile and elegant. We can see the same contrast in the four-square composition of Hunt's *Rienzi* and the more elegant but spatially less coherent composition of Millais's *Isabella*. Millais's depiction, because it shows the waterfall from a greater distance, has a smaller scale and more comprehensive view. In Hunt's, on the other hand, there is a sense of physical solidity, bulk, and weight which is lacking in Millais's. Details such as the water-plants above the fall have a simple integrity as separate things in *The Haunted Manor*, while in the Millais they merge together in a complicated tangle.

The waterfall and surrounding plants fill most of Hunt's composition. They are studied as physical objects, carefully delineated and solidly modelled, but without concern for conditions of outdoor light and atmosphere. Sunlight falls only in the bit of added landscape along the top of the picture. Unlike the background of Millais's picture, which recedes to a distant horizon, Hunt's is packed with detail: a fence and hayrick to the left, and a house, the haunted manor which gives the picture its name, to the right. All are bathed in a vibrant golden light which gives them a prominence disproportionate to the amount of space they occupy. The contrast to the sombre, earthy massiveness of the foreground makes them appear almost as magical visions, and Hunt's title indicates he intended the effect.

We have already discussed Hunt's major exhibited pictures from *Rienzi* of 1849 to *The Hireling Shepherd*, which he began in the summer of 1851 and exhibited the following year. While in the country in 1851, Hunt also began *The Light of the World* (Pl. 50), which he did not finish and exhibit until 1854. Mainly because of its religious content, this painting was Hunt's first to achieve any popular success, and it is still his best-known work. But in addition to bearing a religious message, *The Light of the World* is an outdoor night scene painted with Hunt's usual rigour.

Although Hunt may have intended *The Hireling Shepherd* to embody a symbolic message, we have seen that when it was first exhibited it was received and criticised primarily as a work of extreme realism or naturalism. The opposite was true of *The Light of the World*. When it was exhibited at the Royal Academy in 1854 along with *The Awakening Conscience* (Tate Gallery, London), which Hunt intended as its material counterpart, the two immediately raised questions about what they meant. Ruskin responded to these questions on behalf of Hunt, who was then in Egypt, by writing a second pair of letters to *The Times*. These letters were mainly devoted to explanations of the pictures' obscure or puzzling content, but in the letter about *The Light of the World* Ruskin also insisted upon its truth, and he drew a distinction between true Pre-Raphaelite work and its imitations:

> The true work represents all objects exactly as they would appear in nature in the position and at the distance which the arrangement of the picture supposes. The false work represents them with all their details, as if seen through a microscope. Examine closely the ivy on the door in Mr. Hunt's picture, and there will not be found in it a single clear outline. All is the most exquisite mystery of colour; becoming reality at its due distance. . . . The spurious imitations of Pre-Raphaelite work represent the most minute leaves and other objects with sharp outlines, but with no variety of colour, and with none of the concealment, none of the infinity of nature.[10]

50 (facing page) William Holman Hunt, *The Light of the World* 1851–4. Oil on canvas, 49³/₈ × 23¹/₂. Keble College, Oxford.

51 William Holman Hunt, *View of the River Thames* 1853. Oil on panel, 5³/₄ × 7³/₄. Fitzwilliam Museum, University of Cambridge.

Ruskin did not cite specific examples of the spurious imitations, but he declared they covered half the walls of the Academy. That he felt it necessary to draw this distinction is indicative of how common minutely drawn detail was in English painting in the 1850s. The differences he points out are a result of the extraordinary labours of Hunt and Millais in working directly out of doors. They not only painted elaborate detail, they painted it directly from nature, and their originality lay as much in the observation behind their works as in the treatment. Ruskin commented that Hunt's ivy did not show sharp outlines. Despite the minuteness of detail, Pre-Raphaelitism was not a linear style. Hunt and Millais painted from nature; they did not draw. They saw and recorded in terms of the touch of colour rather than the drawn outline. Neither artist made careful black-and-white outline drawings of natural detail such as those by the German Nazarenes or by an English painter like Leighton.[11]

Hunt painted *The Light of the World* as a night scene to convey his message of Christ as the bearer of light to the sinner. Ruskin in his letter about the painting interpreted the reddish light from Christ's lantern as the light of conscience, and he contrasted it to the light of Christ's nimbus, which he described as the light of the hope of salvation. Thus, the light has a symbolic function, like the ivy and weeds on the door, which, according to Ruskin, indicate that the door to the human soul has long been unopened.[12] Hunt began painting the background out of doors by moonlight on 7 November 1851, while he and Millais were living at Worcester Park Farm, near Ewell. He had a straw hut built to protect him from the cold, and he continued to work out of doors at night until they returned to London on 6 December. His subsequent work on the painting in his London studio in Cheyne Walk, Chelsea, was also done at night during periods of full moon. For Christ's lantern he had a lantern made to his designs, and he painted the foreground detail by the light it cast.

The Light of the World was the first of several outdoor night scenes by Hunt. It shows considerably less natural detail than the contemporary sunlit *Hireling Shepherd*, and the colours are also, of course, much more subdued. Those in the foreground have a reddish glow from the light cast by the lantern; those in the moonlit background are cool greens. A by-product of Hunt's work on *The Light of the World* during the winter of 1853 is a small nocturnal view over the Thames from Hunt's studio (Pl. 51). It shows the deep green water of the river illuminated by golden moonlight on the left and by lights from buildings on the Battersea shore on the right. This is only a small oil sketch (5³/₄ × 7³/₄ inches), which Hunt made from his window and gave to Millais, but it is nonetheless remarkable for its breadth and simplicity. Hunt could do without the insistent detail and strident colours of his sunlit paintings, and this small, almost Whistlerian, sketch demonstrates to what degree he could adapt himself to what he saw before him.

Although Hunt commenced *The Light of the World* in the same year as *The Hireling*

Shepherd, he completed it only in time to send to the Royal Academy in 1854. In the meantime he had painted another outdoor picture. When he exhibited *The Hireling Shepherd* at the Royal Academy in 1852, an admirer, Charles Maud, commissioned him to paint a replica of the group of sheep in the painting's background. Hunt agreed to the commission, but he later sought and received permission to paint an independent picture of sheep instead. He spent the summer and autumn of 1852 at Fairlight, near Hastings on the Sussex coast, painting the picture, *Strayed Sheep* (Pl. 52), and an additional small landscape, *Fairlight Downs – Sunlight on the Sea* (Pl. 54). Robert Braithwaite Martineau, who in the previous year had started taking instruction from Hunt, had a place near Fairlight, and it was probably because of his proximity that Hunt decided to work there. Through Martineau, Hunt acquired another disciple, Edward Lear, who shared lodgings with him during his stay. Lear had been painting landscapes professionally since the 1830s. He had been only moderately successful, but his desire to be instructed by Hunt, who was fifteen years his junior, and who had never yet exhibited a pure landscape, is testimony to the impact of the landscape passages in *The Hireling Shepherd* when it was seen by Lear at the Academy in May.[13]

Strayed Sheep was commissioned as a picture of sheep, and so it is more than a landscape. It has also frequently been interpreted as more than a picture of sheep. F. G. Stephens wrote in 1860 that it was 'of men, not of sheep'.[14] Ruskin in his Oxford lectures of 1883 claimed that it was in its deeper meaning the first of Hunt's sacred paintings, and he applied to it the lines from Isaiah liii. 6, beginning 'All we like sheep have gone astray'.[15] There also seems to be another kind of symbolism in the picture. Hunt first exhibited it at the Royal Academy in 1853 under the title 'Our English Coasts, 1852', which, Stephens wrote, 'might be taken as a satire on the reported defenseless state of the country against foreign invasion'. This interpretation is not as frivolous as it at first might seem. Hunt's picture composed of a flock of sheep on a cliff, with the sea below to the left, echoes in reverse Edwin Landseer's *Peace*, which appeared at the Royal Academy in 1846 and in 1852 was in the National Gallery in the Vernon Collection (Pl. 53). In *Pre-Raphaelitism and the Pre-Raphaelite Brotherhood* Hunt cited *Peace* as a work 'of real point and poetry', which should never be forgotten despite his lower opinion of Landseer's ordinary productions.[16] The point of *Peace* was as a pendant to a companion picture of *War* (destroyed: formerly Tate Gallery). It shows not only sheep, one of which grazes in the mouth of an abandoned cannon, but also goats, a sheepdog, gulls, and a picnicking family. There are biblical overtones in the imagery: in the figures, who suggest a Holy Family, as well as in the sheep, but they enhance the pacific mood of the scene rather than transform it into a vehicle of religious symbolism. We have seen that in 1850 Landseer also exhibited a *Lost Sheep*, appending to it a biblical quotation.[17] However, this picture of a shepherd carrying a sheep had no visual similarity to *Strayed Sheep*, and, as Hunt originally titled his picture 'Our English Coasts', their later similarity of titles is accidental. Landseer's *Peace* showed the Channel coast near Dover with its defences fallen into disrepair, and *Strayed Sheep* also shows the unguarded Channel coast, whatever else it may mean as well.[18]

Strayed Sheep is a picture of sea, cliffs, sheep, and plants, all lit by brilliant sunlight. It is in a lighter and brighter palette than *The Hireling Shepherd*, or, indeed, almost any preceding oil painting except some of Turner's later works, and, whereas Turner was generally looked upon as extravagantly visionary, Hunt's picture is a sunlit view of a recognisable spot on the South Coast of England. His sunlight does not dissolve objects but emphasises their particular qualities. It glows through the thin membranes of the sheeps' ears, and it illuminates each leaf, blossom, and butterfly separately (see detail, p. 72). Hunt's concern was with what light does to the colour of the specific object or surface, not with the general visual effect. Each thing is obtrusively itself, tightly painted and brightly coloured. The wool of the foreground sheep, if examined closely, reveals an incredible welter of small touches of different colours – red, blue, pink, yellow – as if the artist had observed each strand separately. The earth in the foreground is reddish in sunlight, but violet in shadow. The grey rocks in the centre of the painting become blue in shadow, and the shadows under the legs of the sheep lying down on the upper right are clear blue. We have seen coloured shadows before, in *The Hireling Shepherd* and in Ford Madox Brown's *Pretty Baa-Lambs* and *An English Autumn Afternoon*, but in *Strayed Sheep* Hunt pursued his study of reflected colour with greater consistency throughout the picture. We see it not only in the minutely observed foreground details, but also in the distance. The bit of sky above the cliff is little more than a luminous void, but the sea on the left is broken up into prismatic blues, greens, and violets. The horizon is indistinct

52 William Holman Hunt, *Strayed Sheep*
(Our English Coasts, 1852) 1852. Oil on canvas,
17 × 23. Tate Gallery, London.

and, at the point where the promontory of the cliff meets the sea, lost in haze. F. G. Stephens explained this as a result of the sun shining upon the further side of the cliff: 'the sunlight lying upon the place was reflected into a whitish hazy glare, originated by the exhalations that arise from the cliff, which showed above and around it, softening the line of the horizon on the sea, though the cause was invisible, – a very subtle piece of observation, which we never remember to have seen painted before.'[19]

Hunt remained at Fairlight working on *Strayed Sheep* until December 1852. Because he spent more time on it than he had intended, he decided that he must ask more than the seventy pounds he had originally agreed upon with Maud. Through the winter of 1852–3 he delayed delivering the picture, and he considered painting yet another sheep picture to fulfil the commission. His correspondence at this time is full of unhappy references to the painting, which ceased when Maud agreed to pay an additional fifty pounds.[20] In 1853 Hunt exhibited the picture at the Royal Academy, where it was well received. Even the *Art Journal*, which had been consistently hostile to him, praised it. In the following year it won the fifty pound prize at the Birmingham Academy, and in 1855 it was selected to be among the English pictures sent to the *Exposition Universelle* in Paris.

Among the Pre-Raphaelite pictures shown in the Paris exhibition, which, among others, also included *The Light of the World* and Millais's *Ophelia*, *Strayed Sheep* seems to have made the strongest impression. Thomas Armstrong, who was a student in Paris in 1855, wrote in his memoir that he expected the French to disapprove of a kind of work so utterly new and unknown, and he was surprised on the opening day of the exhibition to see a group of French artists standing before *Strayed Sheep* and admiring it.[21] Armstrong also wrote that he tried to give Delacroix some idea of the Pre-Raphaelite movement before the exhibition began. He apparently had some success; on 30 June 1855, Delacroix recorded in his journal that he had spent the morning looking at the

English pictures, which he had admired very much: 'I am really astounded by Hunt's sheep.'[22] The French critics generally recognised the picture's originality but had mixed opinions about its success. In general, they agreed that it may have been truthful, but that it did not appear very natural. The *Art Journal*, in a survey of French criticism of English pictures at the exhibition, quoted the *Athenaeum Français*: 'The grass gives the individuality of each blade, each with its own light, its reflection and its shadow – each part astonishes by the truthfulness of its reproduction, and nevertheless the whole wants truth, and wholly fails to recall nature.'[23] Another critic quoted by the *Art Journal*, Maxime du Camp, saw Hunt as a disciple of Landseer who by his 'false and fantastic tints' succeeded in painting a picture which seemed to be seen through a prism.[24] Du Camp was perhaps more perceptive than the *Art Journal*, which found the Landseer connection ludicrous. Théophile Gautier devoted a chapter of his *Beaux-Arts en Europe* to Millais and Hunt. He compared *Strayed Sheep* to a work by Charles de la Berge, a French painter with a reputation for a fanatical love of finish, and declared that the Hunt made the de la Berge look like a *vague pochade*. Hunt's details took on an exaggerated importance, as if seen through a microscope; a blade of grass was as important as a tree. No painting in the exhibition was as disconcerting; although it appeared most false, it was 'précisément le plus vrai'.[25]

Gautier thought that Millais and Hunt would create a school in England, but he doubted that they would be imitated in France, for the practical reason that their methods were too demanding. On both counts Gautier was correct, although we could adduce additional reasons why French artists did not imitate Pre-Raphaelite detail. Nonetheless, Hunt's equation of light and colour, which produced a prismatic palette, did anticipate central interests in subsequent French painting. At the end of the century, Robert de la Sizeranne, in *La Peinture Anglaise contemporaine*, a work of unquestioning Anglophilic enthusiasm, did claim that Pre-Raphaelitism had contained the germ of all contemporary painting, and he made *Strayed Sheep* his chief example:

> The blood-red sheep in indigo bushes, on rocks chiselled like sugar-candy, under an audacious sky, recall the worst excesses of our 'luminists'; and, remembering that this picture dates forty-one years back, it is a question whether it is not one of the earliest manifestations of the open-air school, and whether the violet horses of M. Besnard are not the descendants, by a strange pedigree, of the red sheep of Mr. Hunt. With all his extravagances Hunt made a colour speak which before him had slumbered heavily. Sometimes it is only a flash, but by this flash it may be seen how right the P.R.B. were to desert the studio for the fields, and a misunderstood tradition for nature.[26]

Although de la Sizeranne was right in recognising the revolutionary and prophetic qualities in Hunt's picture, there is no evidence that it had any actual influence on the younger French artists. In England, with more historic justification, similar claims were made for the picture. In 1859, Ruskin cited *Strayed Sheep* in *Academy Notes*, along with Hunt's *Valentine Rescuing Sylvia from Proteus* and Turner's *Sun of Venice* and *Slave Ship*, as an example of a magnificent effect of sunshine colour 'of a kind necessarily unintelligible to the ordinary observer', which he contrasted to the popularly effective sacrifice of colour in Cuyp, Claude, Wilson and all other supposed masters of sunshine.[27] In his Oxford lectures of 1883, published as *The Art of England* in 1884, Ruskin reconsidered the picture, which he had seen exhibited at the Fine Art Society in London the previous year. In the first lecture of the series, which was devoted to Hunt and Rossetti, Ruskin claimed that a new 'attentive' landscape had arisen in England. The first example had been the apparently unimportant picture, *Strayed Sheep*, which

> at once achieved all that can ever be done in that kind . . . It showed to us, for the first time in the history of art, the absolutely faithful balance of colour and shade by which actual sunshine might be transposed into a key in which the harmonies possible with material pigments should yet produce the same impressions upon the mind which were caused by the light itself.

All earlier work had either subdued nature into narrower truths or had been conventional:

> Turner's, so bold in conventionalism that it is credible to few of you, and offensive to many. But the pure natural green and tufted gold of the herbage in the hollow of that little sea-cliff must be recognized for true merely by a minute's pause of attention.

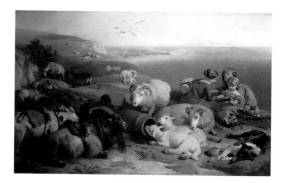

53 Edwin Landseer, *Peace* exhibited 1846. Oil on canvas, 34 × 52. Destroyed (formerly Tate Gallery, London).

54 William Holman Hunt, *Fairlight Downs –
Sunlight on the Sea* 1852–8. Oil on panel,
9 × 12¹/₄. Collection of Lord Lloyd Webber.

Standing long before the picture, you were soothed by it, and raised into such peace
as you are intended to find in the glory and stillness of summer, possessing all things.[28]

In 1859, Ruskin pronounced it impossible to paint sunshine colour with the pitch of
light which has true relation to the shadow. But he declared that sunshine was necessary
to landscape, and that the public would come to understand its expression. Now, twen-
ty-four years later, the public was apparently ready for Hunt, if not for Turner. Hunt's
colours were still not literally true, but he had found the equivalents to give the optical
impression of sunlight.

Hunt began *Fairlight Downs – Sunlight on the Sea* (Pl. 54) in August 1852, while still
working on *Strayed Sheep*, but he completed it on a return visit to Fairlight only in 1858.
It is a landscape painting, as opposed to a picture of animals in a landscape setting, show-
ing a view of the sea from the Sussex Downs. In the foreground a dog chases a stick, and
there are some sheep, but they are incidental to the wider sweep of the terrain and the
contrast between the shaded landscape and the sunlit sea. As Hunt's title indicates, the
main subject is the play of sunlight on the sea, whose colour F. G. Stephens described as
that of turquoises and pearls.[29]

Hunt first exhibited *Sunlight on the Sea* at the end of 1858 in an exhibition at a com-
mercial gallery, where it deeply offended the critic for the *Art Journal*, who saw only
exaggeration: 'So subservient here is nature to execution, that we feel only the insolence
of manner.'[30] The critic and amateur artist Philip Gilbert Hamerton also saw it when it
was exhibited and wrote an article, 'The Relation between Photography and Painting',
comparing it to a marine photograph by Gustave le Gray. Hamerton concluded that
Hunt's painting was superior to the photograph because 'painting is a great intellectual
art; an art of compensation, and compromise, and contrast; an art capable of moderation,
and subject to mastery.' It had colour and was truer in light and dark, in perspective, and
in the quantity of information it provided, whereas the photograph could accurately
record the effect of light on the sea, but falsified everything else.[31]

At the beginning of 1854, after completing *The Light of the World* and *The Awakening Conscience*, Hunt set off on a trip to the Holy Land in fulfilment of a long-standing ambition. His main reason for going was religious: he wished to paint biblical subjects in their actual settings and he apparently first intended to paint a picture of Jacob in the wilderness, set in the desert of Sinai. Hunt arrived in Cairo in January 1854. There he was joined by the landscape painter Thomas Seddon, who had preceded him to the East. The two made plans for their excursion to Sinai, practising for the trip by camping in a tent near the Pyramids and seeking the advice of Edward Lear, who was also in Egypt at the time and was an experienced traveller. However, the project had to be abandoned; on 27 March Seddon wrote to his fiancée:

> You will be, perhaps, surprised to hear that our plans are changed; but the fact is, that Hunt discovered, two or three weeks ago, that when Jacob left his father's house he was a middle-aged man of forty, which has stopped him from painting a picture of him in the wilderness, as he had intended to have done at Sinai; so that, not being a landscape painter, he thought he could not spend a whole summer there.[32]

Instead, Hunt and Seddon travelled to Jerusalem. As soon as they arrived there, in June 1854, Hunt set to work upon an ambitious figural painting of *The Finding of the Saviour in the Temple* (City Art Gallery, Birmingham). He originally hoped to have this picture ready for the next year's Royal Academy exhibition, but, because of various difficulties, chiefly the lack of willing models, he was not able to complete the picture in the East. He brought the partly completed canvas back with him to London in 1856 and continued to work on it there, finally finishing it in 1860. In its background there is a minutely delineated view of the Mount of Olives, which Hunt based on a 'Map-like sketch', made from the roof of the Mosque As Sakrah, but this bit of city-scape forms only a small part of the painting, which depicts an event taking place inside the Temple.

In the autumn of 1854, when Hunt realised that he would not be able to exhibit *The Finding of the Saviour* in 1855, he decided to put it aside and paint another picture, one in which there would be only an animal model, and, hence, no problems with difficult humans: *The Scapegoat* (Pl. 55). He still had trouble with his models, one of which died, and he did not have *The Scapegoat* ready for exhibition in 1855 either, as he completed it only in June of that year, but he did exhibit it in 1856. The subject, which Hunt explained in a long note in the Royal Academy catalogue, is the Old Testament Scapegoat who is driven from the Temple on the Day of Atonement, bearing the sins of the community. He wears around his horns a scarlet fillet, which will become white if the sins are forgiven. In Leviticus, the goat is said to bear the iniquities into a land not inhabited, which in Hunt's visualisation has become the barren shore at the southern end of the Dead Sea.

The picture is thus of a religious subject, based on the Bible and also upon the *Talmud*. It is symbolic; the sacrificial goat is a type of the Saviour. But the goat is also a goat, and in the context of Hunt's art he is related to the sheep of *The Hireling Shepherd* and *Strayed Sheep*. Like those pictures, *The Scapegoat* has a connection with Landseer. When Hunt thought of the subject, while studying the Jewish ritual, it struck him as one suited for Landseer: 'I had in fact resolved to take the opportunity to talk to him of it; but now I reflected that in Syria I had a possibility of painting it worthily which he could never have.'[33] Hunt's thinking of Landseer may have led to his visualisation of the barren shore where the goat has wandered to expire. The subject parallels pictures of animal drama by Landseer such as *The Sanctuary* of 1842 (Royal Collection), which shows an exhausted stag, who has fled his pursuers to the deserted shore of a highland loch, or the painting Landseer exhibited in 1844 as *Coming Events Cast their Shadows Before* (or *The Challenge*; Pl. 56), which shows two stags about to fight.[34] In the background of *The Sanctuary*, on the other side of the water, the sun sets emblematically over a range of mountains, as it does in *The Scapegoat*. In *The Challenge*, the subject is not as close as that of *The Sanctuary*, and it is seen by moonlight rather than the setting sun; but in the foreground Landseer's stag stands on a barren shore across which dead trees lie, and in the distance, again on the far side of a body of water, there is a range of mountains. Their bottoms are in shadow, but the upper parts are lit by the moon, giving the setting a feeling of visionary unreality. Hunt's goat stands on the salt marshes at the edge of the Dead Sea, his feet breaking through the crust. Around him are the skeletons of animals which previously died there, and in the background, across the sea, are the mountains of Edom, whose upper reaches are a flaming violet in the setting sun. The setting is, if anything, even more unworldly and inhospitable than those of Landseer's paintings.

55 William Holman Hunt, *The Scapegoat* 1854–5. Oil on canvas, 33³/₄ × 54¹/₂. Lady Lever Art Gallery, Port Sunlight.

56 Edwin Landseer, *Coming Events Cast their Shadows Before (The Challenge)* exhibited 1844. Oil on canvas, 38 × 83. Collection of the Duke of Northumberland.

Hunt decided to paint *The Scapegoat* in the early autumn of 1854. With some friends, he made a trip to the Dead Sea in October to look for a site, finally selecting a salt-encrusted shore at Oosdom (or Usdum), which he believed to be the biblical Sodom, at the southern end of the Sea. He deferred beginning the painting until the correct season, well after the Day of Atonement. On 13 November 1854, he left Jerusalem to encamp at Oosdom and begin the picture's background view of the mountains of Edom across the Sea. He stayed there slightly under a fortnight. He took a white goat with him from Jerusalem, but, as with *The Hireling Shepherd*, he did no more than the landscape on the spot, leaving the goat to be painted back in Jerusalem. Hunt was well aware of what an extraordinary venture he had undertaken, and he kept a diary of the trip. From this we learn that he began by copying in the distant mountains, and that he worked at all parts of the picture except the goat. Because of the impatience of his Arab guides, he had to cut his stay shorter than he intended. When he left, no part of the picture was entirely finished.

> I left reluctantly altho' what is done already inclines me to continue it at home in hopes of making a picture of some interest in its components – it would not all be painted so scrupulously from nature as I should like but at least I have made every exertion to obtain the proper opportunity and some truth in its features must be the result I hope.[35]

In Jerusalem, after his return, he painted the goat, a camel's skeleton from one found locally, and the rest of the foreground details. He painted the sky from the roof of a friend's house which allowed him a view of the mountains beyond the Dead Sea.

The lengths to which Hunt went to paint his background emphasise the fact that *The Scapegoat* is not only a picture of a goat, or of a religious symbol; it also contains an extensive landscape, which purports to be an accurate representation of a specific place. There is no scriptural source for showing the goat on the shores of the Dead Sea; the choice of location was apparently Hunt's idea. His belief that a picture of the place would be of interest for its own sake was why he did not forego the subject in favour of Landseer but painted it himself. In March 1855 he wrote to Rossetti, 'I don't know I should have thought the subject demanding immediate illustration had I not had the opportunity of painting this extraordinary spot as background from nature.'[36] While at

work on the painting he was informed of the existence of an etching of the subject of *The Scapegoat*. He had believed that no one had painted the subject before, but the new information did not disturb him: 'I don't care for anything that could be designed in England as the interest of the illustration depends upon the locality so much.'[37] In his diary of the trip to the Dead Sea Hunt described a view to the south of the Sea which he had seen en route:

> Never was so extraordinary a scene of beautifully arranged horrible wilderness . . . I can understand the use of art in thinking how interesting a picture of such a scene would be, and in thinking that I was doing right morally in undertaking a work of similar value in conveying important knowledge I commended myself to God's merciful protection.

When Hunt exhibited the picture at the Royal Academy he began the explanatory note in the catalogue with an identification of the site before going on to explain the biblical meaning of the subject.

The location, in addition to its own topographical interest, was also appropriate to Hunt's subject. Hunt's description of the site in his diary shows that he saw a deep significance in its desolate beauty:

> The mountains lie afar beautiful as precious stones but near they are dry and scorched, the rose colour is the burnt ashes of the grate, the golden plain is the salt and naked sand. The Sea is heaven's own blue like a diamond more lovely in a king's diadem than in the mines of the Indies but as it gushes up through the broken ice-like salt on the beach, it is black, full of asphalt ocum – and in the hand slimy, and smarting as a sting. No one can stand and say it is not accursed of God. If in all there are sensible figures of men's secret deeds and thoughts, then is this the horrible figure of Sin – a varnished deceit – earth joys at hand but Hell gaping behind, a stealthy, terrible enemy for ever.

As if that was not enough, Hunt seems to have done everything in his power to emphasise the unworldly, hellish aspects of the scene. The goat stands in as hopeless a situation as could be imagined; his doom is foreshadowed by the skeletons surrounding him. The setting sun has turned the sky orange and the distant mountains into lurid purples and violets. In a small version of the picture (City Art Gallery, Manchester), in which Hunt experimented with a black rather than white goat, he also introduced a rainbow, 'the celestial image of Heaven's mercy,'[38] but in the finished picture there is no such sign of hope.

The background of *The Scapegoat* was the most extensive and most ambitious landscape that Hunt had yet painted. The picture is a bit larger than *The Hireling Shepherd* and considerably larger than *Strayed Sheep*, and the landscape is relatively more important in the composition than in either of these works. It also contains a distant view which is more important than the study of foreground detail. In this respect, *The Scapegoat* is comparable in Hunt's art to *The Blind Girl* and *Autumn Leaves* in Millais's, and all three pictures were exhibited in 1856. Like Millais's pictures, *The Scapegoat* also shows some loosening of the minute Pre-Raphaelite handling of previous years. The foreground detail and the wool of the goat do not have the same crispness or elaboration as comparable parts of *Strayed Sheep*. The background also seems less crisp than anything in Hunt's previous works, but there is nothing in any of them that is at all comparable. Like the background of *Autumn Leaves*, it shows distant hills at sunset, and there is a new range of emotive colours. But whereas Millais was slipping towards a more conventional vision, so that Ruskin could compare him to Giorgione, Hunt was becoming more extraordinarily personal. Throughout the painting we can see the concern with reflected light and colour of Hunt's earlier pictures pushed to new extremes. In previous pictures, however garish or forced their colours might seem, Hunt had at least applied his vision to the depiction of the familiar English landscape. In *The Scapegoat* his lack of pictorial inhibition was combined with a landscape which was both unfamiliar and, by English standards, fantastic. Hunt may have painted what he saw, but by choice he saw strange things, and he saw them at their most vivid pitch. He chose to paint at sunset, and he waited for months in Jerusalem before finishing the picture so he could paint pink clouds into the normally empty sky. The colours are seen with an intensity and expressive power which go beyond naturalistic observation. Behind the goat, the landscape screams out in oppressive, strident chords which underscore the message of impersonal and implacable doom.

The public reaction to *The Scapegoat* was mixed. Most critics did not see a deep meaning in the subject, and many were dubious about the picture's value as a record of the place. The *Art Journal* decided that the picture was 'useless for any good purpose'.[39] The only interesting thing to its critic's eye was the deposit of salt in the foreground; he declared flatly that the mountains of Edom were not as red and blue as Hunt had painted them. Even Ford Madox Brown, who admired the painting – 'by the might of genius out of an old goat & some saline incrustations can be made one of the most tragic & impressive works in the annals of art' – was disturbed by the background which was 'hard in colour & eats up the foreground'.[40] Ruskin devoted a long review to the painting in *Academy Notes*, but he also had mixed feelings. He praised Hunt for undertaking it, and he asserted its value as a record of the place:

> Of all the scenes in the Holy Land, there are none whose present aspect tends so distinctly to confirm the statements of Scripture, as this condemned shore. It is therefore exactly the scene of which it might seem most desirable to give a perfect idea to those who cannot see it for themselves; it is that also fewest travellers are able to see; and which, I suppose, no one but Mr. Hunt himself would ever have dreamed of making the subject of a close pictorial study.

He praised the temper and the toil which produced the picture, but, 'regarded merely as a landscape, or as a composition', the picture was a total failure. It lacked nearly all the 'effective manipulation' of Hunt's earlier works. It had no good hair-painting, nor hoof-painting, and the animal in the exact centre made it look like a sign. The mountains were also a failure, but Ruskin forgave this, because 'the forms of large distant landscape are a quite new study to the Pre-Raphaelites, and they cannot be expected to conquer them at first'. Ruskin also forgave Hunt's making the reflection in the water brighter than the sky above it, though when Millais did the same thing the following year in *A Dream of the Past: Sir Isumbras at the Ford* (Pl. 43) he called it 'singularly disgraceful'. In Hunt's case, Ruskin surmised, correctly, that the water and the sky were painted separately at different seasons. Thus, although both were painted from nature, they were discordant, and the reflected colours could not be toned down because of their complexity.[41]

Ruskin's criticisms of the reflections in Millais's picture as well as in *The Scapegoat* evidently festered in Hunt's mind and led to an exchange of letters between the critic and artist in 1858. Ruskin refused to reconsider the criticism, 'for in my poor travels as far as Naples, I noticed that neither the laws of reflection – refraction – or gravitation – underwent any change in that latitude; so I considered myself quite justified in assuming they were constant as far as Syria'. Hunt responded by arguing for truth of impression in place of the laws cited by Ruskin:

> There can be no doubt that in fact the light reflected in water is more or less lower in tone than the sky above. It is brought down thus however into violent opposition with the darkest parts of the subject which, to the eye, gives it a luminosity such as no opposition of mere pigment will produce unless the literal truth of proportion is departed from. To the eye in some cases the reflection is *quite as bright* as the sky itself – Millais who always works on impression and not theory – painted his water thus in the Dream of the Past.[42]

Hunt then went on to tell Ruskin that his criticism had led Millais to tone down the water in *Sir Isumbras* and spoil the picture.

Before 1854 Hunt painted only an occasional pure landscape, as opposed to landscape backgrounds to other kinds of pictures. Most of the earlier landscapes that we now know can be classified as studies or ancillary works rather than independent pictures. It is worth noting that Hunt did not exhibit any of his earlier landscapes until after his trip to the East, and in the cases of *The Haunted Manor* and *Fairlight Downs – Sunlight on the Sea* he probably did not complete them until then. In the East, he did paint a considerable number of landscapes in watercolour, three of which he exhibited along with *The Scapegoat* at the Royal Academy in 1856, as soon as he returned. The interest of the places depicted was clearly the motivation for these works, as it was for the background of *The Scapegoat*, and Hunt exhibited them with titles indicating exactly what sites they showed. Previously his landscape studies and landscape backgrounds had had no topographical interest. In *Strayed Sheep*, which does show a specific place, the distinctive character of the terrain is not very important, and when Hunt exhibited the picture he did not indicate the location; his concern was not with the place but with nature. In the East, Hunt

reversed his priorities, and his Eastern landscapes have something of the quality of a tourist's mementoes of famous and faraway places.

Hunt did not go to the East to paint landscapes, but in Egypt, where he first arrived, he discovered that he could not easily paint figural subjects. He disliked the Egyptian scenery: 'The country offers nothing with more than antiquarian interest as landscape; the Pyramids themselves are extremely ugly blocks, as one always knew, and arranged with most unpicturesque taste . . . There are palm trees about, which attract my passing admiration, but for all else one might as well sketch in Hackney Marsh.'[43] He professed no interest in modern Cairo, but he did feel a duty to record traditional manners and customs that were passing away, and he began two genre subjects: *A Street Scene in Cairo: The Lantern Maker's Courtship* (City Art Gallery, Birmingham) and *The Afterglow in Egypt* (Southampton Art Gallery). He had difficulties in both works in getting models to sit, and he finished neither picture until long after his return to England, but he had no such troubles with landscape; so, despite protestations of not wishing to be a *paysagiste*, he began to paint views in watercolour. By limiting his landscapes to this medium, he apparently felt he was making less of a commitment to the lower category of subject.

Soon after Hunt's arrival in Egypt, he encamped with Thomas Seddon at Giza, near the Sphinx. Both artists painted watercolours of the Sphinx. Hunt's, which he exhibited at the Royal Academy in 1856, shows the head of the Sphinx seen from the rear, with a view over the desert beyond to the pyramids of Saqqara on the horizon (Pl. 57). At the time Hunt and Seddon were at Giza the French Egyptologist Auguste Mariette was excavating the Sphinx, and Hunt's curious view may have been intended to show the recently uncovered rock. In the foreground lies a dead snake, probably the one whose killing Hunt described in a letter to Thomas Combe.[44] He may have included it in the watercolour for the amusement of Seddon, who had a passion for snakes and snake-charmers. At Giza Hunt also began two watercolours of gazelles in the desert: a small

57 William Holman Hunt, *The Sphinx, Giza, Looking towards the Pyramids of Saqqara* 1854. Watercolour, 10 × 14. Harris Museum and Art Gallery, Preston.

58 William Holman Hunt, *Cairo: Sunset on the Gebel Mokattum* 1854. Watercolour, 6½ × 14. Whitworth Art Gallery, University of Manchester.

one signed and dated 1854 (Walker Art Gallery, Liverpool), and a larger one, which he did not complete until 1866.[45] In the former a single gazelle is the main subject; in the latter four gazelles are seen in the midst of a panoramic desert landscape. These beasts, along with the snake in *The Sphinx* and a flock of ducks in the foreground of a slighter watercolour of *The Great Pyramid* (private collection),[46] suggest that Hunt in the period following the success of *Strayed Sheep* was as ready to become an *animaliste* as a *paysagiste*. Indeed, *The Scapegoat*, begun later in 1854, was a considerably more ambitious undertaking than any of Hunt's pure landscapes.

Seddon remained at Giza, with a few interruptions, until he and Hunt left Egypt for Jerusalem, but Hunt moved back to Cairo, returning in April to Giza to finish his view of the Sphinx. In Cairo he painted a watercolour which he exhibited in 1857 as 'Sketch from a House in New Ca., Looking Towards Gebel Mokattum', but which has since usually been known as *Cairo: Sunset on the Gebel Mokattum* (Pl. 58). The Gebel Mokattum, or el Muqattam, is the range of barren hills bordering the city to the East. The real subject of this watercolour, and to a degree of that of the Sphinx, is the colour of the desert, which Hunt did find beautiful despite his dislike of Egyptian scenery.[47] In *The Sphinx* the desert is golden; in *Sunset on the Gebel Mokattum* it is a brilliant pink, and the buildings of Cairo in the middle distance are orange in the late afternoon sun. In both the colours are at an even higher pitch than in *Strayed Sheep*, Hunt's most recent attempt at painting sunlight. Cast shadows on the hills and in the foreground of *The Sphinx* are bright blue, and in *Sunset on the Gebel Mokattum* the foreground, which is in shadow, is blue and violet.

Hunt and Seddon left Egypt in mid-May 1854. They arrived in Jerusalem on 3 June. Hunt remained there until October 1855, then travelled overland north to Beirut, and sailed for Constantinople and home in November 1855. He was more enthusiastic about Palestine than about Egypt. To his pious eyes most of the landmarks had an intrinsic interest and appeal, but he also found the landscape beautiful for its own sake. Long passages in his memoirs describe his rapturous response to the scenery. He repudiated the prevailing opinion that the scenery in itself was devoid of attraction. Agriculturally, much of it was unproductive,

> But there is a beauty independent of fruitfulness, which perhaps it is too much to expect all to see, just as it is unreasonable to require the ordinary observer to appreciate the proportions and lines of a human skeleton . . . Syria is intrinsically beautiful. The formation of the country, the spread of the plains, the rise of the hills, the lute-like lines of the mounts, all are exquisite; and with these fundamental merits there is often enough of vegetation to add the charm of life to the whole.[48]

Now Hunt did wish to make a pictorial record of the scenery, and he wrote to Rossetti complaining that he was unable to do so:

I should be dreadfully sad in leaving the place with so little of its countless beauties on canvas or in any way portrayed, for in fact, I can promise literally nothing. The figure picture I am doing has no landscape, and the other is of a distant place. One can do nothing in so short a time as a twelvemonth.[49]

59 William Holman Hunt, *Jerusalem by Moonlight* 1854–5. Watercolour, $8^3/_4 \times 14$. Whitworth Art Gallery, University of Manchester.

Nonetheless, although Hunt promised literally nothing, he did paint several watercolours in and around Jerusalem and on his trip north at the end of his stay.

At the Royal Academy in 1856 he exhibited two which he had made in Jerusalem. These were *Jerusalem by Moonlight: Looking over the Site of the Temple to the Mount of Olives*, which is reproduced in Hunt's memoirs as 'Mahomedan Festival at Jerusalem' and has also been called 'Jerusalem during Ramazan' (Pl. 59), and *View from the Mount of Offence, Looking Towards the Dead Sea and the Mountains of Moab: Morning*, which is usually known as *The Dead Sea from Siloam* (Pl. 60).[50] These two works are approximately the same size as *The Sphinx*, which he exhibited with them in 1856, and *Sunset on the Gebel Mokattum*, with fourteen inches as the horizontal and larger dimension of each. Hunt also made one larger watercolour in Jerusalem, *The Plain of Rephaim from Mount Zion* (Pl. 61), which is 14 × 20 inches, and a second the same size of *Nazareth* (Pl. 62), but he did not exhibit these two works until 1861. In his memoirs Hunt mentioned working on the former landscape just before his departure from Jerusalem; the latter he began during a stay of several days at Nazareth on his journey to Beirut. In a diary he kept during the trip he recorded working on the watercolour of *Nazareth* from 24 to 27 October, labouring each day from before sunrise until sunset. On 25 October he wrote, 'If I can only advance it enough it will be a great pleasure to me all my days in England', but he left off two days later with sorrow that he could not bring the drawing to a higher state of completion.[51]

Although Hunt's remark in his diary implies that he intended to keep *Nazareth* in his own possession, in 1861 it was bought by Thomas Plint along with *The Plain of Rephaim*, *Jerusalem by Moonlight*, *The Dead Sea from Siloam*, and *Cairo: Sunset on the Gebel Mokattum*. Plint died shortly after, and in the sale of his collection at Christie's in 1862 the Hunt watercolours were accompanied by the following note in the catalogue: 'The five well-known works, begun from nature in 1855, and completed in 1861, lately exhibited.'[52] As the three smaller watercolours had all been exhibited in 1856 and 1857 (and again in

60　William Holman Hunt, *The Dead Sea from Siloam* 1854–5. Watercolour, 9³⁄₄ × 13³⁄₄. Birmingham Museum and Art Gallery.

1861), the 'completed in 1861' would seem to refer to the two larger ones, which first appeared publicly only in 1861.

Jerusalem by Moonlight was apparently the first watercolour Hunt undertook in the Holy Land. In *Pre-Raphaelitism and the Pre-Raphaelite Brotherhood* there is a description of its commencement:

> One evening at home, when the moon was shining splendidly, I raised myself to look over the high wall on my roof, and stood gazing on the impressive view of the Mosque As Sakrah [on the site of the Temple], the swaying dark cypresses; the arcades and eastern wall stood back-grounded by the Mount of Olives. It was a poetic and absorbing scene, and watching it from hour to hour for the most suitable light and shade, the moonlight effect enchanted me, and I proceeded to make a drawing.[53]

Hunt does not mention the torchlit procession which can be seen in the centre of the scene, and Judith Bronkhurst has suggested that it was a later addition. His initial inspiration was the poetic effect of the moonlight. Thus, the watercolour continues the interest in nocturnal effects which he had displayed in *The Light of the World* and in his slight sketch of the *Thames by Night*. As in those works, there is a combination of artificial light and natural moonlight, and the colours are predominantly pale blues and greens. Despite the difference in colour, the composition is similar to that of *Cairo: Sunset on the Gebel Mokattum*. Both are views across cities to hills beyond, and both have running across the foregrounds the parapets of the roofs which provide the vantage-points. In the lower left corner of *Jerusalem by Moonlight* a woman leans across the wall to watch the procession; *Cairo: Sunset on the Gebel Mokattum* shows a child looking over the wall and a woman sifting grain.

Hunt's other Eastern landscapes also have high vantage-points. That is not so obvious in *The Sphinx*, but we are high enough to see to Saqqara some ten or eleven miles to the south. In *The Plain of Rephaim from Mount Zion* and *Nazareth* there are figures on high foreground promontories which are squeezed into the corners of the compositions.

In *The Dead Sea from Siloam* the land drops away from the vantage-point so abruptly that there is no actual foreground, but we see the tops of the trees growing on the slope before us and a small figure climbing in them. These foreground figures and their situation above the landscapes recall Ford Madox Brown's use of foreground figures and plateau landscape in *An English Autumn Afternoon* (Pl. 23). Like Brown, Hunt was not primarily a landscape painter, and his repeated use of similar arrangements is an obvious device to give his views some compositional structure. In the placing of the figures on a foreground plateau we can probably discern Brown's influence, transmitted by Hunt's travelling companion, Thomas Seddon. Seddon used the plateau landscape both in the East in his *Jerusalem and the Valley of Jehoshaphat* (Pl. 104), and earlier in *Léhon, from Mont Parnasse* of 1853 (Pl. 101). Before Seddon travelled to the East, Brown had been his mentor, and the composition of *Léhon, from Mont Parnasse* depends obviously and heavily upon *An English Autumn Afternoon*.

In *Cairo: Sunset on the Gebel Mokattum* and *Jerusalem by Moonlight* the figures are innocuous and seem to exist only to serve a compositional function. But the activity in the foregrounds of Hunt's other Eastern watercolours deserves attention. The snake in *The Sphinx* and the figure in the trees in *The Dead Sea from Siloam* have been mentioned. In *Nazareth* there are two youths, one of whom is reaching for a stone with his left hand in order, apparently, to kill another snake. In *The Plain of Rephaim* a bearded man in Eastern garb carries a small child up the rocky hillside. They are accompanied by another, larger child. The man has lost his hat, which falls through the air below him, and below it are two boys, the lower parts of whose bodies are cut by the picture frame. One boy has his arm upraised, but whether it is to hail the man, attack him, or catch his hat, it is impossible to tell. Although it appears that the man is rescuing the child he carries from the boys, Hunt mentioned in his memoir that he worked on the watercolour in a high wind, so the incident may have only to do with that.[54]

In all the watercolours the figures are placed at the very edge of the composition, and they are usually cut by the frame at the bottom of the picture. In *The Plain of Rephaim* the left side of the picture also slices off the arm of the boy accompanying the bearded man. We have seen that in *Love at First Sight* Hunt cut through the lower extremities of the deer in the foreground with the bottom of his picture. In *Strayed Sheep* the animal nearest us and those along the right hand edge of the picture are again only partly visible within the rectangle of the picture space. Hunt repeated this practice in later works such as the watercolour *Festa at Fiesole* of 1868 (Pl. 68) and the oil painting *The Plain of Esdraelon from the Heights above Nazareth* of 1870–7 (Pl. 65). In all these examples except *Strayed Sheep* the people or animals are only appendages to the landscapes. The works give the feeling that Hunt felt he had to include figures to enliven the compositions, but then he ruthlessly shoved them aside so they would be in the way as little as possible. But he seems also to have wanted to suggest by the way he cut off the compositions or activities that the space of the picture is only an arbitrary slice of a larger whole. The snake in *The Sphinx*, for example, makes the image less self-contained, because it implies an action and an actor who is not shown. In *Fairlight Downs – Sunlight on the Sea*, a dog chases a walking-stick which flies through the air, thrown by the dog's unseen master from outside of the picture space. According to William Michael Rossetti, 'Slight as it is, this small familiar incident brings the whole thing home to you with doubled force of undiluted fact.'[55] What Rossetti, writing in 1858, implied is that Hunt was attempting to enhance the sense of the picture's reality by a snapshot-like exclusion of part of the incident, at a time well before photography itself was capable of snapshot instantaneity.

Hunt painted *The Dead Sea from Siloam* in the light of early morning. It shows the view looking east from Jerusalem toward the Dead Sea, and, as we can see from the shadows of the trees on the lower right, looking into the morning sun. He painted *The Plain of Rephaim* in the evenings, an hour or two before sunset. The view is to the south, and the light falls from the right. The foreground and distant hills are brightly lit, but most of the middle distance is in shadow. In *Nazareth*, upon which because of his limited time Hunt worked throughout the day, the effect is of general open sunniness with little shadow. The view is from the hills north of the town, which is nestled in the middle distance. Beyond stretches a vast, barren landscape, similar to those in *The Plain of Rephaim* and *The Dead Sea from Siloam*. The colours of all three are comparable to those of *Cairo: Sunset on the Gebel Mokattum* although not at quite such a vivid pitch. The mountains in the far distance of *The Dead Sea from Siloam* are seen faintly through the morning mist over the Sea, and the mountains in the distance of *Nazareth* also appear somewhat dematerialised in the brilliant light.

61 William Holman Hunt, *The Plain of Rephaim from Mount Zion* 1855–61. Watercolour, 14 × 20. Whitworth Art Gallery, University of Manchester.

In all three watercolours, however, most of the expanse of landscape is depicted with Pre-Raphaelite precision. As we have seen, what Hunt admired in Syria was the beauty of the larger lines of the landscape. What his views show with insistent clarity is the rigid rocky structure of the terrain, traversed by the long lines of roads, walls, and aqueducts. The horizons are high; the skies are empty, or nearly empty. Vegetation is of minimal importance, and the foregrounds serve mainly as foils for the distant views. If we recall the overweening importance given by Hunt to details of plant life in *The Hireling Shepherd* and *Strayed Sheep*, we can see the very different focus in these landscapes from a few years later. Their large lines give visual embodiment to his comparison of the formation of the country to the human skeleton. Hunt never returned to the microscopic botanic study of the years before 1854, but, unlike Millais, he never abandoned the integrity of vision that lay behind that study. His Eastern landscapes are just as scrupulous as his earlier works, and in their way they are perhaps even more original.

In addition to the six finished Eastern watercolours which we have been discussing, Hunt painted or drew a large number of lesser views during his first trip to the Holy Land. Many of these are chiefly of documentary interest as records of the trip, and they are reproduced as such in *Pre-Raphaelitism and the Pre-Raphaelite Brotherhood*. Occasionally in the medium of pencil, or pencil and body colour, Hunt shows himself capable of an economy and simplicity otherwise rare in his art, but he was never a sensitive draughtsman, and it is impossible to claim high quality for these works. Hunt also made a small etching of the Sphinx by moonlight, with what is apparently the artists' tent in the foreground,[56] and he began at least two drawings, which he never completed, of the same size as *The Plain of Rephaim* and *Nazareth*. One of these is of *The Sea of Galilee* (Pl. 63). At sunrise on 30 October 1855, the day after Hunt left Nazareth, he began the view from the southern end of the sea, with the town of Tiberias in the foreground. He waited to colour the drawing until he had seen the effect of evening. His discovery that there was cholera in the town prevented this, forcing his precipitate departure, but he did finish the drawing in outline. A watercolour by Arthur Hughes showing

the scene by night, which was based on this sketch and upon Hunt's description of the moon rising over the water, is reproduced in *Pre-Raphaelitism and the Pre-Raphaelite Brotherhood*.[57] The other unfinished view was apparently begun in September 1854 on an excursion to Hebron. Hunt worked on it again on his first trip to the Dead Sea to look for a site for *The Scapegoat*. Unlike the outline drawing of *The Sea of Galilee*, this is an unfinished watercolour (Pl. 64), and it reveals only slight traces of pencil with no care-ful outline underlying the colour. The most distant portions of the view are the most highly finished, and the nearer foreground is still bare; there is no hint of the figures and incidents which enliven the foregrounds of Hunt's finished watercolours. Probably because it is unfinished, it shows an uncluttered largeness of vision which makes it in some ways the most immediately appealing of all Hunt's Eastern works.

62 William Holman Hunt, *Nazareth* 1855–61. Watercolour, $13\frac{7}{8} \times 19\frac{5}{8}$. Whitworth Art Gallery, University of Manchester.

63 William Holman Hunt, *The Sea of Galilee* 1855. Pencil, $14 \times 19\frac{1}{2}$. Private Collection.

64 William Holman Hunt, *A Wadi in Palestine* 1854. Watercolour, $13\frac{5}{8} \times 19\frac{1}{2}$. Private Collection.

65 William Holman Hunt, *The Plain of Esdraelon from the Heights above Nazareth* 1870–7. Oil on canvas, 16⅛ × 29½. Ashmolean Museum, Oxford.

On his way home to England, Hunt visited Constantinople and the Crimea. In January 1856 he began a large watercolour, *The Sleeping City* (Ashmolean Museum, Oxford), showing the cemetery at Pera, near Constantinople.[58] Hunt brought it home with the lower part blank and did not finally complete it until 1888. It is mainly a study of foreground objects: trees and foliage fill the background. The result seems like a return to an earlier, more claustrophobic kind of Pre-Raphaelitism, but without the precise detail of Hunt's and Millais's works from the early 1850s.

On later trips to the East in 1869–72, 1875–8, and 1892–3, Hunt painted a few additional landscapes. The most ambitious is a view in oil, *The Plain of Esdraelon from the Heights above Nazareth*, which Hunt began as a study for the background of his large *Shadow of Death* (City Art Gallery, Manchester). It exists in several versions with and without figures. The largest and most highly finished of them (Pl. 65) has shepherds with their flocks in the foreground, and was presumably worked up from a version without figures (private collection), which Hunt began from nature just outside of Nazareth in 1870. It shows everything softened to the same slightly fuzzy texture which appears in much of Hunt's later art. The palette is as bright as ever, but the effect seems rather heavy-handed. Hunt exhibited this picture along with *The Afterglow in Egypt* at the opening exhibition of the Grosvenor Gallery in 1877, where next to works by Whistler, Burne-Jones, and Albert Moore they must have looked garish and old-fashioned. There also exist watercolours of Jerusalem dated 1869 (private collection) and 1892 (William Morris Gallery, Walthamstow), but they are only weaker echoes of Hunt's earlier work. The watercolour of 1892 may have been based on a painting made in 1854 by Thomas Seddon.[59]

After 1856 Hunt also continued to paint landscapes in watercolour on trips made somewhat closer to home. In the autumn of 1860 he visited Devon and Cornwall on a walking tour in the company of Tennyson, Francis Turner Palgrave, Thomas Woolner, and the painter Val Prinsep. His watercolours from this tour, depicting English landscapes, come closest of all his works to conventional English landscape views. *Helston, Cornwall* (Pl. 66) shows rolling, open fields with a stream bordered by trees. It has none of the exotic colour of Hunt's Eastern landscapes, and even in relation to his English pictures, the sunburnt orange-yellow of the fields seems more subdued than the brilliant greens of *The Hireling Shepherd* and *Strayed Sheep*. Nonetheless, it is still strongly coloured. Greens and violets play through the prevailing colours of the fields, and the shadows in the trees and the distant hedgerows on the farther hills are blue. Another smaller watercolour, *Autumn Tints – Ivy Bridge, Cornwall* (private collection), shows a wooded scene

with a rich play of reflected light and colour recalling the background of *The Haunted Manor*. In addition, Hunt made a number of watercolours of waves breaking on the coast. These represent a unique and not very successful venture into depictions of movement and natural dynamism, and they have little in common with any of his other works.[60]

Hunt was in Italy from August 1866 until September 1867, and again from early in 1868 until the summer of 1869. He lived mainly at Florence, but in 1868 he visited Naples and made several watercolours nearby. In 1869, following his election as an honorary associate member of the Old Water-Colour Society, he sent two watercolours of Italian subjects to its summer exhibition. They have disappeared, but from contemporary descriptions they sound most interesting. According to F. G. Stephens's review in the *Athenaeum*, one, *Interior of the Cathedral at Salerno*, was a view from the altar over the brightly coloured floor of the nave. Its effect was one of brilliant daylight: 'The whole is suffused with light at its fullest power without glare, and superb as the multifarious details are, aerial perspective is perfectly preserved in the greatest variety of tints and wealth of tones.'[61] In the opinion of the critic for the *Art Journal*, 'This, as other drawings by Mr. Holman Hunt, may possibly be admired more by artists than the general public; the result strikes us as more clever than agreeable.'[62]

Hunt's second watercolour exhibited in 1869 was *Moonlight at Salerno*, which was a view across the harbour from a high vantage-point; in the foreground a man was reading a newspaper by moonlight. Its main interest apparently lay in the colour of the water and the reflected light of the moon. According to the *Art Journal*, it possessed 'doubtless rare qualities of light and colour, iridescent and opalescent on the sea as it sparkles under the golden moonlight', but 'to ordinary eyes' it seemed too blue. Although this watercolour is lost, a small *Fishing Boats by Moonlight* (Cecil Higgins Art Gallery, Bedford) shows a similar subject of a harbour at night. Another nocturnal watercolour painted by Hunt in Italy is *The Ponte Vecchio, Florence* (Pl. 67). In this work as well, interest lies in the reflections in the water, which provide a mirrored repetition of the bridge and the buildings along the Arno, but illumination now comes from the

66 William Holman Hunt, *Helston, Cornwall* 1860. Watercolour, $7\frac{5}{8} \times 10\frac{1}{8}$. Whitworth Art Gallery, University of Manchester.

67 William Holman Hunt, *The Ponte Vecchio, Florence c.* 1866–9. Watercolour, 10 × 21½. Victoria and Albert Museum, London.

68 William Holman Hunt, *Festa at Fiesole (True Merit Overlooked)* 1868. Watercolour, 13¾ × 19⅞. Private Collection.

lights of the city rather than the moon. As in Hunt's earlier oil sketch of *The Thames* of 1853 (Pl. 51) the colours are in restricted range, and the work has a sobriety quite unlike the dazzle of his sunlit views of approximately the same time.

Hunt's first wife died in Florence in December 1866. His return in 1868 was for the sake of erecting a memorial to her. During this second stay in Italy, he lived outside the city at Fiesole, for reasons of health, and there he 'executed a few watercolour drawings from the hills, and so kept myself in the pure air'.[63] He exhibited one of these, *Festa at Fiesole* (Pl. 68), at the Old Water-Colour Society in 1870. Another showing the same view is *Sunset in the Val d'Arno* (Pl. 69). In 1870 Hunt also exhibited *Sunset at Chimalditi* (or, more properly, *Camaldoli*; Pl. 70). It is similar to the two Florentine watercolours, but is a view over the Bay of Naples.[64]

These panoramic vistas recall Hunt's Eastern watercolours of 1855. *Festa at Fiesole* is a plateau landscape, and its foreground, showing a uniformed band on the road to Fiesole,

is prominent enough to give the work its title and the subtitle of 'True Merit Overlooked'. However, except for the one onlooking and overlooked small boy, all the figures are squeezed into a corner and cut across by the frame. They are rather clumsily drawn, in contrast to the carefully delineated landscape beyond them, and when the work was exhibited they were criticised as 'bilious-looking' and 'little short of ridiculous'.[65] The foreground in *Sunset at Chimalditi* is limited to the tops of plants whose lower portions are cut off by the bottom of the picture. No actual ground is visible, but

69 William Holman Hunt, *Sunset in the Val d'Arno* 1868. Watercolour, 14 × 19³/₄. Johannesburg Art Gallery.

70 William Holman Hunt, *Sunset at Chimalditi* 1868. Watercolour, 14 × 20¹/₈. Present location unknown.

the plants establish that we are on a promontory. A tall thistle rising almost to the top of the picture on the right provides a *repoussoir* foil to the distant emptiness of the landscape below. Turner had painted several well-known pictures of the same vicinity, most notably *The Bay of Baiae, with Apollo and the Sybil* of 1823 and *The Golden Bough* of 1834 (both in the Tate Gallery),[66] in which he had progressively whittled away the foreground masses of trees of traditional Claudian compositions. In choosing to paint this hallowed terrain, Hunt must have been keenly aware of Turner's precedence, and his reduction of the foreground trees to a solitary weed seems like a conscious further step in this progression. In the third panoramic landscape, *Sunset in the Val d'Arno*, he eliminated all but a suggestion of immediate foreground. There remain only a wisp of smoke in the lower left corner and a small clump of foliage in the lower right; beyond, the picture consists entirely of the landscape far below our vantage-point. The composition does not seem the less successful for the loss of the foreground; however, this is the only one of Hunt's finished panoramic landscapes in which he dispensed so completely with foreground elaboration. In the others, he seems to have felt that something was necessary, no matter how extraneous it might be to the rest of the composition.

The topographical interest in these watercolours is more limited than in Hunt's Eastern views, and none stresses notable local features. In fact, Ruskin, who owned *Sunset at Chimalditi*, referred to it as 'sunset on the Egean' or as a Greek sunset.[67] The primary interest of all three is the sun. In *Festa at Fiesole* it is behind dark cypress trees, creating an incandescent burst of orange and red light and making the sky a patchwork of yellow and blue. In *Sunset in the Val d'Arno*, the sun is behind clouds and its beams fall on the valley. In *Sunset at Chimalditi* it is not behind anything, but is just above the horizon, surrounded by a dazzling halo of light.

When Hunt exhibited *Festa at Fiesole* and *Sunset at Chimalditi* in 1870, F. G. Stephens tried to explain the works:

> The aim, as we understand it, of the painter has been to render by means of painting two of those effects of light on the retina which, because of their extreme delicacy and marvellous difficulty, have not been attempted before; unless by Turner, with circumstances less favourable than those under which Mr. Hunt has worked, the appearance of intense radiance on the eye in looking at a landscape has not yet hitherto been successfully attempted.[68]

Stephens declared that Hunt had succeeded perfectly. The critic for the *Art Journal* was less enthusiastic, but perhaps more searching:

> The works he has here exhibited may be accounted as extraordinary phenomena both in Nature and Art, and yet as an earnest endeavour to paint what is unpaintable, this strange and startling attempt is not unworthy of respect. As a kind of kaleidoscopic arrangement of colour, this study of sky, earth, and water taken from a mountain top [*Sunset at Chimalditi*] is curiously interesting. But we do not regard the effect depicted as true to outward nature, it is rather the result of a frenzied vision; the eye when dazzled by effects of light sees colours which do not exist outwardly and physically, but only inwardly and within the mind's consciousness. It is an interesting question, not easy of solution, how far a painter is justified in throwing into his picture a poetic cast of thought, a frenzy of colour, which corresponds not to nature but to his individual idiosyncracies. Turner's practice must be taken as an argument that cuts both ways, and we cannot but consider that Holman Hunt falls into an extravagance which even in Turner is not excused. The *Sunset* before us wants the moderation of Art and the modesty of Nature.[69]

Despite approval on the one hand, and disapproval on the other, Stephens's 'effects of light on the retina' and the *Art Journal*'s 'eye when dazzled by effects of light' are not far apart. The latter's criticism of the extravagance of Hunt's colour recalls French criticism of *Strayed Sheep* in 1855.[70] In the period between *Strayed Sheep* and the Italian landscapes, Hunt's art became less ostensibly naturalistic. Whereas *Strayed Sheep* looked forward to Impressionism, *Sunset at Chimalditi* looks back to Turner. Both Stephens and the *Art Journal* mentioned Turner in discussing the watercolours, and it is noteworthy that Ruskin bought *Sunset at Chimalditi*, the only work by Hunt he ever owned. He placed it in the drawing school at Oxford, along with many of his Turners, and described it in a letter to Charles Eliot Norton as 'so true that everybody disbelieves its being true at all'.[71]

After 1869 Hunt never again painted landscapes with the same concentrated energy. The most ambitious of his later landscapes are two watercolours of Alpine scenes, which

71 William Holman Hunt, *London Bridge on the Night of the Marriage of the Prince and Princess of Wales* 1863. Oil on canvas, 25⅝ × 38⅝. Ashmolean Museum, Oxford.

he painted in 1875 and 1883. The first of these he exhibited at the Old Water-Colour Society in 1879 under the title *Study of Moonlight Effect from Berne Overlooking the River Nydeck to the Oberland Alps* (Rijksmuseum, Amsterdam). It has a plateau composition; two figures on a terrace in the foreground look out at the river valley and the moonlit fleecy clouds above. The other, *The Apple Harvest – Valley of the Rhine, Ragaz* (City Art Gallery, Birmingham), which Hunt exhibited in 1885, shows a mountain valley with peasants working in the foreground. The hour is midday, and the colours are bright in the sun, but the figures are clumsy and the painting seems heavy-handed. Still later watercolours are a large *Stratford-on-Avon*, signed and dated 1888 (Herbert Art Gallery, Coventry), a night scene, *The Square, Athens*, painted in 1892 and exhibited in 1893 (private collection), and a smaller twilight *Corfu*, which is signed and dated 1893 (private collection).[72]

In addition to Hunt's watercolour landscapes, many of his later paintings have extensive outdoor passages. The Holy Family in *The Triumph of the Innocents* (Walker Art Gallery, Liverpool) moves through a nocturnal landscape, and the ritual of *May Morning on Magdalen Tower* (Lady Lever Art Gallery, Port Sunlight) takes place before the streaming pink clouds of dawn. In 1863, the marriage of the Prince of Wales inspired Hunt to paint *London Bridge at Night* (Pl. 71), showing a rejoicing crowd streaming across the torchlit and banner-bedecked bridge. It is a curious response to the event, as there is no sign of the royal couple. Hunt was interested in the 'Hogarthian humour' of the scene and in recording a scene of contemporary history, in this instance the appearance of a London crowd.[73] He exhibited the picture at a commercial gallery the following year. A pamphlet published at the time[74] describing the picture and pointing out its numerous incidents – the apprehension of a thief, a soldier angry at a chimney sweep, etc. – emphasises the kind of anecdotal detail that had brought paintings such as *Derby Day* by William Powell Frith their great popular success. The picture is also Hunt's most ambitious night piece. The main light of the painting comes from flares and illuminations along the bridge, but their light is contrasted with the softer light of the moon in the upper left corner of the picture, a contrast reminiscent of the eighteenth-century nocturnal paintings of Joseph Wright of Derby. There are also reflections of the lights in the river, as well as wind and a London fog, all elements usually associated with mood and mystery, but here treated with factual literalness.

In the same years Hunt, instructing his sister in painting, began a picture of pigeons for her to finish. His sister apparently soon lost interest, and Hunt went on to finish the painting. It is signed and dated 66–75, but according to *Pre-Raphaelitism and the Pre-Raphaelite Brotherhood*, Hunt completed it in 1866.[75] He exhibited it at the Royal Academy in 1867 with the title *The Festival of St Swithin* (Pl. 72). Like *Strayed Sheep* and *The Scapegoat*, it is an animal painting in the tradition of Landseer, but there is a landscape below and beyond the pigeons in and about their dovecote, and, as the name implies, it is also a picture of rain.[76] Rain falls in sheets across the picture; it hits the roof of the dovecote and spatters in the air, and along the edges it collects and falls in drops.

72 William Holman Hunt, *The Festival of St Swithin* dated 1866–75. Oil on canvas, 28³/₄ × 35⁷/₈. Ashmolean Museum, Oxford.

For once in Hunt's painting there is palpable moisture in the atmosphere, and the scale of colour is subdued to a prevailing grey.

Hunt painted *The Ship* (Pl. 73) in Jerusalem in 1875 as an experiment with materials available to him there, as those he had sent from England had failed to arrive, but it was obviously undertaken as more than a technical exercise. Based on sketches he had made on the P. & O. ship coming to the Holy Land in the same year, the picture was intended by the artist to illustrate Tennyson's quatrain from 'In Memoriam':

> I hear the noise about thy keel,
> I hear the bell struck in the night,
> I see the cabin window bright,
> I see the sailor at the wheel!

73 William Holman Hunt, *The Ship* 1875. Oil on linen, 29¹/₂ × 38. Tate Gallery, London.

Consequently, it is a night scene, with the bright lights of cabin and deck and the red flame from the smoke stack contrasted with the moonlit sky. Painted at the same time that Whistler was painting his *Nocturnes* and exhibited in 1879 at the Grosvenor Gallery, where Whistler had attracted considerable attention, indeed notoriety, the picture, among other things, served to remind the gallery-going public of Hunt's long-standing, albeit very different, engagement with nocturnal subject matter. Packed with figures, animals, and incident, this depiction of night could hardly be less Whistlerian. *The Ship* is a strange and striking painting, which it is difficult to refrain from describing as eccentric, and it demonstrates once again that Hunt's literal vision was also an intensely personal one.

Outdoor Painting by other Members of the Pre-Raphaelite Circle

Among the original members of the Pre-Raphaelite Brotherhood, only Hunt and Millais displayed a strong interest in out-of-door painting. Thomas Woolner was a sculptor. William Michael Rossetti was not an artist at all, and Frederick George Stephens was one only briefly. Both Rossetti and Stephens became critics who were to remain loyal advocates and, eventually, historians of the movement. James Collinson, on the other hand, soon resigned from the Brotherhood and abandoned painting when he converted to Roman Catholicism and entered a Jesuit monastery. After leaving the monastery in 1854 he took up painting again, but he was no longer part of the Pre-Raphaelite group. A painting by Collinson of a mother and child in a landscape is in the Yale Center for British Art (Pl. 74). A label on the back gives his address as Queen's Road, Chelsea, which was the address listed for him in the Royal Academy catalogue of 1855, the first year Collinson exhibited following his monastic interlude. He could not have been there much before that spring, as a letter dated 4 June 1855, from William Michael Rossetti to Holman Hunt, who was then in the East, contained the announcement that Collinson had 'reappeared in the light of the sun', and that he was living with the painter Richard Burchett, another Catholic convert, whose address in 1855 was also recorded as 11 Queen's Road.[1] A master in the government school of art at South Kensington, Burchett painted one memorable landscape, *A Scene in the Isle of Wight* (Victoria and Albert Museum), which shows a view across Sandown Bay to Culver Cliff in the distance.[2] Collinson's painting has the same view in the background; so it seems likely that the two pictures were painted at the same time, on a joint trip while the artists were sharing lodgings. The treatment of detail in both works is daintily precise, but neither picture has Pre-Raphaelite brilliance or vibrancy. As Holman Hunt said about Collinson's earlier work, 'with form so lacking in nervousness as his, finish of detail is wasted labour.'[3]

Collinson was at best a minor artist, so whether a picture like this should be considered technically Pre-Raphaelite is an academic question. Other than Hunt and Millais, the only member of the original Brotherhood who made a significant contribution as a painter was Dante Gabriel Rossetti, and Rossetti's indifference to what Hunt considered the ruling principle of the movement was notorious. Rossetti painted his first picture as a Pre-Raphaelite, *The Girlhood of Mary Virgin* (Tate Gallery), while sharing a studio with Hunt, and in a naive way it does show some of the concern with natural detail that characterises the early works of Hunt and Millais. But while in Hunt's and Millais's painting the tentative naturalism of 1848 and 1849 led to much more ambitious treatment of nature in their pictures of the early 1850s, Rossetti moved in the opposite direction. *The Girlhood of Mary Virgin* includes a row of carefully painted leaves along the top and a bit of landscape out of the window, but Rossetti's painting of the following year, *Ecce Ancilla Domini!* (Tate Gallery) shows two figures in a bare room, with almost all traces of the outside world gone. He did make a few sporadic later attempts at painting outdoor scenes. In the autumn of 1850, when Hunt went to Knole Park to paint the background of *Valentine Rescuing Sylvia from Proteus*, Rossetti accompanied him so that he might also paint out of doors. Hunt described how he fared:

I ran up occasionally to see him, and found him nearly always engaged in a mortal quarrel with some particular leaf which would perversely shake about and get torn

74 James Collinson, *Mother and Daughter:
Culver Cliff, Isle of Wight, in the Distance*
c. 1855. Oil on panel, 20¾ × 16⅝. Yale Center
for British Art, New Haven.

off its branch when he was half way in its representation. Having been served thus
repeatedly, he would put up with no more such treatment, and left canvas, box, and
easel for the man to collect when at dusk the barrow came for my picture, he stalk-
ing back to the lodgings to write and to try designs.[4]

Rossetti's struggles with nature were for the background of a large picture, whose sub-
ject he originally planned to be 'Il Saluto di Beatrice'. It is worth noting that Rossetti,
who had no previous experience at all in painting landscape, began to work directly out
of doors on a large canvas; he did not begin by making smaller and more controllable
studies from nature. He soon left off, but he took up the canvas again in 1872 as *The
Bower Meadow* (Pl. 75), which has two women playing a lute and a zither in the fore-
ground and a pair of dancing figures behind them. The background, the product of his
outing of 1850, shows a screen of trees across the horizon and open meadow between
the trees and the figures. It is similar to the further background of Hunt's *Druids*, begun
in 1849 (Pl. 5), and to Hunt's small, related *Love at First Sight* (Pl. 47), which he began on
an earlier excursion with Rossetti. But the background trees form only a minor part of
The Bower Meadow, and in the foreground there is none of the leaf-by-leaf detail of the
foreground of the *Druids*.

For the background of his modern moral subject begun in 1853, *Found* (Delaware Art
Museum, Wilmington), Rossetti planned an extensive cityscape, including a view of
Blackfriar's Bridge at dawn. However, although his ambitions were high, they never
reached fruition, and he left the picture unfinished. Much of the background was evi-
dently painted by Edward Burne-Jones and by Henry Treffry Dunn, Rossetti's studio

assistant, after his death.[5] In November 1854 he worked on *Found* while staying with Ford Madox Brown at Finchley, and Brown described his struggle to paint a calf: 'he paints it in all like Albert Durer hair by hair & seems incapable of any breadth – but this he will get from going over it from feeling at home. From want of habit I see nature bothers him – but it is sweetly drawn & felt.'[6]

Nature never ceased to bother Rossetti, and after *Found*, he abandoned all attempts at naturalism. His forte was inventive design, and his finest achievements as a painter are his quaintly decorative watercolours from the 1850s. In these small works the settings are often highly elaborated, but they have little to do with natural appearances. One of the most beautiful of them, *The First Anniversary of the Death of Beatrice* (Ashmolean Museum, Oxford), does have as background a view of Florence seen through a window, which seems mainly a fanciful product of the artist's imagination. This watercolour was seen by Ruskin in April 1854, just when Effie was about to leave him, his friendship with Millais was floundering, and he was ready for a new protégé. On 10 April he wrote to Rossetti and praised it for unlikely, but for Ruskin characteristic, reasons:

> I think it a thoroughly glorious work – the most perfect piece of Italy, in the accessory parts, I have ever seen in my life – nor of Italy only – but of marvellous landscape painting. I might perhaps, if we were talking about it, venture to point out one or two things that appear to me questionable.[7]

This letter began a friendship between Ruskin and Rossetti which continued into the 1860s. At first, Ruskin nurtured a hope that his new friend would take some interest in

75 Dante Gabriel Rossetti, *The Bower Meadow* 1850–72. Oil on canvas, 33½ × 26½. Manchester City Art Gallery.

landscape, as we can see from a series of letters written by Ruskin to the artist in October 1855. The first asks, 'If I were to find funds could you be ready on Wednesday morning to take a run into Wales, and make me a sketch of some rocks in the bed of a stream, with trees above, mountain ashes, and so on, scarlet in autumn tints?' The second attempts to pacify Rossetti, who had apparently taken offence at the suggestion: 'I should never think of your sitting out to paint from Nature. Merely look at the place; make memoranda fast, work at home at the inn, and walk among the hills.' Finally, the series closes with Ruskin chastising Rossetti, who had been ready to take the money to go to Paris, but not to paint landscapes in Wales.[8] Ruskin also proposed that they visit Switzerland together in 1856, but the trip did not come to pass.[9]

Many of Rossetti's works of the 1850s and later do include landscape backgrounds. In 1858, to complete the watercolour *Writing on the Sand* (British Museum), he borrowed two sketches by George Price Boyce of the Devonshire coast.[10] In 1863 he was collecting stereoscopic photographs of cities to use for the background of *Helen of Troy* (Kunsthalle, Hamburg), and later his erstwhile assistant, Charles Fairfax Murray, provided him with both sketches and photographs from Italy to use for backgrounds.[11] What Rossetti studiously avoided after 1854 or 1855 was any direct exposure to the natural world.

Pre-Raphaelitism, as it was perceived by the public in the 1850s, was created by Millais and Hunt, rather than Rossetti, and the most obvious characteristic of the new style was the elaboration of natural detail. That by 1853 the movement was generally thought of as mainly concerned with close natural detail is demonstrated by a pair of small pictures of *Puck and the Moth*, which a painter named Edward Hopley exhibited at the British Institution in that year (Pls 76 and 77). These pictures, which, according to the *Art Journal*, were intended to contrast 'the spirit of pre-Raffaelism with that of post-Raffaelism',[12] are virtually identical in subject and in treatment of the figure. But, while in one the surroundings are murky and subordinate to the figure, in the other they are filled with microscopic plant life, and there is a charming landscape background across which chugs a diminutive train. In the same year Hopley wrote *A Letter on Pre- and Post-Raffaelism*, in which he argued that the moral of a picture must suffer when struggling against 'irresistible littleness and indubitable cobwebs and caterpillars'.[13]

The quintessential Pre-Raphaelite composition consists of a single figure or a simple group of figures before an ivy-covered wall or a foliate background. Millais established it in *Ferdinand Lured by Ariel* (Pl. 7), and he repeated it in his most popular paintings of the following years, the *Huguenot* (Pl. 35) and *The Proscribed Royalist*. *Ophelia* is essentially the same picture turned on its side (Pl. 10). The appeal of the arrangement lay in its simplicity and lack of the artificiality to which the Pre-Raphaelites objected in more ambitious compositions. The simplicity of the figural arrangement allowed the artist to devote that much more attention to the careful copying of the natural world. In the early 1850s for followers of the Pre-Raphaelites, as for Millais, nature generally consisted of detail seen at close range. In the middle of the 1850s Millais's backgrounds opened out into more extensive views in *Autumn Leaves* and *The Blind Girl*, and a comparable opening out followed in the painting of other artists of the group.

Apart from Ford Madox Brown, the first close associate of the Pre-Raphaelite Brotherhood was Charles Allston Collins, who shared the critical vicissitudes of Hunt and Millais as early as 1850. His art is usually dependent on that of Millais, and his best-known picture, *Convent Thoughts* (Pl. 9), reflects the composition of Millais's *Ferdinand Lured by Ariel*, which had been exhibited a year earlier. Collins's technical abilities were limited, and all his figures have a stiffness which gives his paintings a look of amateurish awkwardness. Nevertheless, he was responsible for one of the first Pre-Raphaelite landscape paintings to be completed and exhibited: *May, in the Regent's Park*, signed and dated 1851 and shown at the Royal Academy in 1852 (Pl. 78). It is a view from an upstairs window at 17 Hanover Terrace, overlooking the Park, where the Collins family lived, and, as such, it prefigured Ford Madox Brown's view out of a window, *An English Autumn Afternoon* (Pl. 23), commenced in October 1852. Collins's title evidently refers both to the month and to the hawthorn, or May, tree in blossom in the left foreground.[14] The picture shows a part of the contemporary London in which the artist lived, and, thus, it might seem to anticipate not only Brown but also the French Impressionists' engagement with modern Paris, and indeed a few Impressionist pictures of London, such as paintings of Hyde Park and Green Park by Monet (Rhode Island School of Design and Philadelphia Museum of Art), but in the mid-nineteenth century there was nothing particularly modern in painting urban views, nor in painting

parks. What is perhaps most remarkable about the subject is how signs of a modern Victorian city are conspicuously absent. In place of buildings, traffic, and crowds, we see only two diminutive figures strolling on the Outer Circle in a setting that is otherwise positively bucolic, complete with grazing sheep. There is none of the intimacy with the place that we find in Brown's landscapes. The vantage point is elevated and from outside the park proper, looking over a private garden containing the May and other planting in the foreground. Nevertheless, everything, near and far, is depicted with minute precision. One reviewer suggested that the view was seen through an eyeglass.[15] The *Art Journal* characterised the picture as, 'certainly among the most eccentric of the curiosities of landscape painting',[16] but went on to say that it was exquisitely painted. Although Millais had not painted anything comparable, the *Athenaeum* accused Collins of exaggerating Millais's mannerisms, an appropriate criticism regarding most of Collins's other works. It then went on:

> The botanical predominates altogether over the artistical, – and to a vicious and mistaken extreme. In nature there is air as well as earth, – she masses and generalizes where these facsimile makers split hairs and particularize. They take a branch, a flower, a blade of grass, place it close before them and as closely copy it, – forgetting that these objects, at the distance imagined in the picture, could by no means be seen with such *hortus siccus* minuteness.[17]

While the objection to painting distant objects with *hortus siccus* minuteness was only relevant to Collins's picture among the Pre-Raphaelite works on view in 1852, it anticipated many similar criticisms of Pre-Raphaelite landscapes made in subsequent years, and the attack on 'facsimile makers' was directed at Pre-Raphaelitism in general, rather than specifically at Collins.

76 Edward Hopley, *Puck and the Moth* exhibited 1853. Oil on board, 10⅛ × 6¼. Private Collection.

77 Edward Hopley, *Puck and the Moth* exhibited 1853. Oil on board, 10⅛ × 6¼. Private Collection.

78 Charles Allston Collins, *May, in the Regent's Park* 1851. Oil on panel, 17½ × 27⁵⁄₁₆. Tate Gallery, London.

May, in the Regent's Park appears to have been Collins's most venturesome attempt at an outdoor subject. Painted, or begun, in the spring of 1851, it preceded *The Hireling Shepherd* and *Ophelia*, and, as a pure landscape, it stands apart from them. Collins was with Hunt and Millais when they were at Ewell painting the backgrounds of these pictures in the summer and autumn of 1851. He began there a picture of the Nativity with an elaborate background of 'chestnut foliage and arboreal richness'. This Nativity evolved into a scene of more modern charity, showing a French woman bringing a cloak to a poor family in a shed. It was exhibited at the Royal Academy in 1854 as 'A Thought of Bethlehem', but Collins seems to have subsequently reworked or partly effaced it, and it may eventually have been destroyed. In 1873, Holman Hunt found the background painted at Ewell, removed from the stretcher, lying on Collins's deathbed.[18] Collins's last picture to appear at the Royal Academy was *The Good Harvest of 1854*, which he exhibited in 1855 (Pl. 79). It shows a continuing dependence upon Millais; the background of ivy on a brick wall comes straight from the *Huguenot*. In 1857 he exhibited works at Liverpool and in the Pre-Raphaelite exhibition in Russell Place, but he soon after gave up painting for writing.

Another associate of the Pre-Raphaelites, whose painting career was even shorter than Collins's, was Walter Howell Deverell, whose early death in 1854 cut off what was certainly a more promising talent. Deverell's *Scene from 'The Twelfth Night'*, of 1850 (Forbes Magazine Collection), is a complex figural composition reminiscent of Millais's *Isabella*. A *Scene from 'As You Like It'*, exhibited at the Royal Academy in 1853 (City Art Gallery, Birmingham), is compositionally simpler, showing three figures before a wooded background. Deverell painted the picture while sharing a studio with Rossetti in Red Lion Square, and he painted the Forest of Arden 'from the dusty foliage of that dingy precinct'.[19] More interesting as outdoor paintings are *The Irish Vagrants* (Johannesburg Art Gallery) and *The Pet* (Tate Gallery). The former, which Deverell left unfinished at his death, has an extensive background of rolling fields and rows of cornshocks. *The Pet* of 1852–3 shows a woman with a birdcage in the doorway of a conservatory, and a garden beyond. Its compositional simplicity is accompanied by a breadth of handling that differs considerably from the carefully copied detail in most Pre-Raphaelite pictures of this early date. John Gere pointed out that Deverell's breadth is combined with a lack of

didactic or narrative purpose, and he suggested that Deverell, had he lived, might have succeeded, where Millais failed, in achieving a breadth of form without a diminution of the quality of his painting.[20]

Deverell and Collins were both close to the early history of the Pre-Raphaelite Brotherhood, and both were considered for membership in the Brotherhood. In actual output, however, neither compares in importance with Arthur Hughes, whose best works rank alongside those of Millais, Hunt, and Brown. The appeal of Hughes's art stems largely from its delicate sentiment. He could not be considered a bold explorer of the natural world, as in their various ways were Millais, Hunt, and Brown, but landscape settings do play a major role in most of his painting.

Hughes was converted to Pre-Raphaelitism by reading *The Germ* in 1850. His first work of note was an *Ophelia*, which he exhibited at the Royal Academy in 1852 (Pl. 80). That was the year that Millais exhibited his *Ophelia*, but apparently Hughes, although he had previously met Hunt and Rossetti, did not meet Millais until varnishing day at the Academy in 1852 and knew nothing of Millais's picture. His painting differs from Millais's both in the moment depicted and in general style. Ophelia sits at the edge of the water, shedding flowers into the brook. In the immediate foreground the plants in and along the edge of the water are precisely delineated, but the rest of the painting dissolves into un-Pre-Raphaelite vagueness, which suggests a deep space quite unlike that of Millais. Colour is not tied to descriptive detail as in the Millais, but is itself evocative of mood. The sky is deep green above, and the haze over the horizon is a murky purple. The foreground colours are darker than the brilliant ones achieved by Millais using a wet white ground. The water is almost black, while the lighter greens of the grass-covered shore, the orange and green of the scum, and the orange rock with purple lichens to the right of the girl create a patterned effect against it.

Hughes was twenty years old in 1852. The modelling of the figure of Ophelia is still reminiscent of the life class and shows evident *pentimenti*. Nonetheless, the haunting quality of the landscape is effective, and its atmosphere and space suggest the possibility of Hughes's art developing along other lines than those of Millais's exclusively botanical scrutiny. Indeed, Hughes's *Ophelia* anticipates Millais's later effort to gain

79 Charles Allston Collins, *The Good Harvest of 1854* exhibited 1855. Oil on canvas, 17^1/$_4$ × 13^3/$_4$. Victoria and Albert Museum, London.

80 Arthur Hughes, *Ophelia* exhibited 1852. Oil on canvas, 27 × 48¾. Manchester City Art Gallery.

breadth and mood in his *Autumn Leaves* of 1856. Nonetheless, when Hughes met Millais in 1852 he fell heavily under his sway. Several of his pictures from the 1850s – *April Love* (Tate Gallery), *The Long Engagement* (Pl. 81), *Fair Rosamund* (National Gallery of Victoria, Melbourne) – follow the pattern set by Millais in *Ferdinand Lured by Ariel* and the *Huguenot*. The background of *April Love* was painted in 1855 in the open air in the garden of a Mr Cutbush at Maidstone.[21] Hughes began *The Long Engagement* in 1853 as a picture of Orlando in the Forest of Arden, painting the background from nature with Pre-Raphaelite care. In August 1854 he wrote to William Allingham describing the difficulties:

> Painting wild roses into Orlando has been a kind of match against time with me, they passing away so soon, like all lovely things *under* the sun (eh?) and as sensitive as beautiful. The least hint of rain, just a dark cloud passing over, closes them up for the rest of the day perhaps. One day a great bee exasperated me to the pitch of madness by persisting in attacking me, the perspiration pouring down my face in three streams the while – and another I had to remain for three hours under a great beech tree with roots all unearthed, and years upon years of dead leaves under his shade, listening to the rain plashings.[22]

In 1855 Hughes submitted the picture to the Royal Academy, where it was rejected. He then repainted it, replacing Orlando with a pair of ageing Victorian lovers, and exhibited it at the Royal Academy in 1859 with a quotation from Chaucer:

> For how myght sweetness ever hav be known
> To hym that never tastyd bitternesse.

The painting, begun in 1853, abandons the style of Hughes's own *Ophelia*, exhibited in 1852, to emulate that of Millais's. The drawing and colouring of every leaf and blossom are clear, separate, and precise (see detail, p. 102). There is no spatial depth; the background is entirely filled with foliage pressing upon the figures, and the bright colours bring each detail forward to the surface. The figures do not stand out from their setting; everything is of equal value, and the couple only emerges as part of an overall surface pattern. When compared to Millais, Hughes seems even more rigid in avoiding any suggestion of depth and more consistent in the treatment of the picture's surface. We feel the forms taken in pictures such as Millais's *Ophelia* were the result of the artist's peculiar approach to recording natural phenomena, but in Hughes's picture they are the product of a deliberate denial of traditional pictorial space, which had become part of a

81 (facing page) Arthur Hughes, *The Long Engagement* 1853–9. Oil on canvas, 41½ × 20½. Birmingham Museum and Art Gallery.

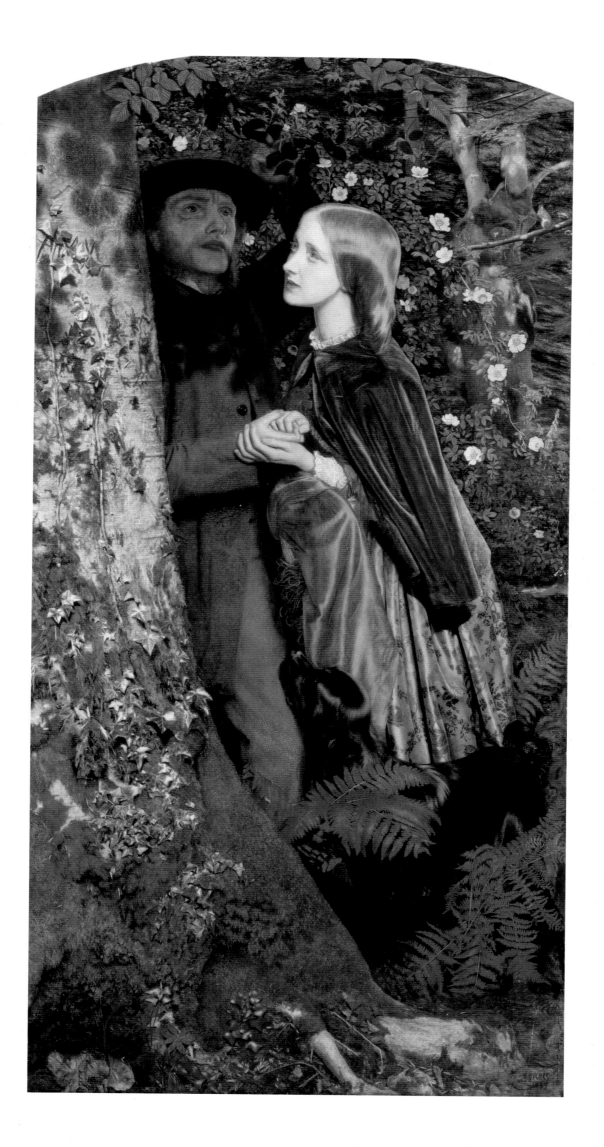

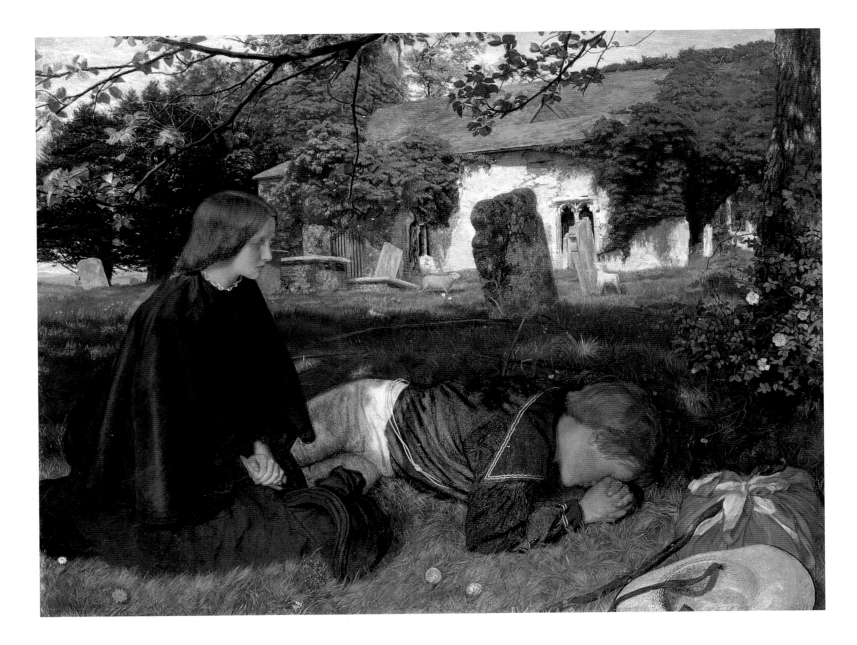

recognisable Pre-Raphaelite manner. As the critic for the *Art Journal* wrote, 'This is a professedly "Pre-Raffaelite" work, with everything in it rushing out of the frame, and introducing as much of the crudity of the manner as can be shown on a limited field.'[23] Nevertheless, the foliate and floral surroundings give the picture its meaning. The subject is the long engagement, and our awareness of nature growing, blossoming, and reproducing itself heightens the poignancy of the sterility of the two protagonists.

In his pictures exhibited in 1856 Millais introduced a new breadth of space and of effect. Hughes followed him in *Home from Sea*, which he began in the summer of 1856 (Pl. 82). This painting also has a complicated history. It is signed and dated 1862, and Hughes exhibited it at the Royal Academy in 1863; however, in main lines it dates from 1856 and 1857. Hughes painted the background from nature during the summer of 1856 in the churchyard at Chingford, Essex, and added the figure of the boy crying on the grave in the spring of 1857. He exhibited the picture in the summer of 1857 as *A Mother's Grave* at the Pre-Raphaelite exhibition in Russell Place, and later in the same year in America as *Home from Sea – The Mother's Grave*. The figure of the boy's sister was added later, probably in 1862, the date on the picture.[24] Thus, once again, the background came first. It is still highly detailed, still, by landscape standards, a close study of a circumscribed area. But, in contrast to *The Long Engagement*, whose background dates from 1854, *Home from Sea* does reveal an attempt to establish space within the picture. There is a ground plane which recedes to the church at a recognisable distance behind the figures. Foreground details such as flowers on the trunk of the tree to the right and branches above the figures are carefully finished, but they do not fill the picture, and, consequently are not as obtrusive as the foliate detail in *The Long Engagement*. In some respects – shape, placement of figures, intensity of greens, sheep in the background – *Home from Sea* recalls Holman Hunt's *Hireling Shepherd*. Nevertheless, if we recall the dependence of Hughes's

earlier paintings upon Millais, it is probably correct to see his new-found spaciousness as part of the same pattern, in this instance depending more upon *The Blind Girl* than upon *Autumn Leaves*.

A drawing of the composition of *Home from Sea*, as it originally existed, without the sister, is in the Ashmolean Museum. The attitude of the boy lying on the ground in grief has been traced back to the frontispiece of the first issue of *The Germ*: an etched illustration by Holman Hunt to Thomas Woolner's poem 'Of My Lady in Death'. But it has also been noted that Hughes himself had painted a picture of a figure lying in a landscape possibly as early as 1849 (Pl. 83).[25] Comparison of that work, *The Young Poet*, with *Home from Sea* shows not only the greater detail in Hughes's work after he came into the Pre-Raphaelite sphere of influence, but also changed spatial relationships. The ground upon which his earlier poet lies appears to recede continuously from the bottom edge of the picture to the horizon, which is just above the figure's head but at an indeterminate distance in space. In *Home from Sea* the immediate foreground, upon which the boy lies, slopes upward; above him, at about the middle of the picture, the angle of vision changes, and we look across a horizontally receding plane to the old church and surrounding trees, which reach almost to the top of the painting. The figures and their surroundings are pushed forward to the surface of the painting instead of being in its space, as is the poet, and there is little feeling of depth in the background behind them. The abrupt horizontal recession across the churchyard creates a space that we can recognise because of the relative scale of things, but, in effect, the background, like that of Millais's *Blind Girl*, goes up more than it goes back, and the whole composition crowds toward the surface. Originally, the composition must have broken into two distinct halves across the middle of the picture. Hughes may have added the upright figure of the girl to please a client, but she also links the upper and lower halves of the painting.

The Young Poet recalls traditional imagery of the melancholy poet, as it appears, for example, in the well-known portrait of Brooke Boothby by Joseph Wright of Derby in the Tate Gallery. After 1856 Hughes painted several further pictures of figures lying out of doors on the ground. They include *The Woodman's Child* of 1860 (Tate Gallery), *The Rift within the Lute*, which Hughes exhibited at the Royal Academy in 1862 and which has melancholy as its subject (City Art Gallery, Carlisle), and the later *Compleat Angler* of *c.* 1884, which shows a girl lying by a stream, reading a book (private collection). In a second, smaller version of *The Rift within the Lute*, titled *Enid and Geraint* (private collection), which was bought by the same patron who bought *Home from Sea*, Hughes also added an upright figure, to similar effect.[26]

The Woodman's Child shows a small girl sleeping in the foreground while her parents are tiny figures at work in another sharply receding background. The picture has no evident connection with Millais's earlier *Woodman's Daughter*, or with Coventry Patmore's poem on which the Millais was based. *The Rift within the Lute* was exhibited with lines from Tennyson's *Idylls of the King*, but it does not appear to be a specific illustration; in its background are a small hunter and a hound. The second version, with Geraint added, is more obviously Arthurian, or Tennysonian. Both *The Woodman's Child* and *The Rift within the Lute* have forest settings, and the natural details, including in the former a squirrel and a bird watching the sleeping child. In different ways both works are about being close to nature, and natural detail is more prominent in them than in *Home from Sea*.

Another group of works by Hughes from around 1860 have sunsets in their backgrounds. The most ambitious of them is *The Knight of the Sun* of 1859–60 (Pl. 84), which shows a dying knight being carried through a forest while the sun sets in the distance. In 1893 Hughes wrote that a 'study of the sky reflecting river seen thro' a wild cherry tree autumn turned' gave him the idea for the subject,[27] but the effect of the sunset reflected in a river was also preceded by Henry Wallis's *Stonebreaker* exhibited in 1858 (Pl. 85), and behind both pictures lay the sunsets in Millais's *Autumn Leaves* and *Sir Isumbras*, exhibited in 1856 and 1857. The forest setting, like the settings of *The Woodman's Child* and *The Rift within the Lute*, is painted with painstaking attention to detail. Although Hughes was obviously influenced by Millais in other ways, he did not quite so readily abandon Pre-Raphaelite detail. The details in *The Knight of the Sun*, however, no longer have the brilliant pitch of colour of those in *The Long Engagement*. They are subdued because it is twilight, and to allow the sunset to glow more effectively without undue competition. By subordinating his foreground colours, Hughes did exactly what early critics of the Pre-Raphaelites claimed they were incapable of: he made the whole more important than the parts. But in doing so, Hughes also sacrificed

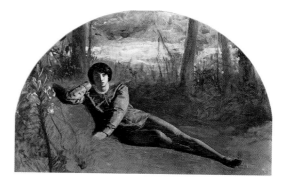

83 Arthur Hughes, *The Young Poet c.* 1849. Oil on canvas, 25 × 36. Birmingham Museum and Art Gallery.

84 Arthur Hughes, *The Knight of the Sun*
1860. Oil on canvas, 40 × 52³/₁₆. Collection of
Lord Lloyd Webber.

the vibrancy of a picture like *The Long Engagement*, in which every leaf and petal is alive
with a life of its own. Robert Ross wrote that Hughes's earlier works were 'like some
brilliant Easter morning in a radiant spring'.[28] Alas, Hughes's spring lasted for only a few
years. He may have tried to retain it, but the twilight of *The Knight of the Sun* marks a
drawing back to a more conventional vision. Hughes continued to paint pictures with
outdoor settings – and occasional pure landscapes – through the rest of his long life.
Many still follow Pre-Raphaelite prototypes from the 1850s. For example, a portrait of
a boy dated 1868 (private collection) shows yet another brick wall descended from
Millais's *Huguenot*.[29] Other late works are less obviously Pre-Raphaelite. *The Potter's
Courtship*, exhibited at the Royal Academy in 1886 (Laing Art Gallery, Newcastle upon
Tyne), has a blue Mediterranean background which is closer to Alma-Tadema than to
Pre-Raphaelite pictures. But, whatever the stylistic connections, Hughes's later art is not
very interesting. As John Gere has written, it does not even have 'the positive quality of
vulgarity', which distinguishes the later works of Millais.[30]

By the middle of the 1850s, Pre-Raphaelitism was no longer simply a matter
of Hunt, Millais, Rossetti, and a few close friends, but had achieved a widely felt influ-
ence in English painting. In the introduction to his *Academy Notes* of 1856, Ruskin
announced that the Pre-Raphaelites had 'completely and confessedly' won the battle:
'animosity has changed into emulation, astonishment into sympathy, and . . . a true and
consistent school of art is at last established in the Royal Academy of England.'[31]
Ironically, by 1856 Millais's style was beginning to show change, and in the following
year Ruskin would lament his disastrous decline. Millais's art was the model for most
Pre-Raphaelite imitators, and most of them followed him into mediocrity. The Pre-
Raphaelite Renaissance, as defined and so jubilantly hailed by Ruskin in 1856, was by
1860 largely a thing of the past. And by that year, Ruskin had ceased publishing his

Academy Notes. Nonetheless, in the years 1856–9 enough good and occasionally memorable pictures were exhibited by artists who had lately come to the Pre-Raphaelite fold, and who for the most part would soon desert it, to justify Ruskin's claims about a school. Two of those artists were Henry Wallis and William Shakespeare Burton.

Although Wallis's education included not only the usual study at the Royal Academy schools, but also a period spent in Paris at the Ecole des Beaux-Arts and the studio of Charles Gleyre, whatever French influence there may have been upon his art is less apparent than that of Pre-Raphaelitism. He first exhibited at the Royal Academy in 1854, and he created a sensation in 1856 with *The Death of Chatterton* (Tate Gallery), which Ruskin called, 'faultless and wonderful: a most noble example of the great school'. Two years later Wallis exhibited a picture of a dead stonebreaker with a quotation from *Sartor Resartus* by Thomas Carlyle for a title (Pl. 85), which Ruskin declared the picture of the year, 'and but narrowly missing being a first rate of any year'.[32]

The Death of Chatterton is an interior scene, with only a view over the London skyline though a garret window, but the other picture is an outdoor painting and a remarkable one. The stonebreaker lies dead upon his litter of rocks at sunset. Behind him are a fern-covered bank, a river in a valley below, and hills beyond. In a sense, the picture follows the Pre-Raphaelite pattern of the single figure in an elaborate and brightly coloured environment, but the extensive background and sunset effect reflect the later development of Pre-Raphaelitism in Millais's *Autumn Leaves*. Some details such as the leaves above the horizon are minutely and separately painted, but in the larger mass of the bank behind the dead man, the minutely drawn foliate detail of Hunt, Millais, or Hughes is absent. Throughout the foreground Wallis's colours have an extremely high

85 Henry Wallis, *The Stonebreaker* exhibited 1858. Oil on panel, 25³/₄ × 31. Birmingham Museum and Art Gallery.

key. They are thinly painted over a white ground, and the effect is dazzling. As there is relatively little detail – simply areas of green and red, suggesting patches of grass and earth – the foreground comes to the surface primarily as abstract colour. Individual details such as a rodent at the dead worker's foot, and even the stonebreaker himself, do not stand out, but are absorbed as part of the whole. The figure is painted in earthier colours than his setting. Nature glows vibrantly, but the dead man recedes into the landscape and becomes the quieter in death.

In *Academy Notes* Ruskin wrote that Wallis's foreground seemed somewhat hastily painted, but he forgave it as the colours were beautiful and it would have been in false taste to elaborate the subject further. He was more critical of the distance, which suffered from 'a too heavy laying of the body of paint'. The blue of the hills was 'too uniform and dead', and the sky above them had 'no joy nor clearness when it is looked into'. Although joy is possibly the last quality we would expect to find in a painting of such a gloomy subject, it is possible to see what Ruskin meant. In treatment of both foreground and background, Wallis seems to have adopted Pre-Raphaelite effects of colour without basing them on the scrupulously detailed observation of earlier Pre-Raphaelitism. But, although Ruskin partially disapproved, Wallis was remarkably successful in retaining the vibrancy of early Pre-Raphaelite colour and handling while incorporating them into a broader effect.

Unfortunately, much of Wallis's *œuvre* has disappeared, and of his other known works only *The Death of Chatterton* is of comparable quality or interest. A small oil sketch dated 1859, of a coastline (Walker Art Gallery, Liverpool), also shows a twilight subject, but the handling is heavier and broader than that in *The Stonebreaker*. Personally, Wallis seems to have been on the periphery of the Pre-Raphaelite group. In 1854 Rossetti wrote in reply to a query by the collector Francis McCracken that he had only seen one picture by Wallis and that he considered it inferior to a picture of high merit such as Deverell's *Irish Vagrants*.[33] In 1857 Wallis did not participate in the Pre-Raphaelite exhibition held at Russell Place, but he did later belong to the Hogarth Club, whose membership consisted of the Pre-Raphaelite group and some associates. In 1858 he ran off with George Meredith's wife. He travelled extensively in later years and became an expert on ceramics. He also worked in watercolour and was elected an associate member of the Old Water-Colour Society in 1878 and a full member two years later.[34]

William Shakespeare Burton was another member of the Hogarth Club, who seems otherwise to have had only slight personal contact with the Pre-Raphaelite group. In 1856 he exhibited *The Cavalier and the Puritan* at the Royal Academy (Pl. 86). The picture was not included in the first edition of the exhibition catalogue, but it was well hung. Ruskin found the subject not very intelligible, but the painting masterly, and the painter 'capable of the greatest things'.[35] The picture is a costume piece set in the seventeenth century, in subject very like Millais's *Proscribed Royalist*, and the elaborately and minutely detailed setting seems to depend upon Millais's example. In good Pre-Raphaelite fashion Burton worked directly from nature and was reported to have had a hole dug for himself and his easel to enable him to study closely the brambles and ferns in the foreground.[36] According to F. G. Stephens, 'After this supreme effort of his art had failed to secure that honour it merited the painter lived an almost embittered man.'[37] The artist disappeared so completely from sight that Stephens, writing in 1886, thought that he had long been dead, though in fact he lived until 1916 and in later years painted pictures of religious subjects.

Equally obscure is William J. Webbe, whose works from 1854 and the following few years show Pre-Raphaelite elaboration of microscopic foreground foliage pushed to an almost insane extreme. *A Hedge Bank in May*, dated 1854 and exhibited at the British Institution in 1855 (private collection),[38] is like a magnified detail from Holman Hunt's *Strayed Sheep*, exhibited in 1853, upon which it obviously depends. In a roundel eleven inches in diameter, the heads of two sheep loom over a tangle of flowers and foliage, through which a snake slithers. Just visible, cut off by the frame at the top of the picture, are the four tiny feet of another sheep or lamb. *After Sunset*, dated 1855 and exhibited at the Society of British Artists in 1856 (Pl. 87), shows a rabbit in the midst of a similar jumble of leaves and flowers in another round, but slightly larger composition. In both pictures the technique is drier and more linear than Hunt's, and nature is seen in still-life detail, as in the closely focussed studies of birds' nests painted in watercolours by William Henry Hunt, who was probably as much a model for Webbe as Holman Hunt. There are also striking resemblances between Webbe's pictures and roughly contemporary photographs of similar subjects taken by John Dillwyn

Llewelyn.[39] His earlier paintings generally depict animals, although their titles do not always indicate it. What he evidently saw as his masterpiece was *The White Owl* (private collection), which he showed at the Royal Academy in 1856, where it was applauded by Ruskin,[40] and again in the International Exhibition of 1862. That picture is strictly an animal painting, with the owl seen against a black background rather than the foliate surroundings which demand our attention in *A Hedgebank in May* and *After Sunset*.

In 1857 two paintings by Webbe were included in the exhibition of mainly Pre-Raphaelite pictures sent to America. In a letter briefly identifying the participants, William Michael Rossetti described his works as 'Good typical specimens of that class of Praeraffaelitism which confines itself to representation without invention of subject'.[41] Despite that cool endorsement, one of Webbe's pictures, *Twilight*, quite probably identifiable as the *After Sunset* of 1855 (Pl. 87), was one of the star works of the exhibition. Ruskin's American friend Charles Eliot Norton declared that it should not be allowed to return to England, and a group of Boston ladies proposed joining together to buy it.[42]

From 1855 through 1860 Webbe lived on the Isle of Wight, and in addition to pictures of animals he also exhibited a few landscapes. In 1862 he travelled to the Holy Land, and all his subsequent exhibited works in the 1860s were of Eastern subjects. *The Lost Sheep* of 1864 (Pl. 88) shows another subject dependent on Holman Hunt's pastoral imagery, and the landscape seems equally to show his influence. A shepherd carries a sheep before mountains of pink and blue and a sky of green, while the spiky weeds in

86 William Shakespeare Burton, *The Cavalier and the Puritan* exhibited 1856. Oil on canvas, 36 × 41. Guildhall Art Gallery, Corporation of London.

87 William J. Webbe, *After Sunset* 1855. Oil on canvas, 14 in diameter. Museum of Fine Arts, Boston.

88 William J. Webbe, *The Lost Sheep* 1864. Oil on panel, 13 × 10. Manchester City Art Gallery.

the foreground, pink and violet, could have grown from seeds fallen from those in *The Light of the World*. Despite Webbe's loyal emulation of Hunt, he is not mentioned in *Pre-Raphaelitism and the Pre-Raphaelite Brotherhood*, but the first volume reproduces a drawing of *The Church of the Sepulchre* apparently by Webbe (it is captioned 'Webb'),[43] so the two artists may have had some personal contact.

In Scotland, the impact of Pre-Raphaelitism can be seen most evidently in the work of Jospeh Noel Paton. Born in 1821, the same year as Ford Madox Brown, Paton was older than the members of the Pre-Raphaelite Brotherhood, and he was a successful artist before they had formed their group. He competed in the competitions for the Houses of Parliament and won prizes in 1845 and 1847. His successful picture of the latter year, *The Reconciliation of Oberon and Titania* (National Gallery of Scotland, Edinburgh), was bought by the Royal Scottish Academy in 1848. The subject is an imaginary fairyland, which is teeming with tiny figures drawn in minute and highly finished detail. On the basis of its success and that of a sequel of 1849, *The Quarrel of Oberon and Titania* (National Gallery of Scotland), Paton was elected an associate member of the Royal Scottish Academy in 1847 and a full member in 1850.

In the 1850s Paton incorporated Pre-Raphaelite close observation of nature into his already laborious style. The best example is *The Bluidie Tryste* of 1855 (Pl. 89), which clearly shows the influence of Millais, specifically of *The Proscribed Royalist*. The waterfall in the foreground is reminiscent of Millais's waterfall in his portrait of Ruskin. Paton and Millais had been friends since 1843, when they were students in the Royal Academy schools together. Paton could have seen the *Portrait of Ruskin* in Millais's studio, and they may have had some contact when Millais was in Scotland working on the picture, as well as from 1855 onwards when Millais lived in Scotland. In August 1853, Ruskin wrote to his father from Glenfinlas mentioning Paton as one of the Scottish artists looking forward to his forthcoming Edinburgh lectures.[44]

Paton exhibited *The Bluidie Tryste* at the Royal Academy in 1858. Ruskin gave it a mixed review; he disliked the gloomy subject and the lack of subtlety in the colour, but he praised the draughtsmanship and Paton's intense care in treating what mattered most to Ruskin: 'There is more natural history in it than in most others in the rooms; the little pinguicula alpina on the left, the oxalis leaves in the middle, the red ferns, and small red viper on the right, are all exquisitely articulated as far as form goes.'[45]

Ruskin declared that Paton's minute execution proved him capable of all perfection, despite the weakness of colour. However, *The Bluidie Tryste* seems to have been Paton's supreme attempt at this kind of Pre-Raphaelite botanic scrutiny. *Hesperus, the Evening Star, Sacred to Lovers* of 1857 (Museum and Art Gallery, Glasgow), which Paton exhibited at the Royal Academy in 1860, has an outdoor setting, but shows much less natural detail, owing to the evening light.

Noel Paton's younger brother, Waller Hugh Paton, painted brightly coloured and highly detailed landscapes which have been called Pre-Raphaelite. He seems to have had no direct connection with the artists in London, but in 1858 Ruskin wrote a letter to the *Witness* in Edinburgh defending one of his pictures, *The Mouth of Wild Waters, Inveruglas* (Pl. 90), against criticism made in the *Scotsman*.[46] A notebook kept by the artist records that he painted it between 18 June and 19 August 1857, entirely on the spot, although he 'glazed and softened it a little' in 1861, and that, while he painted it, Noel was at work close by.[47] Inveruglas Water flows into Loch Lomond in the Highlands. Noel made several watercolors at Inveruglas while the two brothers worked together, and at least one of them, dated 21 August 1857, shows a view much like that in Waller's painting.[48] Both brothers evidently aimed to paint dramatic Highland scenery in close Pre-Raphaelite detail, with somewhat theatrical results. Waller Paton's later painting consisted mainly of more conventional views of Scottish scenery, without any pronounced Pre-Raphaelite quality.

Another older artist of Scottish origin was William Bell Scott. He was born in 1811, and hence was a mature artist by the time Pre-Raphaelitism came into being. He was also a poet, and his connection with the Pre-Raphaelites stemmed from Rossetti's admiration for his poetry. From 1843 until 1864 Scott was master of the government school of design in Newcastle; so, although he became a close friend of Rossetti and other members of the group, sheer physical distance kept him apart.

Scott's best-known works are a series of scenes from the history of Northumberland, which he painted for the central hall at Wallington Hall, near Newcastle. These occupied him from 1856 until 1861. The subjects range in time from the Roman occupation of Britain to the nineteenth century. Several of them have extensive landscape backgrounds,

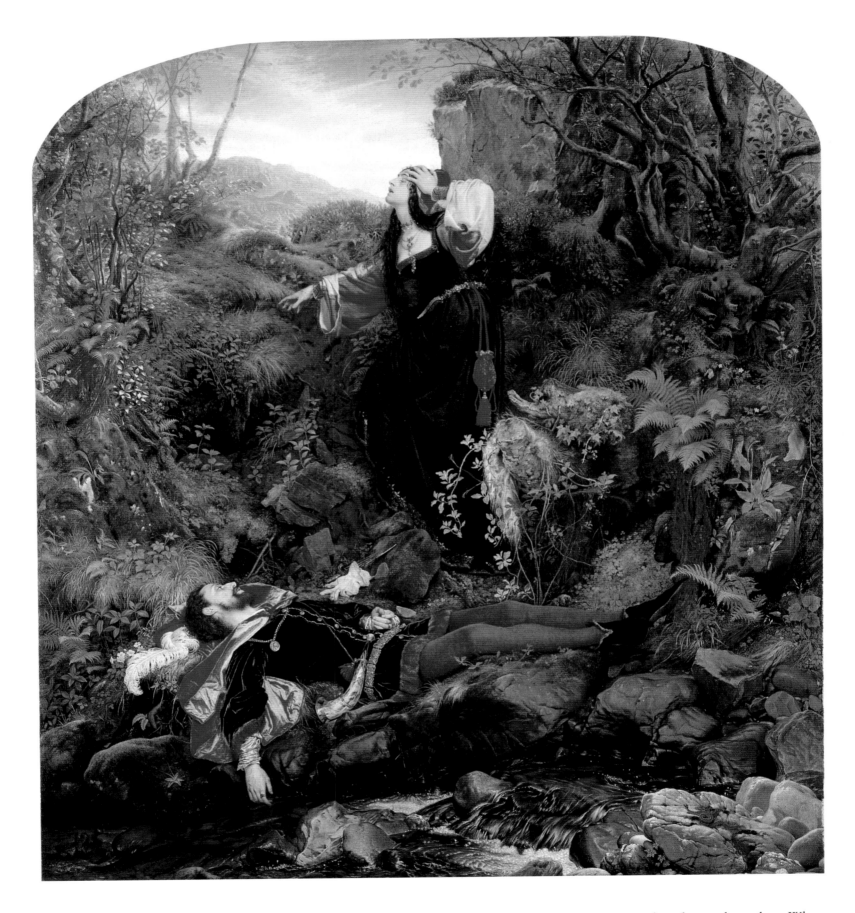

89 Joseph Noel Paton, *The Bluidie Tryste* 1855. Oil on canvas, 28¾ × 25⅝. Glasgow Art Gallery and Museum.

which show the places where the events were supposed to have taken place. When Rossetti saw a photograph of the first of the paintings, *St Cuthbert*, he wrote to Scott in February 1857 to praise it:

> I suppose it is the only picture existing as yet of so definitely 'historical' a class, in which the surroundings are real studies from nature; a great thing to have done . . . The whole scene too, and the quiet way in which the incident is occurring, at once strike the spectator with the immense advantage of simple truth in historical art over the 'monumental' style.[49]

OUTDOOR PAINTING BY OTHER MEMBERS OF THE PRE-RAPHAELITE CIRCLE

90 Waller Hugh Paton, *The Mouth of Wild Waters, Inveruglas* 1857. Oil on canvas, 28 × 35½. Private Collection.

Although Scott's subject was in itself 'historical', Rossetti's use of the word may have been prompted by Ruskin's recent description of Thomas Seddon's pictures painted in the East as the first 'truly historic landscape art'.[50] He praised Scott for doing what Seddon's travelling companion Holman Hunt had set out to do in painting religious pictures in the actual Holy Land. The picture admired by Rossetti shows Cuthbert consenting to become bishop in 675. The setting is Cuthbert's retreat in the Farne Islands off the coast of Northumberland. In the National Gallery of Scotland there is a watercolour study for the background, inscribed 'Landing Place, St. Cuthbert's Island', and another study for the wall behind the figures, made from a different site. There are also various other studies for the Wallington murals including an extensive landscape for *The Building of the Roman Wall*. The watercolour studies show little Pre-Raphaelite character, and, despite Rossetti's admiration, the same may be said of the backgrounds of the finished pictures Scott based upon them.

The most interesting picture of the series is *Newcastle Quayside in 1861*, which brings history up to the present (Pl. 91). The subject is analogous to that of Ford Madox Brown's *Work* (Pl. 21), but whereas Brown's picture shows an age-old form of labour set in Georgian Hampstead, Scott's shows the full impact of the industrial revolution. The labourers hammering in the foreground are men from Robert Stephenson's locomotive factory. They work in a picturesque jumble of motifs from modern Tyneside, including in the lower right corner a plan of a locomotive and a newspaper dated 11 March 1861, which contains advertisements for a panorama of Garibaldi in Italy, for a photographer, and for Scott's School of Design. The composition is a kind of plateau landscape, as in more conventional ways are several of the other Wallington paintings. In this case, the foreground activity appears to be taking place on the upper floor of a building, the side of which has been cut away to form an open loggia overlooking the commercial activity on the quay below. In the distance is Stephenson's recently built High Level Bridge, across which steams a train.

Scott had previously employed a similar composition in *Albrecht Dürer of Nuremberg* of 1854 (Pl. 92). In this picture the German artist stands on the balcony of his house looking down at a busy square. The painting's meticulous topographical accuracy reflects a spirit akin to that of Pre-Raphaelitism. However, Scott's picturesque medieval town, his articulation of foreground and distance by light and shadow and modification of tone, and the linear treatment of detail link this view more closely to an older tradition represented by an artist such as Samuel Prout than to Pre-Raphaelitism. If Scott is more precise and accurate in detail than Prout, an important reason is Scott's lifelong devotion to Dürer, the subject of his picture.

91 William Bell Scott, *Newcastle Quayside in 1861* 1861. Oil on canvas, 74 × 74. The National Trust, Wallington Hall.

92 William Bell Scott, *Albrecht Dürer of Nuremberg* 1854. Oil on canvas, 23⅛ × 28¼. National Gallery of Scotland, Edinburgh.

Somewhat later, around the time he was completing his cycle at Wallington, Scott painted several landscapes more obviously affected by Pre-Raphaelitism. One of the first of them is *View of Ailsa Crag and the Isle of Arran*, painted in 1860 (Pl. 93), for which sight of Holman Hunt's *Fairlight Downs – Sunlight on the Sea* (Pl. 54), exhibited in the winter of 1858–9, may have provided the initial inspiration. Scott's painting shows a similar view through a cleft to the sea and is in an even higher-pitched palette with more obtrusive Pre-Raphaelite foreground detail, but the picture also has a topographical interest lacking in the Hunt. The view is from near Penkill Castle in Ayrshire, which is a few miles from the coast opposite Ailsa Crag, and which became Scott's part-time home in 1859, when he met and began living with the castle's owner, Alice Boyd.

Probably the most ambitious of Scott's landscapes is *The Gloaming: Manse Garden in Berwickshire* (Pl. 94), signed and dated 1863. It was preceded by a painting in watercolours of the same subject and a smaller oil, both dated 1862.[51] Looming over the garden in the foreground, is a spiky Gothic tower silhouetted in the dusk, which Richard Dorment has identified as the recently built Ayton Castle in Berwickshire. Pictures like this, and others showing empty seashores at twilight, such as a painting dated July 1863 now in the William Morris Gallery at Walthamstow, seem to echo depictions of similar subjects in earlier nineteenth-century German landscapes by Caspar David Friedrich and his followers, and they may indeed owe a debt to German art, as well as to Pre-Raphaelitism. Scott travelled in Germany in the 1850s because of his curiosity about contemporary German painting. He retained sufficient interest in German art and culture to form a collection of Dürer's prints and to publish a monograph on Dürer in 1869. In 1873 he published a book on modern German art. Dorment has pointed out that in the watercolour version of *The Gloaming* there is no gate in the wall between the garden and the castle and that in the earlier version in oil the gate has a triangular pediment. Hence, the gate would seem to be Scott's invented addition to the scene, departing from literal truth and added for symbolic reasons, in a manner reminiscent of Friedrich's heavily symbolic paintings.

Although Scott was influenced by Pre-Raphaelitism, he did not adopt the Pre-Raphaelite method of painting directly from nature. He believed that the best education

OUTDOOR PAINTING BY OTHER MEMBERS OF THE PRE-RAPHAELITE CIRCLE

for an artist was daily sketching in a pocket sketch-book. Because Holman Hunt did not have the habit of constantly making rapid records of what he saw about him, Scott felt he was a limited artist, 'a slave to the circumstances under which he worked'.[52] As we have seen, Scott based his Wallington murals on watercolour studies. Large numbers of additional sketches by him also exist. These sketches (Pl. 95) often show a rapid calligraphic drawing and a liveliness of colour which gives them a verve and freedom otherwise rare in Pre-Raphaelite works. But they are manifestations of the continuation of a duality which Hunt eliminated by painting directly out of doors. The sketches, like so many sketches by earlier artists, are appealing, but the finished works based upon them lack that sense of freshness of vision, which characterises Hunt's, Millais's, and Brown's best works.

Frederick Sandys appeared on the Pre-Raphaelite horizon in 1857 with a caricature of Millais's *Sir Isumbras* in which the knight's horse has become a donkey labelled 'J. R. Oxon', the knight is Millais, and his two passengers are Holman Hunt and Dante Gabriel Rossetti. On the basis of this unlikely beginning Sandys and Rossetti became close friends. Sandys's art has much more to do with Rossetti's than with the naturalistic side of Pre-Raphaelitism; in fact, it has so much to do with Rossetti that their friendship ended in 1869 when Rossetti accused Sandys of plagiarising his ideas.[53] Sandys did not work mainly in oil, although he did paint some oil paintings. He was primarily a draughtsman of incredible virtuosity, and his chief contribution to the history of English art lies in the black-and-white illustrations which he made during the 1860s. Many of these illustrations have landscape settings drawn in complex and minute detail, and for them he made equally minute preparatory studies. George du Maurier, freshly arrived in London and trying to establish himself as an illustrator, could only marvel at Sandys's execution and the ten to twelve hours of work a day behind it. Du Maurier noted the effort which Sandys put into his studies: 'If he has a patch of grass to do in a cut, an inch square, he makes a large and highly finished study from nature for it.'[54] Many of these preparatory studies are known. They are generally larger than the finished wood engravings, and they are minutely and beautifully drawn. An example is a pencil drawing of *Wild Arum and Grass* (Pl. 96). The drawing measures $7^5/_{16} \times 6^1/_8$ inches; Sandys used it for

93 William Bell Scott, *View of Ailsa Crag and the Isle of Arran* 1860. Oil on canvas, $12^{15}/_{16} \times 19^1/_4$. Yale Center for British Art, New Haven.

94 William Bell Scott, *The Gloaming: Manse Garden in Berwickshire* 1863. Oil on canvas, 15½ × 24. Philadelphia Museum of Art.

95 William Bell Scott, *Ascending St Gothard from Altdorf c.* 1862. Watercolour, 7 × 5. National Gallery of Scotland, Edinburgh.

a tiny detail of the foreground plants in his illustration *The Old Chartist*, which measures only 4³⁄₁₆ × 5 inches overall (Pl. 97). In addition, there are three other studies of natural detail for *The Old Chartist* in Birmingham. Sandys employed two of them for other works as well: he used a pen-and-ink drawing of a thistle also in a wood engraving of 1863, *Life's Journey*, and he used a watercolour study of ivy growing on a post (Pl. 98) in an oil *Portrait of the Reverend James Bulwer* (Pl. 99).⁵⁵

Sandys's finished illustrations, such as *The Old Chartist* and *Life's Journey*, have an emphasis on botanic detail in their foregrounds, crowded compositions, and high horizons, all of which indicate an affinity with earlier Pre-Raphaelite work. Among the illustrators of the 1860s, whose activity followed the lead of the Pre-Raphaelites' illustrations to the Moxon edition of Tennyson of 1857, Sandys has the closest relation with the Pre-Raphaelite naturalism of the previous decade. This relation can also be seen in his paintings. *Autumn* (Norwich Castle Museum) has a subject of youth and age and a landscape setting of a river and bridge at twilight, which depend quite obviously on Millais's *Sir Isumbras*. The *Portrait of the Reverend James Bulwer* has a background wall with ivy growing on it which is yet another descendant of Millais's *Huguenot*.

Yet, despite his personal as well as stylistic connections, Sandys's method of working was quite distinct from the Pre-Raphaelites' and stemmed from another tradition. He was a native of Norwich, and he continued to list a Norwich address in the Royal Academy catalogues until 1865, although during the early 1860s he resided for periods of months with Rossetti in Chelsea. Sandys had plenty of exposure to the artists of his native city. One of his chief patrons, the Reverend Bulwer, had earlier patronised John Sell Cotman and owned a large collection of drawings by Cotman and other Norwich artists. A number of Sandys's early drawings are copies after Cotman, and he started making his own careful drawings from nature in Norfolk before he had any contact with the Pre-Raphaelites. When Sandys came into contact with the Pre-Raphaelites, he continued to draw from nature; he did not paint directly. The number of drawings which exist by him and the reappearance of motifs in more than one finished work indicate that his practice was to make sketches independently and then compose his pictures or illustrations from separate studies he had previously made. But he also made

OUTDOOR PAINTING BY OTHER MEMBERS OF THE PRE-RAPHAELITE CIRCLE

studies as he needed them. A diary which he kept while working on the portrait of the Reverend Bulwer shows that he made drawings for the ivy in the background (City Art Gallery, Birmingham) after he had begun the painting. When he copied in the background from the drawings, he eliminated numerous details, making the ivy less complex than in the original sketches.

Sandys was not the only artist to be drawn into the Pre-Raphaelite orbit at the end of the 1850s by the magnetism of Rossetti. Two others were William Morris and Edward Burne-Jones. As students together at Oxford in the mid-1850s they became aware of Ruskin and of Pre-Raphaelitism. Several letters written by Burne-Jones while at Oxford indicate that the message of *Modern Painters*, which had possessed such potent appeal for Holman Hunt a decade earlier, still had not lost its force:

> He [Ruskin] is the most profound investigator of the objective that I know of: the whole work is evidence of a painfully careful study of nature, universally and particularly; in aesthetics he is authority. Above all things I recommend you to read him, he will do you more good in twenty chapters than all the mathematics ever written.[56]

In 1856 William Morris, who was independently wealthy, gave tangible proof of his admiration for the early Pre-Raphaelite paintings by purchasing Arthur Hughes's *April Love* and Ford Madox Brown's *Hayfield* (Pl. 26). But the appeal for both Morris and Burne-Jones of the kind of careful study of the natural world which these pictures represented and which *Modern Painters* called for was soon to give way to that of the more poetic and more decorative art of Rossetti. Both began to paint under Rossetti's direction, but Rossetti started them working with conventional Pre-Raphaelite care. He wrote to William Bell Scott about Morris's first picture, *Sir Tristram after his Illness in the Garden of King Mark's Palace, Recognised by the Dog he Had Given to Iseult*, 'It is being done all from nature of course.' Earlier, in February 1857, he had written to Scott about Burne-Jones's drawings, which were 'marvels of finish and imaginative detail, unequalled by anything unless perhaps Albert Dürer's finest works.'[57] Morris's first picture has disappeared; his one known easel picture, *Queen Guenevere*, of 1858 (Tate Gallery), has an interior setting and is little more than a pastiche of Rossetti's Arthurian watercolours of 1857, such as *The Tune of Seven Towers* (Tate Gallery), which Morris bought from Rossetti. Burne-Jones's early drawings show an equally strong dependence upon Rossetti; his *Going to the Battle*, drawn in 1858 (Fitzwilliam Museum, Cambridge), for example, echoes both Rossetti's *Before the Battle* of 1858 (Museum of Fine Arts, Boston)

96 Frederick Sandys, *Wild Arum and Grass* c. 1861–2. Pencil, 7⁵⁄₁₆ × 6¹⁄₈. Birmingham Museum and Art Gallery.

97 Frederick Sandys, *The Old Chartist* 1862. Wood engraving by Joseph Swain, 4³⁄₁₆ × 5. Published in *Once a Week*, VI, 1862.

98 Frederick Sandys, *Study of Ivy, c.* 1861–2. Watercolour, 6³/₄ × 3³/₈. Birmingham Museum and Art Gallery.

99 Frederick Sandys, *The Reverend James Bulwer* 1863. Oil on panel, 29³/₄ × 21³/₄. National Gallery of Canada, Ottawa.

and, in the background, his earlier illustration of *St Cecilia* for the Moxon Tennyson. Like Rossetti's *St Cecilia*, Burne-Jones's drawing has an outdoor setting, but one in which the creation of a medieval world is more important than the study of nature. The drawing is larger than Rossetti's illustration, and the detail is more elaborate and more minute, but as Rossetti's letter to Scott hints, Burne-Jones drew so minutely at least partly in emulation of Dürer.

Many of Burne-Jones's later paintings have extensive landscape backgrounds, and in a few cases they show specific places. The background of *Aurora* (Queensland Art Gallery, Brisbane) is based on a sketch of a canal at Oxford made in 1867.[58] Three watercolour landscapes by Burne-Jones in Birmingham seem to have been made in 1863 and are loosely related to the background of the watercolour *The Merciful Knight* (also in Birmingham).[59] The landscapes are not very Pre-Raphaelite; all three are studies for background masses of trees, and their foregrounds are empty. In the finished *Merciful Knight*, the landscape setting plays a subordinate, albeit thematically important, role in the composition. Often, when Burne-Jones's backgrounds play a larger part, they depend more upon earlier art than upon the artist's own response to nature. For some works, such as *The Mill* (Victoria and Albert Museum), the earlier art was Venetian; in many others it is Pre-Raphaelite. Behind the foliate elaboration of the celebrated *Briar-Rose* series of 1870–90 (Buscot Park, Berkshire) we can see the Pre-Raphaelite foliage of Millais's *Ophelia*. In *The Briar Wood*, the first painting of the series (Pl. 100), there is no spatial

100 Edward Burne-Jones, *The Briar Wood* 1870–90. Oil on canvas, 49 × 98¹/₄. The National Trust, Buscot Park.

depth, and the entire background is filled with botanic detail. But there are important differences between Millais and Burne-Jones. Millais's picture is a record of the painstakingly observed variety of natural detail, whereas in the Burne-Jones there is just one kind of plant, which is repeated over the entire picture surface, drawing it into a consistent two-dimensional pattern. Natural details are used, but naturalism is no longer important. Burne-Jones frankly stated that the 'Direct transcript from Nature', which the Pre-Raphaelites in the 1850s had tried to achieve, was of no interest to him:

> I suppose by the time the 'photographic artist' can give us all the colours as correctly as the shapes, people will begin to find out that the realism they talk about isn't art at all but science; interesting, no doubt, as a scientific achievement but nothing more. Some one will have succeeded in making a reflection in a looking glass permanent under certain conditions. What has that to do with art?[60]

Although Burne-Jones was only four years younger than Millais, he started to paint over a decade later, and as an artist he belonged to another generation. The term 'second-generation Pre-Raphaelites' has been used for Burne-Jones and Morris. Their generation was the same as Whistler's, and they helped to create the Aestheticism which came to dominate progressive English art in the 1860s and 1870s. A perhaps inevitable conflict between this new taste and the naturalistic orientation of the 1850s came into the open in 1877 when Ruskin attacked Whistler's *Nocturnes* exhibited at the Grosvenor Gallery, the newly founded temple of Aestheticism, and Whistler sued Ruskin for libel. Burne-Jones appeared as a witness in the trial on Ruskin's behalf because of old loyalties, but he could almost as easily have been on the other side. He had been taken up by Ruskin early on, but their friendship briefly foundered around 1870 because of differences in their beliefs. Burne-Jones was offended by Ruskin's dislike of Michelangelo. Ruskin disapproved of Burne-Jones's working methods, and he could not understand the painter's lack of interest in the natural world: 'Nothing puzzles me more than the delight that painters have in drawing mere folds of drapery and their carelessness about the folds of water and clouds, or hills, or branches. Why should the tuckings in and out of muslin be eternally interesting?'[61] Around 1870, not only Burne-Jones, but also Frederic Leighton, Edward Poynter, Albert Moore, and Whistler were more interested in folds of drapery than in hills or branches. All of these artists owed debts to Pre-Raphaelitism, but for none of them was the close study of nature any longer important in the way that it had been for Hunt, Millais, and Brown, and almost all their contemporaries during the 1850s.

Thomas Seddon

We have seen that in the years following 1851, Hunt, Millais, and Brown studied the natural world more and more closely, and that Ruskin frequently discussed and defended the works of the first two as if they were landscape paintings. Hence, it should come as no surprise that as the Pre-Raphaelite impulse became widespread during the 1850s a number of artists tried to paint pure landscapes based on Pre-Raphaelite principles. These artists, for the most part, came to Pre-Raphaelitism slightly later than such painters as Hughes and Deverell, discussed in the preceding chapter; nevertheless, they did rapidly gain considerable prominence in the second half of the decade. This prominence was short-lived, and most of them are forgotten today. But the importance that at least one biased observer ascribed to Pre-Raphaelite landscape painting is manifested by the amount of attention devoted to these painters in Ruskin's *Academy Notes*, whose years of publication, 1855–9, correspond to the period of their greatest activity. Slightly later, William Michael Rossetti, discussing the International Exhibition of 1862, wrote, 'Landscape of late years has come almost wholly into the domain of Praeraphaelitism', and the artists he deemed worthy of mention were the same group that Ruskin had praised and encouraged in *Academy Notes*.[1] One centre of Pre-Raphaelite landscape painting was Liverpool. The Liverpool artists were in close touch with developments in London, but they form a separate group because of their geographical isolation, and they are discussed in a separate chapter. The impact of the movement on a number of artists who were not intimate members of the Pre-Raphaelite group is discussed in the last three chapters. Four artists – Thomas Seddon, George Price Boyce, John William Inchbold, and John Brett – were close personal associates of the Pre-Raphaelite group, and in all of them, in one way or another, Ruskin took an active interest. The works of these four men, along with the landscapes of Ford Madox Brown and Holman Hunt, provide the central material for any consideration of Pre-Raphaelite landscape painting.

The oldest of these artists and the first to come into the Pre-Raphaelite milieu was Thomas Seddon. Born in 1821, Seddon was the son of a well-known furniture-maker. In 1841, to prepare himself to enter the family business, he went to Paris for a year to study ornamental art. Following his return he worked as a furniture-designer through the 1840s, but, although he was reasonably successful, winning a prize for a sideboard from the Society of Arts in 1848, he had ambitions for 'higher art'. It is possible that in Paris he had come into contact with the group of expatriate English artists which included Ford Madox Brown, as in London these artists, now returned home, were his teachers. Seddon first studied drawing at night with Charles Lucy in Camden Town. Lucy had been a student of Paul Delaroche in Paris and was a friend of Ford Madox Brown; the two shared a studio in 1844 and 1845. Seddon also drew from the model at the Clipstone Street Artists Society, and by 1850 he was working in Brown's studio.[2] He began a copy of Brown's *Chaucer* (the version now in the Tate Gallery), and in 1851 Brown gave him the study for the picture's background, *The Medway Seen from Shorn Ridgway* (Pl. 15). Brown and Seddon remained close friends until the latter's death in 1856. Brown's diaries and letters are full of references to advising and helping his friend, and, according to both Rossetti and Holman Hunt, Brown was largely responsible for Seddon's first picture exhibited at the Royal Academy, *Penelope*, shown in 1852 (private collection).[3] In 1850 Seddon was instrumental in establishing in Camden Town the

Facing page: Thomas Seddon, *Léhon, from Mont Parnasse, Brittany* (detail of Pl. 101).

101 Thomas Seddon, *Léhon, from Mont Parnasse, Brittany* 1853. Oil on canvas, 23 × 30. Museo de Arte de Ponce, Puerto Rico.

North London School of Design for the instruction of working men in drawing. Brown served as an instructor in the school, and was for a period beginning in 1852 its headmaster. Brown was also friendly with the rest of the Seddon family: in 1849 he painted portraits of Seddon's parents in exchange for a sofa, and Charles Seddon, one of Thomas's brothers, owned *An English Autumn Afternoon*.

Seddon began painting landscapes while still working in the furniture business. In the summer of 1849 he spent several weeks painting at Betws-y-Coed in North Wales, and in the summer of the following year he painted at Barbizon. His work from this period has disappeared, and his later work gives little hint either of the influence of David Cox, who was the dominant figure at Betws-y-Coed, or of Théodore Rousseau and other Barbizon painters. According to the life of Seddon written by his brother the architect John Pollard Seddon, he was already more concerned at this time with careful detail than with painterly breadth:

> He would stoutly maintain that it was far better to secure but two or three good studies during the usual stay which each artist was able to make, than to confine their practice, as was usual, to mere sketching. Instead of the single day which they usually devoted to an important scene and a large canvas, in his opinion weeks would hardly suffice.[4]

In December 1850 Seddon had an attack of rheumatic fever which was almost fatal, and only after this did he give up his role in the furniture trade to become an artist in earnest. To recuperate he went to Wales, remaining there from August 1851 until early in 1852. In a letter written in September 1851 he mentioned making a study at Tintern and two other studies. One of them must have been the *Scene on the River Wye* which he sent to an exhibition of sketches in the winter of 1852.[5] At the Royal Academy in 1852 he

exhibited his *Penelope*, and in the summers of 1852 and 1853 he went to Dinan in Brittany. He became engaged to a girl from Dinan, whom he married in 1855, and in the last few years of his life Dinan was his second home. In 1852, he painted a small landscape, *A Valley in Brittany*, which he exhibited at the Royal Academy in 1853. In a letter to Brown written from Dinan, he described it as a complicated undertaking, with 'specimens of every tree in the universe'.[6] In 1853 he painted a larger landscape showing the ruined priory of Léhon just outside Dinan. He exhibited this picture at the Royal Academy in 1854 as *Léhon, from Mont Parnasse, Brittany* (Pl. 101).

Léhon, from Mont Parnasse, the earliest landscape by Seddon that we can now identify, clearly echoes *An English Autumn Afternoon* (Pl. 23), which Brown had begun the previous year. Like that painting, Seddon's picture shows a group of casual observers on a high foreground promontory, overlooking but distinctly separate from a valley below. In the valley, the tiny figures of a religious procession leaving the ruined monastery correspond to the agricultural labourers in Brown's picture. The horizon is high, and most of the picture is filled with the carefully delineated foliage of the trees in the middle distance, but a further range of hills is visible in the far distance (see detail, p. 128). All this again reflects *An English Autumn Afternoon*, but in comparison Seddon's picture seems less purely visual than Brown's; Seddon appears to have been more concerned with describing than seeing. While Brown's subject was a suburban view of no particular significance in itself, which was chosen because it lay outside a back window, Seddon's picture shows the picturesque ruins of a medieval monument. Throughout Brown's picture there are ambiguities, the result of his apparent unwillingness to impose an order upon the confusion of nature as he saw it. In Seddon's picture everything is clear and precise; Brown's spatial confusion has been resolved, and things fit together in an orderly fashion. Also, reflecting Seddon's relative inexperience as a painter, his picture is stiffer and drier in execution. Nonetheless, *Léhon, from Mont Parnasse* is far from an inconsiderable accomplishment. It reveals the painstaking attention to detail that was to characterise Seddon's later Eastern landscapes, as well as an ability to combine detail with a panoramic sense of the landscape as a whole. The religious procession fills only a small part of the picture area, but the entire landscape focuses upon it, and both procession and landscape gain dignity by the juxtaposition.

All Seddon's other landscapes now known are associated with a trip that he made to the East with Holman Hunt in 1853 and 1854. Seddon's reasons for making this trip were mixed. Partly they were religious. According to his brother, he had contracted in Paris 'a taste for pleasure and dissipation', for which, following his illness, he tried to atone. Through his letters written from the East runs a heavy stream of penitent religiosity. But Seddon was also aware of his inexperience as an artist. He hoped to give his works a saleability by giving them the unusual and extra-artistic interest of the biblical landscape. Furthermore, he hoped to profit from the example and advice of his travelling companion, Holman Hunt.[7] Although he preceded Hunt to the East by several weeks, he waited for his arrival to begin an important work, in order to have his advice on 'the best points of view'.[8]

Seddon arrived in Cairo in December 1853. There, while waiting for Hunt, he had the brief companionship of another Hunt disciple, Edward Lear, who was setting off on a trip up the Nile. Although Seddon delayed commencing any big work, he did sketch various subjects, including Richard Burton fresh back from his trip to Mecca.[9] Seddon completed three of his Egyptian sketches after his return to England and exhibited them at the Royal Academy in 1856. Their titles – *An Arab Sheikh and Tents in the Egyptian Desert – Painted on the Spot*; *Dromedary and Arabs at the City of the Dead, Cairo, with the Tomb of Sultan El Barkook in the Background*; and *Interior of a Deewan, Formerly Belonging to the Copt Patriarch, near the Esbekeeyah, Cairo* – and, indeed the actual appearance of the *Dromedary and Arabs at the City of the Dead*, which has recently come to light in two versions,[10] suggest that Seddon's initial interest was in the exotic and picturesque qualities of the East, rather like those displayed in the works of John Frederick Lewis. It is possible that Seddon's decision to paint in the East was in part inspired by the sensational success of Lewis's Eastern subjects exhibited at the Old Water-Colour Society in 1850 and 1852. After Seddon's return, when he sold a picture to Lord Grosvenor, he proudly reported to Ford Madox Brown that it would hang with two works by Lewis, 'which is honorable company' (Holman Hunt, on the other hand, dismissed Lewis as a painter of 'Egyptian Social Scenes').[11]

Seddon's practice of sketching in Cairo was in accord both with the methods of older artists such as Lewis and with the advice of Brown, who had apparently felt that Seddon

102 Thomas Seddon, *The Pyramids of Giza* 1854. Oil on canvas, 21 × 31. Private Collection.

should paint his pictures back in England. But while sketching may have been encouraged by Brown, it did not find a place in the stricter Pre-Raphaelite dogma of Holman Hunt, and when Hunt arrived in Cairo at the end of January 1854, Seddon stopped sketching.[12] In February the two artists encamped at the Pyramids of Giza. Hunt soon returned to Cairo, but Seddon remained at Giza for most of his time in Egypt working on a picture of the Pyramids (Pl. 102). Like Hunt, Seddon was disappointed by the Egyptian scenery, and he professed little admiration for the Pyramids:

> I must say that both Pyramids and Sphinxes, in ordinary daylight, are merely ugly, and do not look half as large as they ought to look, knowing their real size; but in particular effects of light and shade, with a fine sunset behind them, for example, or when the sky lights up again, a quarter or half an hour afterwards – when long beams of rose-coloured light shoot up like a glory from behind the middle one into a sky of the most lovely violet – they then look imposing, with their huge black masses against the flood of brilliant light behind them.[13]

The painting shows the evening hour he described, with pyramids and glowing beams of light reflected in a pool of water. It has little Pre-Raphaelite detail, and the ephemeral effect of evening, which in Seddon's opinion gave interest to the subject, had, by its nature, to be mainly a product of the studio, based on earlier sketches and memory, rather than of the direct work from nature called for by Hunt.

At Giza, Seddon also made a carefully finished watercolour showing excavations taking place before the Sphinx (Pl. 103). In his published correspondence there is no reference to this drawing, but a letter written in March 1854 gives a description of the activities shown:

> It is very amusing just now to watch the operation which Mr. Marriette is carrying on for the French Government round the Sphinx, where he is searching for an entrance. There are about one hundred children removing the sand. Some eight or ten men and bigger boys fill small round baskets with sand, and there are two groups, one of boys and the other of girls. Some older ones lift the baskets on to the heads of the

THOMAS SEDDON

103 Thomas Seddon, *The Great Sphinx at the Pyramids of Giza* 1854. Watercolour, $9^{3}/_{4} \times 13^{3}/_{4}$. Ashmolean Museum, Oxford.

children, who carry them up the slope in two long processions, the head boy and girl singing, and the others all joining in chorus, and laughing and joking and shouting, while two or three majestic old Arabs stand by as overseers, with store of vociferation and blows, not serious, which, coming on their loose drapery, only just keeps them at work, and rather increases the laughter than otherwise.[14]

'Mr. Marriette' was Auguste Mariette, the French Egyptologist, whose activities were also recorded by Holman Hunt in a drawing of Fellah children carrying sand (private collection).[15] Hunt's watercolour of the back of the Sphinx (Pl. 57) shows the geological structure of the rock, which Mariette's excavations had partly revealed. Seddon's view is more anecdotal and more conventional. His watercolour is also more linear and less strongly coloured than Hunt's, but the two works are approximately the same size, and their compositions balance in a way that suggests that they may have been conceived as pendants.

The two artists left Egypt in May and arrived in Jerusalem on 3 June 1854. Seddon immediately encamped on a hill south of the city, and there he remained for the rest of his stay. His main project was an elaborate picture, *Jerusalem and the Valley of Jehoshaphat from the Hill of Evil Counsel* (Pl. 104), which he painted from a hundred yards higher up the hill than his tent. He also began a smaller view of Mount Zion and two watercolours. Like Hunt, he was more enthusiastic about Palestine than about Egypt, and, as with Hunt, this was partly due to religious reasons:

Besides the beauty of this land, one cannot help feeling that one is treading upon holy ground; and it is impossible to tread the same soil which Our Lord trod, and wander over His favourite walks with the apostles, and follow the very road that He went from Gethsemane to the cross, without seriously feeling that it is a solemn reality, and no dream.[16]

But there was more to the Holy Land: 'Independently of the undying interest that must ever belong to Jerusalem, the country is exceedingly beautiful, and by no means the barren place I expected'. Seddon was delighted to see hills again after spending six months on 'a plain of flat mud like Egypt'. He filled his letters with rapturous descriptions of the country, and he set to work with enthusiasm. His routine was single-minded and simple: 'I get up before sunrise, breakfast, and paint till eleven; then read, *darn*, dine, or sleep till two; then paint till six; then I have to return, put up my things, and go out for a walk'.[17]

He could live outside the city in isolation and stick to this routine because he planned to stay in the Holy Land for a strictly limited time. On 3 August he reported that he had done about half his large picture, and that he hoped to leave within five weeks.[18] Because of illness, he was forced to postpone his departure, but he did leave on 19 October, and he was back in Dinan by 4 November (Hunt remained a year

104 Thomas Seddon, *Jerusalem and the Valley of Jehoshaphat from the Hill of Evil Counsel* 1854–5. Oil on canvas, 26½ × 32¾. Tate Gallery, London.

longer, leaving Jerusalem in October 1855). Seddon had still not completed all his pictures by the date of his departure but planned to finish them in Dinan, using sketches and photographs. A friend in Jerusalem, James Graham, was a photographer, and Seddon admired his views:

> I hope to bring some of them to England for him, so that I shall be able to show them to you [Seddon's fiancée] and supply my own want of sketches. They are extremely valuable, because perfectly true as far as they go; however, they will never supplant the pencil, for there is much in photographs that is false; the greens and yellows become nearly as black as the shadows, so that you often cannot distinguish which is shadow and which grass.[19]

This is Seddon's only recorded reference to Graham's photographs, and there is no documentary evidence to what extent, if at all, he used them in finishing his pictures.

Seddon stayed two months in Dinan; then he returned to London, and in the spring of 1855, he held a private exhibition of his works. This seems to have been quite successful, but his *Pyramids* was rejected at the Royal Academy. In the autumn of 1855 he exhibited the watercolour *The Great Sphinx at the Pyramids of Giza* at the Liverpool Academy. In 1856 he exhibited three Egyptian sketches at the Royal Academy, and in the autumn of that year he exhibited *Jerusalem and the Valley of Jehoshaphat* and *Mount Zion* at Liverpool.

Apparently Hunt and Seddon were not as close as their joint travel would suggest. Seddon's pranks on their trip from Cairo to Jerusalem seem to have irritated Hunt,[20] and in Jerusalem, living apart, they had little contact with one another. Upon Seddon's return to London in January 1855, Ford Madox Brown recorded in his diary: 'Hunt, he tells me,

gave him no advice at all, he has been prepossessed against him, I fear'.[21] In Seddon's letters from Jerusalem there is almost no mention of Hunt, and the only attention to Seddon's pictures recorded in Hunt's memoirs was at the very end of his companion's stay in Jerusalem:

> Seddon had asked me to pronounce upon his picture of Jerusalem and Siloam from Aceldama. It was painted throughout elaborately and delicately, but it was scarcely in the pictorial sense a landscape. Sitting before the spot I pointed out to him how completely the tones and tints failed in their due relation, and how essential it was that he should supply the deficiency, explaining that in conventional art the demand for variety of tones was satisfied by exaggeration and tricks, and that these had increased the due expectation for effect to such an extent that when a work was done strictly from Nature, unless all the variety that Nature gave was rendered by the painter, the spectator had good cause for declaring the work crude and false; in short, that the more truth there was in one direction, the greater there must be in others. I calculated that to do the scene any justice he must work upon his canvas fully another three weeks.[22]

Seddon did not follow Hunt's advice, but returned home without completing the picture: 'I told him that I would toss all my pictures into the fire rather than stay a moment over the time I had fixed'.[23] Although he worked on his pictures for two additional months in Dinan, when he showed them to Ford Madox Brown, Brown also was dismayed: 'His pictures are cruelly PRB'd . . . The high finish is too obtrusive. However, they present qualities of drawing and truthfulness seldom surpassed; but no beauty, nothing to make the bosom tingle. Could I but have seen them in progress: I will do all I can to make him improve them yet, but it is late.'[24] Brown did do what he could, and he repainted the sky of the *Pyramids* himself.[25] There is no mention in Brown's diary of *Jerusalem and the Valley of Jehoshaphat*, but, with or without Brown's advice, Seddon did work on it in London early in 1855. On 5 March he described it as quite finished, and 'much improved by a rather deeper blue sky'.[26] Otherwise, as Brown feared, by the time Seddon was in London it was too late to make much change in such an elaborately wrought painting. Seddon defended the accuracy of his vision – 'I really believe that there was no more atmosphere at the time' – but he resolved to avoid such 'peculiarities' in the future.[27]

Jerusalem and the Valley of Jehoshaphat is a plateau landscape, showing a foreground hillside with a sleeping shepherd and a flock of sheep and goats, a valley over which the eye must jump, and a panoramic landscape beyond. It is comparable in composition to *Léhon, from Mont Parnasse*, but the view is less intimate. Most of the landscape is seen at a considerable distance, and, therefore, the scale is small. The hills are bare, rather than covered with trees, so that geological detail is of prime importance, and, because of the nature of the terrain, the effect is arid. The painting does reveal a concern with reflected light and colour corresponding to that of Brown and Hunt. The shadows of the trees on the hill to the right are bright blue, and throughout the picture shadows are full of colour. But there is relatively little shadow in the picture, most of which shows bare earth under burning sunlight, and the contrasts between light and shadow are harsh and unsubtle. We do not feel that Seddon saw in terms of light and colour, as did Brown. The painting seems more like a drawing to which colour has been added; indeed, the carefully drawn patterns of terraces and erosion on the distant hills take on rhythms of their own, giving to the picture a remarkable quality of calligraphic fantasy. *Jerusalem and the Valley of Jehoshaphat* is a supreme example of Pre-Raphaelite attention to physical fact exclusive of other interests, but this stemmed from the artist's limitations, or inexperience, and, as we have seen, the artist and his closest associates agreed that the result was not entirely satisfactory.

Seddon also continued to work on *Mount Zion* after his return to England, completing it by adding to the foreground an eagle which he painted from one shot and sent to him by a friend in Jerusalem.[28] This picture has disappeared, but the detail of the eagle suggests that it may be reflected in Holman Hunt's watercolour view of the same site dated 1892, which also has an eagle in the foreground (William Morris Gallery, Walthamstow).

The two watercolours that Seddon began in Jerusalem are described in a letter which the artist wrote from his tent:

> Today I have been going on with a watercolour drawing of the mountains of Moab, beyond the Dead Sea, looking down the Valley of Hinnom. I have taken them half an

105 Thomas Seddon, *The Well of Enrogel*
1854. Watercolour, 9³/₄ × 13³/₄. Harris Museum
and Art Gallery, Preston.

hour before sunset, when they are bathed in a mist of rosy light, while the valley in front is in shadow. It never does to be too confident, but, if it is finished as it is begun, it will be the best watercolour landscape that I have done. I began that, and another of Joab's well, and the great threshing-floor in front, with the oxen treading the corn, as watercolour is not so laborious as oil.[29]

The latter watercolour is *The Well of Enrogel* (Pl. 105), which shows the activities in the valley immediately below Seddon's tent. The small scale and careful detail recall *Jerusalem and the Valley of Jehoshaphat*, and, as in the painting, the view is from above. In the immediate foreground there is a small figure whose body is cut by the frame in a manner reminiscent of some of Holman Hunt's foreground figures. This watercolour provided the model for the background of Ford Madox Brown's *Coat of Many Colours* (Pl. 29).[30]

The other watercolour (Pl. 106) is quite different. It is a view of the mountains beyond the Dead Sea some forty or fifty miles away. The Sea itself is not visible. The hour is just before sunset, and the sky is green, as the artist described it in a letter written shortly after arriving in Jerusalem and before he began to paint the view.[31] The mountains in

106 Thomas Seddon, *The Mountains of Moab*
1854. Watercolour, 9¹⁵/₁₆ × 13⁷/₈. Ashmolean
Museum, Oxford.

the late afternoon sunlight are deep violet, and the foreground is in strongly differentiated shadow. Stylistically, the watercolour is closer to Holman Hunt's Eastern landscapes than to Seddon's other works, and, although Seddon described it in colouristic terms early in his stay in Jerusalem and promised that it would be the best watercolour landscape he had done, Hunt's hand may, in fact, be present. In his memoir, Hunt claimed to have completed one of his travelling companion's watercolours when Seddon returned home, and a letter written by Hunt in Jerusalem to Seddon in Dinan in January 1855 states that he was then working in the evenings on a sketch by Seddon.[32] If, as indicated in Seddon's letters, he began only two watercolours while at Jerusalem, Hunt's intervention seems more probable in *The Mountains of Moab* than in the drier *Well of Enrogel*, and the fact that he worked on it in the evening, the time shown, confirms the identification. It is impossible to say how much of the finished picture is due to Hunt, but wherever lies the responsibility, it does have a breadth and richness of colour unequalled in Seddon's few other known works.

In London Seddon not only continued to work on the pictures that he brought back from the East, but also began to paint new Eastern subjects. The most important of these was a large *Arabs at Prayer in the Desert*, which he left unfinished at his death (Pl. 107). In Cairo he had made several sketches of camels and arabs, and he borrowed details in this picture from them. The foreground camel is copied directly from the earlier *Dromedary and Arabs at the City of the Dead, Cairo*. In painting a major work in the studio and basing it on earlier work rather than direct observation, Seddon was not following strict Pre-Raphaelite practice, and the result looks more like an Eastern subject by John Frederick Lewis than one by Holman Hunt. Indeed, he may have been inspired by Lewis's *Well in the Desert* (Victoria and Albert Museum),[33] which had been exhibited at the Old WaterColour Society in the spring of 1855, shortly before Seddon began his picture.

A slighter picture, which Seddon apparently painted entirely after his return, is a *View on the Nile*, dated 1855 (Pl. 108). In his letters from Egypt Seddon described two trips on the Nile, the first to Saqqara in December 1853, the second a longer trip through the Delta with Hunt on their way to Jerusalem the following May. The picture combines elements from both trips: the sunset effect recalls Seddon's description of 'the picturesque palm trees, and long sloping yards of the boats, looking black as night against the red golden sky' on the trip to Saqqara, while the water buffalo in the foreground are from the latter voyage.[34] The chief interest of the picture is in the colour of the Egyptian sunset, and there is relatively little topographic detail. This emphasis on effect can probably be explained as Seddon's response to the criticism which his Eastern views had drawn:

107 Thomas Seddon, *Arabs at Prayer in the Desert* begun 1855. Oil on canvas, 25³⁄₈ × 44¹⁄₈. The Forbes Magazine Collection, New York.

108 Thomas Seddon, *View on the Nile* 1855. Oil on canvas, 8 × 12. Ashmolean Museum, Oxford.

of being over-literal, dry, and without atmosphere. As he wrote in May 1855, 'I know in my style of painting it is the side likely to err on, and I shall try and shew in my work this summer here that I do not do so'.[35] Unfortunately, in correcting his errors Seddon made the *View on the Nile* a rather characterless work. Its composition is reminiscent of Dutch river landscapes, and it displays none of the individuality which, whatever their shortcomings, Seddon's other Eastern landscapes do have.

Having achieved some reputation as a painter of the Holy Land, Seddon returned to the East in the autumn of 1856. He intended to paint views of the Dead Sea and of the cedars of Lebanon,[36] but he contracted dysentery *en route* and died in Cairo on 23 November 1856, just a month after his arrival. Following his death, meetings were held, an exhibition arranged, and a subscription was put under way to purchase *Jerusalem and the Valley of Jehoshaphat* for the National Gallery. The most interesting aspect of this activity – aside from the fact that *Jerusalem and the Valley of Jehoshaphat* did enter the National Gallery – was the participation of Ruskin.

Ruskin had visited Seddon's exhibition in 1855, and, according to the artist, he had been enthusiastic:

> Mr. Ruskin also came and stayed a long time. He was very much pleased with everything, and especially 'Jerusalem', which he praised wonderfully; and in good truth it is something for a man who has studied pictures so much to say, 'Well, Mr. S., before I saw these, I never thought it possible to attain such an effect of sun and light without sacrificing truth of colour'.[37]

This opinion differs from that of Seddon's friends, and it is difficult to consider truth of light and colour among the strengths of Seddon's works known today. Ruskin, if not misquoted, may have been flattering the artist; in any case, when he later praised Seddon's work, it was for other, more limited reasons. Ruskin spoke at a meeting held at Holman Hunt's house shortly after Seddon's death. There, he credited the paintings with a utilitarian value:

> Mr. Seddon's works are the first which represent a truly historic landscape art; that is to say, they are the first landscapes uniting perfect artistical skill with topographic accuracy being directed with stern self-restraint to no other purpose than that of giving to persons who cannot travel trustworthy knowledge of the scenes which ought to be most interesting to them. Whatever degrees of truth may have been attained or attempted by previous artists have been more or less subordinate to pictorial and dramatic effect. In Mr. Seddon's works the primal object is to place the spectator, as far as art can do, in the scene represented, and to give him the perfect sensation of its reality, wholly unmodified by the artist's execution.[38]

Ruskin spoke again at a *conversazione* held on 6 May 1857 at the Society of Arts in connection with the posthumous exhibition.[39] In this talk he suggested that Seddon was an artist of no unique talent; his work was important not because it was remarkable, but because it was of a class that could and should be imitated by other artists. Ruskin then went on to place Seddon within the context of Pre-Raphaelitism. He defined the movement as 'the pursuit of truth in art, with a useful purpose', but he added that there were two distinct types of Pre-Raphaelites:

There were the poetical Pre-Raphaelites and the prosaic Pre-Raphaelites, and the prosaic were the more important of the two. The spirit of the present age was strictly scientific, and all that they could do more than was done in the earlier ages must be on the side of truth, and could not be on the side of imagination . . . Science had brought forward the disposition to test facts more accurately, which was adverse, more or less, to imagination, but which should direct to the grasping of facts around them; and it was this special direction of painting, which, he believed, ought to be cultivated.

If an artist had imaginative powers they would come out anyway, but it was a great waste to try to make all minds imaginative.

In all ages, there were two great classes of artists, men of inventive minds, and men of more or less prosaic minds; and the great danger of following the theory of beauty only, was to make the matter-of-fact minds comparatively useless, and yet they were the most common amongst them. There were more men capable of pursuing a simple problem, or representing a simple fact, than there were men capable of following at any distance in the path of the great inventive painters.

Seddon had painted at least one imaginative picture, his early *Penelope*, which Ruskin called 'noble', but the artist had measured his strength and turned 'from the paths of imagination to those of historical and matter-of-fact representation'. Ruskin thought that the change had come at a propitious moment. Because of the destruction of monuments and places of beauty which was taking place at an accelerated pace all over Europe, 'he was anxious that pictures in modern days should be addressed to the representation simply of facts, to the representation either of architecture or scenery, of which the associations were likely to be swept away by what was called modern progress or improvement'.

This was a curiously limited role to be urged by the champion of Turner, who was still in the process of writing *Modern Painters*; nevertheless, the proposal repeats a theme which had appeared in Ruskin's pamphlet *Pre-Raphaelitism*, published in 1851. Questioning whether the artist had any useful function, Ruskin had there concluded that the artists' 'true duty' was, 'the faithful representation of all objects of historical interest, or of natural beauty existent at the period; representation such as might at once aid the advance of the sciences and keep faithful record of every monument of past ages which was likely to be swept away in the approaching era of revolutionary change.'[40] The main addition in the speeches on Seddon was the term 'historic landscape', which, as employed by Ruskin in 1857, had no resemblance to its traditional use to describe a type of idealised landscape incorporating historical events or figures. In the first volume of *Modern Painters* he had used the word 'historical' in a different sense, defining as 'historical' those truths 'which tell us most about the past and future states of the object to which they belong'.[41] He applied this concept to landscape, but he did not use the expression 'historic landscape'. In 1851 Ruskin emphasised the value of pictures as historical records; now he also assigned to them the role of substituting for travel. This idea did appear elsewhere in his criticism; for example he praised *The Scapegoat* for giving a perfect idea of a scene to people who could not see it for themselves.[42]

Holman Hunt had ideas about the value of a work of art similar to those of Ruskin. Shortly before leaving Jerusalem in 1855 he wrote to William Michael Rossetti:

I am not satisfied with the thousand books of travel that come out every year, but even these in all their triviality and superficiality are a keen reproof to painters. I have a notion that painters should go out two by two, like merchants of nature, and bring home precious merchandise in faithful pictures of scenes interesting from historical considerations or from the strangeness of the subject itself . . . in Landscape this is an idea which Lear has had some time . . . everything must be painted even the pebbles of the foreground from the place itself . . . I think this must be the next stage of P.R.B. indoctrination and it has been the conviction which brought me out here . . . I remember that Ruskin details a scheme corresponding in some degree but with some reservations as to the men to be thus employed.[43]

He felt that much of *The Scapegoat*'s value lay in conveying knowledge about the place. He also took a dutiful interest in recording traditional Eastern manners and customs that were about to disappear.[44] And, of course, he was much more responsible than Ruskin for Seddon's following the path of 'matter-of-fact representation'. Apparently Ruskin had not known Seddon before his Eastern trip, and had not, therefore, directly encouraged him. He never mentioned Seddon's painting on any other occasion; so it seems that

the two talks on Seddon were inspired by the special circumstances rather than by great admiration for his work. Nonetheless, in discussing Seddon's art, Ruskin expressed theories which were central in his assessment of Pre-Raphaelite landscape painting. The role that he ascribed to Seddon was that which he was to urge upon younger artists like John Brett, and he later measured Brett's *Val d'Aosta* by the same standards of historic landscape which he had used for Seddon.[45]

Jerusalem and the Valley of Jehoshaphat was the first – and for a long time, the only – Pre-Raphaelite picture in a public collection. It therefore attracted a degree of attention that otherwise it would hardly have deserved, and in books such as Richard and Samuel Redgraves' *Century of Painters of the English School*, published in 1866, or Philip Gilbert Hamerton's *Life of Turner*, published in 1878, it stood for the movement. Neither of these books had anything new or illuminating to say about Seddon's picture, but Hamerton's book elicited an objection from John Pollard Seddon, the artist's brother, who wrote to the *Athenaeum* in 1879. He accepted Hamerton's discussion of the picture as fair, but then pointed out that *Jerusalem and the Valley of Jehoshaphat* was exceptional in his brother's *œuvre*, and he went on to question the application of the term 'Pre-Raphaelite' to Seddon:

> I remember well his correcting me with earnestness when I applied to him the term 'Pre-Raphaelite', which Mr. Hamerton has in this passage used with regard to him. 'Do not call me so'; said he, 'I greatly admire much in the works of my friends who have assumed the name, but I do not wholly agree with them, and I have my own ideas as to painting, which I shall endeavour to work out independently'.[46]

Although this letter was written twenty-three years after Seddon's death, there is no reason to doubt that it reflected the artist's view of himself. *Jerusalem and the Valley of Jehoshaphat* is an exceptional work, and it may have seemed so to the artist. We have seen that due to the initially unfavourable reaction to this picture and to Seddon's other Eastern pictures, the artist did resolve to change his style, and the direction of this change was away from Pre-Raphaelitism towards a more conventional vision. Yet, because of Seddon's early death, he can not be said to have succeeded in working out his ideas independently. All of Seddon's landscapes were painted between 1852 and 1856. Consequently, his known *œuvre* has a unity and consistency which we can not find in the larger outputs, dating from much longer working careers, of artists such as Inchbold and Brett. In their careers, Pre-Raphaelitism was an interlude, as it might well have been in Seddon's had he lived longer. But in his few working years he was not able to emerge from the shadows of Brown and Hunt. Despite disclaimers, and despite the limited and derivative nature of the works themselves, Seddon was the purest Pre-Raphaelite landscape painter.

George Price Boyce

George Price Boyce was born in 1826. He was trained as an architect, and in 1846 he went to work for the firm of Wyatt and Brandon. Although after three years he gave up architecture to become a painter, buildings appear in many of his paintings, and they are always drawn with a sureness and precision that reflects his training. As a painter he worked primarily in watercolour; his first master was David Cox, whom he met in Wales in 1849.[1] Starting in 1851, Boyce kept a diary, which is an important source of information about Rossetti and other members of the Pre-Raphaelite circle, and entries for 1851, the first year in which he kept it, record lessons from Cox on a subsequent trip to Wales.[2] Cox's influence is evident in most of Boyce's early watercolours, and as late as the autumn of 1855 Boyce was painting broad atmospheric watercolours of Welsh scenery following Cox's example.

In 1849 Boyce met Thomas Seddon. The two painted together at Dinan in Brittany in 1853, and Boyce later bought Seddon's watercolour of *The Great Sphinx* (Pl. 103). Probably through Seddon, Boyce met Dante Gabriel Rossetti, who became his closest friend among the Pre-Raphaelite group. In 1858 Rossetti borrowed two sketches made by Boyce of Babbacombe Bay in Devon in 1853 to use for the background of his watercolour *Writing on the Sand* (British Museum).[3] Through Rossetti in 1853 Boyce met Hunt and Millais, and in the following year he met Ruskin. Shortly after Ruskin had first called upon Rossetti in the spring of 1854, Rossetti took him round to Boyce's to see two drawings by Rossetti in Boyce's collection. Ruskin also looked at some of Boyce's own drawings and started to give advice, which Boyce recorded in his diary:

> On my expressing my liking for after sunset and twilight effects, he said I must not be led away by them, as on account of the little light requisite for them, they were easier of realization than sunlight effects. He was very friendly and pleasant and encouraging in manner, and showed no conceit, grandeur, or patronizing mien . . . He said he would be glad to call again and see my drawings.[4]

In the summer of 1854 Boyce went to Venice on a trip apparently inspired by Ruskin. Two letters from Ruskin to Boyce, dated 14 and 28 June 1854, were obviously written in reply to requests for advice. In the first, Ruskin apologised for having encouraged Boyce to travel: 'I am vexed at thinking that I have perhaps been partly instrumental in leading you into the expense and trouble of a long journey, when there was quite enough material to employ you delightfully nearer home.' He recommended that Boyce work in Verona and that in Venice he should draw the exterior of St Mark's: 'It answers precisely to your wishes, as expressed in your note, *near* subject – good architecture – colour – light and shade.'[5]

Boyce did commence a study of the exterior of St Mark's,[6] and in the second letter Ruskin applauded the undertaking: 'I am sure you will find it delicious.' However, Boyce seems also to have expressed an interest in the interior, which Ruskin tried to discourage: 'The outside is the finer study – the inside is too Rembrandtesque – too much dependent on flashing of gold out of gloom – which is always effective – but comparatively vulgar – and for the rest – exhausted in idea by many painters before now.'

This echoes the advice which Ruskin gave Boyce when they first met. In both cases, he inveighed against dark effects, and, although he did so because they were easy or

109 George Price Boyce, *Near the Public Gardens, Venice* 1854. Watercolour, 7³⁄₈ × 10⁵⁄₈. Private Collection.

vulgar, the advice also reflects the constant theme in Ruskin's criticism that clear delineation is more important than pictorial effectiveness. It is related to Ruskin's idea of the usefulness of recording monuments and places of interest, which he expressed in his pamphlet *Pre-Raphaelitism*, and which he here urged upon Boyce. He suggested that Boyce stop in Rouen on his way home, because northern architecture was being destroyed far faster than Italian. Three years later, Ruskin repeated this point more emphatically in his eulogies of Thomas Seddon.

Ruskin, when in Venice in 1852 preparing *The Stones of Venice*, had collected photographs of Venetian architecture, which he compared to his own drawings. Apparently Boyce did likewise, and his comments drew a reply from Ruskin in a note appended to his second letter: 'What you say of Calotypes is quite true – you know they not only misrepresent colour but violently exaggerate shadow and thereby lose all truth – except of drawing.' Extreme clarity, combined with an exaggerated perspective, gives many of Boyce's later watercolours what might be considered a photographic look. In 1865, he bought five photographs from Julia Margaret Cameron ('for which, being an artist, I paid half-price'),[7] but there is no evidence that Boyce ever used photographs for his own work, and in 1854 he and Ruskin seem to have been in complete agreement about the failings of the medium.

Boyce remained in Venice and Verona until November 1854. In December, in London, he attended a lecture by Ruskin at the Architectural Museum. After the lecture the two men spoke. Ruskin immediately invited himself to look at Boyce's recent drawings and expressed the hope that Boyce was by now 'a confirmed Pre-Raphaelite'.[8] As we have noted, in 1855 Boyce was still painting Welsh scenery in a style that was almost the antithesis of Pre-Raphaelitism, and his Venetian watercolours also reveal him as far from being a 'confirmed Pre-Raphaelite'. A number of the Venetian views are remarkably broad and atmospheric (Pl. 109). On coarse paper, like that often used by Cox, and in a murky, almost monochromatic palette, they show that Boyce still retained his liking for twilight despite Ruskin's advice. Boyce also made more careful architectural studies in Venice and Verona, and these come closer to being the kind of careful record urged by Ruskin (Pl. 110). However, Boyce had drawn architectural subjects before 1854, notably in Westminster Abbey,[9] and it is difficult to see any distinctly Pre-Raphaelite quality in the drawings from his trip.

In the summer of 1856 Boyce went to Switzerland, to Giornico in the Ticino Valley between Bellinzona and the St Gothard Pass. This was a region that Ruskin frequently visited and wrote about (he had recently studied the topography of the Ticino in preparation for his discussion of Turner's *Pass of Faido* in the fourth volume of *Modern Painters*, published in 1856), so it is probable that this trip was inspired by Ruskin as well. At Giornico, Boyce injured his hip while 'giving chase to a trio of country lasses'. This injury was serious enough to force him to stop work for a long period. To the Pre-Raphaelite exhibition in Russell Place and the American Exhibition of British Art of 1857 he sent works dating from before 1856. In 1857 he did paint his one oil painting now known, a rather conventional and thinly painted *Girl by a Beech Tree* now in the Tate Gallery, and he exhibited two works that seem to have been in oil at the Royal Academy in 1858.[10]

After 1858 Boyce returned to watercolour, and in the following few years he did become a confirmed Pre-Raphaelite. Much of his work from this period shows scenery

110 George Price Boyce, *Tomb of Cangrande della Scala, S. Maria Antica, Verona* 1854. Watercolour, 15 × 11. Lyman Allyn Art Museum, New London, Connecticut.

on and near the Thames between Reading and Oxford. A good example is *The Mill on the Thames at Mapledurham* (Pl. 111), which is signed and dated July 1860. The subject is a picturesque complex of rustic buildings, which are delineated in minute detail. The colours, especially the greens of the foliage, are bright and quite unlike those of Boyce's watercolours of the early 1850s. The effect is one of rural domesticity, rather than natural grandeur. The space is strictly limited by the buildings and trees running across the picture, and it is populated by minutely drawn genre figures, ducks, and domestic animals. An engaging, somewhat whimsical, personal quirk in many of Boyce's depictions of architecture is the barely noticeable inclusion of people and occasionally pets – a cat in this example – looking out of windows and doorways: details so tiny that they are easily overlooked, but giving a compelling, yet playful, dimension of life to the structures the figures inhabit.

The sense of intimacy is even greater in *At Binsey, near Oxford* (Pl. 112), which is dated September 1862. A mother and child are seated in the foreground; two guinea-hens scavenge in the grass before them; and a rustic fence and farm buildings close off the view. The foliage of a pair of trees fills the upper half of the composition, forming a screen of delicately drawn leaves across the surface of the picture. There are, of course, birds in the branches (see detail, p. 238). Screens of trees through which farm buildings may be seen appear in a number of other watercolours. A beautiful earlier example is *Streatley Mill* of 1859, which also has a pair of figures reclining in the foreground reminiscent of those in Ford Madox Brown's *English Autumn Afternoon*. A later example is *Windmill Hills, Gateshead-on-Tyne* of 1864–5, in which the murky city of Newcastle is faintly visible in the background (Laing Art Gallery, Newcastle upon Tyne).[11]

Many of Boyce's other watercolours from the 1860s also show restricted spaces and emphasised foregrounds. Most appealing is a work from 1863, *Red Barn at Whitchurch* (Pl. 113), showing an enclosed barnyard in whose straw-filled foreground small pigs seem to swim, their black silhouettes rising gracefully out of the straw like porpoises out of the sea. A watercolour in the Tate Gallery, *Landscape at Wotton, Surrey: Autumn*, dated 1864–5 (Pl. 114), has a field with crows in the foreground and a fence running in sharp perspective to a red-brick building in the distance. In this work and in others by Boyce,

111 George Price Boyce, *The Mill on the Thames at Mapledurham* 1860. Watercolour, 10½ × 22. Fitzwilliam Museum, University of Cambridge.

112 George Price Boyce, *At Binsey, near Oxford* 1862. Watercolour, 14¹¹⁄₁₆ × 21¼. Cecil Higgins Art Gallery, Bedford.

the spatial relationships often recall those in pictures by Ford Madox Brown. The emphasised foreground and relatively small building are like those in *Carrying Corn* (Pl. 25) and *The Pretty Baa-Lambs* (Pl. 13). The screen of trees in *At Binsey* is similar to the screen of trees through which the landscape is seen in Brown's watercolour *Hampstead from My Window* (Pl. 27), and there is yet closer compositional similarity in a later and broader watercolour, *From a Window at Ludlow* of 1871 (Pl. 115).

Boyce's first foreign travel after his accident at Giornico was to Egypt in the winter of 1861–2. There he shared a house in Giza with two artists, Egron Lundgren and Frank Dillon, neither of whom had any Pre-Raphaelite connections. Probably inevitably owing to the nature of the place and perhaps also reflecting the influence of his companions, Boyce's Egyptian watercolours look quite unlike his English subjects from just before and after his trip, and perhaps because Egypt did not invite the same kind of close intimacy as the domestic landscape, they do not seem very Pre-Raphaelite.[12] They show their subjects in relatively conventional topographical views and convey little of the excitement of discovery of a radically unfamiliar world that we see in Holman Hunt's Egyptian watercolours. At their most ambitious, they seem like broader and simpler versions of John Frederick Lewis's Eastern subjects, without Lewis's virtuosity. Boyce left Egypt before his two companions, and, back in London in April 1862, he showed Rossetti the results of his trip. Rossetti 'did not like what I had done in the East. Said that all things that artists brought from the East were always all alike and equally uninteresting.'[13]

In the middle of the 1860s Boyce's art began to lose the bright colouring and minute detail of his work of a few years earlier. While throughout his life most of his work retained a distinctive precision and clarity, many of his works from the 1870s and 1880s such as *From a Window at Ludlow* (Pl. 115) show a loosening of touch. In 1862 Boyce took Rossetti's old rooms in Chatham Place, Blackfriars, overlooking the Thames. Like Rossetti, he was a friend of Whistler; and in February 1863 Whistler began an etching of the Thames from Boyce's window. Boyce himself also made studies of the river and its urban surroundings. In June 1863, he recorded in his diary that he had made 'a study

113　George Price Boyce, *Red Barn at Whitchurch* 1863. Watercolour, $8^1/_{16} \times 11^5/_{16}$. Ashmolean Museum, Oxford.

114 George Price Boyce, *Landscape at Wotton, Surrey: Autumn* 1864–5. Watercolour, 9¾ × 13¾. Tate Gallery, London.

115 George Price Boyce, *From a Window at Ludlow* 1871. Watercolour, 5½ × 7⅞. National Gallery of Scotland, Edinburgh.

of moonlight effect on river from my balcony',[14] and, in an exhibition of sketches in 1866, he exhibited, as 'Rough Night-Sketch of the Thames Near Hungerford Bridge', an example of this kind of study (Pl. 116), which he had evidently made somewhat earlier.[15] This activity was well before Whistler started painting the Thames at night around 1870, and it is tempting to think that Whistler's interest in nocturnal views of the river might owe something to Boyce. In 1854 Ruskin had tried to discourage Boyce's liking for 'after sunset and twilight effects'. The artist's renewed interest in the poetry of night and moonlight is symptomatic of the breakdown in the 1860s of the Pre-Raphaelite impulse toward strict objectivity.

Boyce was elected an associate member of the Old Water-Colour Society in 1864 and a full member in 1878. He died in 1897 after a long career of producing competent and attractive, if slightly dull watercolours. He had independent means and was perhaps as avid a collector as an artist (he owned works by Corot, Daubigny, and Delacroix, as well as by Rossetti, Seddon, and Inchbold). His diary shows that he was always modest about his own work, and it was apparently because of his unassuming nature that he took so long to advance from associate to full membership in the Old Water-Colour Society. In later years, he did have one vocal admirer, the Pre-Raphaelite-turned-critic, F. G. Stephens. In Stephens's descriptions of English private collections, which appeared periodically in the *Athenaeum*, Boyce's works invariably received glowing praise. Thus, a larger version of the *Red Barn at Whitchurch*, which Stephens saw in the collection of Isaac Lowthian Bell near Durham, was singled out because of the breadth and dignity with which the artist had treated 'homely, if not ignoble materials'. As the Bell collection contained a sizeable group of works by Boyce, Stephens began his article about the collection with a general discussion of Boyce's art: 'He comes nearer to Mr. Holman Hunt among living artists in his execution, which is faithful, strong, elaborate, powerful in colour and tone, and marked by learned and careful drawing . . . Their nearest point of resemblance is, that they are, probably, the two most uncompromising realists in Europe.'[16] This is a strong statement, claiming much more than Boyce would have

claimed for himself. If, in perspective, it seems remarkably insular, it does suggest that there was at least a distinct individuality to Boyce's art, visible beyond the artist's modesty and the limitations of scale and medium. Following his death in 1897, Boyce was largely forgotten as an artist, remembered, if at all, mainly because of his diary and the glimpse that it gives us of Rossetti and his milieu. An exhibition at the Tate Gallery in 1987 put his art back on the map and brought recognition of the distinctively subtle beauty to be found in it.

116 George Price Boyce, *The Thames by Night from the Adelphi c.* 1860–2 (exhibited 1866). Watercolour, $8^{3}/_{4} \times 13^{1}/_{8}$. Tate Gallery, London.

John William Inchbold

Inchbold was an artist of greater ambition and stature than either Seddon or Boyce, but until 1993, when he was the subject of a comprehensive exhibition with an authoritative catalogue,[1] he was largely forgotten, and he remains an elusive figure. He was a bachelor 'of a sensitive and retiring disposition', who left relatively few traces of his life other than his art. The most complete early account of his life appeared in the catalogue of a modest memorial exhibition held in the year of his death, and already for the anonymous author of that brief notice many of the details of the artist's life seem to have been cloaked in obscurity.[2]

Inchbold was born in Leeds in 1830 and came from a prosperous middle-class family. His father, who died when John William was two years old, had been an editor and proprietor of a newspaper, the *Leeds Intelligencer*. Inchbold had some instruction in drawing in Leeds, and then went to London at the age of sixteen or seventeen to learn lithography in the firm of Day and Haghe, with which his family had connections through publishing. He also studied at the Royal Academy schools, and in 1849 and 1850 he exhibited watercolours at the Society of British Artists.

There are watercolours by Inchbold from 1849 showing subjects on the Yorkshire coast near Leeds (Pl. 117; his first exhibited watercolour in 1849 was *Scarborough and Whitby Point, from Filey Rocks*), and from 1849 and 1850 showing views on the Thames (Pl. 118). These early works are remarkably broad, displaying nothing of the prevailing early Victorian tendency toward careful detail, much less any evident awareness of Pre-Raphaelitism. The Thames sketches record the atmospheric effects of certain times of day, chiefly dawn, and the transparent washes, which make even St Paul's appear to be dissolved in light and atmosphere, bring to mind on a less accomplished level some of Turner's watercolour sketches made on his first trip to Venice in 1819, such as the celebrated *San Giorgio Maggiore, Sunrise* (Tate Gallery), which it seems unlikely that Inchbold could have known. An older artist whose work he presumably did know well at the beginning of his career was David Roberts, as Day and Haghe were producing the magnificent lithographic illustrations of Roberts's *Views in the Holy Land, Syria, Idumea, Egypt, and Nubia* at precisely the time of Inchbold's apprenticeship there.

In 1851 Inchbold exhibited two watercolours at the Royal Academy, and in the following year he exhibited a single work, apparently in oil. None of these works can now be identified. The titles of the two watercolours, 'Study from Nature – Evening' and 'Sketch in November', suggest that these works continued the artist's interest in atmospheric effects of the two previous years, but in 1852 there evidently was a change. Inchbold's exhibited picture was titled 'A Study', which does not tell us much, but William Michael Rossetti, in his review of the Royal Academy exhibition in the *Spectator*, classed it with Collins's *May, in the Regent's Park* (Pl. 78) and a picture by William Millais as an example of the progress of Pre-Raphaelitism in landscape painting. The subject, according to William Michael, was a tree-stump and scattered leaves.[3]

This is the first mention of Inchbold in connection with Pre-Raphaelitism. We do not know how or when he came into contact with the group, but as a young artist around 1850 he would have had abundant exposure to the new movement. In the following years Inchbold became a rather uneasy personal associate of the Rossettis. There are several references to him in Dante Gabriel Rossetti's letters, but their tone is usually less than affectionate: 'I hate Inchbold or should be happy to call on him with you'; 'Inchbold

Facing page: John William Inchbold, *The Chapel, Bolton* (detail of Pl. 119).

117 John William Inchbold, *Flamborough Head* 1849. Watercolour, 9½ × 12¼. Private Collection.

118 John William Inchbold, *Thames, Early Morning c.* 1849. Watercolour, 10 × 14. Yale Center for British Art, New Haven.

is less a bore than a curse'.[4] To this latter pronouncement, William Michael Rossetti, who edited the letters, added the protest that he knew Inchbold well and liked him, but he had to admit, 'there was in him something between uneasy modesty and angular self-opinion, not promoting smoothness of intercourse.'[5] Inchbold was also a friend of Swinburne, who in the autumn of 1864 spent three months with him in Cornwall, working on 'Atalanta in Calydon'. Following Inchbold's death in 1888, Swinburne wrote an ode in his memory, and in a letter written at the same time gave another hint of Inchbold's quirkiness of character: 'He had not many friends, being very shy and rather brusque in manner, so that people were apt to think him odd.'[6] For Swinburne, Inchbold was 'a very old and dear friend', whose apparent oddness was far outweighed by his 'inexhaustible kindness and goodness, and his beautiful sincerity and simplicity of character'. In 1869, when Inchbold was on hard times, even Dante Gabriel Rossetti, his previous opinions notwithstanding, took a central role in organising a lottery on his behalf.[7]

Inchbold's Pre-Raphaelitism is very evident in what was apparently his second oil painting to be shown at the Royal Academy, *The Chapel, Bolton*, exhibited in 1853 (Pl. 119). The subject is drawn from his native Yorkshire; the ruins of Bolton Abbey are less than twenty miles from Leeds. In the Royal Academy catalogue he accompanied the picture with two lines from the first canto of a poem by Wordsworth, 'The White Doe of Rylstone', which is set at Bolton:

> Nature softening, and concealing,
> And busy with a hand of healing.

119 John William Inchbold, *The Chapel, Bolton* 1853. Oil on canvas 25½ × 33. Northampton Art Gallery.

Although the picture has nothing to do with the narrative content of the poem and is more than an illustration of these lines, the subject is in close accord. It is not a topographically informative view of the ruins, but a picture of crumbling stone, covered by lichens and ivy, and surrounded and partly hidden by foliage and flowers (see detail, p. 148).

The composition of *The Chapel, Bolton* echoes in reverse that of the watercolour of *c.* 1849, *Thames, Early Morning*, being based on architectural mass receding diagonally into the picture. This similarity is not coincidental; Inchbold relied on a few compositional formulae, which he repeated over and over throughout his career. Similar spatial recession can also be seen in some of his watercolours of the Yorkshire coast (Pl. 117). But, while *The Chapel, Bolton* and *The Thames, Early Morning* may have similar compositions, they are completely different in effect, and the difference is due to Pre-Raphaelitism. The painting has the hallmarks which we have seen in pictures such as Millais's *Ophelia* and *Huguenot* of a year earlier: microscopic detail, bright colours, and shallow space. There is none of the feeling of atmosphere which plays a large role in the earlier watercolour, and the mass of the building, instead of forming a *repoussoir* leading the eye to a distant vista, creates a barrier which is continued by the trees on the left. As in Millais's works, botanic detail fills a large part of the picture, and the beauty of the conscientiously delineated leaves, blossoms and ancient stone gives the picture most of its charm. When we compare it to the earlier watercolour we can see the price Inchbold paid for this charm. So could the critic for the *Art Journal*, who, when it was exhibited in 1853, dismissed it with one sentence: 'This picture very much requires the relief of light and warmth'.[8]

At the Royal Academy in 1855 Inchbold exhibited a second picture painted at Bolton Abbey (Pl. 120). Again he included lines from 'The White Doe of Rylstone' in the catalogue:

> And through yon gateway, where is found,
> Beneath the arch with ivy bound,
> Free entrance to the churchyard ground,
> Comes gliding in with lovely gleam,
> Comes gliding in serene and slow,
> Soft and silent as a dream
> A solitary Doe!

Wordsworth's poem begins with a description of a crowd gathering for a service in the chapel, which still exists within the ruins of Bolton Abbey. As soon as the people have gone inside, the doe appears, as described in the lines quoted. In subsequent lines the people leaving the chapel see the doe and discuss her as part of the legend of Rylstone, the telling of which forms the substance of the poem.

Here, the picture illustrates the poem: the white doe does appear before the gateway to the churchyard. But beyond that there is no narrative element. No people are present, and there is little feeling of their proximity. The mood of solitude is enhanced by a rabbit, not mentioned in the poem, sitting on the ground to the left of the doe. The interest in the picture, as perhaps inevitable in a landscape painting, is not in the story but in its setting: in the ruined walls and the view over the valley of the Wharfe beyond.

The background view, which is lovely in its own right, is more extensive than that in the earlier Bolton picture, but it is still severely restricted to what can be seen through the arched opening of the walls and forms a tiny part of the composition, less than one twelfth of the total picture surface. For the rest, the painting is a picture of foreground grass and stone walls, and, as such, it is another variant of a standard Pre-Raphaelite type stemming from Millais's *Huguenot*, although as Inchbold's deer is thematically and proportionately less important than Millais's lovers, the background is more important and more elaborate. An arch in one wall reveals a second wall, which is embellished by a blind arcade as well as by the arched opening to the landscape beyond. But essentially the effect of the picture is one of two-dimensional surfaces enriched by the two-dimensional details of ivy, lichens, and the colour and texture of the stone.

As in Inchbold's earlier picture of Bolton, and indeed all his other oil paintings from the 1850s, the paint is thinly applied over a white ground, in some places so thinly that the white shows through unaffected by the local colour. The result is quite distinctive and cooler, less harsh, than that of the colours in the early pictures by Millais and Hunt. The artist clearly had trouble in painting the doe, and the very noticeable *pentimenti* around the legs are a reflection of the difficulty of retouching when painting in transparent colours over a white ground.

120 John William Inchbold, *At Bolton (The White Doe of Rylstone)* 1855. Oil on canvas, 27 × 20. City Art Gallery, Leeds.

121 (facing page) John William Inchbold, *A Study in March (In Early Spring)* exhibited 1855. Oil on canvas, 20 × 13½. Ashmolean Museum, Oxford.

At the Royal Academy in 1855 Inchbold exhibited two additional pictures. One was *A Study in March*, which he accompanied with another quotation from Wordsworth, from Book I of *The Excursion*: 'When the primrose flower peeped forth to give an earnest of the spring'. This can be identified as an undated picture in the Ashmolean Museum, also called *In Early Spring* (Pl. 121), which has primroses in the foreground and is sufficiently small and restricted in subject to have been called a study. The distant background is of little importance, and most of the picture consists of a foreground slope, upon which the primroses grow, and bare trees, whose leafless branches form a filigree against the sky. Beneath the largest tree are a ewe and two lambs, which, like the primroses, are part of the new life of spring.

In light of the fact that the three pictures by Inchbold which we have so far considered were all accompanied in the Royal Academy catalogues by quotations from Wordsworth, it is worth recalling that Ruskin in the first volume of *Modern Painters* had held up a passage form Wordsworth as an example of careful finish:

The thoroughly great men are those who have done everything thoroughly, and who, in a word, have never despised anything, however small, of God's making, and this is the chief fault of our English landscapists, that they have not the intense all-observing penetration of well-rounded mind; they have not, except in one or two instances, anything of that feeling which Wordsworth shows us in the following lines:

So fair, so sweet, withal so sensitive; –
Would that the little flowers were born to live
Conscious of half the pleasure which they give.
That to this mountain daisy's self were known
The beauty of its star-shaped shadow, thrown
On the smooth surface of this naked stone.

That is a little bit of good, downright, foreground painting – no mistake about it;
daisy, and shadow, and stone texture and all. Our painters must come to this before
they have done their duty.[9]

In 1856, in the third volume of *Modern Painters,* Ruskin cited this passage when
defending himself against charges of inconsistency for praising both Turner and the Pre-
Raphaelites: 'Our painters did come to this, did do their duty, and did paint the daisy
with its shadow'.[10]

Ruskin and the Victorians have been criticised for admiring Wordsworth for the
wrong reasons, for his minute fidelity of natural description, when, in fact, this was not
one of the poet's real interests. One critic has suggested that the quotations from
Wordsworth in the first volume of *Modern Painters* would only strike the eye of a man
concerned about such things.[11] There is some truth to this; most students of poetry cite
Girtin or Constable in relation to Wordsworth, not Inchbold. Nonetheless, the descrip-
tions that Ruskin quoted are in the poetry, and a painter like Inchbold obviously felt an
affinity. Inchbold himself wrote verse, publishing in 1876 a volume of sonnets entitled
Annus Amoris, and many of his poems, bearing such titles as 'Early Spring' or 'Love's
Autumn Buds', show a heavy debt to Wordsworth. Yet, although the foreground of *A
Study in March* is painted with a care which Ruskin (who called it 'exceedingly beauti-
ful')[12] might have found worthy of Wordsworth, the passage accompanying the picture
in the Royal Academy catalogue does not describe the primrose, but cites it as the
embodiment of a season. In the painting, the individually studied flowers are not ends in
themselves, as they sometimes seem to be in Ruskin's discussions, but parts of a larger
nature. The details are factual, but not all fact is prosaic, as we can see in Wordsworth, and
in much of Ruskin. The subject of the picture is not botanical illustration, but the poet-
ry of the season, and this is a subject fully in harmony with the poetry of Wordsworth.

Inchbold painted a few other comparably close – or closer – studies of natural detail.
He exhibited one, *A Study, 'The Common Grass',* at the British Institution in 1854, and
another, *Mid-Spring* (Pl. 122), at the Royal Academy in 1856, accompanying the latter with
a line by Tennyson: 'You scarce can see the grass for flowers'. The picture shows a path
through a forest, but it is all foreground, with no sky and hardly any depth. The lower half
is full of minutely painted bluebells, or wild hyacinths, and the whole is a tour-de-force
of concentrated focus, as well as painstaking elaboration. As the *Art Journal* wrote, 'The
flowers certainly faded, the grass withered, and the leaves fell before this picture could
have been painted'. Even Ruskin felt that Inchbold had taken an impracticable project
and in *Academy Notes* urged the artist to choose subjects with more mass of shade.[13]

Paintings such as *A Study in March* and *Mid-Spring* are Inchbold's most characteristi-
cally Pre-Raphaelite works. But the almost exclusive concentration upon foreground
detail, which distinguishes them, was not his only concern. During the same period,
1853–6, he painted another group of pictures which show extensive landscape views. The
first of them is *Anstey's Cove, Devon* (Pl. 123). Although signed and dated 1854, this paint-
ing must have been substantially painted in 1853, as it was completed by April 1854, in
time to be submitted to the Royal Academy. It was rejected, but before that happened
Millais saw it among the pictures sent in to the Academy and described it in a letter to
Holman Hunt as 'a lovely landscape with the sea and cliffs (not in the least like yours)
quite original and exquisitely truthful and refined'.[14] Millais's 'yours' must have been
intended to refer either to Hunt's *Strayed Sheep* (Pl. 52), exhibited at the Royal Academy
the year before, or to the still unfinished *Fairlight Downs – Sunlight on the Sea* (Pl. 54), and
he was right to tell Hunt that *Ansteys Cove* was not in the least like them. As a view of
rocky cliffs and sea it is more like Inchbold's own watercolours of the Yorkshire coast
made in 1849 (Pl. 117). *Anstey's Cove* is clearly Pre-Raphaelite; the colours are bright
throughout, and the foliate detail in the foreground is as beautifully and delicately drawn
as that in Inchbold's more intimate studies. The sea-mews in flight recall and may have
been partly inspired by the swallows in Hunt's *Hireling Shepherd*. But Pre-Raphaelitism
is here welded on to older types of landscape composition. The curving shore line, seen
from above, recalls not only Inchbold's pre-Pre-Raphaelite watercolours, but also seven-
teenth- and eighteenth-century views of the Lakes of Albano and Nemi by Claude

122 John William Inchbold, *Mid-Spring*
exhibited 1856. Oil on panel, 20½ × 13½.
Private Collection.

Lorraine, Richard Wilson, and John Robert Cozens. There is no evidence of how aware
Inchbold may have been of such earlier works, and if we compare his picture with any
of them the differences are as evident as and more important than the similarities. The
sky is of minor importance in the Inchbold, and there is none of the vaporous sugges-
tiveness of a Cozens: the cliffs on the far side of the cove are clear and hard, precisely
faceted and brightly coloured. It can be argued that the composition was dictated by the
configuration of the place depicted, but the artist chose his subject and his vantage-
point, and in his later works views from high vantage-points looking over curving shores
appear repeatedly. These compositions are a type of the plateau landscape, which we have
seen used by other Pre-Raphaelite artists, but Inchbold's use of the high foreground is
not markedly similar to that in Brown's *English Autumn Afternoon* or Seddon's *Léhon, from
Mont Parnasse*, which are roughly contemporary. No human figures are visible in *Anstey's
Cove*, and it has none of the cosy intimacy of Brown's and Seddon's landscapes. The sub-
ject is not Inchbold's domestic environment, but a place of impersonal scenic grandeur.
Comparable scenery can be seen in another Devonshire landscape, which is also signed
and dated 1854 (Pl. 124). This picture, which was left to the Tate Gallery by Inchbold's

123 John William Inchbold, *Anstey's Cove, Devon* 1853–4. Oil on canvas, 19⅞ × 26¹³/₁₆. Fitzwilliam Museum, University of Cambridge.

chief patron, Sir John Russell Reynolds, has been variously called *The Dewar-Stone, Dartmoor* and *The Moorland*. It evidently is the picture which Inchbold exhibited at the Royal Academy in 1855 as *'The Moorland' – Tennyson*. It has none of the smiling sunny attractions of flowers, sea and sky of *Anstey's Cove*; rather it is a murky view over a vast and barren landscape, inhabited in the foreground by a solitary and sinister raven or crow. Although only the words 'The Moorland' (in quotes) accompanied the picture in the Royal Academy catalogue, they were there ascribed to Tennyson, and Ruskin's editors subsequently identified them with a line from 'Locksley Hall' – 'o the dreary, dreary moorland! o the barren, barren shore!' – which is not inappropriate to this dreary and barren prospect.¹⁵ The Dewar (or Dewer) Stone is a cliff overlooking the River Plym on the south-western edge of Dartmoor.

Even more inhospitable and remote is the terrain shown in *The Cuillin Ridge, Skye* (Pl. 125). This picture is not dated, but it can be identified as *The Burn, November – The Cucullen Hills*, which Inchbold exhibited at the Royal Academy in 1856. 'Cucullen' is one of the many variants of 'Cuillin', the name of the bare and precipitous range of mountains on the Isle of Skye in the Hebrides, off the western coast of Scotland. In the foreground there is carefully painted foliage, like that in the foreground of *Anstey's Cove*, but it is squeezed into a corner, and behind it the burn forms a barrier blocking rather than encouraging our entrance into the further landscape. There are a few hardy sheep on the hills in the middle distance, but no humans are present, and there are no roads, cottages, or other marks to indicate that people have ever penetrated this forbidding land. None of Inchbold's other known early pictures show any figures either, but subjects such as Bolton Abbey at least imply that someone was there once.

In many of Inchbold's titles indications of time are more important than indications of place. For example, his two watercolours at the Royal Academy in 1851 were *Study from Nature – Evening* and *Sketch in November*. In 1855 came *A Study in March* and in 1856, *Mid-Spring*. In the title of *The Burn, November – The Cucullen Hills* both time and place

JOHN WILLIAM INCHBOLD

124 John William Inchbold, *The Moorland (Dewar-Stone, Dartmoor)* 1854. Oil on canvas, 13³/₄ × 20¹/₂. Tate Gallery, London.

are specified, and in the picture both are important. The mountains are painted with a hard clarity, which demands our belief in their topographic accuracy,[16] but they are also seen under the long shadows of evening. Before them hangs a thin strip of cloud, which is both a specific temporal effect, and a reflection of the extraordinary atmospheric effects for which Skye is famous. Over the distant horizon, to the right of the mountains, is an orange and purple sunset. It forms a relatively small part of the picture as a whole, but departs from the clear sunlit detail in most earlier Pre-Raphaelite paintings. In 1856 Millais's *Autumn Leaves* and Holman Hunt's *Scapegoat*, both with sunset backgrounds, also appeared at the Royal Academy; so Inchbold's sunset can be explained as part of a larger redirection in which Pre-Raphaelite artists started to pay attention to atmospheric and temporal effects. But in his case, such attention was not an entirely new departure. In '*The Moorland*' of 1854 the distance is lost in purple haze, and enough of Inchbold's early watercolours from 1849 and 1850 show atmospheric effects of dawn and evening to make the sunset in *The Cuillin Ridge* seem like a continuation or revival of a pre-Pre-Raphaelite preoccupation.

Despite the departure from strict Pre-Raphaelitism that Inchbold's interest in atmospheric effects might imply, the works which he exhibited in the years 1852 through 1856 established him as the most prominent Pre-Raphaelite landscape painter. In 1857, in a letter describing the artists participating in the American Exhibition of British Art, William Michael Rossetti wrote that Inchbold ranked 'perhaps highest of the strictly Pre-Raphaelite landscape painters', and he added as an inevitable corollary, 'Much praised by Ruskin'.[17] Ruskin had known Inchbold since at least 1854, when he wrote his letter to *The Times* explaining Holman Hunt's *Light of the World*. The first version of the letter had also included remarks about Inchbold and Charles Robert Leslie. When the letter was not printed, Ruskin, thinking it too long, eliminated the comments about Leslie and Inchbold and resubmitted it.[18] We do not know what he said about either artist, but as Inchbold's picture of that year, *Anstey's Cove*, was rejected by the Academy, Ruskin must have protested. Also, as he could not have seen the picture on the Academy's walls, we can assume that he saw it in the artist's studio. In March of the following year he borrowed one of Inchbold's pictures to show to Charles Kingsley to convert the writer to Pre-Raphaelitism. In May he put off visiting Rossetti so that he could see Inchbold before Inchbold left town,[19] and in the same month, in the first *Academy Notes*, he proclaimed '*The Moorland*' 'the only thoroughly good landscape' in the Royal Academy exhibition. In 1856 Ruskin criticised Inchbold's choice of subject in *Mid-Spring*, but he praised the 'exquisite painting of withered heather and rock' in *The Burn, November – The Cucullen Hills*, and in the summer he met Inchbold at Lauterbrunnen in Switzerland. In 1857 Ruskin did not go to the Alps, but he commissioned four drawings of cottages from Inchbold, who was at Chamonix. In 1858 they were together for two weeks at Fluelen and Bellinzona in Switzerland.[20]

Although the documentation of their relationship is slight, not going much beyond the few dates and references just cited, it seems clear that Ruskin's interest in Inchbold

125　John William Inchbold, *The Cuillin Ridge, Skye (The Burn, November – The Cucullen Hills)* exhibited 1856. Oil on canvas, 20⅛ × 27⅛. Ashmolean Museum, Oxford.

was the result of the artist's application of Pre-Raphaelitism to landscape subjects. And it seems equally clear that Inchbold went to Switzerland directly or indirectly because of Ruskin. The Alps were one of Ruskin's passions. His own most ambitious drawings are of Alpine subjects. Long descriptions of the mountains fill his writings, and in *Modern Painters* he urged that more pictures be painted of the Alps.[21] As soon as Ruskin met Millais he invited him to Switzerland, and in one of his first published defences of the Pre-Raphaelite movement he fantasised about Millais's painting a mountain landscape.[22] Ruskin only succeeded in getting Millais as far as the Trossachs, but it was perhaps inevitable that, when a younger artist emerged who was a Pre-Raphaelite landscape painter, he would soon be in Switzerland, with Ruskin at his side. Ruskin not only commissioned Alpine subjects from Inchbold, he also worked to see that they were properly painted. A letter from Ruskin to his father gives a picture of the treatment:

> The two little drawings of which you speak in my bedroom are Inchbold's; the cottage, one I chose and made him draw at Lauterbrunnen; the Thun, bought when he couldn't sell anything, to help him a little. It isn't good for much, but is like a sweet Swiss evening. I wanted and ordered of him (paying him when he was at Chamouni last year) four more cottages; but he got entirely off the rails at Chamouni, and the cottages are failures. I stayed with him, or rather, made him stay with me, at Bellinzona, in order to make him understand where he was wrong. He was vexed with his work and, yet, thought it was right, and didn't know why he didn't like it, nor why nobody liked it. It was a delicate and difficult matter to make him gradually find out his own faults (it's no use *telling* a man of them), and took me a fortnight of innuendoes. At last I think I succeeded in making him entirely uncomfortable and ashamed of himself, and then I left him.[23]

In 1857, the year following his first visit to Switzerland, Inchbold exhibited one Alpine subject at the Royal Academy, *The Jungfrau, from the Wengern Alp,* and one at the Pre-

Raphaelite exhibition in Russell Place, *Mid-day on the Lake of Thun*. He exhibited nothing at all in London either in 1858 or 1859. In 1860 he sent the same or another *Lake of Thun* to the Royal Academy and a picture entitled 'Above Lucerne' to the Liverpool Academy. This picture may be *The Lake of Lucerne, Mont Pilatus in the Distance*, dated 1857, which is Inchbold's sole Alpine picture from these years now known (Pl. 126). Another, *A By-Path to Chamouni*, apparently from Inchbold's stay at Chamonix in 1857, was engraved in the *Art Journal* in 1871.[24] According to the short text which accompanied the plate, Inchbold painted the picture on the spot during a residence of several months near Sallanches, which is a few miles to the west of Chamonix.

Both *A By-Path to Chamouni* and *The Lake of Lucerne* show vast views, combining leaf-by-leaf foreground foliage with prospects of distant mountains. In *The Lake of Lucerne* the vantage-point is high above the lake, and the composition is built around the curve of the shore, like that of *Anstey's Cove*, but the foreground in *The Lake of Lucerne* is considerably less important than in *Anstey's Cove*. There are vines along a wall, and some branches with vines growing up them reach into the picture, but no ground plane is visible. This abbreviation of the foreground is comparable to that in the watercolours that Holman Hunt brought back from the East in 1856.

An even more noteworthy change from *Anstey's Cove* can be seen in the palette of *The Lake of Lucerne*. Whereas in the former picture the colours are bright, in the latter they are light. They are blues and greens, as in the earlier picture, but now so uniformly pale that the picture looks like a watercolour. Inchbold's method of allowing the white ground to show through almost unaffected by the local colour is particularly evident in the foregound leaves, but nowhere in the picture is there much depth of colour. Nor is there any feeling of the richness of oil paint, which, despite the detail, we can still feel in a picture such as *Anstey's Cove*. The painting appears to have been painted as thinly as

126 John William Inchbold, *The Lake of Lucerne, Mont Pilatus in the Distance* 1857. Oil on board, 14$\frac{1}{4}$ × 18$\frac{1}{2}$. Victoria and Albert Museum, London.

possible with a uniform stipple and a minimum of oil medium. The result is a uniformly flat, matt surface.

Despite or because of these 'peculiarities' (the term used by the *Art Journal* to describe the difficulties which the engraver of *A By-Path to Chamouni* had to overcome), *The Lake of Lucerne* is a jewel-like small painting, which makes the disappearance of Inchbold's other Alpine works from the 1850s seem a major loss. The feeling of almost visionary calm over the placid lake surrounded by mountains is akin to the mood that wafts over many of the Alpine watercolours of John Robert Cozens. It also seems to look forward to the more self-consciously subjective views of Alpine lakes by the Swiss painter Ferdinand Hodler. *The Lake of Lucerne* represents the end of Inchbold's truly Pre-Raphaelite pictures, but it is the most beautiful of them all.

It is difficult to determine what role Ruskin may have played in shaping a work such as *The Lake of Lucerne*. The location was one he loved and to which he repeatedly returned; Fluelen, where he met Inchbold in 1858, is on the shore of the lake. The effect of the distant mountains, with the outlines crisply drawn and the interiors lost in haze, is close to that in many of Ruskin's own drawings, and the similarity is heightened by the fact that Inchbold's picture looks so much like a watercolour. Yet all the evidence suggests that Ruskin did not think much of Inchbold's Swiss pictures. In his letter to his father, quoted above, Ruskin was scornful about Inchbold's drawings. In the *Academy Notes* for 1857 he ignored *The Jungfrau, from the Wengern Alp* except for a passing mention in a discussion of a picture by Daniel Maclise.[25] As Ruskin was the one critic from whom Inchbold could have felt that he deserved some attention, there certainly was implied disapproval in his silence. Ruskin's disapproval may have been the reason why the artist did not exhibit at all in 1858 and 1859. Neglect publicly and 'a fortnight of innuendoes' privately must have been discouraging to a man as touchy and insecure as Inchbold.

Since Ruskin did not discuss Inchbold's Swiss works, we can only speculate about why he was not enthusiastic about them. In 1856 he had criticised Inchbold for painting pictures without enough mass of shade, and he may have felt that the light palette of *The Lake of Lucerne* was a flagrant repetition of this fault. Also, he might well have felt that Inchbold relied too heavily on conventional compositional formulae, that the pictures were too composed, at the expense of a direct 'rejecting nothing, selecting nothing' approach. In his letter to his father, Ruskin did not specify what went wrong when Inchbold 'got entirely off the rails at Chamouni', but he was complaining about Inchbold's drawings rather than his paintings. His tepid praise of one drawing as 'like a sweet Swiss evening' tells us that the drawing embodied concerns of a sort that we have seen Ruskin discourage when advising Boyce a few years earlier.[26]

The artist's next known painting following *The Lake of Lucerne* was *Furze Blossom from Devonshire* (Pl. 127), which is signed and dated 1858–9. He exhibited it at Liverpool in 1860 and at the Royal Academy in 1861. As Christopher Newall points out, it must have been begun in May or June of 1858, before the fortnight of innuendoes from Ruskin in Switzerland in the summer. Devon was where Inchbold had previously painted *Anstey's Cove* and *'The Moorland'*, and in returning there he returned to an area which he knew and for which he clearly had some feeling, rather than painting scenery that had been pre-selected for him by Ruskin. He did not specify the site of *Furze Blossom*, but the terrain is much like that in *'The Moorland'*, and the relationship in scale between near and far distances is similar. Despite the vastness of the landscape falling away beyond, we see a group of rabbits in the foreground with surprising intimacy. In size and position, they correspond to the crow in *'The Moorland'*, but rabbits and crows carry very different associations, and the brilliant yellow furze blossoms, which fill half of the later painting, make it brighter, more cheerful, and more inviting than its predecessor. While seen closely, the blossoms are depicted more as a mass of colour than as individual flowers, like the bluebells in *Mid-Spring*, and consequently the painting has a largeness and compositional breadth that seems to turn away from Pre-Raphaelite elaboration of detail. Similar breadth allied with grandeur of scenery can also be seen in *King Arthur's Island, Tintagel, Cornwall* (private collection), one of three paintings of Cornish scenery that the artist exhibited at the Royal Academy in 1862.[27]

In the spring or summer of 1862 Inchbold went to Venice, where he evidently remained until 1864. William Michael Rossetti met him there in July of 1862,[28] and drawings by him of Venetian subjects are dated 1862, 1863, and 1864. In the spring of 1863 he submitted a Venetian subject, *Venice from the Public Gardens* (Pl. 128), to the Royal Academy; it was rejected but included in a small protest exhibition organised by Holman Hunt.[29] He also exhibited pictures of Venice painted or begun during this visit at the

127 John William Inchbold, *Furze Blossom from Devonshire* dated 1858–9; exhibited 1861. Oil on canvas, 24¼ × 35¼. Private Collection.

Royal Academy in 1865 and 1873, and there are others, which he did not exhibit, such as *On the Lagoon, Venice* (Pl. 129).[30]

In most of Inchbold's Venetian pictures the Lagoon is more important than the city proper. Because of that, they inevitably recall paintings of the Lagoon by Turner such as *Campo Santo, Venice* (Toledo Museum of Art) or *The Sun of Venice Going to Sea* (Tate Gallery), but some of the views over water also recall compositional formulae that Inchbold had employed ever since his Thames and Yorkshire watercolours of 1849. In *Venice from the Public Gardens*, which looks back toward San Giorgio Maggiore and the centre of the city from the eastern end of the island, we see a variant of his familiar shorelines, now moved from the left to the right-hand side of the picture. Other pictures show more radical departures. In *On the Lagoon*, the only land in sight is a thin strip across the horizon. The immediate foreground is open water, in which the brightly coloured sails of a fishing boat are reflected. This emptiness and the picture's limited range of pale blue and pink colours seem the antithesis of the highly detailed and brightly coloured Pre-Raphaelitism of the 1850s. While the early-morning calm may hark back to Inchbold's Thames watercolours of 1849 and 1850, the compositional simplicity and tonal harmony look forward to Whistler.

Because it shows the city after sunset, *Venice from the Public Gardens* seems even more Whistlerian. The fading sunset glow in the sky and its reflection in the still water show a feeling for crepuscular effects which we saw anticipated in 'The Moorland' and *The Cuillin Ridge* (and was presumably anticipated as well in Ruskin's 'sweet Swiss evening'), while the city itself is only a dark silhouette along the horizon. Its towers, causing long reflections in the water, and the pinpoints of light within the darkness have an effect similar to those which appear in Whistler's nocturnal views along the Thames and in the few oil paintings from Whistler's Venetian trip of 1879–80. While there is no recorded proof to establish that Whistler and Inchbold knew one another, as there is in the case of Boyce, they moved in the same circles, and during the mid-1860s were both close friends of Swinburne. They could not have failed to meet, and Whistler could not have escaped seeing Inchbold's art, whatever he may have subsequently remembered of it.

In 1865 and 1866 Inchbold was in Spain. A landscape with orange trees in the foreground, showing the coast near Valencia, is dated 1865 (Pl. 130). Another landscape, *Spring Time in Spain* (City Art Gallery, Birmingham), is the same size and apparently dates from the spring of 1866, although it bears the date 1869, when Inchbold completed and sold it.[31] Several related drawings are also known.[32] The paintings show spacious and populated agricultural landscapes, complete with farm buildings, of a sort he had not previously painted. Figures had started to appear in some of his Venetian paintings (see Pl. 128), and they have a real prominence in the Spanish pictures, as if the artist were making a conscious effort to humanise his heretofore impersonal art. However, neither people nor farms and farm buildings seem to have been of lasting interest to Inchbold, and these are the only works in which they play much of a role.

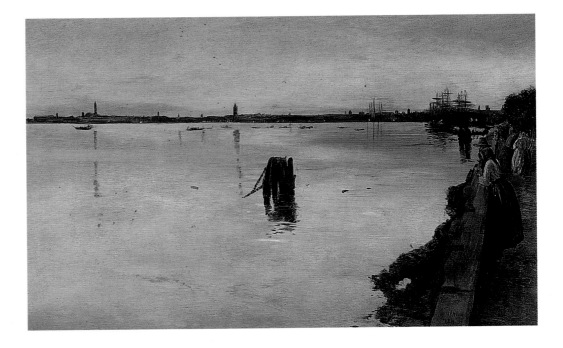

128 John William Inchbold, *Venice from the Public Gardens* exhibited 1863. Oil on canvas, 13½ × 20½. Private Collection.

In 1866 he also visited – or, at least, remembered – Yorkshire. Now in the Tate Gallery are three small oil sketches, two of which are inscribed 'Recollection – Barden Fells, 1866' and 'Recollection – Strid, Barden Tower, 1866' (Pls 131 and 132). An inscription on the verso of the third, *Peat Burning* (Pl. 133) is illegible. The Strid is a rapids on the Wharfe a few miles above Bolton Abbey; Barden Tower and Barden Fell overlook it. The sketches have little topographical detail, and, since they are titled 'Recollections', they were probably not painted on the spot. One bears Inchbold's London address, Lincoln's Inn Fields, along with his monogram and the date on the front of the picture. The three sketches are all broadly painted, and, although they show extensive landscapes, they are essentially two dimensional in effect. By 1866 we might well expect a certain two-dimensionality in the work of any artist moving in progressive circles, responding to the tendency to flatness appearing in the paintings of Burne-Jones, Whistler, and others during the decade, and it is possible that the sketches reflect an acquaintance on the part of Inchbold with Japanese prints. These small and private works represent a more adventurous side of his art than we

129 John William Inchbold, *On the Lagoon, Venice*, 1862–4. Oil on canvas, 15 × 28. City Art Gallery, Leeds.

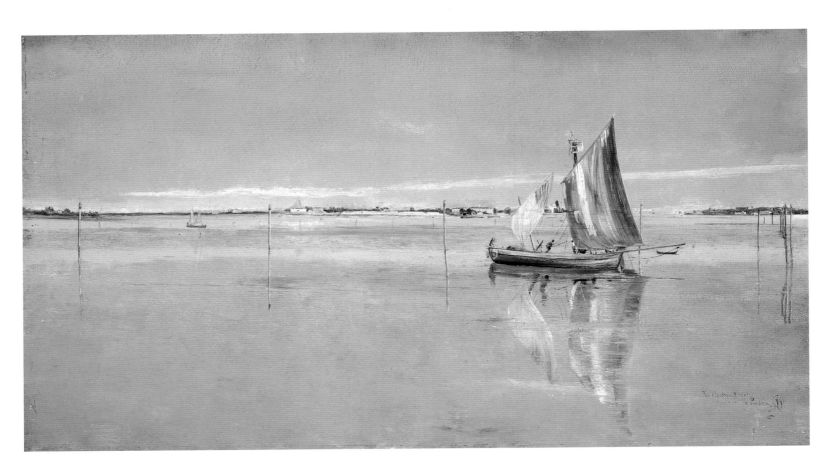

JOHN WILLIAM INCHBOLD

130 John William Inchbold, *Cordelia, Valencia*
1865. Oil on canvas, 12 × 18. Private
Collection.

see in the more finished works intended for exhibition and sale, but they share the somber mood evoked by the vast, empty landscape that provided him subject matter throughout his career. Here, in sketches, the murky colours and strong brushwork embody more overtly emotional content than he allowed to appear in other works. That content is most evident in *Peat Burning*, the boldest of the sketches, in which the foreground is filled with red flames.

The drama of the oil sketches can be seen on a more public scale in *Stonehenge from the East* (Pl. 134), Inchbold's largest painting, which was rejected by the Royal Academy in 1869. This picture shows the monument under a cloudy sky, with the rays of the setting sun filtering through the stones. Following its rejection by the Royal Academy, Inchbold exhibited it in a 'Select Supplementary Exhibition' of refused pictures, and he wrote to both William Michael Rossetti and the collector James Leathart trying to sell it. To the former, he explained his ambitions in the picture:

I have tried to secure architectural grandeur and natural sublimity, especially that religiousness by the introduction of the sun setting in the very centre of the altar-like portal; whilst the clouds are meant to suggest what is at once fiery and spiritual, the forms being (as often in nature) scarcely draped in cloudy matter. At the base is a barrow of the big past about which the everlasting flowers are opening seed-petals to the wind.[33]

1869 was a difficult year for the artist. In January he had to give up his studio in Lincoln's Inn Fields, and, according to William Michael Rossetti's diary, he lived successively with John Brett, Burne-Jones (without invitation), and Charles Augustus Howell. This evidently inspired Dante Gabriel Rossetti's limerick:

There is a mad artist named Inchbold
With whom you must be at a pinch bold:
Or else you may score
The brass plate on your door
With the name of J. W. Inchbold.[34]

131 John William Inchbold, *Recollection –
Barden Fells, 1866*. Oil on paper, 9³/₄ × 6³/₄.
Tate Gallery, London.

132 John William Inchbold, *Recollection –
Strid, Barden Tower, 1866*. Oil on paper,
9³/₄ × 6³/₄. Tate Gallery, London.

Inchbold never again had a proper London residence, and in subsequent years his address
as listed in Royal Academy catalogues was either that of his patron Sir John Russell
Reynolds or the Charing Cross Hotel, from where he was already writing to Leathart
by October 1869. An undisguised note of financial desperation runs through his letters
of this time; at the beginning of the year things were at such a pass that friends, led by

133 John William Inchbold, *Peat
Burning c. 1866*. Oil on paper,
6³/₄ × 9³/₄. Tate Gallery, London.

Dante Gabriel Rossetti and Howell, and without Inchbold's knowledge, organised a raffle of some of his drawings as a way of helping him out.[35]

In April or early May of 1869 he fled to the Isle of Wight, where he remained at least through August. At the Royal Academy in the following year he exhibited a subject from the Isle of Wight, *The Under-cliffe, Spring Time* (Pl. 135), and this picture, although dated 1870, must have been painted substantially in 1869 to have been ready in time for submission to the Royal Academy in April. This painting of a fresh and flowering coast has none of the portentous heaviness of the *Stonehenge*, and its blue sky and sunlit flowers in the foreground seem like a reversion to Inchbold's Pre-Raphaelite style of the 1850s. However, if we look again at *Anstey's Cove* (Pl. 123), which presents the closest parallel to *The Under-cliffe*, we can see that the detail in the later picture is neither as elaborate nor as microscopically fine. In addition, the presence of small figures in the Isle of Wight picture helps to create a more intimate mood than that of *Anstey's Cove* and Inchbold's other pictures from the 1850s. The figures humanise the landscape and add sentiment, but in a manner that seems essentially conventional. The mood is light in *The Under-cliffe*, but, nonetheless, we feel it to be a mood deliberately sought by an artist who is making an effort to please, and this distinguishes the painting from his seemingly more impersonal ones, which, in the work of a solitary and reclusive man, often seem to convey deeply personal and private meanings.

Inchbold exhibited a related subject from the Isle of Wight, *The Upper cliff*, at the Royal Academy in 1871. In 1876 he exhibited a large painting of Gordale Scar in Yorkshire (now in the Tate Gallery).[36] The subjects of his watercolours dating from the first half of the 1870s range from lurid sunsets over the Yorkshire coast to delicately pretty views of Stratford-on-Avon. In 1874 an etching after a watercolour by Inchbold of *Charing Cross* appeared in the *Portfolio*, and the brief article accompanying it stated that in the last year or two Inchbold had been making a series of watercolour sketches along the Thames and elsewhere in London.[37] The etching is a nocturnal view of Charing Cross Station seen from across the river and shows the same stretch of urban river as Boyce's *Thames by Night* (Pl. 116), but from the opposite side of the river. Like Boyce's earlier sketch, the etching appears very Whistlerian, but, as we have seen, Inchbold's interest in nocturnal effects, like Boyce's, antedated Whistler's, and the publication of the etching in 1874 may have been intended to demonstrate Inchbold's independent treatment of such subjects. In 1876, the year of his volume of verse, *Annus Amoris*, a second etching showing an interior of Westminster Abbey, was published in the *Portfolio*, and in 1879 another Westminster Abbey appeared, this time etched by the artist himself.[38] He visited North Africa in the winter of 1876–7 and exhibited an Algerian subject at the Academy in 1878.

Some time in the later 1870s, possibly by 1877, the date on a watercolour of Clarens (private collection), Inchbold took up residence near Montreux on the shores of Lake Geneva, and he seems to have remained there except for occasional visits to England

134 John William Inchbold, *Stonehenge from the East* exhibited 1869. Oil on canvas, 33½ × 71½. Society of Antiquaries, London.

135 John William Inchbold, *The Under-cliffe –
Spring Time* 1869–70. Oil on panel,
22½ × 33½. Private Collection.

until his death (at his sister's home near Leeds) in January 1888. Most of his recorded
or dated works from 1880 onwards are views of the east end of Lake Geneva or the
country immediately around it. He exhibited pictures of the lake and nearby scenery
at the Royal Academy in 1882 and 1885, and these were his only works to appear at
the Academy during the decade. At least two oil paintings of Lake Geneva (National
Gallery of Ireland, Dublin, and private collection)[39] are now known, and there are
numerous watercolours. Many of the watercolours show variations of the same view,
looking from a high vantage-point over the curving shore of the lake to the moun-
tains in the south. In most of these views the Castle of Chillon is either distinctly or
faintly visible, depending upon atmospheric conditions. A characteristic example is the
View above Montreux, dated 1880, in the Victoria and Albert Museum (Pl. 136). Like all
this group of watercolours, in composition it recalls the *Lake of Lucerne* of 1857 (Pl.
126). The delicate pattern of bare branches also recalls the minutely drawn branches in
such earlier works as *A Study in March* (Pl. 121). But here the branches of the fore-
ground trees are used as a foil to the hazy indistinctness of the rest of the landscape,
rather than described in detail for their own sake. The vaporous effect is subtle and
lovely, but it is remote from the crystalline Pre-Raphaelite clarity of Inchbold's earlier
works.

Through most of his life Inchbold seems to have cut a rather sad figure. The
American painter Elihu Vedder, who met him in Italy, wrote that there was 'something
forlorn' about him.[40] Inchbold himself in writing to William Michael Rossetti in 1869
about his *Stonehenge* found it necessary to apologise for the picture:

> It is not, as you know, very easy to gain success perfect and complete in a picture like
> this, painted almost entirely from nature with another and entirely distinct vision before
> the imagination, and perhaps with a heart somewhat maimed and broken by that dead-
> ly and relentless opposition I seem to inspire most innocently in some quarters.[41]

William Michael Rossetti described Inchbold as an artist who, after starting as a Pre-
Raphaelite landscape painter, was harassed by ill success into frittering away his powers.[42]
For William Michael there was no question that Inchbold's later works represented a
decline from his peaks of Pre-Raphaelite achievement. If we accept this judgement, it is
tempting to see Ruskin as the villain. Inchbold's years in Switzerland seem to have been
the time when he turned away from strict Pre-Raphaelitism, and the rough treatment
which he received there from Ruskin may have caused not only the change but per-
manent damage as well. It is clear from Inchbold's letter to William Michael, quoted
above, that he considered himself a damaged creature. Yet, to lay at Ruskin's feet chief
responsibility for a career that lasted thirty years after their contact ended seems exces-
sive, and when we look at Inchbold's career as a whole we should hesitate in ascribing
to either Ruskin or the Pre-Raphaelite movement more importance than they deserve.

All of Inchbold's genuinely Pre-Raphaelite works which are now known date from
within five years of one another, from 1853 to 1857. Although this was the period of his

best-known paintings, it was only an interlude. Both before it and after it, he painted in a very different fashion, and many of his later works have more in common with his juvenile works of 1849 and 1850 than with those from his Pre-Raphaelite years. Following Inchbold's death, Swinburne, who was a closer friend and had less of a Pre-Raphaelite candle to burn than William Michael Rossetti, described his artistic output as comparable to Turner, without a mention of Pre-Raphaelitism.[43] When the etching after *Charing Cross* was published in *Portfolio* in 1874, the unsigned text accompanying it included the following assessment of Inchbold's art: 'Mr. Inchbold interprets his subjects with great taste and feeling, idealizing always to some extent, so that his drawings tend rather to a spiritual and not quite substantial conception of things, than to a material solidity; but in times of a vulgar yet powerful realism, this refinement is like poetry after prose.' In the artist's *oeuvre* there is considerable variety, but also consistency. This description of his art fits most of it, with the only partial exception of those pictures dated from 1853 to 1857. 'Idealizing always to some extent' comes close to being the polar opposite of the quest for exact truth to nature which underlay the close Pre-Raphaelite study of the natural world. After 1857, vestiges of Pre-Raphaelitism remained a part of Inchbold's art; for example, as we can see from his letter to William Michael Rossetti quoted above, he continued to paint directly from nature even in works such as *Stonehenge*, whose appearance is in no way Pre-Raphaelite. In all of Inchbold's pictures, even the most Pre-Raphaelite of them, there is a subjective and poetic dimension strong enough to suggest that in falling under the sway of Pre-Raphaelitism, he was struggling against his own natural inclinations. That is testimony to the attraction of Pre-Raphaelitism in the 1850s, but the discipline of Pre-Raphaelite close study of nature and even Ruskin's innuendoes were probably good things for an artist otherwise tending to 'a spiritual and not quite substantial conception of things'. Under the influence of Pre-Raphaelitism Inchbold did paint beautiful pictures, and, as he drifted away, particularly in Venice from 1862 to 1864, he continued to produce some of the most original and individual landscape paintings of the period.

136 John William Inchbold, *View above Montreux* 1880. Watercolour, $12^1/_8 \times 19^{13}/_{16}$. Victoria and Albert Museum, London.

John Brett

John Brett was born in Surrey in 1831, the son of an army officer. He entered the Royal Academy schools in 1854 after having had some preliminary instruction in drawing in Dublin, where his father was stationed. Hence, although Brett was only a year younger than Inchbold, he began his painting career several years later, and he emerged on the Pre-Raphaelite scene much later. Inchbold first exhibited at the Royal Academy in 1851, and in the following year William Michael Rossetti categorised his art as Pre-Raphaelite. Brett did not exhibit at the Royal Academy until 1856.

It appears that Brett originally intended to be a figural artist rather than a landscape painter, and he held to that ambition for many years. As late as 1863 Ruskin lamented the time he wasted by 'hankering after being a *figure* painter'.[1] His first contribution to the Royal Academy consisted of three portraits, and in 1857 he exhibited a painting entitled *Faces in the Fire*, showing a boy seated by a hearth, and he exhibited two important subsequent pictures, *The Stonebreaker* (Pl. 139) in 1858 and *The Hedger* (Pl. 141) in 1860, with titles describing the figures, which are indeed as important in the compositions as their settings, in the latter, more important. Many portrait drawings by Brett belong to the artist's descendants and are of high quality. A beautifully understated portrait by him of a Mme Loeser, usually known as *Lady with a Dove* (Tate Gallery), dates from 1864, and, apart from a bristly self-portrait in Aberdeen from 1883, would seem to be one of the last manifestations of his hankering to be a figure painter.

A painting of a landscape dated 1852, two years before Brett entered the Royal Academy schools, is in the Fitzwilliam Museum (Pl. 137), and numerous early landscape drawings belong to descendants of the artist. None of these landscapes is very remarkable. The earlier ones are broadly handled, but within the conventions of amateur sketching of the time. Those dating from 1853 to 1855 show increasing care and accuracy of draughtsmanship, reflecting the general mid-Victorian tendency toward tighter handling, but they do not show any specifically Pre-Raphaelite influence, and they give no hint of the departure shown in Brett's first exhibited landscape, the *Glacier of Rosenlaui* (Pl. 138), which is signed and dated 23 August 1856, and which he sent to the Royal Academy in 1857 along with *Faces in the Fire*.

A trip to Switzerland in the summer of 1856, during which he painted the *Glacier of Rosenlaui*, was the turning point of Brett's career. Rosenlaui and Wengern Alp, where Inchbold was working during the same summer, are both in the Bernese Oberland, less than fifteen miles apart, so it was perhaps inevitable that the two English landscape painters would discover one another, even though they apparently had not met before. In the following December, summing up the year's achievements in his diary, Brett wrote that he had first met Inchbold on the Wengern Alp and watched him work on *The Jungfrau from the Wengern Alp*, the picture Inchbold exhibited at the Royal Academy the following year.[2] This was the moment of revelation for Brett, who 'there and then saw that I had never painted in my life, but only fooled and slopped, and thenceforward attempted in a reasonable way to paint all I could see.' Inchbold insisted that Brett remain in Switzerland to complete the *Glacier of Rosenlaui* as carefully as possible in every detail, and he even lent Brett money to enable him to do so.

Ruskin was also in the Bernese Oberland in the summer of 1856, and he visited Inchbold there, at Lauterbrunnen, which is just down the hill from the Wengern Alp. He

Facing page: John Brett, *The Stonebreaker* (detail of Pl. 139).

137 John Brett, *Landscape* 1852. Oil on board, 7 × 10. Fitzwilliam Museum, University of Cambridge.

did not see Brett, whom he had not yet met. Nonetheless, although Brett did not know Ruskin and had profited from watching Inchbold work, the *Glacier of Rosenlaui* is the most Ruskinian of any Pre-Raphaelite painting. The boulders in the foreground are drawn with such exactitude that the picture seems more like a geological illustration than a conventional landscape view. The actual Glacier of Rosenlaui is at the foot of two of the most spectacular peaks in the Alps, the Wellhorn and the Wetterhorn, but that is hardly evident from Brett's picture. His single-minded concentration on a few square yards of foreground detail is comparable to that shown in many of Ruskin's studies of Alpine rocks, and, like Ruskin's earlier studies, Brett's picture is based on careful draughtsmanship throughout. The colours are subdued, and, although the shadows in the crevices of the ice are blue, those under the foreground boulders are black. The sky is grey, and nowhere does the colour show Pre-Raphaelite luminosity or brilliance.

Brett's picture was not the only study of Alpine glaciers undertaken in the summer of 1856. While Brett was at Rosenlaui, T. H. Huxley and John Tyndall were also in the Bernese Oberland investigating glaciers. In 1857 they published a joint paper 'On the Structure and Motion of Glaciers'. Ruskin was soon plunged into the controversy which this paper aroused because of its attack on the theories of his friend and mentor James Forbes, but, despite the coincidence of time and subject, Brett's painting does not appear to have had any connection with Huxley's and Tyndall's investigations. Neither the structure nor the motion of the glacier seems to have been as important to the artist as the rocks lying before it. This careful study of rocks not only points to Ruskin as the picture's inspiration, but to a specific source in Ruskin's writings: the fourth volume of *Modern Painters*, which had been published on 14 April 1856.

Subtitled 'Of Mountain Beauty', that volume is more about geology than painting. Ruskin considered it the most valuable part of the entire work, and it had an impact in spheres other than the artistic one. According to Leslie Stephen, 'the fourth volume of *Modern Painters* infected me and other early members of the Alpine Club with an enthusiasm for which, I hope, we are still grateful'.[3] Stephen started to climb in the Alps in 1857, in part because of Ruskin, and the Alpine Club was founded in the same year. The core of Ruskin's volume is his discussion of the rock structure of the mountains. The rocks which make up the central mountain peaks he divided into two classes: compact crystallines (granites) and slaty crystallines (gneiss). All other rocks, such as slates and marbles, were by his standards inferior and less beautiful. Ruskin concluded his discussion of mountain forms by pointedly lamenting the lack of any careful treatment of stones in modern painting: as stones are mountains in miniature, 'they seem to have been created especially to reward a patient observer'.[4] Yet, although Ruskin himself made countless careful studies of different rocks, to illustrate slaty crystallines in this chapter he used a daguerreotype instead of one of his own drawings, for the first and only time in *Modern Painters*. In the accompanying text he apologised for the illustration's inadequacy, which was due to the impossibility of showing the colour of the stone surface.[5] A few months after he had made this apology, he made what was probably his single most ambitious study of Alpine rock, showing a block of gneiss at Chamonix (Pl. 170).

Brett's picture is a picture of what Ruskin was writing about, and because it is an oil painting it shows what Ruskin was unable to show in his black-and-white illustration. The distinctive characteristics of granite and gneiss as described by Ruskin are exactly

those which distinguish the boulder without interior lines at the centre of the fore-
ground of the *Glacier of Rosenlaui* from the larger, sinuously marked stone immediately
behind it. The more fractured stone in the lower right corner appears to be an exam-
ple of what Ruskin called slaty coherents. Although we can only speculate about Brett's
response to Ruskin's geological discussions, everything we know about him makes it
seem probable that he would have read and taken to heart the fourth volume of *Modern
Painters* as soon as it was published. Once Ruskin and Brett met, Ruskin showed much
greater respect for Brett's mind than he had for Inchbold's: in the fifth volume of

138 John Brett, *Glacier of Rosenlaui* 1856. Oil
on canvas, 17¹/₂ × 16¹/₂. Tate Gallery, London.

Modern Painters, published four years after the fourth, Ruskin quoted Brett and described him as 'one of my keenest-minded friends'.[6] Like Ruskin, Brett was genuinely interested in science, and in later life he became an active astronomer. In 1870 he participated in a trip to Sicily sponsored by the Royal Astronomical Society to observe a solar eclipse. He eventually became a fellow of the Society and published numerous observations of planetary detail in its *Notices*.

Although Brett first met Inchbold in the summer of 1856, he may have had earlier contact with other members of the Pre-Raphaelite circle. He was a friend of Coventry Patmore, who had been an intimate of the Pre-Raphaelite group since the formation of the Brotherhood. A drawing of the poet by Brett is dated 1855, and one of the three portraits Brett exhibited at the Royal Academy in 1856 was of Mrs Patmore.[7] Also, in 1856 Brett rented a studio from Charles Lucy, a friend of Ford Madox Brown and first teacher of Thomas Seddon, and thus he had an additional means of contact with the group. By the autumn of 1856 he knew Dante Gabriel Rossetti. Rossetti saw the *Glacier of Rosenlaui* in Brett's studio and took it home to show Ruskin. According to the same diary entry in which Brett recorded his debt to Inchbold, Ruskin praised the picture unreservedly, but when the *Glacier of Rosenlaui* and *Faces in the Fire* appeared at the Royal Academy the following May, Ruskin mentioned neither of them in *Academy Notes*.

Following the Royal Academy exhibition of 1857, Brett sent the *Glacier of Rosenlaui* and a watercolour to the American Exhibition of British Art. He exhibited additional works at the Pre-Raphaelite exhibition in Russell Place in 1857 and at the Liverpool Academy, but from the evidence of the prices he asked and a few references in his letters it appears that all of them were drawings or watercolours. One watercolour, *The Wetterhorn, Well Horn and Eiger, Switzerland*, was a view of towering Alpine peaks,[8] but the titles of others, such as 'Grass' or 'Moss and Gentians from the Engels Hörner', tell us that they were close studies of natural detail. In 1858 Brett again sent watercolours to Liverpool, but for the last time. He exhibited only one work, *The Stonebreaker* (Pl. 139), at the Royal Academy in 1858, and in each of the following three years he exhibited only one picture per year.

The Stonebreaker is signed and dated 1857–8. Its subject is a young boy who must labour while birds sing and his dog plays in the midst of a sun-filled landscape. At the same Royal Academy exhibition of 1858, Henry Wallis exhibited his picture of a stonebreaker who has succumbed to his back-breaking labour (Pl. 85), accompanying it in the catalogue with a quotation from Carlyle. Brett's picture also has a message, but in contrast to the stark tragedy of Wallis's, it seems only sentimentally pathetic, in the more typically Victorian vein of Richard Redgrave's seamstresses and governesses. Indeed, the landscape in which the boy works is so lovely that it requires an act of intellect for us to think of the picture as an image of exploitation rather than of idyllic rural life. Pre-Raphaelite pictures of poignant figures in beautiful and beautifully painted settings that preceded it include Millais's *Blind Girl* (Pl. 41), exhibited in 1856, and Arthur Hughes's *Home from Sea* (Pl. 82), which was shown in its original form at Russell Place in 1857.

Wallis's and Brett's pictures are so dissimilar that it seems irrelevant to ask whether either artist was aware of what the other was doing. Neither picture shows any evident connection with Courbet's *Stonebreakers* (Pl. 2) of a few years before,[9] but Brett's painting could owe a debt to Landseer's *Stonebreaker's Daughter* of 1830 (Victoria and Albert Museum), which had been engraved. Both pictures have a somewhat ambiguous poignancy, and, more specifically, the Brett, like the Landseer, contains a white terrier. This is a small enough point, but in the 1850s any English artist painting a terrier could hardly have been oblivious to Landseer, especially if he was an assiduous reader of Ruskin.[10]

Brett's younger brother was the model for the child-labourer. The setting is Surrey. Box Hill near Dorking is in the background, and a milestone inscribed 'London 23' is in the foreground, pinpointing the site.[11] The picture shows the same minute precision as the *Glacier of Rosenlaui* not only in the foreground but in the view of the slopes of Box Hill in the background as well (see detail, p. 168). The colours of the foreground foliage are vibrantly bright in Pre-Raphaelite fashion, much brighter than any of the colours in the *Glacier of Rosenlaui*. However, in the background the colours are considerably modified so that the greens of Box Hill are markedly lighter and paler than those of the foreground plants. The effect of atmosphere is even more evident in the further distance on the right, which eventually becomes lost in a blue haze. Although by the standards of earlier English landscape painting this effect of atmosphere is hardly noteworthy, by Pre-Raphaelite standards it is. If we compare *The Stonebreaker* with Ford Madox Brown's

English Autumn Afternoon (Pl. 23), the much greater tonal contrast between foreground and background in Brett's painting is evident. The result is more spacious and less two-dimensional in effect.

The Stonebreaker is usually said to have made Brett's reputation. By the nature of its subject, it is a more immediately appealing, as well as a more conventional picture than the Glacier of Rosenlaui. Yet, when first exhibited, it was not well received, and it was ignored by most reviewers with the exception of Ruskin, who concluded his review of the Royal Academy exhibition of 1858 by praising the painting enthusiastically:

> This, after John Lewis's, is simply the most perfect piece of painting with respect to touch in the Academy this year; in some points of precision it goes beyond anything the Pre-Raphaelites have done yet. I know no such thistle-down, no such chalk hills, and elm trees, no such natural pieces of faraway cloud, in any of their works.
>
> The composition is palpably crude and wrong in many ways, especially in the awkward white cloud at the top; and the tone of the whole a little too much as if some of the chalk of the flints had been mixed with all the colours. For all that, it is a marvellous picture, and may be examined inch by inch with delight; though nearly the last stone I should ever have thought of anyone's sitting down to paint would have been a chalk flint. If he can make so much of that, what will Mr. Brett make of mica slate and gneiss! If he can paint so lovely a distance from the Surrey downs and railway-traversed vales, what would he not make of the chestnut groves of the Val d'Aosta! I heartily wish him good-speed and long exile.[12]

Ruskin's reference to Lewis is of more than incidental interest, as Brett himself, in later years, declared Lewis 'the greatest of all modern artists, except Turner'.[13] Ruskin had praised Lewis's Frank Encampment in the Desert of Mount Sinai (Yale Center for British Art), exhibited at the Old Water-Colour Society in 1856, as 'among the most *wonderful*

139 John Brett, *The Stonebreaker* 1857–8 Oil on canvas 19½ × 26½. Walker Art Gallery, Liverpool.

pictures in the world', and he claimed that nothing comparable had been painted since Veronese. In the following years, however, he began to temper his admiration for Lewis; in 1858, while he was comparing Brett's execution to that of Lewis, he complained that Lewis's pictures were not dramatic enough, a complaint which would be echoed in his criticism of Brett in the following year.[14]

There are traces of re-painting around the clouds at the top of the picture; so Ruskin's criticism may have prodded Brett to repaint them. The comment about mixing chalk with all the colours is a temperate echo of Ruskin's long-standing dislike of atmospheric effects, most vociferously expressed in his criticism of Claude. As a criticism of Brett, it was close to the mark, for Brett in a letter written to his sister in 1858, advising her on painting techniques, did recommend mixing white with the colours to make the paint more manageable. This is a different method from the usual Pre-Raphaelite one of painting in unmixed colours over a white ground, which Brett apparently used for the foreground plants in *The Stonebreaker*. In the same letter, the artist denied using any systematic method of tonal modification to give distance: 'If you paint the things the right colour, and put in only as much detail as you see, they will do, and won't want any forcing back.' To get the exact colour of nature, he advised his sister to look through a hole in a card, a method employed by Ruskin in his teaching at the Working Men's College.

More interesting than Ruskin's praise or criticism of *The Stonebreaker* – and probably more puzzling to his contemporary readers – were his concluding remarks about the inferiority of chalk flint to mica slate and gneiss, and of the 'Surrey downs and railway-traversed vales' to the chestnut groves of the Val d'Aosta. These not only repeated his often-stated preference for Alpine scenery to English, but also referred to Brett's plans for his next undertaking. Slightly over a month after Ruskin had wished him good-speed and long exile, Brett set out for the Val d'Aosta in the Italian Alps. Ruskin's mouth-watering comments about a picture which was not yet begun encourage the suspicion that he was the instigator of the project. He did not commission Brett's *Val d'Aosta* (Pl. 140) – when Brett sent it for exhibition at the Liverpool Academy in 1859 it was for sale[15] – but he was intimately involved in its creation, and eventually he purchased it.

Why did Brett go to the Val d'Aosta rather than to the Valley of Chamonix on the other side of Mont Blanc, or to the Bernese Oberland, or to the Lake of Lucerne, all of which play a larger and more important role in Ruskin's writing? The most probable explanation is that Ruskin was planning to be in Turin during the summer and hence would be accessible if the artist needed his advice. Brett arrived at the town of Aosta at the end of June 1858 and immediately set to work at the Château St Pierre, a few miles further up the valley. Ruskin arrived in Turin in the middle of July and remained there until the end of August. On 14 August he wrote to Brett asking him to join him at Turin,[16] and just before leaving he wrote to his father:

> Turin, August 26. I mentioned that Mr. Brett was with me at La Tour. He has been here a week today. I sent for him at Villeneuve, Val d'Aosta, because I didn't like what he said in his letter about his present work, and thought he wanted some lecturing like Inchbold: besides that, he could give me some useful hints. He is much tougher and stronger than Inchbold, and takes more hammering; but I think he looks more miserable every day, and have good hope of making him completely wretched in a day or two more – and then I shall send him back to his castle. He is living *in* that castle which I sketched so long ago in Val d'Aosta – Château St. Pierre.[17]

La Tour is Torre Pellice, in the mountains to the south-west of Turin. The useful hints that Ruskin hoped to receive were for the final volume of *Modern Painters*, in which Brett is indeed quoted.[18]

One of Brett's sketchbooks contains a few drawings made during his visit to Turin. The most interesting are a pair showing rocky hillsides and bearing the initials J.M.W.T. One, dated 25 August, is a delicate pencil drawing with each rock and bush carefully delineated and modelled. This drawing is comparable to drawings throughout Brett's sketchbooks and is clearly by him, despite the posthumous initials of Turner. The other drawing is in pen and appears to be not by Brett, but by Ruskin. It is a more diagrammatic drawing in which the details of rocks and bushes are subordinated to the lines of the sloping hillside. Also bearing Turner's initials, this drawing contains an implied criticism of Brett's, demonstrating that Turner saw the grand lines of nature, not just niggling details. The only other hints that we have of Ruskin's hammering are a few descriptive notes of scenery, which Brett made in the same sketchbook on his return

140 (facing page) John Brett, *Val d'Aosta* 1858. Oil on canvas, $34\frac{1}{2} \times 26\frac{7}{8}$. Collection of Lord Lloyd Webber.

trip to the Val d'Aosta from Turin.[19] An example is his description of Verrès, between Ivrea and Châtillon: 'a little plain shut in by very fine mountain forms – a very good old fort or tower – also some very good bits of building – very few stones on plain – average trees – not much vine – about the best of the little towns in the valley.' These attempts to analyse the merits and faults of scenery, although not couched in Ruskinian language, were probably the results of Ruskin's urging Brett to give more consideration to choosing suitable subjects. A leitmotiv in Ruskin's discussions of Pre-Raphaelite works in *Academy Notes* was his criticism of their badly chosen subjects, and he may well have felt that Brett, after travelling halfway across Europe to an Alpine valley, was still not painting a subject of appropriate grandeur. In 1851, on his most recent visit to the Val d'Aosta, Ruskin had described the scenery in the upper part of the valley around Aosta, near where Brett was painting, as uninteresting compared to that in the narrower lower part between Châtillon and Ivrea.[20] The notes in Brett's sketchbook all describe locations between Châtillon and Ivrea, but Ruskin's advice, whatever it may have been, did not prevent Brett from returning to St Pierre. He remained there working on the painting until the middle of November and exhibited the completed *Val d'Aosta* at the Royal Academy the following May.

Like *The Stonebreaker*, the *Val d'Aosta* is a plateau landscape, with a genre figure and a domestic animal in the foreground. But now the figure, a sleeping girl, is relatively anonymous and unimportant, and the foreground serves mainly as a *repoussoir* for the landscape beyond. This is a view up the valley of the Dora Baltea, looking to the west from the castle of St Pierre at Villeneuve. The mountains in the distance are the Testa du Rutor, covered with snow, and Monte Paramont, to its right. These are neither the highest nor the most dramatic mountains overlooking the Val d'Aosta. If Brett had travelled further up the valley to Courmayeur he could have painted the Italian flank of Mont Blanc, and from other points in the valley he could have seen the Matterhorn and Monte Rosa. Even at St Pierre, as T. S. R. Boase pointed out, Brett turned his back on the most spectacular scenery.[21] La Grivola, due south of St Pierre, and visible up the Val di Cogne, is higher than the mountains painted by Brett, and a more dramatic feature in the landscape.[22] Brett also excluded picturesque features of another sort, showing neither his own Château St Pierre nor the nearby Châtel Argent, two fortified medieval castles which form conspicuous landmarks in the valley. The *Val d'Aosta* is not a picture of romantic scenery or towering mountains, but of a valley with its peaceful agricultural life, which is enclosed by mountains. The distance from St Pierre to Monte Paramont is a little over twelve miles. The painting shows each tree, each vine, each cottage, even peasants working in the fields, through a substantial part of those twelve miles. The minute precision of handling equals that of *The Stonebreaker* and is more awe-inspiring because applied to such a vast panorama. The chief benefit of Brett's working in the Alps was not that he could see and paint high mountains – he avoided the highest and partly hid by cloud those he did show – but that he himself could have a high vantage-point from which he could see and paint ever more cottages and fields and trees.

Brett had English predecessors who had worked in the Val d'Aosta. Turner made several sketches in the vicinity of St Pierre.[23] But there is little in common between Turner's dramatic visions of the mountains and Brett's conscientiously detailed geographical statement. His documentation of not only the topography and geology, but also the cultivation and life of the valley, is closer in spirit to the elaborately constructed 'universal landscapes' painted earlier in the century by the Austrian artist Joseph Anton Koch, although if we look at an actual Alpine scene by Koch, for example *The Bernese Oberland* of 1815 (Osterreichische Galerie, Vienna),[24] the marked stylistic differences, as well as the time lag, make any influence seem unlikely. A younger Austrian artist, Ferdinand Waldmüller, continued to paint comparable subjects, in a more meticulous style than Koch, past the middle of the century. In 1856 Waldmüller had an exhibition in London, at Buckingham Palace.[25] Brett could well have seen his works, but, again, it seems unlikely that Waldmüller would have had any real importance for Brett. What is most distinctive about the *Val d'Aosta*, the amount of information it provides, is not the result of imported ideas, but the culmination of the Pre-Raphaelite impulse to detailed naturalism.

When the *Val d'Aosta* appeared at the Royal Academy in 1859, one Pre-Raphaelite, or former Pre-Raphaelite, had little good to say of it. Millais wrote to his wife,

> There is a wretched little work like a photograph of some place in Switzerland, evidently painted under his [Ruskin's] guidance, for he seems to have lauded it up sky-high; and that is just where it is in the miniature room! He does not understand

my work, which is now too broad for him to appreciate, and I think his eye is only fit to judge the portraits of insects.[26]

This comment mainly reflects Millais's dislike of Ruskin, his anticipation of the hostile criticism which his own paintings were about to receive, and how far he had moved from his earlier Pre-Raphaelite concerns, but we also learn from it that the picture was badly hung. It was ignored by most of the press, but in *Academy Notes* Ruskin more than compensated:

> Yes, here we have it at last — some close-coming to it at least — historical landscape properly so called — landscape painting with a meaning and a use. We have had hitherto plenty of industry, precision quite unlimited, but all useless, or nearly so, being wasted on scenes of no majesty or enduring interest. Here is, at last, a scene worth painting — painted with all our might (not quite with all our heart, perhaps, but with might of hand and eye). And here, accordingly, for the first time in history, we have by help of art, the power of visiting a place, reasoning about it, and knowing it, just as if we were there, except only that we cannot stir from our place, nor look behind us. For the rest, standing before this picture is just as good as standing on that spot in Val d'Aosta, so far as gaining of knowledge is concerned; and perhaps in some degree pleasanter, for it would be very hot on that rock today, and there would probably be a disagreeable smell of Juniper plants growing on the slopes above.[27]

Ruskin then proceeded to describe in detail what a 'simple-minded, quietly living person, indisposed towards railroad stations or crowded inns', might learn from the painting about 'what a Piedmontese valley is like in July'.

This concept of historic or historical landscape is the same as that which Ruskin had applied three years earlier to Thomas Seddon. It will be remembered that Ruskin had called Seddon's art the first 'truly historic landscape art', whose purpose he defined as 'that of giving to persons who cannot travel trustworthy knowledge'.[28] His forgetful claim that Brett's picture achieved this 'for the first time in history' reflects his lack of engagement with Seddon, while his active involvement in the creation of the *Val d'Aosta* no doubt abetted his loss of memory.

Ruskin concluded his description of the painting by calling it, 'a notable picture truly; a possession of much within a few square feet'. But he then went on to criticise it with sufficient vigour to negate most of his praise:

> Yet not, in the strong, essential meaning of the word, a noble picture. It has a strange fault, considering the school to which it belongs — it seems to me wholly emotionless. I cannot find from it that the painter loved, or feared, anything in all that wonderful piece of the world. There seems to me no awe of the mountains there — no real love of the chestnuts or the vines. Keenness of eye and fineness of hand as much as you choose; but of emotion, or of intention nothing traceable. Not but that I believe the painter to be capable of the highest emotion: any one who can paint thus must have passion within him; but the passion here is assuredly not out of him. He has cared for nothing, except as it was more or less pretty in colour and form. I never saw the mirror so held up to Nature; but it is Mirror's work, not Man's.

Ruskin criticised particularly Brett's painting of the sky, and then in his final paragraph, he summed up the painting's strengths and weakness: 'Historical landscape it is, unquestionably; meteorological also; poetical — by no means: yet precious, in its patient way; and, as a wonder of toil and delicate handling, unimpeachable.'

This criticism does not seem unjust, but from a partisan such as Ruskin it is surprising. The gist of much of his writing of the previous fifteen years had been to encourage exactly the kind of detached scientific observation that here reaches its apogee. In his speech on Thomas Seddon, when proselytising for 'historic landscape', he had argued that artists should be as scientific as possible. 'If they imparted knowledge and industry enough, the imagination would come out.' But Brett had imparted knowledge and industry enough, and the imagination had not come out. Ruskin had had high hopes for the painting and had even committed himself publicly to its success in the previous year's *Academy Notes*. That it failed to meet his expectations was more than a disappointment; it was a disillusionment which coincided with, and perhaps helped to produce, a major redirection in Ruskin's career. After 1859, he ceased publishing *Academy Notes*, and he largely abandoned his active encouragement of contemporary artists. The failure of the *Val d'Aosta* was the failure of the movement which he had adopted and attempted to direct.

Ruskin's most specific criticism of the picture had to do with the sky:

This absence of sentiment is peculiarly indicated by the feeble anger of the sky. Had it been wholly cloudless – burning down in one calm field of light behind the purple hills, all the rest of the landscape would have been gathered into unity by its repose; and for the sleeping girl we should have feared no other disturbance than the bleating of the favourite of her flock . . . But now she will be comfortlessly waked by hailstorm in another quarter of an hour; and yet there is no majesty in the clouds, nor any grand incumbency of them on the hills; they are but a dash of mist, gusty and disagreeable enough – in no otherwise to be dreaded.

It was Brett's misfortune that he painted his clouds at the same time that his critic was preparing the section of *Modern Painters* entitled 'Of Cloud Beauty'. In the summer of 1858, Ruskin made several studies of cloud effects over the mountains. He reproduced a number of them in the fifth volume of *Modern Painters*, and another, *A July Thunder Cloud in the Val d'Aosta, 1858*, served to illustrate a lecture, 'The Storm Cloud of the Nineteenth Century', which he gave in 1884.[29] In these drawings the clouds are spectacular, dwarfing the mountains. Ruskin described his drawings as literal representations, but they have an exuberance which makes Brett's clouds seem insipid in comparison.

What Brett's clouds do is conceal the outlines of the mountains. The painting is not only less spectacular meteorologically than it would have been if he had painted clouds like Ruskin's, but also less spectacular topographically than it would have been with an empty sky. Either kind of spectacle would have taken the viewer's mind and eye from the prosaic fields of the valley to more romantic heights. Brett's refusal to allow such a distraction, or to make the drama of mountains and stormy sky the real subject of his painting, demonstrates the gulf between him and an earlier artist such as Turner. Nonetheless, the examples of Turner's keen observation which Ruskin endlessly cited in *Modern Painters* do often make Turner's pictures sound quite like the *Val d'Aosta*, and Ruskin had tried since 1851 to prove that Turner and the Pre-Raphaelites were fundamentally akin. He could mention Millais's portrait of himself in the same breath with Turner because the subjects of the two artists were so far apart that there was no real basis of comparison. However, Brett, by painting a vast Alpine landscape, did put himself in a position to be compared directly with Turner. Ruskin did not mention Turner in his review of Brett's picture, but his feelings for the Alps and for Turner's paintings were inextricably mixed. Seen in contrast to the paintings which provided a visual equivalent to Ruskin's own emotional responses to the mountains, Brett's scientific detachment must have seemed the more disappointing. Ruskin expressed his disappointment in the review of the painting; he did not suggest the possibility that the emotional level, which he demanded, and the load of factual information, which Brett presented, might have been in any way incompatible.

Despite his disappointment, Ruskin bought the picture. He did so out of a sense of responsibility when no other purchaser was forthcoming.[30] He put it up for sale in 1869 but bought it back. He later mentioned it twice in his published writings. In 1875, in a revival of *Academy Notes*, he bemoaned a decline in Brett's art:

Since the days when I first endeavoured to direct the attention of a careless public to his conscientious painting of the Stonebreaker and Woodcutter, he has gained nothing – rather, I fear, lost, in subtlety of execution, and necessitates the decline of his future power by persistently covering too large canvas. There is no occasion that a geological study should also be a geological map; and even his earlier picture, which I am honoured in possessing, of the Val d'Aosta, would have been the more precious to me if it had been only of half the Val d'Aosta.[31]

In 1880 he lent the picture to an exhibition on the Isle of Man and supplied a note for the catalogue. He described the circumstances under which it was painted, then continued:

I at that time hoped much from his zeal and fineness of minute execution in realizing, with Dürer-like precision, the detail of Swiss landscape. Had he sympathised enough with Swiss and Italian life, his work might have become of extreme value; but, instead, he took to mere photography of physical landscape, and gradually lost both precision and sentiment . . . There is no pretence of composition, or, as usually understood, of painter's skill in this picture. It is the careful delineation of what is supposed to be beautiful in itself; and it has lost, instead of benefited, by the unwise introduction of storm on the hills for the sake of variety. In good, permanent, and honourably

finished oil-painting this picture cannot be surpassed; it is as safe as a piece of china, and as finished as the finest engraving.[32]

Both of these passages express Ruskin's disappointed hopes for Brett, and the second suggests that a loss of 'both precision and sentiment' began during his work on the *Val d'Aosta*. It is generally believed that Brett's art began to change immediately afterwards, probably as a reaction to Ruskin's badgering. It did change, more in response to the unfavourable critical reception of the picture and the consequent difficulty in selling it, than because of Ruskin's rough treatment, but also because the artist was unable or unwilling to repeat the superhuman effort required by the *Val d'Aosta*. In his diary in December 1858 he pronounced it his last landscape,[33] and his painting of the following year, *The Hedger* (Pl. 141), showing a genre figure working in a landscape, reverted to the type of subject of *The Stonebreaker*. In his diary, Brett pointedly contrasted *The Hedger* with its predecessor:

> Who knows what will be the fate of the Hedger. I hope it will be more felt than the Aosta; it is much more strongly painted, and is deeper in colour; not half so delicate and refined perhaps, but I cant think how I ever got the Aosta done. I have worked at the Hedger harder I think but there is nothing in it compared with the other nor anything like the difficulties.[34]

His hopes for *The Hedger* were realised; the critics liked it, and he had no difficulty in selling it, for the same price, £300, that he had asked for the *Val d'Aosta*.

Brett spent the summer of 1861 again in the Alps. He exhibited two Alpine subjects at the Royal Academy in 1862, but neither seems to have been such a herculean tour-de-force as the *Val d'Aosta*, and one was in watercolours.[35] In the winter of 1861–2 he was in Florence, where he made a watercolour of the Ponte Vecchio which he later sold to Ruskin's father.[36] A letter from Ruskin to his father, dated 2 May 1863, refers to this drawing:

> I have to-day your interesting letter about Brett. I am much obliged by what you have done for him: nor do I think it will be useless. I've written to him repeating what I told him three years ago – that painting large studies by way of pictures was simply ridiculous – that he must make small ones first, saleable, and learn to choose subjects. The little Florence will, I think, be very pleasant to me – it is sure to be 'preciously' like.[37]

The comment about choosing subjects repeats once again a complaint Ruskin had been making about the Pre-Raphaelites ever since 1852. The practical notion that small works are more saleable than large ones had surfaced earlier in advice that he gave to Alfred William Hunt in 1858,[38] but there is a further dimension to his criticism of 'painting large studies by way of pictures'. On the same day he wrote to his father, he wrote to Brett:

> You perish, hitherto in making big studies and supposing that they are pictures (Anthony did the same thing in an inferior way.) Neither you, nor I, could ever paint a picture, properly so called. But it is quite possible, with your powers or mine, to (as mine once have been – though it can never be) – to paint something not offensively declaratory of it *not* being a picture. Something which shall fulfill all the ordinary conditions of a picture – except *the* condition (which the public never sees) of having an idea in it. Neither you nor I will ever have an idea. We have nothing better than thoughts.
>
> But to accomplish this you . . . must make quantities of black and white studies. There is no possibility of picture making without this. Hunt with all his tremendous powers will never paint a picture but by chance for want of it. Millais' highest results have been got at through pen and ink – so Rossetti – so Jones.[39]

This sounds like a repudiation of the Pre-Raphaelite method of painting directly from nature and of the kind of careful work from nature in pictures certainly intended as more than studies that Ruskin had previously encouraged, in the portrait of himself by Millais, for example (Pl. 36). Writing to Brett in 1863, Ruskin did not state explicitly that only studies should be painted from nature, while finished pictures should be painted in the studio, but that is what the letter implies, and that is consistent with his pre-Pre-Raphaelite writing. Back in 1843, the famous passage about rejecting nothing, selecting nothing in *Modern Painters* I, followed a call for exhibitions of studies of landscape in chalk or sepia and preceded a prescription for making pictures on the basis of separate

studies.[40] The Pre-Raphaelite artists were to add the notion of painting entire pictures directly out of doors to his calls for detail and finish. Although Ruskin clearly encouraged such a procedure in practice when Millais was painting his portrait and, we can assume, when Brett was painting the *Val d'Aosta*, it never became an important desideratum in his critical writing, and, as we have seen, he had no use for Ford Madox Brown's paintings, the most radical examples of Pre-Raphaelite outdoor painting. He himself was a lifelong sketcher, who always worked on a modest scale, and his rather insulting equation of Brett's powers with his own, told the artist that he should aim no higher. He clearly would have been happy if Brett never painted large pictures at all, and, as we have seen, he continued to rail against the size of Brett's paintings in the *Academy Notes* of 1875. In 1876 he wrote to a younger painter, Albert Goodwin, lamenting Goodwin's 'taking to oil and to large canvases', and his arguments to Goodwin can be applied to Brett. Although the letter was directed primarily against the use of oil, it also elaborated Ruskin's preference for small studies:

> Large canvases mean the complete doing of what they contain, and the painting of not more than three or four in the year, while I think you have eyes to discern every summer three or four and forty, of which it is a treason to your genius to omit such record as would on small scale be easily possible to you.
>
> And as a mere matter of personal comfort, twenty people can enjoy a small drawing for one who wants to cover half a furlong of wall.[41]

Ruskin's preamble to this advice was the assertion that 'all great efforts are failures . . . we only use our powers fully by doing what we know we can do well and enjoy doing, better and better every day.' Since Brett's *Val d'Aosta* was, if anything, a great effort, according to Ruskin's later view of things it had been doomed to failure. Ruskin's disappointment with the results of the project which Brett had undertaken at his bidding was probably one of the causes for his later belief in the preferability of moderation in artistic ambitions, and his criticism of Brett in 1863 was one of the first manifestations of this belief. Their friendship ended in the following year, not because of Ruskin's disapproval of Brett's art, but because of a scientific disagreement. As Ruskin explained in a letter to Rossetti, written in 1865,

> I will associate with no man who does not more or less accept my own estimate of myself. For instance, Brett told me, a year ago, that a statement of mine respecting a scientific matter (which I knew *à fond* before he was born) was 'bosh'. I told him in return he was a fool; he left the house, and I will not see him again 'until he is wiser'.[42]

Brett returned to Florence in the winter of 1862–3 and spent the subsequent two winters in the vicinity of the Bay of Naples. To the Royal Academy of 1863 he sent a painting of *Florence from Bellosguardo* (Pl. 142). Together with a second picture it was rejected, causing suspicions of foul play.[43] 1863 was the only year between 1856 and Brett's death that he was not represented at the Academy, but rejection did him no harm; as George du Maurier wrote to Thomas Armstrong, 'Brett whose picture was kicked out sold it immediately, which very likely wouldn't have happened had he met with justice.'[44] The view of Florence is from the south-west, looking across the city toward Fiesole and the Apennines. The time is late afternoon, as we can tell from the long shadows of the trees in the olive grove in the foreground, and the entire picture is suffused in a rosy glow. In painting a view of Florence, Brett turned to what was perhaps the inevitable subject for a landscape painter belonging to a movement calling itself Pre-Raphaelite, and the result is one of the most extraordinary of all Pre-Raphaelite pictures. It shows basically the same view as the many views of Florence from Bellosguardo painted by the eighteenth-century expatriate English artist Thomas Patch, but without the staffage and conventional Claudian framing trees that soften the earlier paintings.[45] Bellosguardo was a centre for the English community in Florence, renowned for its view, with the Val d'Arno below, 'vast and delicate, as if it were a painted picture'.[46] Brett's painting of that view is vast, but hardly delicate, displaying single-mindedness carried to the point of monomania. *Florence from Bellosguardo* does not surpass the *Val d'Aosta* in the amount of detail it contains, but, unlike the earlier picture, it shows a man-made world where the shapes are essentially all the same. Instead of a continuously varying landscape, there is endless repetition of pitched roofs and rectangular windows. Brett himself may have decided that this type of all-inclusive panorama required too much sheer work. In subsequent years he frequently painted pictures from high vantage-points, but not of subjects demanding the detailed treatment of the *Val d'Aosta* or the *Florence*. In pictures that

141 (facing page) John Brett, *The Hedger* 1860. Oil on canvas, $35\frac{7}{16} \times 27\frac{9}{16}$. Private Collection.

142 John Brett, *Florence from Bellosguardo*
1862–3. Oil on canvas, 23$\frac{1}{2}$ × 39$\frac{1}{2}$. Tate
Gallery, London.

143 John Brett, *Massa, Bay of Naples* 1864.
Oil on canvas, 25$\frac{1}{4}$ × 40$\frac{1}{4}$. Indianapolis
Museum of Art.

he sent to the Royal Academy in 1864 and 1865, *Massa, Bay of Naples* (Pl. 143) and *Morants Court in May* (Pl. 144), he continued to paint with minute Pre-Raphaelite care, but in neither work does the quantity of detail have such pronounced importance as in Brett's earlier paintings.

Massa, Bay of Naples is a coast scene, and water fills the foreground. The town of Massa, or Massalubrense, on the Sorrento peninsula, is seen at some distance and occupies only a relatively small part of the picture as a whole. A watercolour showing the same precipitous coast, *Near Sorrento* (City Art Gallery, Birmingham), is dated October 1863.[47]

Morants Court in May was painted for £100 as one of a pair of commissioned pictures of a house near Sevenoaks in Kent. It is a Victorian descendant of the eighteenth-century country-house portrait, but it is not a picture of a mansion set in a landscaped park. Rather, it shows a modest farmhouse, of no architectural pretension, a cow and calves in a field before it. The companion painting, now lost but known through an old photograph, showed the house from the opposite direction, with a scene of ploughing and pigs rooting in the newly turned earth in the foreground, at a greater distance from the house. In *Morants Court in May* the house and its immediate surroundings are painted with delicate precision, while the foreground and distance play subordinate roles. If we compare the painting with *The Stonebreaker*, which is approximately the same size, we can see that, by eliminating intricate foreground foliage and an extensive background view, Brett reduced substantially his own labour (or – since we do not know how much work he devoted to either picture – our sense of his labour) and gained a more unified vision, less subdivided into separately observed details. However, separately observed details, laboriously recorded each and all, give *The Stonebreaker* a vibrant freshness which is no longer present in these works from the following decade. Brett's new sophistication, or prudence, was at the expense of the belief that a picture could be all-encompassing, which is one of the most distinctive ingredients of Pre-Raphaelite landscape painting.

Watercolours that Brett made near Goring-on-Thames in 1865 (Pl. 145) and on the Isle of Wight in 1866 (Birmingham Museum and Art Gallery) are comparable to *Morants Court* in the amount of detail they show and have a poetic, dream-like or visionary stillness otherwise rare in Brett's art.[48] A less poetic, but still highly detailed, watercolour of Yarmouth, filled with boat-building and other activity, is signed and dated 1868 (private collection).[49]

Brett's exhibited oil paintings from 1866 through 1870 have disappeared, but the two paintings which he sent to the Royal Academy in 1871, *Etna from the Heights of Taormina* (Pl. 146) and *The British Channel Seen from the Dorsetshire Cliffs* (Pl. 147), are both now in museums. The former picture was a product of the artist's trip to Sicily in the winter of 1870–1 to observe an eclipse. When it was exhibited, the *Art Journal* called it 'a carefully mapped-out scene' in the 'now all but extinct style once known as Pre-Raphaelite'.[50] We will address the extinction of Pre-Raphaelitism in chapter fourteen. The description of the painting seems fair enough, although if we compare *Etna from Taormina* with the

144 John Brett, *Morants Court in May* 1864. Oil on canvas, 17½ × 27½. Private Collection.

145 John Brett, *Near Goring-on-Thames* 1865. Watercolour, 12 × 16. Whitworth Art Gallery, University of Manchester.

Val d'Aosta we can see that it is more conventionally topographical and considerably less finely detailed. Brett had been in the Val d'Aosta for over five months; he was in Sicily for approximately two and did not devote himself just to painting while there. The *Val d'Aosta* measures $34\frac{1}{2} \times 26\frac{7}{8}$ inches; *Etna from Taormina* measures $33 \times 48\frac{1}{2}$ inches. It is not a huge painting, but the increase in size in this and other works provoked Ruskin's complaint in 1875 that Brett covered 'too large canvas. There is no occasion that a geological study should also be a geological map.'

Like *Etna from the Heights of Taormina*, *The British Channel Seen from the Dorsetshire Cliffs* is a view from a height over a vast distance, but the view now is over water. *Massa, Bay of Naples* (Pl. 143) and other works from his visit to Naples in 1863–4 provide the earliest evidence of Brett's interest in the sea. At the Royal Academy in 1864 he also exhibited *A North-west Squall in the Mediterranean*. From 1865 until his marriage in 1870 he seems to have spent much of his time in various fishing or yachting ports around England and Wales. After his marriage he regularly spent his summers with his family aboard a yacht, cruising and sketching in the waters surrounding the British Isles. After 1871 he travelled no further abroad than Cherbourg and Etretat, and almost all of his later pictures are views either of or from the coast of Britain. While *Etna from Taormina* is a last echo of the 'all but extinct style once known as Pre-Raphaelite', *From the Dorsetshire Cliffs* can serve to represent the remaining two-thirds of Brett's professional life, which he devoted to painting seashores and the sea.

Between 1870 and 1901 he sent an average of three pictures a year to the Royal Academy, measuring up to 42×84 inches each, the size of *From the Dorsetshire Cliffs*. These were in addition to a mass of oil sketches produced during the summers. In the autumn of 1886 he exhibited a group of forty-six sketches and three small paintings in an exhibition entitled *Three Months on the Scottish Coast*. In the catalogue Brett stated that this exhibition represented an average summer's work, and he explained his procedures.[51] The sketches were painted from nature in single sittings of two or three hours, and each was supposed to be a single observation unadulterated. The small pictures were the products of days unfit for sketching out of doors. His large pictures, which he described as abstracts of several observations, were painted in the studio in the winter. Brett was proud of his efficiency and claimed that his practice of painting at once, without retouching, reduced his labour to about a third of that of most artists. The sketches are generally all the same size, 7×14 inches, and the larger pictures, with only rare exceptions, retain the same proportions. Not surprisingly, in light of this standardised mass production, the seascapes all tend to look rather alike. The most memorable of them are the pictures of expanses of open sea such as *From the Dorsetshire Cliffs* or *Britannia's Realm* of 1880, both of which are in the Tate Gallery. Their clarity of vision combined with bright prismatic colours might be considered reminiscent of Pre-Raphaelitism, but the remote emptiness

of these views is the antithesis of the loving closeness of Pre-Raphaelite detail. Ruskin's criticism notwithstanding, Brett's later pictures do have precision, but it is only too easy to agree with Ruskin's lament about his loss of sentiment.

About that quality Brett had this to say: 'Sentiment in landscape is chiefly dependent on meteorology.'[52] Such a remark may well be true; it says essentially the same thing as Constable's 'It will be difficult to name a class of landscape in which sky is not the keynote, the standard of scale, and the chief organ of sentiment',[53] but it says it in a manner that has become mechanistically impersonal. Brett concluded his essay in *Three Months on the Scottish Coast* with the assertion, 'the out-of-doors world is entirely at the command of the landscape painter, and if he does not depict it accurately it is not because of the imperfection of his means and appliances, or the inherent weakness of his art, but merely because he lacks intelligence and information.' Brett had intelligence and information, and his later pictures do depict the out-of-doors world with cold accuracy. The larger ones do embody his self-assured power of analytic observation, and

146 John Brett, *Etna from the Heights of Taormina* 1870-1. Oil on canvas, 33 × 48½. Mappin Art Gallery, Sheffield.

147 John Brett, *The British Channel Seen from the Dorsetshire Cliffs* 1871. Oil on canvas, 41¾ × 83¾. Tate Gallery, London.

many of the oil sketches are even sensitive. Sensitivity, however, did not hold a very important place in Brett's scientific scheme of things, and 'insensitive' is an adjective which has been applied frequently to his later works. The pictures were, nonetheless, products of a lucidly systematic intelligence, and they brought the artist recognition and success. *Britannia's Realm* was a Chantrey Bequest purchase in 1880, and in the following year Brett was elected an associate member of the Royal Academy. He remained an associate, never becoming a full member, but, except for Millais, no other painter from the Pre-Raphaelite group of the 1850s entered even that far into the fold.

The Liverpool School

Outside London, the Pre-Raphaelites received their most friendly reception in Liverpool. The annual exhibition of the Liverpool Academy became a Pre-Raphaelite domain, and a group of local Liverpool artists fell heavily under Pre-Raphaelite influence.

In 1850, a young Liverpool painter, William Lindsay Windus, was encouraged by a local collector, John Miller, to visit the exhibition of the Royal Academy in London to see what other painters were doing. There he saw Millais's *Christ in the House of His Parents*, and his excitement about this picture was apparently enough to form a basis for the conversion of several of his associates. In 1851, Holman Hunt sent *Valentine Rescuing Sylvia from Proteus* to the exhibition of the Liverpool Academy, and it won the prize given annually to a work by a non-member. This success led to the Pre-Raphaelites' adoption of Liverpool as a regular place of exhibition.[1] Between 1851 and 1859, Hunt, Millais, and Brown each won the annual prize twice. In the other three years it went to William Dyce, to Brown's friend Henry Mark Anthony, and to Augustus Egg, who also had Pre-Raphaelite ties. When Millais's *Blind Girl* won the prize in 1857, it provoked violent opposition from a conservative faction of the Academy and in the press. The controversy drew a letter from Ruskin supporting the Academy's choice;[2] it also led to the formation of a rival group and to the eventual demise of the Liverpool Academy. The Liverpool artists themselves participated in some of the activities of the London Pre-Raphaelites. In 1857 several sent pictures to the exhibition in Russell Place and to the American exhibition of the same year, and the category of non-resident artistic members of the Hogarth Club was dominated by Liverpool painters.

Windus was the leading figure of the group, and he remains the best-known. His first work to show Pre-Raphaelite influence was *Burd Helen* (Walker Art Gallery, Liverpool), which he exhibited at the Royal Academy in 1856, and which drew Ruskin's glowing praise. Three years later, he exhibited *Too Late* (Tate Gallery). This picture also drew a long but less sympathetic review from Ruskin.[3] Both paintings reflect Millais in the figural style, and Pre-Raphaelitism in general in their subjects. Both are outdoor pictures, but the settings are of relatively minor importance. *Burd Helen* is based on a Scottish Border ballad, and for the sake of verisimilitude Windus painted its background on the Isle of Arran. As in the early pictures of Hunt and Millais, the landscape seems to have been executed first and the figures added later in the studio. The background of *Too Late* is slightly more elaborate, but neither background is obtrusive or draws attention to itself to the extent that Millais's do. That of the latter picture is pale in colour and so thinly painted that it looks unfinished. As a result, it has an atmospheric breadth atypical of Pre-Raphaelitism.

In 1859 a combination of calamities, including Ruskin's criticism of *Too Late*, almost brought Windus's painting career to an end. During the rest of his long life, he worked only infrequently, and he destroyed much of what he did. All his known works from after 1859 are small, and most are sketches. There are, nonetheless, two small finished pictures, which are essentially landscapes. The earlier is *The Outlaw*, which Windus painted in 1861 and exhibited at the Liverpool Academy in 1862 (City Art Gallery, Manchester).[4] This is almost a problem picture, in which the problem is to find the subject. Two small figures are buried in the foliage in the extreme foreground, and a running hound is barely visible in the background. For the rest, the picture is a landscape seen entirely below the

148 William Lindsay Windus, *The Stray Lamb* 1864. Oil on board, 8³/₄ × 12¹/₂. Walker Art Gallery, Liverpool.

horizon. Except for the figures the colour is green without strong contrasts. The foreground foliage is painted in small detail, which increases its importance at the expense of the figures. The other painting is *The Stray Lamb* (Pl. 148). According to James Smith, a friend and patron, Windus painted it in 1864 near the River Duddon in the Lake District, where he spent summers with the painter Daniel Alexander Williamson.⁵ The lamb, which gives the picture its title, stands on a rock in the left foreground and is tiny in proportion to the picture area as a whole. As in *The Outlaw*, there is no sky; our view consists entirely of rocks and trees with a bit of the water of the stream. The foreground rocks are carefully drawn; those in the background and the foliage are less precise. The colouring is straightforward: grey rocks, green foliage. The banks of the stream in the background are slightly purplish, but not obtrusively so, and the handling has an air of timid delicacy which seems appropriate to the subject.

The Liverpool artist most admired by the Pre-Raphaelites after Windus was the landscape painter William Davis. Davis was born in Dublin in 1812, which makes him considerably older than any of the London Pre-Raphaelites. His artistic education took place in Dublin, and he began his professional career as a portrait painter in his native city. Failing to find patronage there, he soon migrated to Liverpool. He became an associate member of the Liverpool Academy in 1851 and a full member in 1854. He first exhibited landscapes in 1853. The change of subject was made under the influence of another Liverpool artist, Robert Tonge, a gifted painter who had an unfortunately short career. Tonge went to Egypt because of ill health in 1853, at the age of thirty-one, and he died there two years later. Thus, he left Liverpool before he had much opportunity to fall under Pre-Raphaelite influence. His few known works generally show vast landscapes under cloudy skies, painted in a limited range of brown tones (Pl. 149). Davis and Windus are said to have frequently painted the figures in his pictures.

149 Robert Tonge, *Cheshire Landscape* 1853. Oil on canvas, 20 × 34¹/₈. Walker Art Gallery, Liverpool.

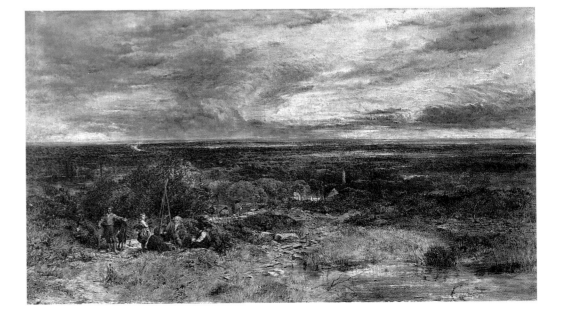

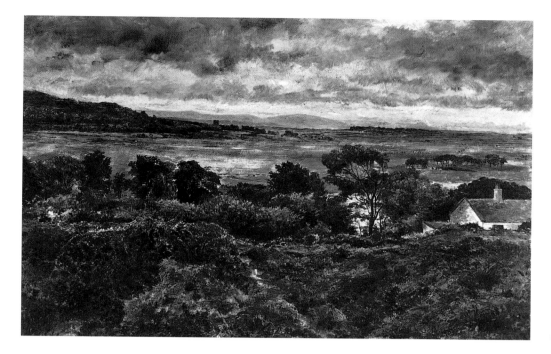

150 William Davis, *Bidston Marsh at Wallasey* 1853 (?). Oil on board, 11⅞ × 17⅞. Walker Art Gallery, Liverpool.

Davis's earliest landscapes are often close to those of Tonge. An example is *Bidston Marsh at Wallasey* (Pl. 150). Both Tonge's and Davis's pictures show a probable debt to John Linnell, and the loose, oily sky of Davis's landscape suggests that he had also looked at pictures by Mark Anthony, who exhibited regularly at the Liverpool Academy from 1851 onwards and was to win its prize in 1854. There is nothing in Davis's picture that gives any hint of an affinity with Pre-Raphaelitism.

In 1855 Davis first exhibited a landscape at the Royal Academy. This painting, *Early Spring Evening – Cheshire*, was badly hung, but Dante Gabriel Rossetti spotted it and described it, along with Inchbold's pictures, as one of the best landscapes in the exhibition.[6] Rossetti also made Ruskin, who had not noticed the picture at the Academy, mention it anyway in *Academy Notes*:

> Absence from London prevents, for the present, my seeing a picture, of which a friend in whose judgement I have great confidence, speaks with unusual enthusiasm – no. 514, *Early Spring Evening* (W. Davis). My friend says it contains the 'unity of perfect truth with invention'. I cannot answer for its doing this, which would place it in the first rank of works of art; but, as it is hung in a place where it is not easily caught sight of, I have little doubt it must be a work of merit.

Ruskin did have a chance to look at the picture before the third edition of the *Notes* was published. He added a supplement mentioning it again, less favourably:

> In the work commended to me by my friend – Mr. Davis's *Spring Evening* (514) – I am disappointed. It is unfair to judge of it in its present position, but it seems to me merely good Pre-Raphaelite work, certainly showing no evidence whatever of inventive power, and perhaps less tact than usual in choice of subject; but it is assuredly superior to any of the landscapes hung on the line.[7]

The picture was also mentioned in the *Art Journal* where it was described as a grassy bank flanked on the left by a screen of leafless trees. The *Art Journal*'s reviewer more or less repeated Ruskin's criticism, but drew the opposite conclusion: 'The choice of such a subject, which has not one picturesque quality, argues considerable self-reliance, and the result justifies the confidence'.[8]

In 1856 Davis sent two further landscapes to the Royal Academy. One of them, *Wallasey Mill, Cheshire*, elicited an ecstatic response from Ford Madox Brown, who wrote in his diary after seeing the Academy exhibition: 'there is & a little landscape by Davis of Liverpool of leafless trees & some ducks which is perfection. I do not remember ever having seen such an english landscape, it is far too good to be understood – & on the floor.'[9] A few months later Brown was in Liverpool and met Davis at the home of John Miller; he described him in his diary:

> I met Davis who brought a little sketch from nature, very beautiful. Miller asked me as a favour to buy it of him, which I could not refuse him although it puts me in the

aucward position of patronising a man whom I think far too well of to attempt the like with – however it is done. This Davis, who has been one of the most unlucky artists in England (now about 40 with a wife & family) is a man with a fine shaped head & well cut features & his manners not without a certain modest dignity, but, as it were, all crushed by disappointment & conscious dependency of Millar [*sic*] who has entirely kept him for years – & the only man in the world who buys his pictures. Very sad – we must hope his turn will come.[10]

By 1857 Rossetti's and Brown's admiration had brought Davis into the sphere of Pre-Raphaelite activities. He exhibited six pictures at the exhibition in Russell Place, and he sent three works to the American exhibition. In 1858 he became a member of the Hogarth Club. However, inclusion in the Pre-Raphaelite group was no guarantee of success. From accounts other than Brown's we know that Davis had a neurotically touchy personality.[11] He refused to have anything to do with dealers, which, of course, increased the difficulty of selling his works. Although he did have consistent support from Miller, and eventually from a few other Liverpool collectors, he was fairly impoverished for most of his life.

Davis's output was large, and there are sizeable groups of his works in the Walker Art Gallery in Liverpool and in the Williamson Art Gallery in Birkenhead. He almost never dated his pictures, and it is hard to identify his works from the titles under which they were exhibited. Neither the *Early Spring Evening* admired by Rossetti in 1855, nor the *Wallasey Mill* praised by Brown in 1856, is now known. A picture of a mill with ducks in the foreground, *Old Mill and Pool at Ditton, Lancashire*, is in Liverpool (Pl. 151). This painting is not dated, but it may serve to give an approximate idea of the appearance of the lost *Wallasey Mill*. Its colours are brighter than those in *Bidston Marsh* of 1853 (Pl. 150);[12] breadth has been superseded by a much smaller touch; and the spaciousness of the prospect in the earlier picture has given way to a more circumscribed view. These changes are in the direction of Pre-Raphaelitism, and we can assume that similar qualities in the works that Rossetti and Madox Brown saw drew their initial attention to Davis. In another undated picture in Liverpool, *At Hale, Lancashire* (Pl. 152), there are also ducks in the foreground, and Davis's careful drawing of the branches and leaves on the trees to the left is yet more obviously Pre-Raphaelite.

Both paintings reflect Davis's affection for humble foreground detail. The duck ponds are not compositional foils for distant views, but are in themselves the objects of loving attention. Davis seems to have had little interest in grander scenery, and a number of stories are recorded of his turning his back on extensive views in order to sketch a duck pond or the opening of a drain.[13] In this respect, his landscapes are like those of Ford Madox Brown, who was also criticised by Ruskin for his choice of subject. In Brown's case, Ruskin's comment about the 'ugly subject' of *An English Autumn Afternoon* was made to the artist,[14] and Ruskin never mentioned Brown's work in print. Ruskin did not comment publicly on Davis's art again after expressing his disappointment in 1855, but in 1857, when Davis sent his pictures to the Russell Place exhibition, Rossetti solicited Ruskin's opinion. Ruskin wrote a letter to Davis which was found in a stamped envelope among Rossetti's papers. Apparently Ruskin had submitted it to Rossetti, who decided against sending it on. The main burden of the letter was a more specific repetition of Ruskin's earlier comments about lack of tact in choice of subject:

My Dear Sir, – I had much pleasure in examining the pictures of yours which Mr. Rossetti showed me this afternoon: they show an exquisite sense of colour, and much tender feeling of the expression of the scenes. Rossetti is himself so much delighted with them that I do not doubt their possessing qualities of peculiar interest to an artist, in the conquering of various technical difficulties. Your work, however, cannot become popular unless you choose subjects of greater interest, nor can I in the least direct you how to choose them – for there seems to me hardly a single point of communion or understanding between you and me as to the meaning of the word, 'Subject'. It seems to *me* that you might have sought over most landscapes for miles together, and not stumbled over anything so *little* rewarding your pains and skills as that 'ditch and wheatfield.'[15]

As we have seen in Ruskin's treatment of John Brett, proper choice of subject was central in his consideration of landscape. The artists who followed his advice soon found themselves in the Alps, and Brett's *Val d'Aosta*, whatever its shortcomings, was at least a picture in which the artist's industry had not been wasted on scenes of no interest. On the other hand, intimate details of the English countryside were unworthy objects of an

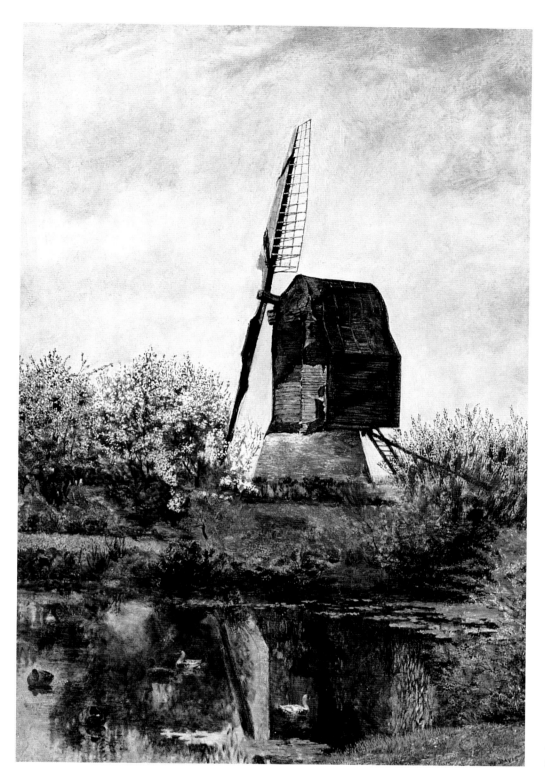

151 William Davis, *Old Mill and Pool at Ditton, Lancashire c.* 1856–60. Oil on canvas, 20⅞ × 14⅛. Walker Art Gallery, Liverpool.

artist's labour. Ruskin made his feelings about this known not only in criticism of specific pictures in *Academy Notes*, but also in more general comments about the Pre-Raphaelites which he included in the later volumes of *Modern Painters*. In the fourth volume, published in 1856, he declared that a proper subject should be both pleasurable and instructive to the general public:

I should particularly insist at present on this careful choice of subject, because the Pre-Raphaelites, taken as a body have been culpably negligent in this respect, not in humble respect to Nature, but in morbid indulgence of their own impressions. They happen to find their fancies caught by a bit of an oak hedge, or the weeds at the side of a duck-pond, because, perhaps, they remind them of a stanza of Tennyson; and forthwith they sit down to sacrifice the most consummate skill, two or three months of the best summer time available for outdoor work (equivalent to some seventieth or sixtieth of all their lives), and nearly all their credit with the public, to this duck-pond delineation. Now it is indeed quite right that they should see much to be loved in the hedge, nor less in the ditch; but it is utterly and inexcusably wrong that they should

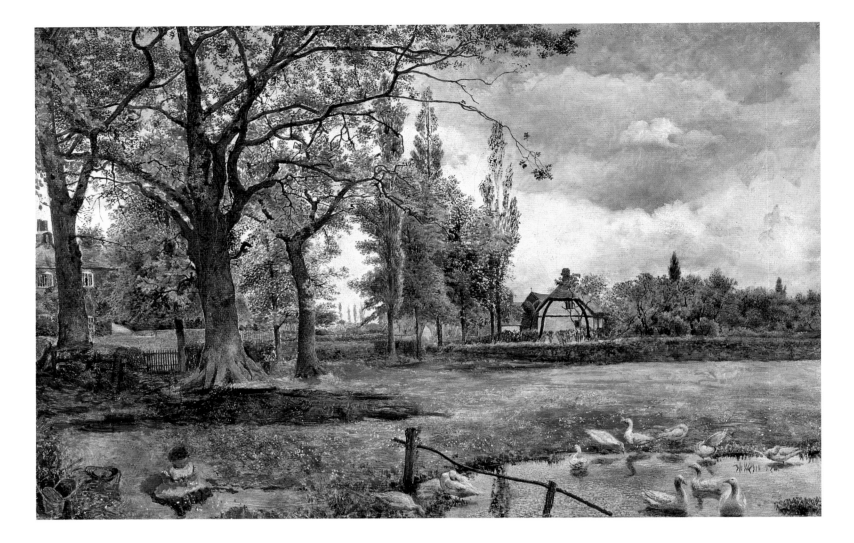

152 William Davis, *At Hale, Lancashire* Oil
on canvas. 13 × 19³/₄. Walker Art Gallery,
Liverpool.

neglect the nobler scenery which is full of majestic interest, or enchanted by histori-
cal association.[16]

In 1856 this discussion of choice of subject was still good-natured scolding, and
Ruskin followed his criticism of Pre-Raphaelite subjects by telling the artists what they
should paint: 'views of our abbeys and cathedrals; distant views of cities, if possible cho-
sen from some spot in itself notable by association; perfect studies of the battle-fields of
Europe, of all houses of celebrated men, and places they loved, and, of course, of the most
lovely natural scenery.' In 1860, Ruskin returned to the subject in the final volume of
Modern Painters. He cited this passage, and then, speaking of the Pre-Raphaelites in the
past rather than present tense, he described their lack of feeling for grand subjects not as
something to be corrected, but as a fatal flaw which had undermined the movement:

> I saw with increasing wonder, that they were almost destitute of the power of feeling
> vastness, or enjoying the forms which expressed it. A mountain or great building only
> appeared to them as a piece of colour of a certain shape. The powers it represented,
> or included, were invisible to them. In general they avoided subjects expressing space
> or mass, and fastened on confined, broken, and sharp forms; liking furze, fern, reeds,
> straw, stubble, dead leaves, and such like, better than strong stones, broad flowing
> leaves, or rounded hills; in all such greater things, when forced to paint them, they
> missed the main and mighty lines; and this no less in what they loved than in what
> they disliked; for though fond of foliage, their trees always had a tendency to congeal
> into little acicular thorn-hedges, and never tossed free. Which modes of choice pro-
> ceed naturally from a petulant sympathy with local and immediately visible interests
> or sorrows, not regarding their large consequences, nor capable of understanding more
> massive view or more deeply deliberate mercifulness; – but peevish and horror-struck,
> and often incapable of self-control, though not of self sacrifice. There are more peo-
> ple who can forget themselves than govern themselves.[17]

Ruskin's choice in 1856 of 'duck-pond delineation' as his example of misplaced skill sug-
gests strongly that he was thinking of Davis, for whom ducks were almost a signature.
The later comments reflect the disillusionment of Ruskin's hopes for Pre-Raphaelitism

which contributed to his abandoning *Academy Notes*. Since Ruskin wrote about the artists' failure when painting mountains, his criticism applies to Brett and Inchbold as much as to Davis or Brown. But the 'sympathy with local and immediately visible interests' is most evident in Brown's and Davis's landscapes. Their inability to share Ruskin's feeling for 'greater things' is an indication of the Pre-Raphaelite generation's abandonment of attitudes which were still basic for Ruskin. The painters were no longer attracted by what previous generations called 'the sublime', and Ruskin was unwilling to accept a feeling for 'a piece of colour of a certain shape' as its replacement.

Davis was not only criticised by Ruskin for his inability to choose subjects. He was also criticised by the generally sympathetic writers, F. G. Stephens and H. C. Marillier, for errors of perspective and proportion.[18] This was a widespread 'failing' in the middle of the nineteenth century. We can see it in different forms in artists as diverse as Dante Gabriel Rossetti and Gustave Courbet, for whom laws of perspective and academic rules of composition were no longer sacrosanct. In Davis's case, as in Rossetti's and Courbet's, the inability to master perspective seems less a weakness than a reflection of other interests. What need did a landscape painter who turned his back on traditional views have of traditional, illusionistic, three-dimensional space? Davis's lack of technical mastery in creating space went hand-in-hand with the abandonment of conventional space-creating compositional devices that was a central element of the Pre-Raphaelite creed since Holman Hunt's attack on brown foliage and dark corners in February 1848.

The result of Davis's 'total disregard of composition' (in Marillier's words) and neglect of the 'requirements of art' (in Stephens's) is that his compositions often stay on the surface of the canvas. *Old Mill and Pool at Ditton* is a brightly coloured, two-dimensional pattern. The mill is of less interest for its picturesque dilapidation than as a coloured silhouette which is reflected in the water below. The foliage of the shrubbery around the mill is not drawn with botanic accuracy, but treated as small points of colour, which are also reflected in the water. There is no space; mill, plants, and pool all exist on one vertical plane. Other compositions recall Ford Madox Brown's landscapes. *A Field of Green Corn* (Pl. 153), which could well be the 'ditch and wheatfield' criticised by Ruskin in 1857 (but could equally well be either the *Green Corn* or the *Cornfield* which Davis exhibited in Liverpool in 1860 and 1861 respectively), is like Brown's *Carrying Corn* (Pl. 25), but Davis has gone further in concentrating upon the foreground while minimising the landscape beyond. It is also more freely painted than Brown's picture. Even more remarkable in its simplicity is the undated *Grass Field* (Pl. 154). In composition and ease of handling this small picture seems to point straight to Impressionism. While the flattening of many Pre-Raphaelite pictures appears as an accidental result of filling the composition with foreground detail in a kind *of horror vacui*, that is not the case with Davis. *A Grass Field* does not have a closely studied foreground, and the view is extensive, yet the result is essentially two-dimensional. Marillier probably would have considered such a picture an example of Davis's disregard of composition, but the disregard now looks like a precocious and sophisticated feeling for the picture surface. The anonymity of the figure, who is neither more nor less important than everything else but simply part of the visual whole, also helps to make *A Grass Field* look like a curious anticipation of Monet, but we can see a precedent for this anonymity in the foreground figure in Brown's *Carrying Corn*.

Davis was not always so precocious. *At Hale, Lancashire* (Pl. 152), for example, has more conventional spatial recession, and the child in the foreground has a personality apart from the setting. Davis's larger pictures frequently have subjects from rural life, which F. G. Stephens compared to those of Jean-François Millet.[19] *Harrowing* (Pl. 155), which Davis exhibited in Liverpool in 1859, shows a boy with a team of horses working at twilight. A church tower is silhouetted on the horizon. This picture was rejected by the Royal Academy, possibly because of the faults of perspective which are evident in the different vanishing-points of the furrows. It was included in the International Exhibition of 1862, where William Michael Rossetti cited the differences between it and Brett's *Val d'Aosta* as evidence of the width of range and aim within the Pre-Raphaelite movement and made the staggering claim, 'With the exception of Turner, we doubt whether any artist of our school approaches nearer to the ideal of true landscape than Davis in this delightful work.'[20]

Later and larger ploughing subjects, one of which Davis exhibited at the Royal Academy in 1870, are in Birkenhead and Liverpool. They show less feeling for mood and an increased sense of two-dimensional pattern. In 1870 Davis moved to London, where, according to Stephens, he changed his style to a broader, more effective one. He died in

153 William Davis, *A Field of Green Corn*.
Oil on panel, 12 × 15. Private Collection.

1873, supposedly of an attack of *angina pectoris* brought about by the bad hanging of one of his pictures in the International Exhibition of 1873.[21] A group of artists led by Brown organised an exhibition and sale of his work to provide for his wife and ten children. Brown tried to get Gladstone to put Davis's widow on the civil list, but failed because of the family's Catholicism. He also helped one of Davis's sons work up a number of unfinished pictures that had been left in the studio, and ultimately did succeed in raising some two thousand pounds.

Davis was a failure by the measures of recognition, reputation, and material success. Living in the provinces, however, and supported by a few loyal patrons, he was relatively free to go his own way, and he did follow a more adventurous path than most of his more established contemporaries. Yet Davis does not seem to have had the self-assurance to follow his independent path very far. There is little consistency in his art. At one moment he is suprisingly modern; at the next he is pedestrian. His best work justifies Brown's enthusiasm, but his output as a whole is disappointing. If he had worked in a more sympathetic atmosphere, he might have become an artist of greater stature, but it

154 William Davis, *A Grass Field*. Oil on canvas, 9 × 13. Present location unknown.

THE LIVERPOOL SCHOOL

155 William Davis, *Harrowing c.* 1859. Oil on canvas, 17¼ × 26. Private Collection.

seems more likely that his isolation allowed him the adventurous aspects of his art, and if he had flourished materially, as in the case of so many other Victorians, it would not have been to the benefit of his painting.

Among the Liverpool artists, as in the Pre-Raphaelite movement as a whole, we can discern a polarity, with Davis at one extreme, and Alfred William Hunt at the other. While Davis was the object of Ruskin's disapproval, Hunt not only drew Ruskin's praise in *Academy Notes*, but also his lasting friendship. Hunt visited Brantwood in Ruskin's old age, and Ruskin was the godfather of one of Hunt's daughters. Like Ruskin, Hunt studied at Oxford, where, again like Ruskin, he won the Newdigate prize for poetry.

Hunt was born in Liverpool in 1830, the son of a landscape painter, Andrew Hunt, and he was active as an artist well before his graduation from Oxford in 1852. His early work is mainly in watercolour and is dependent on the example of David Cox, who was a friend of his father. As late as 1855, Hunt was still painting watercolours of Welsh scenery which show no appreciable Pre-Raphaelite influence, but between 1855 and 1856 his art apparently changed. In the latter year he exhibited at the Royal Academy another Welsh subject, *The Stream from Llyn Idwal, Carnarvonshire*, which Ruskin praised lavishly: 'The best landscape I have seen in the exhibition for many a day – uniting most subtle finish and watchfulness of nature, with real and rare power of composition.' In 1857, Hunt exhibited a picture titled *When the Leaves Begin to Turn,* which again drew Ruskin's superlatives: 'Consummate in easy execution and blended colour; there is nothing else like it this year'.[22] Ruskin did qualify his praise of both pictures, but he effectively proclaimed Hunt's works the most promising landscapes exhibited in 1856 and 1857. Inchbold had held first place in 1855, but in 1856 *Mid-Spring* was 'not a satisfactory picture'. John Brett did not draw Ruskin's public praise until 1858.

Hunt had been offered a fellowship at Oxford and in 1856 was vacillating between an academic and an artistic career. Ruskin's praise decided him in favour of the latter. In 1857, with three pictures accepted by the Academy and more praise from Ruskin, he must have felt that he had made the right decision. Despite Ruskin's admiration, he does not seem to have been a close associate of the Pre-Raphaelites at this time. In 1857 he did not have works in the exhibition in Russell Place, nor in the American exhibition, although other Liverpool artists, including Davis and Windus, participated

156 Alfred William Hunt, *Cwm Trifaen — The Track of an Ancient Glacier c.* 1858. Oil on canvas, 23³/₄ × 35³/₄. Tate Gallery, London.

in both. He was a member of the Liverpool Academy, and in 1858 he became a non-resident member of the Hogarth Club, but not a universally admired one. In December 1858 Dante Gabriel Rossetti described the landscapes he sent there as 'very second-rate'.[23]

Hunt may have thrown his lot in with the Pre-Raphaelites because his successes of the previous years were reversed by the rejection in 1858 of all his entries at the Royal Academy. One of the rejected pictures, *Cwm Trifaen — The Track of an Ancient Glacier*, is now in the Tate Gallery (Pl. 156). This painting of rugged Welsh terrain still retains reminiscences of David Cox in its exaggerated perspective and in the stormy sky, which, obscuring the outer parts of the painting, allows the centre to stand out dramatically. However, the freer handling of Hunt's earlier work has been replaced by much more precisely drawn detail in which lichens, striations, and pebbles are all carefully recorded. The subject, like that of Brett's *Glacier of Rosenlaui* of a year earlier, was probably inspired by the geological parts of the fourth volume of *Modern Painters*, and even the title would seem to come from that volume.[24] Following the rejection of his pictures, Hunt evidently asked Ruskin to look at them, or at one of them. Ruskin did and sent Hunt a critique which seems to be about *Cwm Trifaen*.[25] He praised the picture — 'a wonderful one — *very* wonderful' — but then went on to list three mistaken principles under which it had been painted. First, Hunt did not differentiate sufficiently between areas of light and shadow, whereas he should have subordinated one to the other. Second, he painted too much in a tiny stipple. And, third, despite the obvious geological interest of the site, the subject was badly chosen: 'The conditions of a things being fit for a picture is that every part of it sets off the qualities of the other parts. You have here a waste of stone — every part of which repeats & weakens the rest.' Then in a postscript Ruskin made his main point: 'I want you to feel more the value of *omission*', and he ended by offering practical advice that he would subsequently repeat regarding Brett.[26] It was a mistake to work on such large canvases. 'Paint small, easily saleable pictures. It is much easier to find ten purchasers of 25g[uinea] pictures than one purchaser of a 250 one'.

The criticisms, intended as friendly advice, do seem apt. In traditional fashion, light in *Cwm Trifaen* is used to organise the composition rather than illuminate the subject. A sunbeam melodramatically highlights a rocky outcrop in the middle distance, while the geological detail in the foreground is partly obscured by shadow. We might note, by contrast, the less artful but much clearer light illuminating the foreground of Brett's *Glacier of Rosenlaui*. The emphatic focus on three prominent foreground stones in the *Glacier of Rosenlaui* at the expense of everything else also makes clear Ruskin's point about every part of Hunt's picture repeating and weakening the rest. His criticism of stippling is something that he would return to and elaborate in discussing the laborious detail in Hunt's and other artists' pictures in *Academy Notes* in 1859.

Ruskin wrote this letter to Hunt in May 1858 from France, in the first days of a continental trip that would eventually take him to Turin and his encounter with Brett discussed in the preceding chapter. Despite the considerable differences between

the art of Hunt and Brett, the letter contains the seeds of his public criticism of the *Val d'Aosta* in 1859, and some of his further remarks about Brett. It seems quite likely that Brett heard similar comment from Ruskin at Turin in August 1858, although for him to respond to it might have required bigger changes in what he had set out to do than a well-indoctrinated Ruskinian was prepared to make. 'The value of *omission*', which Ruskin asked Hunt to feel, contradicts the principle of 'rejecting nothing, selecting nothing' proclaimed in *Modern Painters* I, reasserted by Ruskin when defending the Pre-Raphaelites in 1851, and carried to its ultimate extreme in the *Val d'Aosta*.

During this period, Hunt apparently painted directly out of doors in watercolours. A good example is a study of a rocky precipice in Wales, which is signed and dated 1858 (Pl. 157). Atmospheric effect is unimportant, and although the view appears extensive, most of the watercolour consists of lichenous rocks in the immediate foreground. These watercolours from the 1850s are Hunt's freshest and strongest works. Their compositions seem to be the result of a direct confrontation with nature, whereas in his more finished pictures three-dimensional space and atmospheric effect seem to have been grafted on to the subjects to make them more conventionally pictorial. His sketchbooks are preserved in the Ashmolean Museum, and the careful studies of rocks and lichens which they contain demonstrate with what systematic care he prepared his pictures. His habit in later life was to sketch from nature in the summer, and in the winter to paint pictures in the studio from his sketches.[27] This was probably his procedure with *Cwm Trifaen*, and that partially explains why the picture seems artificially composed when compared with the watercolours or with pictures that Brett and other Pre-Raphaelites painted from nature.

After his exclusion from the Royal Academy in 1858, Hunt had three works, probably all in watercolours, in the exhibition of 1859: another Welsh subject and two from near the River Greta in Yorkshire. An oil painting in Liverpool of *Brignall Banks*, which overlook the Greta (Pl. 158), was probably a product of the same sketching trip. The

157 Alfred William Hunt, *Welsh Landscape* 1858. Watercolour, 9⅞ × 14¼. Ashmolean Museum, Oxford.

158 Alfred William Hunt, *Brignall Banks c.*
1859. Oil on canvas, 11¼ × 18⅛. Walker Art
Gallery, Liverpool.

scenery along the Greta had been depicted by numerous earlier artists including Turner
and John Sell Cotman in several beautiful and famous watercolours. In taking it as a sub-
ject, as in painting in Wales, Hunt was following established patterns and, in this respect,
was more conservative or old-fashioned than his Pre-Raphaelite contemporaries. The
picture in Liverpool is a fairly conventional landscape view, treated throughout with
laborious care. The foreground leaves are microscopic, and the rest of the landscape,
which is extensive, is painted in a tiny stipple.

Ruskin did not give Hunt's works exhibited in 1859 the same enthusiastic praise that
he had devoted to those of 1856 and 1857; in fact, he only mentioned Hunt in passing
while discussing a drawing by Henry Clarence Whaite:

> Compare with it the interesting study opposite, by Mr. A. W. Hunt (997. *On the Greta*),
> entirely well meant, but suffering under the same oppression of plethoric labour. I do
> not often, in the present state of the English school, think it advisable to recommend
> 'breadth'; but assuredly both Mr. Whaite and Mr. Hunt, if they wish to do themselves
> justice, ought to give up colour for a little while, and work with nothing but very ill-
> made charcoal which will not cut to a point.

Although Ruskin wrote at some length about Whaite, whose *Barley Harvest* he declared
the most covetable bit of landscape of the year, he criticised Whaite's execution, and this
criticism, couched in general terms, provides an elaboration of what he told Hunt in
1858 and wrote about him in 1859:

> The execution of the whole by minute and similar touches is a mistake. Certain tex-
> tures need to be so produced and certain complexities of form; but the work is never
> good unless it varies with every part of the subject, and is different in method, accord-
> ing to the sort of surface or form required. Nothing finished can be done without
> labour; but a picture can hardly be more injured than by the quantity of labour in it
> which is lost. Uncontributive toil is one of the forms of ruin.
>
> Many other studies of great interest may be found scattered on the walls, in which,
> while there is much to be admired, this is generally to be regretted, that the painters,
> not being able to do their work entirely well, think to make progress by doing a great
> quantity of work moderately well, which will by no means answer the purpose. We
> cannot learn to paint leaves by painting trees-full, nor grass by painting fields-full.
> Learning to paint one leaf rightly is better than constructing a whole forest of leaf def-
> initions.[28]

This is consistent with what Ruskin had written earlier about Pre-Raphaelite detail. In
his discussion of the foliage in *The Light of the World* in 1854, he had drawn a distinction
between true Pre-Raphaelite work and spurious imitations which represented 'the most
minute leaves and other objects with sharp outlines, but with no variety of colour, and
with none of the concealment, none of the infinity of nature'. His criticism in 1859 was
not of Pre-Raphaelite detail, but of insensitive elaboration. Yet, his conclusion that artists
should make careful studies of individual leaves rather than paint trees-full seems to

deny the Pre-Raphaelite practice of painting entire pictures directly from nature and to anticipate his later criticism of Brett's painting 'large studies by way of pictures'. His advice about giving up colour would be repeated in 1863 when he urged black-and-white studies upon Brett.[29] The excess of labour which he lamented in 1859 was an outgrowth of the Pre-Raphaelite care and finish which Ruskin had earlier championed. Something had gone wrong, and Ruskin's criticism here is a reflection of the disappointment of his hopes for the movement as much as is his criticism of the *Val d'Aosta* in the same year.

After 1860, Hunt worked chiefly in watercolour. He became a member of the Old Water-Colour Society in 1862, and he was reasonably successful, although his failure to be elected a member of the Royal Academy was the cause of bitter recriminations.[30] His later watercolours are painted with the same exhausting stipple that we have seen in oil in *Brignall Banks*. Many of them show spectacular and unusual effects of light. Before Hunt's reputation evaporated the best-known example was *A November Rainbow – Dolwyddelan Valley, 1865* (Pl. 159), a large and elaborate watercolour which combines geology, comparable to that in *Cwm Trifaen*, with meteorology. According to H. C. Marillier, it was 'one of the few instances (if not the solitary one) of a rainbow painted according to nature'.[31] The result is so melodramatic that the scientific pretensions seem spurious, but for Hunt's admirers works such as this were products of the highest skill of an artist who combined 'poetical instincts and scientific knowledge'. For Edmund Gosse, Hunt was the one Victorian heir of Turner, and for the young Roger Fry in 1887, his watercolours were 'very magnificent'.[32]

The Liverpool group included several other more-or-less Pre-Raphaelite artists, including two interesting genre painters, James Campbell and John J. Lee. Another Liverpool Pre-Raphaelite, John Edward Newton, painted still lifes, genre subjects and landscapes in microscopic detail. H. C. Marillier described Newton's landscapes as 'little more than handmade photographic transcripts . . . pathetic for the immense care and labour they exhibit, and the extraordinary fidelity of detail, without any corresponding charm.'[33] However, for later observers, one thing which Newton's *Mill on the Alleyn* (Pl. 160) does undeniably possess as a result of the painstaking detail is a naive, primitive charm. More sophisticated were W. J. J. C. Bond and J. W. Oakes, two landscape

159 Alfred William Hunt, *A November Rainbow – Dolwyddelan Valley, 1865.* Watercolour, $19\frac{1}{2} \times 29\frac{3}{4}$. Ashmolean Museum, Oxford.

160 John Edward Newton, *Mill on the Alleyn* c. 1861. Oil on canvas, 12 × 14½. Walker Art Gallery, Liverpool.

painters who came passingly under Pre-Raphaelite influence. Bond was an eclectic artist, who never gained a reputation outside Liverpool. Much of his work is weak imitation of Turner. Oakes moved to London in 1859. In 1874 he was elected an associate member of the Royal Academy. His later pictures are not at all Pre-Raphaelite, but he was a member of the Hogarth Club, and in 1862 William Michael Rossetti included him along with Inchbold, Boyce, Brett, and Davis in a list of Pre-Raphaelite landscape painters.[34] His work of the 1850s seems to have consisted mainly of close foreground studies, which drew some praise from Ruskin.[35]

One other landscape painter should be included in the context of the Liverpool group, although he stands rather apart from the others. This is Daniel Alexander Williamson, who was born in Liverpool in 1823, the son of one Liverpool artist and nephew of another. He went to London in 1847 and remained there until 1860. From 1848 to 1851 he exhibited portraits at the Liverpool Academy, and he exhibited at the Royal Academy every year from 1853 to 1858. Although Williamson continued to exhibit portraits through 1856, the majority of his works from the 1850s are of either sheep or cattle. The main influence upon them seems to have been that of the Barbizon animal painter, Constant Troyon. A watercolour, *Peckham Common – Milking Time* (Pl. 161),

161 Daniel Alexander Williamson, *Peckham Common – Milking Time* c. 1855–60. Watercolour, 11½ × 15⅛. Walker Art Gallery, Liverpool.

for example, recalls in miniature Troyon's huge *Oxen Going to Work: Morning* (Musée d'Orsay, Paris), which was exhibited in the Exposition Universelle of 1855. None of Williamson's work of the 1850s suggests any awareness of Pre-Raphaelitism.

In 1861 Williamson left London to settle in the village of Warton-in-Carnforth in northern Lancashire. In 1864 he moved nearby to Broughton-in-Furness, where he remained for the rest of his life. He seems to have had no personal connections with the London Pre-Raphaelites. He did not exhibit at the Royal Academy after 1858; he did exhibit in Liverpool, although he was not a member of the Liverpool Academy. He was friendly with Windus, and the two painted together in the summers during the early 1860s, when Windus also was living in northern Lancashire, near Preston. Windus and Williamson shared the devoted admiration of one collector, James Smith of Blundellsands, and it is due to Smith that Williamson is remembered at all today. All the pictures by Williamson in the museums of Liverpool and Birkenhead, with only insignificant exceptions, were once in Smith's collection. In 1912 the Manchester City Art Gallery held an exhibition of four northern artists including Williamson. The Williamsons were lent by Smith, who also wrote the appropriate catalogue notes.[36] Smith also privately and anonymously published a small memorial pamphlet about Williamson and Windus which is the chief source of information about the former. Other collectors did own pictures by Williamson, but Smith was far and away his most important patron.

Two small pictures by Williamson in Liverpool justify Smith's attention. Both were painted while Williamson was living at Warton-in-Carnforth. One, *Morecambe Bay from Warton Crag* (Pl. 162), bears a label on its back with Williamson's monogram and the date 1862, the year it was exhibited at the Liverpool Academy. The other, *Spring: Arnside Knot and Coniston Range of Hills from Warton Crag* (Pl. 163), has a label with the date 1863, but apparently was not exhibited.

There can be no doubt about the Pre-Raphaelite influence on these works. *Morecambe Bay from Warton Crag* echoes Holman's Hunt's *Strayed Sheep* (Pl. 52) of a decade earlier.

162 Daniel Alexander Williamson, *Morecambe Bay from Warton Crag* 1862. Oil on board, 9¹⁵⁄₁₆ × 13¼. Walker Art Gallery, Liverpool.

The subject is similar and the prismatic green and violet of the sea are basically Hunt's colours. The luminosity even surpasses *Strayed Sheep*, but, while Hunt's colour seems to be the result of attempting to gain greater naturalism, Williamson's appears to have brightness for brightness's sake. Compared to *Strayed Sheep*, Williamson's painting is much less descriptive and relatively abstract. The trees in the distance are a vivid purple that can not be explained naturalistically, and the other colours are heightened correspondingly. Similarly, Williamson's touch is Pre-Raphaelite in origin, but it is employed to embroider a decorative filigree out of natural materials rather than to describe the natural world with minute precision. Drawing is relatively unimportant; the foreground rocks lack both linear detail and convincing three-dimensional mass.

Spring: Arnside Knot and Coniston Range of Hills is not as close to Hunt, but more individual and more remarkable. While the colour of *Morecambe Bay* seems borrowed from *Strayed Sheep*, in the later picture the colour no longer reminds us of other works. The foreground is made up of bright green grass, orange bracken, and yellow gorse. The group of trees before the rock outcrop are deep purplish red, and Arnside Knot in the distance is vibrantly blue. Throughout the picture the colours are so heightened that the landscape seems to glow. In both pictures there are flocks of birds in the sky, but all else is still. The sheep in the foreground of *Morecambe Bay* seem as immobile as the rocks, and in the foreground of *Arnside Knot* a rabbit crouches motionless. The world is seen frozen for a moment, and with hyper-clarity.

Although inspired by Pre-Raphaelitism, these two small paintings are not mere imitations by a provincial follower. They are highly individual in their departure from the ordinary, and, particularly because of the intensified colours, they bring to mind the visionary works painted by Samuel Palmer at Shoreham in Kent in the 1820s. We do not know if Williamson was aware of Palmer; it is possible that he knew him personally, but unlikely. As far as we know, Williamson did paint out of doors directly from nature, and he did intend the pictures as naturalistic studies. These pictures, painted in the early 1860s, represent a late flowering of Pre-Raphaelite naturalism in which the detail, the clarity, and the bright colours have all become the elements of visionary stylisation.

163 Daniel Alexander Williamson, *Spring: Arnside Knot and Coniston Range of Hills from Warton Crag* 1863. Oil on canvas, 10⅝ × 16. Walker Art Gallery, Liverpool.

THE LIVERPOOL SCHOOL

164 Daniel Alexander Williamson, *Near the Duddon* 1864. Oil on board, 8½ × 14. Williamson Art Gallery and Museum, Birkenhead.

Two other pictures by Williamson from the same period are in Birkenhead. One, *The Startled Rabbit, Warton Crag*, is close in handling to the Liverpool paintings, but it has a genre subject. A girl and a man carrying a bundle of faggots frighten a rabbit, which bounds away. This picture is not dated. The other, *Near the Duddon* (Pl. 164), is signed and dated 1864 and seems to contain two different and conflicting styles. On the right, in the immediate foreground, foliage is painted with leaf-by-leaf Pre-Raphaelite detail. In the background, the distant hills are comparable to the outcrop in *Arnside Knot* of the previous year. They are precisely outlined and strongly coloured in rusty autumnal purples. The rest of the painting is less crisp. It shows a stream with ducks in the foreground, but the stream and its surroundings are painted in a thin washy blur of greens and oranges. There is no detail except in the foliage on the right, and it is impossible to tell where the water ends and the shore begins. There is some similarity to the foreground of water and ducks in Davis's *Old Mill and Pool at Ditton*, in which the reflections have a painterly imprecision, but Williamson has treated the shore as well as its reflection with greater vagueness. The effect is not quite successful; clarity and ambiguity seem too closely juxtaposed. The picture is a transitional work, and the departure from Pre-Raphaelite elaboration in a substantial part of it heralds the redirection of Williamson's subsequent art.

After 1864 Williamson gave up painting in oil for some twenty years. His later oils are distinctly unlike those of the early 1860s, all tending to be misty visions. Although for an admirer like Smith they constituted Williamson's best work, they seem nebulous to the point of vapidity. In the intervening years Williamson worked entirely in watercolour. A large number of his watercolours are in Liverpool, and several are dated 1865. None of them has any similarity to his paintings of the previous few years. Those from the 1860s are reminiscent of David Cox, while the later ones become increasingly indistinct. Without Pre-Raphaelite discipline, Williamson wandered into a hazy dream world, which seems slack and empty compared to the taut intensity of vision of his best pictures. The Pre-Raphaelite influence alone can not explain the high quality of Williamson's work of the early 1860s, but it counts for a lot. Whatever it was that made Williamson a poetic artist during the years he lived at Warton-in-Carnforth, when he left in 1864 he abandoned Pre-Raphaelitism, and his art rapidly changed.

Some Friends and Followers

In November 1849, William Michael Rossetti recorded in *The P.R.B. Journal*, his intermittent diary of the Pre-Raphaelite movement, that John Everett Millais's older brother, William Millais, had begun painting from still life, and that Millais intended to get him to paint landscapes. A month later William Michael mentioned William Millais again; by now he was determined to become a professional artist, and 'John is to bully him into doing nothing all summer but paint in the fields'. In the summer of 1850 William Millais did paint landscapes in Jersey; according to the *P.R.B. Journal* some of them were 'excellent and most promising' and probably would be exhibited.[1]

William Millais did not exhibit any of his landscapes from Jersey, but his activity in the summer of 1850 made him the first artist who set out to be a Pre-Raphaelite landscape painter. He did not become a professional artist, but during the 1850s he produced a substantial body of works which show the application of Pre-Raphaelite care and precision to landscape subjects. In the summer of 1851 he joined his brother and Holman Hunt at Worcester Park Farm, at Ewell in Surrey, where they were working on *Ophelia* and *The Hireling Shepherd* and in 1852 he exhibited his first work at the Royal Academy, *The Rookery, Worcester Park Farm, Surrey*. William Michael Rossetti discussed it in the *Spectator*, together with Collins's *May, in the Regent's Park* and an unidentified study by Inchbold, and announced that it promised 'first-rate things when practice shall have developed the artist's powers, and among them that of representing solidity of form'.[2]

In the following summers, 1852 and 1853, William Millais again accompanied his brother: in the former year to Hayes, south-east of London, where Millais was painting *The Proscribed Royalist*; and in the latter on the trip to the Trossachs in Scotland with John and Effie Ruskin. *Hayes Common*, signed and dated 1853 (Pl. 165), shows the same oak tree as *The Proscribed Royalist* and is painted in comparable Pre-Raphaelite detail. But the view is more spacious and the composition and imagery are more like works by an older artist such as Richard Redgrave than John Everett Millais of the 1850s. *Glenfinlas* (Pl. 166) shows the same stream from a different spot as John Everett Millais's *Waterfall* (Pl. 37) and his portrait of Ruskin (Pl. 36). A fisherman, traditionally said to have been painted by J. E. Millais, is in the middle distance. Like *Hayes Common*, the painting stays within the conventions of early Victorian landscape. Although the rocks in the foreground appear to reflect the same obsessive concern with geological detail as those in the *Portrait of Ruskin*, they are much less meticulously painted. William spent a considerably shorter time in Scotland than his brother (they arrived at Brig o'Turk on 1 July; William left on 18 August; John stayed until the end of October), so it is understandable that his picture shows less painstaking accuracy.

William continued to paint for the rest of his life, but most of his later work is in watercolour. *Hayes Common* and *Glenfinlas* are the largest and most ambitious of his works now known. He never stepped out of the shadow of his more gifted brother; in later years, according to Mary Lutyens, when John Everett Millais showed his works in the studio of his palatial home in Palace Gate, William would hang his works in the hall and catch his brother's visitors as they came and went.[3]

Another sibling landscape painter was John Brett's older sister, Rosa Brett, who exhibited at the Royal Academy initially, starting in 1858, under the name Rosarius, and after 1867 under her own name. Her brother was her main teacher; letters from him to

Facing page: Charles Napier Hemy, *Among the Shingle at Clovelly* (detail of Pl. 182).

her giving advice are preserved;[4] and his influence is evident in the microscopic preci-
sion of her work from the late 1850s and early 1860s. Her first picture exhibited at the
Academy, *The Hayloft*, which shows a cat dozing in a loft (private collection), drew praise
from F. G. Stephens (who apparently had no idea who Rosarius was):

> For minute picking out of every detail of fur, its softness and its gloss, this little pic-
> ture is quite a phenomenon; and the same punctilious finish is carried out into each
> several accessory of bristling straw and the frayed wool waistcoat which the plough-
> man has left behind him. With such a start, and such a foundation of difficult labour,
> Rosarius ought to do something very remarkable – and this, we are inclined to think,
> not only in the way of minuteness, but of characteristic truth of a less special order.

John Brett wrote to his sister upon seeing it, 'The thing is infinitely laughable in the
intensity of its Pre-Raphaelitism'.[5]

Among Rosa Brett's landscapes, the unfinished *In the Artist's Garden* (Pl. 167) shows
comparable Pre-Raphaelite minuteness devoted to grass, the bark of a tree trunk, and
blossoming chestnut and lilacs. The painting is tiny (6¹/₈ × 5⁵/₈ inches). The upper half is
filled with leaves and blossoms and below them is a claustrophobically restricted view
across the lawn of the garden, dappled with sunlight and shade. The painting is an
extreme example of Pre-Raphaelite close study of natural detail, which, because it is

167 Rosa Brett, *In the Artist's Garden*. Oil on board, 6¹⁄₈ × 5⁹⁄₁₆. Private Collection.

small, demands equivalent close study from us, but it is so highly wrought in a delicate filigree of botanic detail, it seems more like a piece of jewellery, or fine needlework, than conventional landscape painting. Rosa Brett's largest known work, *The Old House at Farleigh* of 1862 (private collection) measures less than 14 × 20 inches.[6] Such modesty of scale probably reflects modesty of personality, but perhaps even more the modest aspirations and opportunities normally allowed to women artists in the mid-nineteenth century; that becomes very evident if we contrast Rosa Brett's subjects – her pets, her garden, the surroundings of her home – with the great world explored by her brother. Unlike her brother, she never gave Ruskin or anyone else occasion to complain about her 'covering too large canvas'.

A third Pre-Raphaelite sibling was Joanna Boyce, sister of George Price Boyce. She started exhibiting at the Royal Academy under her own name in 1855, and after her marriage in 1857 to the portrait painter Henry Tanworth Wells she exhibited as Mrs Wells. She was able to lead a much less restricted life than Rosa Brett, studying in Paris under Thomas Couture and travelling in Italy. She is an interesting figure, whose career began auspiciously – in 1855 Ruskin prophesied a place for her in the first rank of painters – but it was abruptly cut short by her death in 1861 at the age of thirty. Her art was mainly figurative and has nothing in common with that of her brother, but she painted some landscapes, of which one, a fully Pre-Raphaelite study of a rocky coast on the Isle of Wight is now known.[7]

Barbara Leigh Smith (or after 1857 Barbara Bodichon) is properly remembered primarily as a feminist and chief founder of Girton College. She was also an artist and a friend of Dante Gabriel Rossetti, who described her as 'a young lady . . . blessed with large rations of tin, fat, enthusiasm, and golden hair, who thinks nothing of climbing a mountain in breeches, or wading through a stream in none, in the sacred name of pigment'.[8] She began to paint under the guidance of William Henry Hunt and other older

168 Barbara Leigh Smith, *At Ventnor, Isle of Wight* 1856. Watercolour, 28 × 42¹/₂. Private Collection.

artists, but when she came into Rossetti's orbit she started to work from nature and, writing to a friend in May 1854, described her current efforts as 'very PRB'.[9] In 1856 William Michael Rossetti wrote in the American journal *The Crayon* that her work was 'full of Pre-Raphaelitism, that is to say full of character and naturalism in the detail, as well as the multiplicity of it'.[10] A watercolour dated 1856 of the Isle of Wight (Pl. 168) is indeed full of the Pre-Raphaelite qualities enumerated by William Michael incorporated into an extensive and fairly traditional landscape view. Following her marriage in the summer of 1857, she visited America with her husband and painted in Mississippi and Louisiana. An engraving of *A Swamp in Louisiana* after one of her drawings appeared in the *Illustrated London News* in 1858, and her American paintings were exhibited by Ernest Gambart in Pall Mall in 1861. She evidently solicited an opinion regarding one of them from Ruskin, who, predictably enough, dismissed it out of hand because of the 'melancholy dangerous solitudes' (in the words of *The Illustrated London News*) it depicted: 'Do you really think that a drawing of an American swamp is a precious thing to bequeath to the world?'[11] After 1857 she lived largely in Algeria (the home of her husband, Eugène Bodichon, a French physician) and drifted away from Pre-Raphaelitism. In 1864 she went to Paris to study with Corot.

Anna Blunden's connection with Pre-Raphaelitism was through Ruskin, with whom she had a tortured correspondence from 1855 to 1862.[12] Blunden painted portraits and exhibited genre paintings during the 1850s. Following Ruskin's advice, who told her in 1862, 'You must give figures up at once, you will never be able to sell one',[13] she turned to landscape. By the summer of 1859, presumably through Ruskin, she had also started a correspondence with John Brett, and Brett seems to have been her chief model as a landscape painter. What would seem to be one of her first works painted after being told by Ruskin to give up figures is a watercolour signed and dated 1862, *View near the Lizard* (Pl. 169). It shows the Cornish coast and, both in subject and style, it resembles pictures by Brett, such as *Massa, Bay of Naples* (Pl. 143). In 1864, when Brett exhibited *Massa*, she exhibited *Mullion Cove, near the Lizard* at the Royal Academy and was linked with Brett in the *Spectator*, which criticised Brett for a 'hard-hearted machine-like method not productive of stirring pictures,' then continued 'In his own line Miss Blunden comes not far behind him.'[14] That sentence probably characterises the relationship accurately, although it must be acknowledged that the evidence available to us suggests that Blunden was ahead of Brett rather than behind. He seems only to have started painting such coastal subjects in the winter of 1863–4, whereas Blunden's *View near the Lizard* is dated 1862, and she exhibited a view of the same stretch of coast, *Kynance Cove*, at the Royal Academy in 1863.

As we have seen in the preceding chapters, John Ruskin, as theorist, critic, patron, and friend, was as centrally involved in the Pre-Raphaelite movement as the artists themselves. He was not a professional artist, but in 1861 George Price Boyce reported in his diary, after dining with Ruskin, that Ruskin intended to give up writing and lecturing to devote himself to painting.[15] Ruskin, of course, did not give up writing and lecturing, and

169 Anna Blunden, *View near the Lizard* dated 1862. Watercolour, 13 × 22¼. Whitworth Art Gallery, University of Manchester.

his painting remained secondary. Nonetheless, he took his drawing seriously and during the 1850s became more and more ambitious in his efforts. Although he did not participate in the Pre-Raphaelite Russell Place exhibition in 1857, he was represented by a watercolour in the American exhibition of the same year, and he was a 'Resident Artistic' member of the Hogarth Club. In 1859 he sent a drawing to the exhibition of the Royal Scottish Academy in Edinburgh.[16] The one oil painting listed in the 'Catalogue of Drawings' in the *Library Edition* of Ruskin's works is there dated 1859. However, as the subject was Glen Tilt in Scotland, which he did not visit in 1859, the origins of the picture must date from an earlier trip, most likely that of 1857.[17] This painting, which was surprisingly large (54 × 36 inches) was given away in 1860. In 1854 he began to plan a history of Switzerland, for which he would provide the illustrations, and in subsequent years he made a large number of careful topographical drawings of Swiss towns for this project. In 1854 he also began to teach drawing at the Working Men's College along with Rossetti and Lowes Dickinson, and he wrote two books based on his teaching, *The Elements of Drawing*, published in 1857, and *The Elements of Perspective*, published in 1859.

Many of Ruskin's own drawings from the later 1850s are not unlike the works of the artists whom he admired and encouraged. The *Study of a Block of Gneiss, Valley of Chamouni* (now usually known as 'Fragment of the Alps'), drawn probably in 1856 (Pl. 170), was the work that Ruskin sent to the American exhibition of 1857. Like some of the watercolours Ruskin made in Scotland in 1857, notably *The Pass of Killiecrankie* in the Fitzwilliam Museum,[18] it is as strongly coloured as an oil painting. The precise geological detail was anticipated in many of Ruskin's earlier studies and cannot be considered a result of Pre-Raphaelite influence, but most of his earlier studies of detail remained studies, whereas in the watercolours of 1856 and 1857 the detailed observation is incorporated into a pictorial whole. Although comparable in subject to the *Gneiss Rock in Glenfinlas* of 1853 (Pl. 38), these slightly later watercolours show considerably more ambition in the use of colour and in the treatment of space. But they represent the height of Ruskin's pictorial ambitions. In the 1860s, when he complained that John Brett painted 'large studies by way of pictures', Ruskin was again generally content to leave his own studies as studies, instead of working them up into completed compositions.

Among the professional landscape painters whose work was affected by Pre-Raphaelitism, the most unlikely was Edward Lear. Born in 1812, Lear had been active as a topographical landscape draughtsman since the late 1830s. Between 1841 and 1852 he published five volumes containing illustrations based on his views in Italy, Greece, and

170 John Ruskin, *Study of a Block of Gneiss, Valley of Chamouni, Switzerland (Fragment of the Alps)* 1856. Watercolour, 12 × 18¼. Harvard University Art Museums, Cambridge, Mass.

171 Edward Lear, *The Quarries of Syracuse* 1847. Pen and watercolour, 13⅞ × 19⅞. Walker Art Gallery, Liverpool.

Albania. These were sufficiently successful for him to be summoned in 1846 to give drawing lessons to Queen Victoria. Lear himself was self-taught as a draughtsman. The distinctive style which he developed during the 1840s was readily translatable into the lithographic illustrations of his books, but when he attempted to paint pictures in oil on the basis of his sketches his lack of training became a major handicap. He had painted occasionally in oils previously, but he first exhibited a picture at the Royal Academy in 1850. He continued to send works there in each of the following six years (after which he did not exhibit at the Academy again until 1870). His increase in ambition meant an increase in frustration. Consequently, in 1850, at the age of thirty-eight, he sat 'with 51 little boys' for the examination to enter the Royal Academy schools.[19] He was accepted, but the Academy schools were of no help for Lear's immediate problem of painting landscapes in oil from his sketches. So in the summer of 1852 he sought Holman Hunt's advice.

Holman Hunt was fifteen years younger than Lear, and in 1852 was only twenty-five years old. His pictures were still considered aberrations by most of the critical press, and none of his exhibited works had been landscapes. That Lear should have turned to Hunt, rather than to an established painter such as David Roberts or Clarkson Stanfield, who painted subjects like those Lear wanted to paint, is remarkable and testifies to the impact which the landscape parts of *The Hireling Shepherd* must have made upon Lear when it was exhibited in May 1852. Hunt was taken to Lear's studio by Robert Braithwaite Martineau, whose *Kit's Writing Lesson*, exhibited at the Royal Academy in 1852 (Tate Gallery), had been painted under Hunt's direction. Lear showed Hunt his sketches and explained the difficulty he had in painting pictures from them. Hunt's reply to this was that he would not paint pictures in the studio from such sketches, but he did not tell Lear to go back to Italy and paint his pictures directly from the subjects they were supposed to show. He took a drawing by Lear of *The Quarries of Syracuse* (Pl. 171) and suggested that all the different elements in it, limestone cliffs, fig trees, and the rest, could be found in England. As a result, when Hunt went to Fairlight, near Hastings, a few weeks later to paint *Strayed Sheep* (Pl. 52), Lear went with him and set to work on a painting of *The Quarries of Syracuse* under Hunt's direction. The two shared a house, and in return

for Hunt's tutelage Lear gave him lessons in Italian. During their evenings together Lear recorded Hunt's advice in a book he called 'Ye Booke of Hunte.'[20]

At Fairlight Lear worked on several pictures, and when Hunt returned to London, he stayed on. He wrote to Hunt in December:

> I really cannot help again expressing my thanks again for the progress I have made this Autumn. The *Reggio* & the *Venosa* are both done & in frame, – except that the latter will have to benefit by some of your remarx when we meet – and I hardly believe I did them. I am now beginning to have perfect faith in the means employed & if the *Thermopylae* turns out right I am a P.R.B. for ever. Indeed, in no case shall I ever return to the old style. The *Venosa* is wonderfully true and brilliant. Of course painting out of doors has been out of the question – but I have sloshed as little as possible . . .'[21]

Lear exhibited *Thermopylae* (Bristol Museum and Art Gallery) at the British Institution in February. He continued to work at Fairlight through the winter on *The Quarries of Syracuse*, which he completed in time to send to the Royal Academy in April. There it was won as an Art Union prize by the Earl Beauchamp.

On receipt of Lear's letter in December, Hunt wrote back that he was delighted to hear of the pictures' completion, adding that he was sure 'they must be very brilliant and charming'.[22] Brilliant they are – in a way that is purely Pre-Raphaelite. The foreground of *Reggio* (Tate Gallery) is filled with cacti, which are as brightly green as the foreground grass in *The Hireling Shepherd*. In the foreground of *Venosa* (Pl. 172) there is a tangle of foliage which is so like the foreground foliage of *Strayed Sheep* that it is tempting to think that it was painted while the two artists were working side by side.

Reggio and *Venosa* were both based on sketches which Lear made on a trip to Sicily and Calabria in 1847. The sketch of *The Quarries of Syracuse*, made on the same trip, is typical of Lear's vignette style of picturesque sketching. A chief object of topographic interest, the city, is near the top of the sheet and seen from a distance of several miles. The large forms in the foreground provide a dramatic foil, but they are treated with less precise detail, and a substantial part of the foreground, including both corners, is empty. The compositions of *Reggio* and *Venosa* suggest that both began as such conventionally organised views. In the finished paintings leaves and cacti fill lower corners which were originally empty. Particularly in *Venosa*, the foliage, which is disproportionate in scale, appears as a display of Pre-Raphaelite observation and labour applied to a picture which otherwise remains fairly conventional.

Hunt and Lear remained friends until Lear's death in 1888. They painted together again at Fairlight in 1858. Lear always referred to Hunt as 'Pa' or 'Daddy' (he could not be a Pre-Raphaelite brother, but he considered himself a Pre-Raphaelite son; Millais was his Pre-Raphaelite uncle). But Lear's Pre-Raphaelitism was short-lived. The finished *Quarries of Syracuse*, which he completed in the winter of 1853 away from Hunt, is less obviously Pre-Raphaelite than the two pictures he completed in the autumn of 1852. As he mentioned in the letter to Hunt quoted above, working out of doors in the winter in England was impossible, so even the *Venosa* was finished in the studio. In the

172 Edward Lear, *Venosa* 1852. Oil on canvas, 19³/₄ × 32³/₈. Toledo Museum of Art.

following July he discovered that there were difficulties in working out of doors in the summer as well. In a letter to Hunt written from Windsor, where he was painting a picture for the Earl of Derby, he complained about the uncooperative weather and concluded:

> It is therefore utterly impossible to do the view on a strictly P.R.B. principle – for supposing a tree is black one minute – the next it's yellow, & the 3rd green: so that were I to finish any one part the whole would be all spots – a sort of Leopard Landscape. I must therefore – if ever there is sun again (toward evening) mark out the shadows properly & work away as I can . . .[23]

In December 1853 Lear went to Egypt. He was together with Thomas Seddon in Cairo for a while, but he set off for a trip up the Nile before Hunt arrived. He apparently left Cairo intending to paint directly from nature in Pre-Raphaelite fashion, but he soon reverted to drawing. On 15 March Seddon wrote to his fiancée, 'Lear returned today. He gave up oil painting, and has brought back an enormous number of sketches, which are exceedingly interesting.'[24] Hunt was in Egypt by then, but Lear returned to England rather than accompanying Hunt and Seddon on to Palestine. He did visit Jerusalem in 1858. A painting of the city from the Mount of Olives, which he completed in 1859 from sketches made on his visit (private collection),[25] suggests that by then he had forgotten whatever Hunt had taught him. When compared to Seddon's *Jerusalem and the Valley of Jehoshaphat* (Pl. 104), showing a comparable view, it seems to have nothing Pre-Raphaelite about it. His stay with Hunt at Fairlight was only an interlude, not a lasting influence.

Another artist older than the members of the Pre-Raphaelite Brotherhood who developed a short-lived passion for detailed naturalism was James Smetham. Smetham was born in 1821 in Yorkshire, the son of a Methodist preacher. He studied in London in the 1840s at Cary's Academy and at the Royal Academy schools. In the early 1850s he was supporting himself by teaching drawing at the Wesleyan Normal School in Westminster when he fell under the spell of Ruskin's writing. He was one of the first three pupils to enrol under Ruskin's instruction when the Working Men's College opened in the autumn of 1854. Ruskin was impressed by 'the talent and industry and thoughtfulness' of Smetham's drawings,[26] and in February 1855 Smetham was invited to dine with Ruskin and his parents at Denmark Hill. A rapturous letter to a friend describing the visit shows that Smetham was more than ready to become a disciple: 'I was in a sort of soft dream all the way home; nor has the fragrance, which, like the June sunset, "Dwells in heaven half the night," left my spirit yet'.[27]

In 1868 Smetham wrote that he had read Ruskin in 1849 and 'determined to put it to the proof, painting several pictures in the severely imitational style'.[28] He was still ready to throw himself at Ruskin's feet five years later, and in 1856, when the third volume of *Modern Painters* appeared, Smetham immediately bought a copy and declared that he would read it, 'with the slowness, iteration, and thought it deserves . . . I have glanced at the chapter on "Finish," and see the exquisite definition of it: "added fact". How clear, how true! Finish, from first to last – added fact. How this leads to the great principle, *study nature*'.[29] His observation of the great principle can be seen in the tiny *Naboth in the Vineyard* of 1856 (Pl. 173), in which the leaves of the vines across the upper part of the picture are painted in Pre-Raphaelite detail. But close study of nature is only part of the picture; Naboth reclines in the foreground enjoying the fruits of his vines while Ahab looks on covetously from the upper left corner. The contradictions in scale within the picture and the strange prominence of the leaves are disturbing, and they do reflect something wrong in Smetham's mental balance. In February 1857 he sent Ruskin a drawing which prompted Ruskin to warn him, 'it is unsafe for you, with your peculiar temperament, to set yourself subjects of this pathetic and exciting kind for some time to come'.[30] This warning was prophetic; Smetham had a breakdown in the autumn of 1857. He soon recovered, but another collapse in 1877 plunged him into insanity for the last twelve years of his life.

In the 1860s Smetham remained a friend of Dante Gabriel Rossetti, and, according to the *Memoir* of Smetham by William Davies, he spent every Wednesday from 1863 to 1868 at Rossetti's studio. However, his devotion to Pre-Raphaelite naturalism was over. Already, when looking at the Turner sketches which Ruskin had put on exhibition at Marlborough House in 1856, he had decided that it was best not to paint finished things from nature, 'but to make slight, often symbolic records, in abundance of facts'.[31] In 1863, despite the generally small scale of his works, he proclaimed himself a 'Monumentalist',

173 James Smetham, *Naboth in the Vineyard* 1856. Oil on panel, $8^3/_4 \times 6^3/_4$. Tate Gallery, London.

whose speciality would be 'Idylls in Oil'.[32] In 1868, in the letter in which he described putting Ruskin 'to the proof', he declared that he soon found the severely imitational style impossible. The true basis of painting was 'the expression of the feeling of an individual man about nature'. His correspondence from the 1860s and 1870s shows not only the redefinition of his own goals, but also a critical reconsideration of Pre-Raphaelitism. In one letter he compared Thomas Seddon's *Jerusalem and the Valley of Jehoshaphat* (Pl. 104) with William Collins's *Seaford, Sussex* of 1844 (Victoria and Albert Museum), both of which were then hanging at South Kensington, and he decided that Collins's scheme of light and shade in relation to the picture as a whole was as true as Seddon's 'flat accuracy'. Although he found Seddon's lighting quite correct, and much feeling in his details, he preferred the Collins.[33] In another letter, written in 1870 praising Rembrandt's landscapes, he declared, 'The pre-Raffaelite dicta of ten years ago would have laid these landscapes dead. The "awe of observation" peeping and botanizing, and putting the screw on square inches, would slay all such art, and it is the grandest of all.'[34]

Among living landscape painters, Smetham had greatest respect for John Linnell and Samuel Palmer, both of whom were well along in years by the 1860s and represented a continuation of pre-Pre-Raphaelite attitudes towards landscape. Specifically, Linnell and Palmer were a link with Blake, for whom Smetham, like Rossetti, had the profoundest admiration. In a long review of the first edition of Alexander Gilchrist's *Life of Blake* (which was printed in the second edition) Smetham praised Linnell for 'that grandeur and sense of awe and power of landscape', the germ of which had been contained in Blake's illustrations for Thornton's *Virgil*.[35] In turn, Rossetti, in a note which also appeared in the second edition of Alexander Gilchrist's *Life of Blake*, wrote that Smetham was more closely akin to Blake than any other living artist and that he was 'often nearly allied by landscape intensity to Samuel Palmer'.[36] This connection with Palmer and also with Linnell is more evident in most of Smetham's landscapes than any Pre-Raphaelite influence. *Going Home*, a watercolour painted just before Smetham's final breakdown (Pl. 174), is so similar to some of Palmer's etchings, *The Weary Ploughman* for example, that there can be no doubt that Palmer had become the chief influence on the *quondam* disciple of Ruskin. We have seen affinities between both Ford Madox Brown and Daniel Alexander Williamson and Palmer, but these seem to have been the result of approaching nature in similar ways, not of imitating Palmer. In Brown's and Williamson's

174 James Smetham, *Going Home c.* 1877.
Watercolour, 14$\frac{1}{2}$ × 20$\frac{1}{2}$. Walker Art Gallery,
Liverpool.

œuvres the affinity with Palmer is most evident in their most Pre-Raphaelite landscapes.
In Smetham's case the affinity with Palmer replaced Pre-Raphaelitism.

Ruskin had a number of other students at the Working Men's College who spent the rest of their lives in his shadow. One of them, William Ward, became a drawing master for people who applied to Ruskin for assistance; he was later employed by Ruskin to make copies of Turner's watercolours. Another, George Allen, engraved many of the illustrations in Ruskin's books and eventually became Ruskin's publisher. More important as an artist in his own right was John Wharlton Bunney. Born in 1828, Bunney was a clerk with Smith, Elder and Co. (Ruskin's publishers until George Allen replaced them), when he became a pupil at the Working Men's College. In 1857 he exhibited a painting and a watercolour in the American Exhibition of British Art and was described by William Michael Rossetti as a pupil of both Ruskin and Dante Gabriel Rossetti.[37] Like other painters who were willing to listen to Ruskin he was soon in the Alps. In 1864 he exhibited at the Royal Academy *Autumn Snow in the Bonneville Valley, Savoie.* His address listed in the catalogue of the 1864 exhibition was Florence, and he continued to reside primarily in Florence for the rest of the decade. He was a friend there of Holman Hunt, who was in Florence intermittently from 1866 to 1869. A *Landscape from Fiesole*, which is dated 1867 (Pl. 175), once belonged to Hunt. It shows

175 John Bunney, *Landscape from Fiesole* 1867.
Watercolour, 19$\frac{1}{4}$ × 29$\frac{1}{2}$. Private Collection.

a view comparable to those in Hunt's watercolours *Festa at Fiesole* (Pl. 68) and *Sunset in the Val d'Arno* (Pl. 69), but in a drier, more linear and more literal style, without the lurid sunset colour which is such a prominent feature of Hunt's watercolours.

In 1869 Ruskin spent the summer, from May to August, in Verona making studies for what seems to have been intended as a 'Stones of Verona'. Bunney worked as his assistant, making large coloured drawings of the buildings. Ruskin drew the detail, 'requiring (though I say it) my advanced judgement to render accurately'.[38] No 'Stones of Verona' resulted, but Ruskin did give a lecture, 'Verona and Its Rivers', in February 1870 and accompanied it with an exhibition of drawings and photographs. In the catalogue Ruskin did not make much distinction between his own drawings, those by Bunney and another assistant, Arthur Burgess, and photographs. His comment on one of Bunney's drawings, the *North Porch of the Church of St Fermo* (now in the Ashmolean Museum, along with several other Verona drawings by Bunney), began with the remark that the drawing was 'so faithful and careful as almost to enable the spectator to imagine himself on the spot'.[39] This repeats, almost verbatim, part of Ruskin's criticism of John Brett's *Val d'Aosta*, but whereas Ruskin eventually found Brett's impersonal accuracy disappointing, in Bunney's case he seems to have expected nothing higher. Indeed, Ruskin was soon to commission from Bunney a picture that is among the supreme examples of selfless labour in the history of art.

For the last twelve years of his life, from 1870 until 1882, Bunney worked almost entirely at Venice, and the last six of those years he devoted to one picture, *The West Front of St Mark's* (Pl. 176). From September 1876 to May 1877 Ruskin paid his last visit to Venice, where he worked on a new edition of *The Stones of Venice* and wrote a guide to the Academy and a fragmentary history of the city, *St Mark's Rest*. He also became involved in a campaign to prevent the re-building of the west front of St Mark's, and, fearing the worst, he set several artists to work recording what was in danger of being destroyed. Of these records Bunney's picture is the most monumental. According to Ruskin's editors Bunney spent six hundred days of 'constant labour' upon it, with the intention of making a strictly accurate architectural record.[40] It is the ultimate example of what Ruskin had defined as 'historic landscape art', being of a subject which artist and patron expected to be swept away by 'modern progress and improvement', and coming

176 John Bunney, *The West Front of St Mark's* 1876–82. Oil on canvas, 57 × 89. Collection of the Guild of St George, Ruskin Gallery, Sheffield.

as close as humanly possible to showing that subject 'wholly unmodified by the artist's execution'.[41]

What Bunney achieved was the not inconsiderable feat of making a painting look remarkably like a large (57 × 89 inches), tinted photograph. One day in 1879 or 1880, while the artist was at work in the Piazza San Marco, Whistler managed to sneak up and attach a card to his back saying 'I am totally blind'.[42] In Whistler's estimation this must have seemed not only funny, but at least symbolically true. The thought of artists as disparate as Bunney and Whistler working in Venice at the same time is pleasantly ironic, as is the fact that both were doing it because of Ruskin. Whistler had had to flee to Venice because of bankruptcy caused by his libel suit against Ruskin in 1878. He was commissioned to go to Venice by the Fine Art Society, a gallery with which Ruskin had the closest of associations, and following his return he exhibited his Venetian works in a series of exhibitions at the Fine Art Society. A memorial exhibition of Bunney's works was held in the same premises in 1882.

Following Bunney's death, Ruskin instituted a memorial fund for the benefit of his children. In 1883 he sent the money raised to the artist's widow, accompanying it with a letter in which he stated:

> Mr. Bunney's name will remain ineffaceably connected with the history of all efforts recently made in Italy for preservation of true record of her national monuments; nor less with the general movement in which he so ardently and faithfully shared, for the closer accuracy and nobler probity of pictorial – more especially of landscape – art; a movement which was initiated about the time when he first took up residence in Venice, and of which he remained, to the day of his death, the most clearly recognized exponent and representative to the foreign schools, both of Italy and America.[43]

The 'movement' to which Ruskin referred was largely one of his creation, and the artists involved in it were mostly in his employ. The 'foreign schools, both of Italy and America', can be identified as one Italian painter, Angelo Alessandri, and one American, Henry Newman, both of whom worked extensively for the organisation that gave the 'movement' its focus: the Guild of St George. This was a utopian scheme for the reform of agricultural life in England, which Ruskin began to plan during the 1870s. The Guild of St George did eventually own several tracts of land around England, but soon the better part of Ruskin's energies were devoted to St George's Museum, which was opened in a cottage at Walkley, near Sheffield, in 1876. The museum's first curator, Henry Swan, had been another pupil of Ruskin's at the Working Men's College, and the museum's collections – natural history as well as art – were a reflection of Ruskin's didactic interests. Bunney's *West Front of St Mark's* was commissioned for the museum and was its largest single possession, for which a gallery had to be built behind the original cottage. Most of Ruskin's initial commissions for the museum, beginning in 1876, were of Venetian subjects. In 1879 he started a special fund for 'Memorial Studies of St Mark's' to pay for them. Soon, however, this activity took other directions, and Ruskin had artists working under his orders in France and Switzerland as well as in Italy. What began as a programme of making antiquarian records evolved into one of actively training, encouraging, and patronising a group of young artists – an echo of Ruskin's relations some twenty years previously with the Pre-Raphaelite landscape painters Inchbold and Brett. None of this later group was allowed to take as independent a stance as the earlier painters, and the results, consequently, may have been on a lower level, but relations between patron and artists proceeded without the conflicts that marked Ruskin's earlier attempts at patronage.[44]

One of the artists Ruskin set to work in Venice was Burne-Jones's studio assistant, Thomas Matthews Rooke. During the 1870s, in addition to working for Burne-Jones, Rooke had painted and exhibited a series of Old Testament subjects which had some success. In 1875 he won a Royal Academy competition for a historical picture, and his *Story of Ruth* (Tate Gallery), a triptych exhibited at the Royal Academy in 1877, was one of the first purchases under the Chantrey Bequest. Nonetheless, Rooke was apparently happy to play second fiddle to Burne-Jones, whom he continued to assist for the rest of Burne-Jones's life. In the 1890s he spent 'day after day' painting foreground flowers in Burne-Jones's huge *Sleep of King Arthur in Avalon* (Museo de Arte de Ponce, Puerto Rico).[45] For Ruskin, Rooke first made copies of the mosaics in St Mark's during the summer and autumn of 1879. In 1884 Ruskin sent Rooke to Venice again, then to Ravenna, where he stayed two months, to Brig in the Valais, and, in October, to Sallanches near Chamonix. In 1885 Rooke worked at Chartres from June to December,

177 Thomas Matthews Rooke, *Laon: View of the Town and Cathedral from the Northeast* 1886. Watercolour, 9 × 11³/₄. Collection of the Guild of St George, Ruskin Gallery, Sheffield.

and in 1886 Ruskin sent him to Laon, Auxerre, and Avallon in France, and on to Italy for the winter. He was still in Florence in March 1887, but by June he was back in Sallanches. His watercolours made on these trips are conscientious, accurate records, and they delighted Ruskin: 'Let me congratulate you in the most solemn way on these glorious drawings. Nothing has given me so much pleasure, and the pleasure these drawings give me will be shared by all the good world'.[46]

Rooke's watercolours made at Chartres and the other cathedral cities show architectural subjects, though they often contain extensive landscapes as well (Pl. 177). Those made in Switzerland and near Chamonix are generally of cottages or villages, with the mountains as backdrops rather than the subject (Pl. 178). These humbler aspects of mountain scenery had long appealed to Ruskin. In 1856 and 1857 he commissioned drawings of Alpine cottages from Inchbold. In 1880, when he lent Brett's *Val d'Aosta* to an exhibition and lamented in the catalogue that Brett had sympathised insufficiently with Swiss and Italian life, he went on, 'How lovely an old-fashioned Swiss or Italian village would have been, painted like this single cottage, some future disciple of the school may consider and hope to show'.[47] Four years later, Ruskin apparently designated Rooke as that future disciple. Although Rooke's drawings of ramshackle Swiss cottages have little of Brett's fine precision, they satisfied Ruskin, which cannot be said of the work of either Brett or Inchbold.

Of the other artists who worked for the Guild of St George, the busiest was Frank Randal. He was younger than Rooke, and his employment by Ruskin was intended as an education. He first worked for Ruskin in 1881 at Amiens, where, as Ruskin wrote to the artist, Randal's practice was more important than what he was actually producing. From Ruskin he received a steady barrage of letters full of instruction, advice, and encouragement.[48] In 1882 Ruskin had him back in England, making studies of vegetation, then in France, where Randal worked again in 1883, after a period of sketching animals in the London Zoo. In 1884 Ruskin sent him to Ravenna and Verona, and to the Italian Lakes.

In Randal's case, Ruskin's methods seem to have worked. We can follow the artist's progress from timid pencil drawings made at Amiens in 1881 to elaborate watercolours made in Verona in 1884. A large watercolour of the *Piazza delle Erbe Looking South* Pl. 179) dated August and September 1884, shows the exact rather dry clarity of Bunney with greater genre animation and spatial complexity. As Randal had never met Bunney, who died in 1882, works like this do justify Ruskin's talking about a 'movement', but the founder of the movement was Ruskin, not Bunney. Randal's watercolour is like one of Ruskin's own architectural studies made in Verona and Venice, carried to a degree of

178 Thomas
Matthews Rooke,
Old Chalet at Sierre
1884. Watercolour,
$13\frac{1}{4} \times 9\frac{5}{8}$.
Collection of the
Guild of St George,
Ruskin Gallery,
Sheffield.

179 Frank Randal,
*Piazza delle Erbe
Looking South* 1884.
Watercolour,
$13\frac{7}{8} \times 9\frac{3}{4}$.
Ashmolean
Museum, Oxford.

180 Frank Randal,
*Verona from the
Garden of the
Palazzo Giusti* 1884.
Watercolour,
$8\frac{1}{2} \times 5\frac{1}{4}$.
Collection of the
Guild of St George,
Ruskin Gallery,
Sheffield.

detailed completeness which even Ruskin never attempted. A view of *Verona from the Garden of the Palazzo Giusti* (Pl. 180) is a beautifully careful view over the roofs of the city. A work like this from a high vantage-point still seems fully Pre-Raphaelite and is reminiscent of John Brett's *Florence from Bellosguardo* (Pl. 142), painted twenty-one years earlier. But in comparison with Brett, Randal is more modest in both ambition and attainment. These works were done in exact accordance with Ruskin's instructions, and Ruskin was lavish in their praise: 'Yours of the town from Giusti is extremely marvellous and delicious. You can do *anything* now in realization, and this is beyond all I've seen of the kind.' Ruskin also gave tangible evidence of his approval of Randal's views of Verona by proposing to raise the artist's salary from £160 to £240 per year.[49]

Alas, Randal was not allowed to enjoy his higher pay for very long. Ruskin was laid low by attacks of insanity in 1885 and 1886, and his patronage was brought to an abrupt end. Randal drifted into complete obscurity. Rooke became the object of the semi-charitable patronage of 'The Subscribers of the Society for the Preservation of Pictorial Records of Ancient Works of Art'. This 'Society' consisted of Sydney Cockerell and whoever he could get to contribute. It existed solely to commission each year from 1894 to 1920 a drawing or drawings from Rooke, which it then presented to the Birmingham City Art Gallery. Rooke lived on until 1942, dying at the ripe age of one hundred.

It is perhaps hardly necessary to add that the rapid demise of this movement was inevitable once Ruskin ceased giving it his active support. In the 1880s this quasi-photographic art, whose goal was exact documentation, represented one of the last gasps of a dying tradition of topographical reportage. Unlike the original Pre-Raphaelites, who were the most progressive force in English painting in the 1850s, Ruskin's followers in the 1880s were a tiny backward-looking minority, whose activities were carried on in

181 Albert Goodwin, *St Anthony's Works, Newcastle upon Tyne* 1864. Watercolour, 9¹/₂ × 13³/₄. Private Collection.

the teeth of changing artistic standards. In the same year – 1881 – that Frank Randal began to work under Ruskin, Walter Sickert began to work under Whistler. In May 1886, to publicise the group in the hope of gaining public support, Ruskin presented an exhibition of drawings made for the Guild of St George at the Fine Art Society. In the previous month the first exhibition of the New English Art Club had opened. At exactly the same time in France, Seurat and Signac were exhibiting their Neo-Impressionist works in the eighth and last Impressionist exhibition.

Ruskin's artists shared their exhibition in 1886 with Albert Goodwin, a painter who was not of their group though he was patronised by Ruskin. In the introduction to the catalogue Ruskin worried that the elaborately finished drawings of his artists would look too literal next to Goodwin's sketchier drawings. He decided that the 'resolutely complete works' made for the Guild could not be too highly esteemed for their antiquarian value, but 'for pure artistic delight, an untouched sketch of Albert Goodwin's on the spot is better than any finished drawing'.[50] Thus, even Ruskin was ready to see values other than those of Pre-Raphaelite completeness. The artist about whom he made this judgement was one of a number of young artists who were first attracted to Pre-Raphaelitism in the early 1860s and then moved away from it.

Goodwin was not only attracted to Pre-Raphaelitism, he also had the encouragement of several of the movement's leading figures. Born in 1845, he was found as a boy of fifteen or sixteen attempting to paint from nature by Arthur Hughes, who invited him to come see his work. In the 1860s Goodwin was instructed by both Hughes and Ford Madox Brown, and he was taken up by their patron James Leathart. One of Goodwin's watercolours, which he sold to Leathart, was a view of Leathart's lead factory, *St Anthony's Works, Newcastle upon Tyne*, made on a visit to Newcastle in September 1864 (Pl. 181). This same factory appears in the background of Brown's portrait of Leathart (private collection), painted a year earlier.[51] Goodwin may have visited Newcastle in the company of Boyce, who painted an analogous watercolour view of an industrial landscape, *Near the Ouse Burn, Newcastle*, in September 1864.[52] These views, along with William Bell Scott's painting inspired by the same city, *Newcastle Quayside in 1861* (Pl. 91), are among the few even peripherally Pre-Raphaelite images of the modern industrial world, and they seem somehow connected. Goodwin visited Scott in Newcastle while there in 1864. Stylistically, his view of factories is not particularly Pre-Raphaelite; it is more spacious, more atmospheric, and is without foreground detail. Its sunset effect echoes those in Scott's landscapes of the early 1860s (Pl. 94).

Around 1870 Goodwin met Ruskin. Ruskin asked Goodwin to give him a lesson in watercolour painting, but, as Goodwin later realised, this was Ruskin's flattering way of asking the artist to come and be instructed by Ruskin.[53] In 1871 Goodwin worked at Abingdon and Hinksey near Oxford for Ruskin, and in 1872 he accompanied Ruskin to Italy. He subsequently followed a more independent path, but Ruskin remained friendly and continued to proffer advice. His disapproval of Goodwin's painting in oil has been quoted.[54] Most of the works that Goodwin produced during his long life (he died in 1932) are in watercolour. They show only traces of lingering Pre-Raphaelite influence and are usually easily recognisable because of Goodwin's use of a pen line to define form.

Though Goodwin did not remain a Pre-Raphaelite, Pre-Raphaelitism remained a part of his conscience. In 1918 he completed two pictures for the Royal Academy in less

182 Charles Napier Hemy, *Among the Shingle at Clovelly* 1864. Oil on canvas, $17^{1}/_{4} \times 28^{1}/_{4}$. Laing Art Gallery, Newcastle upon Tyne.

than two weeks and then wrote in his diary, 'How ashamed the Pre-Raphaelites would be of work done in so short a time'.[55] In practice, he not only worked faster, he also found it was better not to work from nature – 'I can paint Switzerland better when it is a somewhat far-away memory . . . the reality would put me out, partly because nature is so changeful' – and he lamented the Pre-Raphaelite liking for bright colours, from which he had not been able to shake himself free – 'I think I have suffered all my artistic life from having started under Pre-Raphaelite superlatives in colours.'[56] As late as 1918, seventy years after the formation of the Pre-Raphaelite Brotherhood, he was still struggling with this heritage: 'I owe so much to Arthur Hughes and to Ruskin, that it has been difficult and hard to unlearn that which I got also from them'.[57]

In the North of England, where Pre-Raphaelitism found its earliest and most consistent patronage, it also attracted disciples. The movement's impact in Liverpool has been discussed in a separate chapter. The second most important provincial centre was probably Newcastle, where William Bell Scott was master of the School of Art, and James Leathart formed a major Pre-Raphaelite collection under Scott's guidance. Henry H. Emmerson (1831–1895) was a local artist instructed by Scott, patronised by Leathart, and mentioned by Ruskin in *Academy Notes* in 1858 for 'a promising average example of the kind of study from nature which fills the rooms.'[58] Charles Napier Hemy, another native of Newcastle ten years younger than Emmerson, also studied under Scott. He left Newcastle around 1860 to enter a Dominican monastery, but returned three years later and began to paint under the combined influence of *Modern Painters*, Scott's teaching, and exposure to Leathart's collection. *Among the Shingle at Clovelly* (Pl. 182), dated 1864 and shown at the Royal Academy in 1865, the first year Hemy exhibited, contains an impressive display of Pre-Raphaelite industry in the one-by-one delineation of the foreground stones (see detail, p. 204). Hemy soon decided that he wanted to return to the Dominicans, and to prepare himself he went to work for Morris and Company. However, marriage put an end to his monastic ambitions, and he returned to painting. He went to Antwerp to study under the Belgian historical painter Baron Henri Leys, then settled down to a successful career of painting rivers, coast scenes, and seascapes, which show no lingering Pre-Raphaelite influence.

Leeds, where the Pre-Raphaelites were patronised by Thomas Plint, was the home of Inchbold, but, as Inchbold went to London to study, his adoption of Pre-Raphaelitism was not the result of local influences. A younger Leeds artist, John Atkinson Grimshaw,

183 Atkinson Grimshaw, *Autumn Glory: The Old Mill* 1869. Oil on panel, 24½ × 34½. City Art Gallery, Leeds.

who remained in the North for most of his life, also fell temporarily under the sway of the movement. The earliest known paintings by Grimshaw date from 1861. His pictures from the 1860s generally show closely studied foreground detail and bright colours, obviously painted in emulation of Pre-Raphaelite pictures. A particularly elaborate example is *Autumn Glory: The Old Mill* of 1869 (Pl. 183), which recalls the background

184 Atkinson Grimshaw, *Nab Scar* 1864. Oil on board 16¼ × 20. Private Collection.

of Holman Hunt's *Haunted Manor* (Pl. 48). Grimshaw looked not only at Pre-Raphaelite pictures, but also at photographs, and the mill in *Autumn Glory*, which has been identified as in the grounds of Dunham Massey in Cheshire, may depend upon a photographic source.[59] A startling example of Grimshaw's use of photographs is *Nab Scar*, signed and dated 1864 (Pl. 184), which faithfully reproduces a photograph in an album owned by Grimshaw (now in the Leeds City Art Gallery) taken by Thomas Ogle of the same view across Rydal Water to Nab Cottage, the one-time home of Thomas de Quincey and Hartley Coleridge.[60] The dependence upon the photograph is so complete, except for Grimshaw's invented foreground, to raise the question of whether the artist had need to visit the site itself. But the scene in the black-and-white photograph has been transformed by a light and bright Pre-Raphaelite palette and exquisitely delicate handling into a picture of enchanted poetic stillness, that seems the antithesis of the literal record upon which it was based.

In the 1870s Grimshaw began to specialise in moonlit landscapes and nocturnal city views in which Pre-Raphaelite influence is less evident. It is worth remembering, however, that Inchbold started to paint nocturnal subjects in the 1860s. In 1871 Inchbold was in Yorkshire, and he painted at least one moonlit watercolour at Scarborough (City Art Gallery, Leeds), where Grimshaw worked regularly. A group of later pictures by Grimshaw of autumn foliage over suburban lanes (Pl. 32) are remarkably similar to the small *Platt Lane* which Ford Madox Brown painted in Manchester in October 1884 (Pl. 31). In this case, Grimshaw's pictures came first, and Brown, who lived in Manchester from 1881 to 1887, could easily have seen them in Northern collections.

William Dyce

William Dyce has already been mentioned in this book as an artist of the 1840s who anticipated the interest of the Pre-Raphaelites not only in early Italian art, but also in outdoor light and colour.[1] Born in 1806, he was considerably older than any of the Brotherhood, and by 1848 he had an established reputation. He never became an intimate associate of the group, as did Ford Madox Brown, and his art kept a strong character of its own. In the 1850s Dyce's chief occupation was the fresco decoration of the Queen's Robing Room in the Palace of Westminster. This was a project of monumental proportions and one which he left unfinished at his death in 1864. He did also paint a number of easel pictures during the later 1850s and early 1860s, which reveal an approach to the natural world influenced by Pre-Raphaelite painting. These pictures are today his best known and most accessible works, but it should be emphasised that they represent a peripheral activity, undertaken as a diversion from the work in fresco which constituted the main labour of the last twenty years of his life.

Dyce painted occasional landscapes throughout his career. His earliest known painting is a rearranged view of Aberdeen in which several local landmarks, including Westburn House, the home of his mother's family, are recognisable (Aberdeen Art Gallery). The style reflects that of the Scottish landscape painters Alexander and Patrick Nasmyth, but on a rather unaccomplished level. The painting is undated, but it was probably done before 1825, when Dyce paid his first visit to Italy.[2] Following his two trips to Italy, Dyce exhibited a number of landscapes in Edinburgh between 1829 and 1832. Some of these were of views in Italy and France; others had titles such as 'Coast Scene: Composition'. None can be surely identified, but a picture of *Fisherfolk near a Wreck*, which is signed and dated 1830 (Pl. 185), must be similar to the exhibited pictures and may well be one of them. This painting is an imitation of pictures of similar subjects by Richard Parkes Bonington, and shows no hint of the influence of the German Nazarene artists who befriended Dyce in Rome in 1827–8. It parallels Dyce's portraits from the 1830s, which also show no reflection of his Italian experience, but recall Raeburn and Lawrence. Some of Dyce's watercolours are so like Bonington that they could easily be attributed to that artist, and as most of Dyce's works are unsigned, it is possible that some do bear the wrong label.

In 1832 Dyce visited Southern France and Venice, where a fellow Scot, David Scott, made a drawing of him sketching from a gondola (Scottish National Portrait Gallery, Edinburgh). A drawing from this trip is inscribed 'Rhône at Avignon' and dated 1832 (Pl. 186). The low horizon, empty, washy sky, and sketchy picturesque details are again reminiscent of Bonington, but the drawing reveals Dyce as less concerned with colour. It is almost in monochrome, the luminous distance and boldly cast shadows giving a sense of Mediterranean light so strong that it destroys colour. The architecturally structured composition of large simple forms bears no resemblance to the delicate linear style of the landscape drawings of the German Nazarenes.

From 1837 to 1843 Dyce painted little because of his teaching duties, and after 1843 he was engaged in painting frescoes in the new Houses of Parliament. He also received Royal commissions for frescoes at Buckingham Palace and at Osborne House. In 1845 he travelled to Italy to study early frescoes, and there, as we have seen, he took a keen interest in the effects of outdoor light which he found in Pinturicchio. His main easel pictures of the 1840s are comparable in style to his frescoes. A *Madonna and Child*

Facing page: William Dyce, *George Herbert at Bemerton* (detail of Pl. 198).

185 William Dyce, *Fisherfolk near a Wreck* 1830. Oil on canvas, 36 × 46. Private Collection.

painted for Prince Albert in 1845 (Pl. 3), for example, combines reminiscences of Raphael with the severity of Quattrocento profile portraits and is more Italianate than any later Pre-Raphaelite picture. The *Madonna* and a pendant *Saint Joseph* have landscape backgrounds, but the backgrounds are of minor importance in the compositions. They are thinly painted on a white ground, which occasionally shows through the brush marks. The outlines are precise, but there is little detail. The background of the *Madonna* consists of generalised mountains, which could be anywhere. In the *Saint Joseph* there is some vaguely Mediterranean architecture.

A small painting of *The Flight into Egypt* (Pl. 187) may date from about the same time or slightly later.[3] It has relatively free brushwork, comparable to that of the two pictures in the Royal Collection, and the landscape consists of large, rounded shapes, broadly composed in light and dark. A small cactus in the foreground indicates the Holy Land, but otherwise there is little sense of exact location. The figures are small, but they dominate the composition. The dark clump of trees behind repeats their shape, and their robes provide the picture's strongest accents of light and colour. Nothing distracts from their quiet movement, and the picture has a tenderness and harmony of mood which increasing literalness seems to have made impossible in Dyce's later paintings. A similar feeling also pervades the small *Gethsemane* (Pl. 188). This painting is undated, and has generally been thought to have been painted in the 1850s. However, there is still no hint of Pre-Raphaelite influence.[4] The twilight glow over the landscape, in which Christ is proportionately smaller than the figures in *The Flight into Egypt*, gives the picture an aura of mystical stillness quite unlike the mood of Dyce's later religious paintings.

186 William Dyce, *The Rhône at Avignon* 1832. Watercolour, 7¼ × 12. British Museum, London.

187 William Dyce,
The Flight into Egypt
c. 1845–50. Oil on
board, 11¼ × 15½.
Private Collection.

188 William Dyce, *Gethsemane c.* 1850–5. Oil
on board, 16½ × 12⅜. Walker Art Gallery,
Liverpool.

189 William Dyce, *Christabel* exhibited 1855. Oil on panel, 21¼ × 17⅝. Museum and Art Gallery, Glasgow.

Of approximately the same size and probably of the same period as these two paintings is a landscape in the National Gallery of Scotland, which has been exhibited under the various titles of 'Welsh Landscape', 'A Loch in Arran', and 'Shirrapburn Loch'.[5] In style and subject it is not unlike the painting of an academician like Thomas Creswick, a near contemporary of Dyce. While it is more detailed than the background of *The Flight into Egypt*, that should be expected, as the landscape is the subject of the picture, not just a setting for the figures.

In 1855, the first year of Ruskin's *Academy Notes*, Dyce exhibited a painting of *Christabel*, 'praying at the old oak tree' (Pl. 189). This bust-length picture of a girl, in an oval frame, is of the traditional Victorian 'Keepsake' type. It is no more archaising than Dyce's *Madonna and Child* of 1845, but the *Art Journal* declared that it had more in common with the Madonnas of Nuremberg or the early Italian school than with the mystic conception of Coleridge.[6] Ruskin was also displeased:

> An example of one of the false branches of Pre-Raphaelitism, consisting in imitation of the old religious masters. This head is founded chiefly on reminiscence of Sandro Botticelli. The ivy leaves at the side are as elaborate as in the true school, but are quite false both in colour and shade. There is some sweet expression in the face.[7]

Ruskin's argument in defence of Pre-Raphaelitism ever since 1851 had been that the movement had nothing to do with archaism. His criticism of Dyce was an attempt to differentiate between the naturalism of the Pre-Raphaelites and revivalism, and to discredit the latter, but the attack must have come as a shock to the artist, who had been the person initially responsible for arousing Ruskin's interest in the younger artists and had been consistently supportive of them.

In 1856 he exhibited a picture of *The Good Shepherd* at the Royal Academy. According to his son, it was only a study, and it went unnoticed by Ruskin. Then, in 1857 he exhibited *Titian Preparing to Make his First Essay in Colouring* (Pl. 190). This picture, which shows the young Titian surrounded by carefully drawn and brightly coloured flowers and foliage, appears to be the product of an effort to paint the sort of Pre-Raphaelite picture which Ruskin had criticised Dyce for failing to paint two years before. It immediately drew a complimentary letter from Ruskin: 'I have not the least idea whether you and I are friends or not – but I can't help *writing* to congratulate you on your wonderful picture. . . . I don't think the colour of the face is right – but you have beat everybody this time in thoroughness'.[8] Ruskin was even more laudatory in print. In *Academy Notes* he devoted a long review to the painting, which began,

> Well done! Mr. Dyce, and many times well done! though it is of little use for any of us to say so to you; for when a man has gone through such a piece of work as this he knows he is right, and knows it so calmly that it does not matter much to him whether people see it or not. This is a notable picture in several ways, being, in the first place, the only one quite up to the high-water mark of Pre-Raphaelitism in the exhibition this year . . . Mr. Dyce has encountered all discoverable difficulties at once, and chosen a subject involving an amount of toil only endurable by the boundless love and patience which are first among the Pre-Raphaelite characteristics.

He then went on to discuss the picture's particular qualities. He praised its 'sculpturesque sense of grace in form', but he was critical of the accompanying deficiency in colouring: 'We cannot part so lightly with the blood of Titian; no boy could ever have coloured a Madonna's face who had so little colour in his own.' He was also critical of Dyce's visualisation of the subject, which did not agree with his own conception (in which Titian spent his boyhood in the Alps), but, except for declaring that Dyce would never 'colour like a Venetian', he made no comment about the vast disparity between Dyce's style and that of his subject. He concluded that no one need hope to do much better in painting dress, flowers, grass, and leafage, and warned his readers, 'It will take about an hour to see this picture properly.'[9]

As seen through this criticism, between 1855 and 1857 the artist abandoned a false style to become Pre-Raphaelitism's most praiseworthy proponent. A major change certainly did take place, and, if it can not be measured in such black-and-white polarities, it was enough to place Dyce's later works among the leading examples of Pre-Raphaelite detail and finish. There is certainly no doubt of Pre-Raphaelite influence on the *Titian*, and all of Dyce's later pictures follow its example of a carefully observed and minutely wrought natural setting, which generally dominates the figural content of the painting. *George Herbert at Bemerton* (Pl. 198), for example, which appeared at the Royal

190 (facing page) William Dyce, *Titian Preparing to Make his First Essay in Colouring* exhibited 1857. Oil on canvas, 36 × 26½. Aberdeen Art Gallery and Museum.

191 William Dyce, *The Good Shepherd* exhibited 1859. Oil on canvas, 31 × 25. St Peter's Church, Little Budworth, Cheshire.

Academy four years later, in 1861, the last year in which Dyce exhibited, also shows a historical figure in a landscape setting. The figure is smaller than the Titian, and the foliate detail is still more elaborate, but this only continues the trend begun in 1857 (see detail, p. 224).

Dyce did not exhibit at the Royal Academy in 1858, but showed a second *Good Shepherd* (Pl. 191) a year later. As noted in chapter two, in 1851 Dyce participated in current theological debates by publishing a pamphlet, *Notes on Shepherds and Sheep*, responding to Ruskin's *Notes on the Construction of Sheepfolds*. The painting shows Christ as the good shepherd, dutifully and lovingly carrying a lamb and conducting his flock through an ivy-covered gate into the protected space of a sheepfold. Holman Hunt in *The Hireling Shepherd* (Pl. 11), a picture seemingly partly inspired by Ruskin's and Dyce's pamphlets, had painted a bad shepherd, who allows his flock to stray, and Dyce's picture of proper pastoral behaviour constitutes, among other things, a later contribution to the exchange.

The Good Shepherd is primarily a painting of the figure of Christ and of sheep; nonetheless, the setting is carefully and minutely delineated. The *Art Journal* described it as 'a landscape with a sheep fold paled in, trees and a cultivated country, such as might be seen in any rural district round London'.[10] In the following year Dyce exhibited two further pictures of biblical subjects, *St John Leading Home his Adopted Mother* (Tate Gallery), and *The Man of Sorrows* (Pl. 192). The former was basically a work from an earlier period; in the Royal Academy catalogue in 1860, it was described as painted in 1844 and revised in 1851. The latter was probably painted in 1859, along with a second biblical painting, *David in the Wilderness* (Pl. 193), which Dyce did not exhibit. Both have extensive backgrounds showing the Scottish Highlands, which Dyce visited in the summer of 1859.

These two paintings depict relatively small figures in extensive landscape settings, reversing the relationship of *The Good Shepherd* of 1859, but with a figural scale not unlike that of the earlier *Flight into Egypt* and *Gethsemane*. If we compare them with those two pictures, we see that the figures are not radically different in style, but that the landscapes display much greater elaboration of detail. Primary importance is given to the accumulation of minutely realised detail of rocks and blades of grass, and for this a more uniform range of tone replaces broad contrasts of light and dark. The focus has shifted from the figures to the landscapes surrounding them. Those landscape settings are appropriate to the subjects. The *Man of Sorrows* was accompanied in the Royal Academy catalogue entry

by a quotation from John Keble, which included the lines, 'What time, unsheltered and unfed,/Far in the wild His steps were driven,'[11] and the traditional title of its companion situates David in the wilderness. Hence the barren settings; but the pictures could stand almost as well without the figures, simply as clearly seen and precisely detailed Scottish landscapes. They are views of Highland scenery into which biblical figures seem to have strayed accidentally, and the contrast between figures and settings gives them an

192 William Dyce, *The Man of Sorrows* c. 1859. Oil on board, 13⅞ × 19¹⁵⁄₁₆. National Gallery of Scotland, Edinburgh.

193 William Dyce, *David in the Wilderness* c. 1859. Oil on board, 13⅞ × 19¹⁵⁄₁₆. National Gallery of Scotland, Edinburgh.

194 William Dyce, *Scene in Arran* 1859. Oil on board, 13¾ × 19¾. Aberdeen Art Gallery and Museum.

anachronistic appeal.[12] The *Art Journal*, describing *The Good Shepherd* in 1859, decided that Dyce, in painting countryside that looked like England, was following 'the simple conceptions of early Florentine painters,' but for some critics the contrast was disturbing. In 1860 F. G. Stephens, writing in the *Athenaeum* (and conscious of the exhibition of Holman Hunt's *Finding of the Saviour in the Temple*, which had opened the month before), criticised *The Man of Sorrows*: 'It is true that the omnipresence of the typical idea may be well conveyed by thus treating it, but the individuality of the Saviour is lost thereby . . . the picture is completely realistic in all respects . . . but why – with all this literalness – not be completely loyal, and paint Christ himself in the land where he really lived?' Elsewhere in the same review, Stephens wrote that Dyce's pictures at the Royal Academy indicated 'a transitional state of mind', and he suggested again that Dyce should go further: 'Mr. Dyce is rapidly becoming a realistic artist – such a one, indeed, that the growing strength of his conviction will soon lead him, when painting a scriptural subject again, to go to the East, and to do so under all possible advantage.'[13]

The Man of Sorrows and *David in the Wilderness* are two pictures from a group of works painted on millboard and with the same measurements – approximately 14 × 20 inches. Others include *The Woman of Samaria* (City Art Gallery, Birmingham), *Henry VI during the Battle of Towton* (Guildhall Art Gallery, London), and scenes in Arran (Pl. 194), and Wales (Pl. 195), The former two are related to Dyce's other pictures of biblical and historical subjects. Both have rising ground and stone walls immediately behind the figures, so, although they contain detailed backgrounds, they do not show extensive views. Neither is dated, nor were they exhibited, but they must have been painted in the late 1850s or early in the next decade.

The latter two pictures can be ascribed to holiday trips taken by the artist. A reference in a letter from Dyce to his brother-in-law written in October 1860, when he had just returned from Wales, accounts for both of them: 'These trips for change of air always pay. I made £400 by my trip to Ramsgate two years ago, and £620 by my last year's trip to Arran, and I hope to make an equally good thing out of the Welsh excursion.'[14] The *Scene*

in Arran bears an inscription on the back: 'painted by William Dyce RA for his father-in-law, James Brand, of Bedford Hill House, Balham in the year 1858 or 1859'. So it must date from the trip to Arran in the latter year. The *Welsh Landscape* is almost certainly from the trip of 1860. An unfinished watercolour, *Goat Fell, Isle of Arran* (Victoria and Albert Museum) and a watercolour of Welsh mountains (Ashmolean Museum, Oxford) were probably also made on the trips in 1859 and 1860. In the letter just quoted, Dyce stated that he had made sketches which he hoped to turn to account. But as the *Scene in Arran* and the *Welsh Landscape* are small and on prepared millboard, which the painter could easily have carried with him, it is likely that Dyce at least began them on his travels.

We also learn from Dyce's letter that the Welsh mountains were more rugged, 'more awful and terrific looking than anything I know of in Scotland.' He ascribed the beauty of the Welsh mountains to their geological formation, and he analysed the reasons for the differences between Welsh and Scottish scenery:

> In Scotland, the granite mountains by the process of disintegration become rounded and their asperities smoothed down – but in Wales, the material being slate rock, it does not crumble like granite into dust or sand, but splits and tumbles down in huge flakes which leave the peaks from which they have fallen as sharp and angular as if they had never been acted upon by the atmosphere at all.[15]

If we compare the *Welsh Landscape* with *The Man of Sorrows*, we see angular rocks in the foreground of one and rounded rocks in the other, and corresponding differences in the configurations of the terrain.

Unlike most of Dyce's earlier paintings, the *Scene in Arran* and *Welsh Landscape* do not have biblical or historical, but genre subjects. Dyce apparently began to take an interest in these subjects only during the 1850s. The first firm date we can associate with this development is 1858, when he exhibited a picture entitled *The Highland Ferryman* (Aberdeen Art Gallery) at the Royal Scottish Academy. He exhibited the same painting at the Royal Academy in London in 1859 as 'Contentment'. When it appeared there, the

195 William Dyce, *Welsh Landscape with Figures* 1860. Oil on board, 13⅞ × 19⅞. Private Collection.

196 William Dyce, *Pegwell Bay, Kent – a Recollection of October 5th, 1858* exhibited 1860. Oil on canvas, 24½ × 34½. Tate Gallery, London.

Art Journal described it as 'a subject in humble life – the only one we remember to have seen by this artist'.[16]

The Highland Ferryman does not show a particularly contemporary figure, but a rural character belonging to a seemingly unchanging way of life. The figures in the *Welsh Landscape* wear traditional and picturesque Welsh peasant costume and seem, like the ferryman, to be relics of another age. Dyce's other genre pictures, however, do not show such concern for indigenous traditions. A small undated picture known as *The Manse* or *Entrance to the Vicarage* (private collection) shows a boy, probably Dyce's son, with a wheelbarrow. *A Scene in Arran* has a group of children splashing in a stream, and Dyce's masterpiece, *Pegwell Bay* (Pl. 196), shows his own family collecting shells while on a seaside holiday. This picture appeared at the Royal Academy in 1860 under the title 'Pegwell Bay, Kent – a Recollection of October 5th, 1858'. Pegwell Bay is just south of Ramsgate, and the picture is a product of the trip there which Dyce mentioned in his letter to his brother-in-law two years later. Donati's comet, which was visible in 1858, appears in the sky. The foreground figures are Dyce's son, his wife, and his wife's two sisters. A figure on the right edge of the canvas carrying artist's equipment may represent Dyce himself. The picture was bought by the artist's father-in-law, James Brand, who owned several of his works.

Among Dyce's other pictures, the one most closely related to *Pegwell Bay* is the *Scene in Arran* of 1859. It was also the product of a holiday trip, and also bought by James Brand. It shows green, grass-covered hills rather than grey chalk cliffs, and, as it is on a smaller scale, the detail seems less obsessively elaborate. Otherwise, the two pictures have much in common: a great deal of litter lying about, small background figures who seem accidentally included in the view, children staring fixedly out of the picture, and frozen main figures who are curiously aloof from one another. Both pictures contain figures caught in acts which seem to be simple movements observed unawares. In *Pegwell Bay* the putative figure of Dyce himself in the background stares at the comet in the sky with his back turned to the foreground figures, and in *A Scene in Arran* the small girl on the

right unselfconsciously holds up her skirt. Such details could be considered photo-graphic – the result of the camera's indiscriminate inclusion of everything within its focus – and *Pegwell Bay* has repeatedly attracted comparison with photographs and sug-gestions that it was influenced by photography, starting with the *Art Journal*'s review of the Royal Academy exhibition in 1860, which described the foreground as 'painted with a truth equal to that of photography'.[17]

Dyce was a friend of his fellow Scottish painter David Octavius Hill, and he was inter-ested enough in Hill's photographic activity to suggest in 1846 that Hill make a trip to Rome with his 'Kalotype machinery'. In 1858, painting a portrait commissioned by Gladstone, Dyce wrote a letter proposing to make photographs of the model.[18] So he was aware of photography and its possible use in connection with at least some aspects of painting. On the other hand, in 1860, the year that *Pegwell Bay* was exhibited, James Dafforne wrote a biographical article about Dyce in the *Art Journal* in which he acknowledged that some critics believed *Pegwell Bay* had been painted from a photo-graph. Dafforne categorically denied it: 'Its wonderful elaborated detail favoured the sup-position; but we happen to know it was done from memory, aided by a slight and hasty sketch, in pencil, of the locality.'[19] Without evidence to the contrary, this denial should probably be accepted, although Dyce may still have adopted stylistic suggestions from photographs by Hill and others. If we compare *Pegwell Bay* with a contemporary pho-tograph of the same locality,[20] we can see that in this instance Dyce not only equalled, but outdid the camera in clarity and thoroughness. Furthermore, the documented occa-sions of the use of photographs by Dyce's contemporaries, Frith for example, led to such different results, that even if Dyce's use of photographs were established, the look of his pictures could hardly be considered an automatic result. Perhaps as important an expla-nation for the personal and unhackneyed quality of these pictures is the fact that they were painted primarily as a diversion and were apparently guaranteed a purchaser with-in Dyce's own family. He was thus free to indulge his remarkably clear vision and imag-ination without the need of consulting conventional taste and forcing his pictures into a mould of smiling prettiness.

The pencil sketch mentioned by Dafforne has not come to light, but a watercolour of *Pegwell Bay* is known (Pl. 197).[21] It shows the same view as the picture, and was appar-ently used in painting it. The watercolour is broader in effect than the painting, or than Dyce's watercolours of Welsh and Scottish mountains. It shows the coast at sunset, with a purplish sky, and without the foreground figures. By incorporating the figures into the painting, Dyce turned a pure landscape into a contemporary genre scene of the type of Frith's *Life at the Seaside*, also painted at Ramsgate, the successful exhibition of which in 1854 had started the mid-century vogue for paintings of the seaside. However, in Frith's picture the landscape setting is incidental; the figures dominate the composition and the main interest is anecdotal. Dyce's figures seem stuck on to what is still essentially a land-scape. They are in the immediate foreground, and the colours of their garments stand out from the almost monochrome greys of their setting. They are before the landscape rather than in it, and their positions seem dictated by the painter's interest in repetition and balance rather than by narrative interests comparable to those of Frith. If we look from the watercolour to the painting, we see Dyce consistently modifying the sketch

197 William Dyce, *Pegwell Bay* c. 1858. Watercolour, $9^3/_4 \times 13^3/_4$. Aberdeen Art Gallery and Museum.

198 William Dyce, *George Herbert at Bemerton*
exhibited 1861, Oil on canvas, 34 × 44.
Guildhall Art Gallery, Corporation of London.

towards greater clarity of structure and geometrical order. The sketch has an atmos-
pheric breadth and a looseness of organisation which have disappeared in the painting.
The foreground figures, the pilings added behind them, and the lines of rock reaching
into the sea provide precise punctuation in a manner that appears arbitrary. Yet the paint-
ing seems, if anything, more natural than the watercolour. It does have the look and the
feel of the seashore, and it has attracted perhaps as many testimonials to its truth as any
nineteenth-century painting.

Marcia Pointon has argued persuasively that *Pegwell Bay* is a meditation about time,
with time manifested in different ways by the ancient rocks of the cliffs and the comet
in the sky.[22] On a more immediate level, the picture does not share the general sunny
pleasantness of Impressionism, and even of much of Pre-Raphaelitism. The landscape is
bleak, the figures collect their shells with a seriousness that verges on gloom, and the
mood is distinctly melancholy. The inclusion of the artist's own family by the edge of the
sea makes *Pegwell Bay* comparable to *Walton-on-the-Naze* painted by Ford Madox Brown
on a holiday on the Essex coast in 1859 (Pl. 28), and both have subjects similar to slight-
ly later paintings of the seaside by the French artists Claude Monet and Eugène Boudin.
In particular, Dyce's heavily clad figures may remind us of analogous figures wrapped in
shawls painted by Boudin at Trouville and Deauville during the 1860s. But the tight
organisation and elaboration of detail in *Pegwell Bay* seem the antithesis of Boudin's
breezy freshness. Dyce obviously spent an amount of time on one painting that the
French artist could have used to paint twenty, and, in fact, Boudin produced countless
more-or-less interchangeable rapid depictions of what is essentially one subject, whereas
Pegwell Bay is a one-of-a-kind picture. Although Dyce sacrificed spontaneity, he entered
into the subject in a way that makes almost all Impressionist paintings seem superficial.
It also makes his own earlier painting of the seaside seem vapidly conventional; we can

measure his growth as an artist by looking back to his *Fisherfolk near a Wreck* (Pl. 185) painted some thirty years before.

While *Pegwell Bay* is usually thought of as a Pre-Raphaelite picture, stylistically it is also quite unlike *Walton-on-the-Naze* and most other Pre-Raphaelite pictures from the preceding decade, mainly because it lacks the brilliant colours of Pre-Raphaelitism. We have seen that Ruskin, while praising *Titian Preparing to Make his First Essay in Colouring*, disliked Dyce's colour. It also came in for criticism from other sources. The *Art Journal* declared *The Highland Ferryman* 'too grey in the foreground and too blue in the distance' and F. G. Stephens thought that *Pegwell Bay* should have deeper tone.[23] When Dyce was in Italy, he had admired the richly coloured flesh tones of Perugino and speculated about theories of prismatic flesh painting,[24] but his own painting of flesh was far from prismatic. Ruskin specifically criticised the lack of colour in the face of his Titian, and Dyce's later pictures tend more and more to lack colour in the flesh tones. The extreme example is *George Herbert at Bemerton* (Pl. 198), in which the face is not even modelled in light and shade, but here Dyce may have been imitating Elizabethan art in a slightly quixotic attempt to match style to subject. In Italy, Dyce also praised the general effect of outdoor colour in Pinturicchio's frescoes, and he went on to emphasise the value of study in the open air. However, what he saw in Pinturicchio was consistency of local colour through both light and shade.[25] This is what we see in Dyce's painting; the colour is local colour, occasionally strong, but never interfering with the linear and structural clarity of the paintings, and never complicated by reflected lights and colours. In 1846 Dyce inveighed against the unnaturalness of conventional studio shadowing. Ten years later he probably found the reflected blues and purples of Holman Hunt and Ford Madox Brown equally unnatural, although he himself had encouraged the study of outdoor light which led to them.

In other respects also, Dyce was more conservative than any of the Pre-Raphaelite group. Even when at his most Pre-Raphaelite, he never provoked the hostile reactions that greeted many Pre-Raphaelite paintings. The *Art Journal* called *Titian Preparing to Make his First Essay in Colouring* 'Pre-Raphaelite', but without 'the inconsistencies and extravagancies presented in the works so called'.[26] Dyce's painting is always clear and controlled, and it lacks the excitement of innovation of the best Pre-Raphaelite pictures. Nonetheless, the minute detail and increasing literalness of Dyce's painting at the end of the 1850s clearly depended upon the Pre-Raphaelite example. His work is not central to the movement, but with sobriety and discipline he built upon Pre-Raphaelitism to paint a handful of the most moving and memorable pictures of the Victorian era.

Pre-Raphaelitism and Nineteenth-Century Landscape Painting

Pre-Raphaelitism as a movement marked an almost complete break in the continuity of the English landscape tradition. This was in part because the original members of the Pre-Raphaelite Brotherhood did not start out as landscape painters. The background of their art lay in the developments in figural painting during the 1840s discussed in the first chapter. They had little interest in the landscape painters of the preceding generation, and when a Pre-Raphaelite school of landscape painting emerged, it had few roots in the immediate past.

English landscape painting of the 1840s did not provide much of a basis for new developments. The great period of English landscape painting was drawing to a close. Constable died in the year that Queen Victoria came to the throne. Turner was painting some of his greatest pictures in the 1840s, but they were far too individual to have had any immediate influence, and by the second half of the decade he was thought to be slipping. In the words of Holman Hunt 'Turner was rapidly sinking like a glorious sun in clouds of night that could not yet obscure his brightness, but rather increased his magnificence. The works of his meridian day were then shut up in their possessors' galleries, unknown to us younger men.'[1] A few artists, notably David Cox and John Linnell, carried some of the breadth of earlier English landscape into the 1850s, and, in Linnell's case, beyond. Cox, during the last years of his life, was admired as the grand old man of English landscape, and he had an early influence on George Price Boyce and Alfred William Hunt, both of whom later fell under the Pre-Raphaelite spell. The Pre-Raphaelites elected Cox an honorary member of the Hogarth Club, and Ruskin regularly praised his work in *Academy Notes*, although he noted that 'Mr. Cox's work is every year broader in handling, and therefore further, as mere work, from the completeness I would generally advocate'.[2] The completeness advocated by Ruskin and practised by the Pre-Raphaelites had nothing to do with Cox, and Cox's popularity in mid-Victorian England is remarkable because, whatever the merits of his art, prevailing taste was moving in another direction.

Landscape painting in the 1840s can be divided into two main classes: topographical and pastoral or rustic. Among painters, the chief topographers were David Roberts and Clarkson Stanfield. There were also large numbers of watercolourists, of whom Samuel Prout, who died in 1852, and James Duffield Harding should be mentioned because of the attention paid them by Ruskin. These artists reflect the taste of the mid-century by the ever greater importance given in their works to accurate reporting of places of interest. David Roberts spent 1838 and 1839 in Egypt and Palestine, and the resulting three-volume *Views in the Holy Land, Syria, Idumea, Egypt, and Nubia*, published between 1841 and 1849, was a monumental precursor of Pre-Raphaelite attempts to make trustworthy depictions of the East. Ruskin's interest in this group of painters is easily understood. Their subjects were the subjects that attracted him and that he would urge younger artists to paint. He had learned to draw by imitating first Samuel Prout, then David Roberts, and he travelled in Italy in 1845 with Harding, while preparing the second volume of *Modern Painters*. Nevertheless, by the 1850s he was generally critical of their reliance upon artifice and convention rather than fresh observation, and Harding and

Facing page: George Price Boyce, *At Binsey, near Oxford* (detail of Pl. 112).

Roberts came in for attacks in *Academy Notes*.[3] William Michael Rossetti, describing the international exhibition of 1855 in Paris, wrote that the works of Stanfield *et al.*, looked 'flimsy and artificial'.[4] This was probably representative of the general Pre-Raphaelite attitude.

The other class of landscape was represented by a number of Academicians – Thomas Creswick, William Frederick Witherington, Frederick Richard Lee, and Richard Redgrave, who was also a figural painter. Their pictures of a rural, pastoral England carried on the tradition of Gainsborough and Constable, but they replaced the breadth of earlier English landscape with a small, dry touch and thinness of paint. Their more careful handling, accompanied by brighter colours, was part of a general redirection of English painting in the 1840s, which culminated in Pre-Raphaelitism, but their tighter detail was not necessarily accompanied by fresh observation. Most landscapes by this generation seem artificial and repetitive. As the Redgraves wrote about Creswick, 'He had a true feeling for the elegance of foliage and for graceful passages of interest in a landscape, but his touch is inclined to mannerism, and there is a good deal of sameness in his work.'[5] Ruskin did not take this painting very seriously. He only mentioned Creswick twice in *Academy Notes*, although he was generally considered the most important landscape painter in the Royal Academy. Here is the first mention:

> This, like most other of the landscapes hung on the line, is one of those works so characteristic of the English school, and so little creditable to them, in which everything is carelessly or ill-painted – because it is in a landscape. Nothing is really *done*. The cows have imperfect horns and hides; the girl has an imperfect face and imperfect hands; the trees have imperfect leaves; the sky imperfect clouds; the water imperfect waves.

That was written in 1855. Ruskin's comments on Witherington and Redgrave in the same year complemented what he had said about Creswick:

> We have here two interesting examples of another fallacious condition of landscape – that which pretends to Pre-Raphaelite distinctness of detail; but is in all detail industriously wrong. In Creswick's work the touches represent nothing; here they represent perpetual error, assuming that all leaves of trees may be represented by oval, sharp-pointed touches of yellow or green – as if leaves had not their perspectives, shadows, and changes of hue like everything else! There is great appearance of fidelity to nature in these works, but there is none in reality; they are mere mechanical accumulations of similar touches, as a sempstress mechanically accumulates similar stitches.[6]

The Pre-Raphaelites had little use for any of these artists, except Creswick, and for him they had special antipathy. In *Pre-Raphaelitism and the Pre-Raphaelite Brotherhood*, Holman Hunt described an unpleasant incident with an Academician who gave Hunt a commission for his *Claudio and Isabella*, then denied it after Hunt had prepared the designs. The Academician was Creswick.[7] Creswick managed to dominate landscape painting in the Royal Academy for some twenty years. His influence was probably a major reason why Pre-Raphaelite landscapes were generally treated badly at the Academy exhibitions, and he was bitterly hated by artists such as Alfred Hunt who had Academic ambitions.[8]

Pre-Raphaelitism did also have substantial support within the Academy. When Creswick repudiated his commission for *Claudio and Isabella*, it was taken up by Augustus Egg. William Dyce encouraged Holman Hunt, and several other older artists welcomed the advent of the new movement. Among them was William Mulready. In the 1840s, Mulready exhibited several landscapes which he had painted about 1810, showing views in Kensington (Pl. 199). They show careful detail, but compositions based on contrasts of light and dark, with a limited range of brownish colours. During most of his career Mulready painted figural subjects, in which landscape backgrounds, if they appeared at all, were summarily treated. However, in 1852, he exhibited a view of *Blackheath Park* at the Royal Academy in which he replaced the tonal breadth of his early landscapes by overall brightness of colour and precise leaf-by-leaf detail (Pl. 200). Mulready's figural paintings of the 1830s and 1840s (Pl. 12) had anticipated and probably influenced Pre-Raphaelite detail and brilliance of colour.[9] *Blackheath Park* carried the qualities of these paintings to another class of subject, but the result differed enough from Mulready's previous work to outrage the *Art Journal*, which called the picture 'a Pre-Raffaellesque eccentricity'. It described the painting as a minute transcription of a locality of no pictorial value, and it criticised the 'lively' green colour; yet, it went on, 'in the whole there is an attractive softness and sweetness of execution, which we presume is proposed as a lesson to those youths who "babble of green fields".[10]

PRE-RAPHAELITISM AND NINETEENTH-CENTURY LANDSCAPE PAINTING

199 William Mulready, *The Mall, Kensington Gravel Pits* c. 1811. Oil on canvas, 14 × 19¼. Victoria and Albert Museum, London.

It is doubtful that Mulready was as conscious of the Pre-Raphaelites when painting *Blackheath Park* as the *Art Journal* suggested, since before 1852 there was not yet any real Pre-Raphaelite landscape painting. But its comments do reflect a perception of common concerns. In 1948 Geoffrey Grigson pointed out a kinship between the Pre-Raphaelites and the group of painters who had studied with the watercolourist John Varley at the beginning of the century.[11] Mulready was a member of the group; others included John Linnell and William Henry Hunt. These artists painted with a concern for careful detail and a crispness of colour that explains much of the respect which the Pre-Raphaelites had for them. They were more humbly pious in their approach to nature than a Constable, more willing to accept nature as it is than to synthesise. Their pictures have more observation of detail and less concern with atmospheric effect as a whole, and it is noteworthy that Constable had a low opinion of both Linnell and Mulready.[12] The

200 William Mulready, *Blackheath Park* exhibited 1852. Oil on panel, 13½ × 24. Victoria and Albert Museum, London.

motto of the group was 'Go to nature for everything', but the purpose of going to nature was not simply naturalistic description for its own sake. The numinous significance they found in natural detail is reflected in a remark by William Henry Hunt: 'I feel really frightened when I sit down to paint a flower', which, as F. G. Stephens respectfully declared, 'was going to nature with a vengeance'.[13]

The importance of Mulready and William Henry Hunt for the Pre-Raphaelites was mentioned in the first chapter. Linnell painted highly detailed landscapes in the second decade of the century. In 1818 he met William Blake and soon after commissioned Blake's *Divine Comedy* illustrations; he also was responsible for introducing Samuel Palmer, who became his son-in-law, to Blake. While the visionary dimensions of Palmer's art owed much to the example of Blake, Palmer was also encouraged to a close, niggling study of nature by Linnell and Mulready. Linnell also told Palmer to study Dürer and Lucas Van Leyden as a means of gaining greater natural truth and escaping the 'effects' of 'the moderns'.[14] This concern with 'archaic honesty' has much in common with the Pre-Raphaelite approach to nature. We have suggested that Ford Madox Brown and Daniel Alexander Williamson occasionally recall Palmer's work in their own pictures. There seems to have been no direct influence from Palmer, but the later artists did paint nature with an outlook much like that urged upon Palmer by Linnell and Mulready, both of whom were still around and encouraging to the young Pre-Raphaelites in the midst of Academic hostility.

Mention must also be made of John Frederick Lewis. Ruskin always called Lewis a Pre-Raphaelite, but Lewis was not an intimate of the Pre-Raphaelites, nor did he have significant influence upon them, at least not until well into the 1850s, when he may have had some importance for Thomas Seddon and John Brett.[15] As Lewis spent the entire decade of the 1840s in the East, without exhibiting in London, his mature art was unknown in England at the time the Pre-Raphaelite Brotherhood was being formed, and he developed his brightly coloured, almost miniaturist style independently of Pre-Raphaelitism. In comparison to Lewis, much Pre-Raphaelite painting seems broad. His pictures reflect similar interests, including a concern for outdoor sunlight, but most of them were painted in the studio after his return from the East, and they have a dainty Victorian prettiness which allowed him to gain popular success and academic distinctions almost as soon as he returned.

For the Pre-Raphaelites themselves, success was slow in coming, and their best work of the 1850s never became really popular. Conservative periodicals such as the *Art Journal* and the *Athenaeum* (until 1860 when F. G. Stephens became its art critic) were always critical of the movement. Although the early Pre-Raphaelite pictures were well hung at the Royal Academy and Millais was elected an associate member of the Royal Academy in 1853, the Academy was unsympathetic to Pre-Raphaelitism in general and to Pre-Raphaelite landscape painting in particular, and there were annual complaints from the artists and from friendly critics, such as William Michael Rossetti and Ruskin, about rejections and bad hanging. As a result, Ford Madox Brown stopped exhibiting at the Academy entirely, and Holman Hunt exhibited there rarely after 1856. In 1857, the Pre-Raphaelites organised their own exhibition in Russell Place, and in 1858 they formed their own exhibiting society, the short-lived Hogarth Club, in order to be independent of the Academy.

From a conservative point of view, and measured by the usual marks of success, Pre-Raphaelite naturalism was an abortive movement of little importance; and painters like Brown, Inchbold, or Brett were notoriously unsuccessful during their best years. On the other hand, if we read Ruskin, we get a different picture. Ruskin was blatantly partisan, and in his reviews he assigned a degree of importance to his favourites, such as Brett, with which few of his contemporaries would have concurred. Nonetheless, he was an observer as well as a proselytiser. From his annual reviews, we can see that each year more and more young artists were attempting to paint from nature in emulation of the Pre-Raphaelites. In figural painting the influence of Frith's genre scenes, commencing in 1854, and of the continentally trained Frederic Leighton, who created a sensation at the Royal Academy in 1855, counteracted that of Pre-Raphaelitism, but in landscape painting there were no such opposing forces. Older artists, such as Creswick, continued their opposition, but otherwise, as Ruskin claimed, and as William Michael Rossetti wrote in 1862, landscape came almost entirely into the domain of Pre-Raphaelitism.

An illustration of the influence of Ruskin and the Pre-Raphaelites on younger painters is provided by the critic and amateur artist Philip Gilbert Hamerton. Around 1860, Hamerton set out to paint landscapes in the Scottish Highlands, living in a tent

and painting directly from nature. While there, he wrote an essay, entitled 'Painting from Nature', in which he declared:

> The practice of painting from nature, in the modern sense, is of very recent adoption. It is probable that before our own time no landscape painter ever began and finished an oil *picture* out of doors and from nature itself. . . . At the present day, however, many painters – especially our younger ones – are devoting immense labour to the finishing of pictures out of doors; a costly and inconvenient proceeding, and one which ought to reward its votaries very richly for all the trouble and fatigue it inevitably entails.[16]

He then proceeded to discuss the pros and cons of painting from nature and to give advice about some of its difficulties. The essay is long-winded and rather pointless, but it does make clear that Pre-Raphaelitism set the standards, and the only two pictures mentioned by name are Seddon's *Jerusalem and the Valley of Jehoshaphat* and Brett's *Val d'Aosta*. More interesting than the essay itself is a note appended by Hamerton in 1873, when his outlook had changed considerably. The note asserts that the younger English painters were misdirected into painting detailed pictures direct from nature, rather than sketches, by the example of the Pre-Raphaelites and by the recommendations of Ruskin. Ruskin's influence was especially harmful:

> He had two very strong and catching enthusiasms, the enthusiasm for natural magnificence and the enthusiasm for novelty and discovery in the Fine Arts. Many of us were fully prepared to be partakers of these enthusiasms, by the same influence of literature and science which had excited them in Mr. Ruskin himself. . . . But our ardour was not really and fundamentally artistic, though we believed it to be so. It came much more from a scientific motive than from any purely artistic feeling, and was a part – though we were not ourselves aware of it – of that great scientific exploration of the realms of nature which this age has carried so much farther than any of its predecessors. While botanists and geologists were occupied in investigating the construction of landscape, we investigated its aspect. . . . We went in the search for rigorously accurate truth, which is an entirely scientific state of mind. Our pictorial work was as much a scientific exposition as the chapters on the structure of the Alps in the fourth volume of *Modern Painters*. And I perceive now, having learned to distinguish between the scientific and artistic spirits, that the proper expression for what I learned in the Highlands . . . would have been, not pictures, but a book with coloured illustrations.[17]

In 1873, Hamerton was living primarily in France, and he felt that the proper practice was that of the French artists who sketched from nature in broad masses and tones but did not concern themselves with detail. In England, artists who had attempted to paint pictures directly from nature in the 1850s later changed their ways:

> The most experienced landscape painters of the generation immediately preceding ours were agreed in the conviction that it was useless to paint pictures from nature, because effects would not stay to be painted. For some years the younger English artists hoped otherwise, but now these men (no longer young men) have also come to recognize the necessity for painting *pictures* in the studio.

Most of the artists discussed in this book did change, as Hamerton claimed was generally the case, and in their later careers did paint their finished pictures in the studio. In the 1850s, nonetheless, they provided the lead for an army of younger artists who attempted to work carefully from nature.

An example is Albert Moore, whose watercolour *Study of an Ash Trunk* of 1857 (Pl. 201) is a study of foliage as microscopically close as anything done in the Pre-Raphaelite sphere. In the 1860s Moore began to paint pictures of women in classical robes which have nothing to do with Pre-Raphaelite naturalism, but during the later 1850s, when he was a student at the Royal Academy schools, the Pre-Raphaelite influence was inescapable. Turner in his will had left money for a gold medal and scholarship to be awarded biennially to an Academy student. After Turner's estate was settled in 1856, the first competition for the medal was held in 1857, the prize to go to the best English landscape. According to Henry Holiday, who was one of the contestants, all the works but one had been studied from nature. Holiday thought that Henry Moore, the older brother of Albert, should have won, but the medal went to the one picture not painted from nature, by a student of Witherington. The next time the competition was held, the Academicians made sure the pictures were not painted from nature by setting as subject 'The Palatine

201 Albert Moore,
*Study of an Ash
Trunk* 1857.
Watercolour,
12 × 9. Ashmolean
Museum, Oxford.

Hill before the Building of Rome'.[18] Despite this opposition, almost every young student at the Royal Academy in the later 1850s, Holiday included, did have a short Pre-Raphaelite period before going on to a career of doing something entirely different.

Despite the short life of the movement, and despite the continuing opposition to it from established landscape painters such as Creswick or Witherington or Harding, Pre-Raphaelitism did permanently deflect the course of English landscape painting. The differences between a popular older artist like Creswick and a popular younger one like Benjamin Williams Leader were substantially due to Pre-Raphaelitism. Leader, born in 1831, began by making careful studies from nature, some of which are not unlike pictures by William Millais, and the outgrowth was the illusion of exact verisimilitude which brought Leader's later works their immense popular success. The watercolours that Myles Birket Foster began to paint around 1859 owe more to older artists such as Creswick or Clarkson Stanfield than to the Pre-Raphaelites, but their bright colours and minute finish distinguish them from the works of the older painters, and in 1860 the *Art Journal* classed them with the Pre-Raphaelite school.[19] The tiny stipple of Foster's *Milk-maid* of 1860 (Pl. 202) is comparable to that in Alfred Hunt's watercolours and is a slightly later example of the plethora of labour about which Ruskin had complained in 1859.[20] Another heir of Pre-Raphaelitism was the Scottish painter William McTaggart. At the end of the 1850s his pictures showed the influence of Pre-Raphaelitism both in colour and detail. As McTaggart grew older he abandoned careful detail, but he retained an interest in outdoor light and colour. Ultimately, he created an insular equivalent of Impressionism, which no longer looked even remotely Pre-Raphaelite. However, McTaggart was a solitary figure working in a provincial centre. When Impressionism came to England, it came late and as an import from France.

When English artists began to realise that painting highly finished pictures directly from nature was an impractical way of working, they did not stop painting highly finished pictures, but stopped painting directly from nature. In the 1860s and 1870s the most talented younger landscape painters turned away from the naturalism of Pre-Raphaelitism to return to a more pictorially disciplined and subjective art. The chief impulse in this redirection came from abroad, and the most important single figure was an Italian painter who paid only a few brief visits to the British Isles: Giovanni Costa. Costa, in turn, owed a considerable debt to French painting, particularly that of Corot.

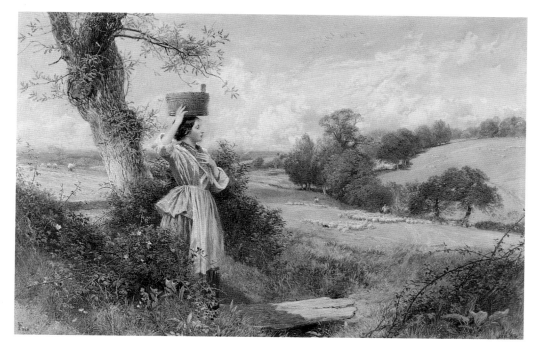

202 Myles Birket Foster, *The Milk-maid*
1860. Watercolour, 11³/₄ × 17¹/₂. Victoria and
Albert Museum, London.

In the 1850s Costa became friendly with two English artists living in Rome, George Heming Mason and Frederic Leighton, and it was through them that he first had an impact in England. He subsequently attracted numerous other English disciples, including William Blake Richmond and the amateur George Howard, who in 1889 became the ninth Earl of Carlisle. These followers formed a little group calling itself the 'Etruscan School'; their bible consisted of Costa's maxims, which Howard recorded:

> The whole of the Etruscan School consists in this – to draw your subject by drawing the spaces of the background.
>
> The Etruscan School consists in seeing the direction of the lines and in drawing them with strength.
> . . .
> A picture should not be painted from nature. The study which contains the sentiment, the divine inspiration, should be done from nature. And from this study the picture should be painted at home, and, if necessary, supplementary studies be made elsewhere. . . .
> Sentiment before everything.[21]

Point by point, this teaching is the antithesis of the Pre-Raphaelite belief in painting pictures directly from nature in scrupulously objective detail.

During the 1850s, Leighton, while he was in Italy, made a large number of pencil drawings of plant forms. These minutely careful drawings were at least partly inspired by *Modern Painters*. In the spring of 1852 he wrote to his mother that he was looking forward to making studies outside Rome during the coming summer: 'I long to find myself again face to face with Nature, to follow it, to watch it, and to copy it, closely, faithfully, ingenuously – as Ruskin suggests, "choosing nothing, and rejecting nothing".'[22] But for Leighton in 1852, Ruskin did not necessarily lead to Pre-Raphaelitism, and the drawings he made owed nothing to the English Pre-Raphaelite painters. Leighton's education took place on the continent, not in England. From 1850 to 1852 he studied in Frankfurt under Edward von Steinle, a follower of the German Nazarenes, and the models for his drawings were Nazarene drawings such as the studies of leaves made by Friedrich Olivier and Julius Schnorr von Carolsfeld.[23] In 1859, after Leighton had come into contact with the English painters (he was a member of the Hogarth Club), he made a large and careful drawing of a lemon tree purposely to outdo the Pre-Raphaelites (Pl. 203).[24] But the contest was a false one. The Pre-Raphaelites painted nature; they rarely drew it, and except in a few works by followers such as Sandys there are no comparable Pre-Raphaelite drawings at all. After the 1850s Leighton stopped making such drawings, but he did paint remarkably beautiful oil sketches on his various travels. These reveal his debts not only to Costa, but also to Corot and a continental tradition of sketching in oil from nature.[25]

George Heming Mason was born in 1818 and lived in Italy from 1843 until 1858. In 1857 he sent a picture of *Ploughing in the Campagna* to the Royal Academy from

203 Frederic
Leighton, *The
Lemon Tree* 1859.
Pencil, 21 × 15¹/₂.
Private Collection.

204 George Heming Mason, *The Gander*
exhibited 1865. Oil on canvas, 18 × 32. Lady
Lever Art Gallery, Port Sunlight.

Rome (Walker Art Gallery, Liverpool). After his return to England he exhibited regularly until his death in 1872, and although he was older than most of the Pre-Raphaelite group, he had probably the greatest single influence on landscape in the period when the Pre-Raphaelite influence was beginning to wane. *The Gander*, which he exhibited at the Royal Academy in 1865 (Pl. 204), is typical of the pictures he painted in England.

They are generally not pure landscapes, but rustic idylls, and they exemplify Giovanni Costa's principles put into effect. They are studio compositions, based on careful spacing and strong linear axes, and they have 'Sentiment before everything'. Most of them show twilight. Mason's pictures also recall contemporary French paintings of rural subjects by Jean-François Millet and Jules Breton, of which he must have been well aware.[26] Mason visited Paris in 1855 and again in 1863 in the company of Costa. In the following year, when Frederick Walker, an artist whose name is often associated with Mason's, visited Paris, Jules Breton was the only living artist whose work attracted him.[27]

Mason at the time of his death was one of a small group of artists painting similar rustic subjects. Of the others – Frederick Walker, George Pinwell, and John William North – Walker is the most interesting in relation to Pre-Raphaelitism. He was a student at the Royal Academy schools in the late 1850s and learned to paint by working directly from nature. In the 1860s he continued to paint out of doors on large pictures even in January and February. He worked on *The Plough* (Pl. 205) in the winter of 1869–70 wearing thick gloves, and on windy days he laid the canvas flat on the ground with stones and lumps of wood on its corners to keep it steady. After painting in detail directly from nature, Walker erased much of what he had done. According to his close friend North, 'His knowledge of nature was sufficient to disgust him with the ordinary conventions which do duty for grass, leaves, and boughs', but, on the other hand,

> Certainly he was not content with his work unless it had suggestiveness, finish, and an appearance of ease; and to the latter I sorrowfully feel that he gave rather too much weight, destroying many a lovely piece of earnest, sweetest work, because it did not appear to have been done without labour. Probably this excessive sensitiveness (to what is after all of minor importance) may have been due to a reaction from the somewhat unnatural clearness of definition in the early pictures of the Pre-Raphaelite Brotherhood.[28]

To an already uneasy mix of naturalism and suggestiveness, Walker added sentiment and grace, inspired partly by Jules Breton, partly by Mason, and partly by the Parthenon frieze (of which Walker had casts in his studio). Despite Walker's arduous work out of

205 Frederick Walker, *The Plough* 1869–70. Oil on canvas, 56½ × 83¾. Tate Gallery, London.

doors, *The Plough* appears very obviously composed in the setting as well as in the figures, the product of a highly conscious attempt to create a two-dimensional frieze-like composition in which the lines of the landscape flow across the canvas, repeating the lines of the ploughman and team.

Walker died in 1875, three years after Mason. Their deaths, along with that of Pinwell, also in 1875, snuffed out what some later nineteenth-century critics considered the most promising development in English painting since Pre-Raphaelitism. However, in Walker's case in particular, although the ambitions were high, they were full of unresolved contradictions, which remained only too evident in the finished pictures. Following Walker's death, Ruskin was asked to express an opinion about his art. Ruskin was not very enthusiastic, and among the things he found to criticise was Walker's refusal to learn anything from the artists who had gone before him, with the result that his art remained 'perpetual experiment instead of achievement'.[29]

If Ruskin had wished, he could have made the same criticism of much earlier nineteenth-century painting, including that of the Pre-Raphaelites. He had, indeed, criticised Constable in similar terms.[30] Most of the best art of the nineteenth century was based upon perpetual experiment, but in England by the 1860s and 1870s the most adventurous experiments were no longer in quest of greater naturalism. Mason's and Walker's painting, like Whistler's and Burne-Jones's, was part of a larger development in English painting which has been termed Aestheticism. In 1877, the year after his comments about Walker, Ruskin praised Burne-Jones's pictures in the opening exhibition of the Grosvenor Gallery as 'the best things the mid-nineteenth century in England could do', but to other pictures of 'the modern schools' in the same exhibition Ruskin was not so generous: 'their eccentricities are almost always in some degree forced; and their imperfections gratuitously, if not impertinently, indulged'. And in the following sentences, the former champion of Turner, and of the Pre-Raphaelites, proceeded to attack 'the ill-educated conceit' of James McNeill Whistler.[31]

Whistler had been a close friend of Dante Gabriel Rossetti during the 1860s, and he had earlier admired Millais. The importance of Millais and Rossetti for several of Whistler's major early pictures, such as *The White Girl* (1863; National Gallery, Washington) and *The Little White Girl* (1864; Tate Gallery), is indisputable. We have also seen affinities between Whistler's Nocturnes and earlier depictions of nocturnal subjects by Holman Hunt, Inchbold, and Boyce.[32] During the later 1860s he struggled to escape from the legacy of the influence of Gustave Courbet, which he had brought from France to England. The severely disciplined and quasi-abstract Nocturnes which he started to paint around 1870, and which were the objects of Ruskin's famous attack, were the most original fruits of that struggle. He responded to Ruskin by bringing suit for libel, and the ensuing trial served to demonstrate that the *avant-garde* attitudes of the early 1850s had become old-fashioned a quarter of a century later. Whistler's 'Ten O'Clock Lecture' of 1885 was a more considered assault on the aesthetics of Ruskin, and its quotable assertions about the differences between art and nature, such as 'To say to the painter, that Nature is to be taken as she is, is to say to the player, that he may sit on the piano', provided ammunition for countless subsequent attacks on Ruskinian standards of naturalism. But later critics who parroted Whistler were flogging a dying horse. By 1885 new influences were beginning to flow across the Channel, which would soon bury the lingering traces of Pre-Raphaelite naturalism under a succession of imitations of Jules Bastien-Lepage, Impressionism, and Post-Impressionism.

The quarrel between Whistler and Ruskin was a quarrel between generations, but it has often been made to sound like a conflict between Victorian insularity and progressive French painting. In fact, Pre-Raphaelitism was an insular movement. Behind the formation of the Brotherhood in 1848 there was some awareness of the German Nazarenes, but as the movement developed in the 1850s and in later years, it turned its back on contemporary art on the continent. Nevertheless, if the English artists were uninfluenced by French painting, they were not unexposed to it. Ford Madox Brown lived in France during the early 1840s and among his close friends were Charles Lucy and Henry Mark Anthony. Lucy, who was a historical painter seven years older than Brown, had studied in Paris at the Ecole des Beaux Arts. In 1857 or 1858 he returned to France, and he lived at Barbizon for the rest of his life. In England he was at different times the landlord of both Brown and John Brett, and he was the first instructor of Thomas Seddon.

Anthony lived in France from around 1834 to 1841. He spent some time at Barbizon and was a friend of Corot and Jules Dupré. In F. G. Stephens's words, 'technically speaking, he was the only one of our landscape painters who could fairly be compared with

Jules Dupré, whose art his resembled in many respects.'[33] That resemblance is evident in paintings of forest scenery such as *Thinking of the Future: an Irish Sketch*, which Anthony exhibited at the Royal Academy in 1845 (Pl. 206), but all of Anthony's landscapes from the 1840s and early 1850s are looser in handling and heavier in colour than Pre-Raphaelite pictures. Nonetheless, Anthony was constantly lauded in William Michael Rossetti's exhibition reviews as the most outstanding landscape painter in England. He won the prize of the Liverpool Academy in 1854, and his pictures were bought by the Pre-Raphaelite collectors J. Hamilton Trist, James Leathart, and George Rae. Ford Madox Brown's diary is full of praise for Anthony – 'like Constable, only better by far' – and we have seen some similarities between Brown's landscapes of 1848 and 1849 and Anthony's pictures.[34] William Davis was also probably influenced by Anthony. In turn, in the 1850s Anthony began to be affected by Pre-Raphaelitism, but the result was a rather unsatisfactory compromise. In 1855 Brown wrote in his diary that Anthony's pictures were all unfinished and could only be finished if Anthony took them back to the places where he had painted them.[35] This entry suggests that Anthony did try to paint directly out of doors. However, his pictures were too large to have been painted comfortably in the open air or with the consistent care of Pre-Raphaelitism. He seems to have attempted to give his pictures a feeling of detailed observation without sacrificing breadth, but he did so at the expense of solidity, and most of his later pictures seem theatrically insubstantial.

Of the immediate Pre-Raphaelite circle, Thomas Seddon painted at Barbizon. Boyce also painted in France, and he owned pictures by Diaz, Daubigny, and Corot. Yet if either artist was ever influenced by the Barbizon painters, he soon changed; none of the known works by either Seddon or Boyce betrays much interest in French painting. Pre-Raphaelite opinions about the Barbizon painters were mixed. Ruskin was always scornful of French landscape painting,[36] but it is never clear exactly what artists he was talking about. Holman Hunt's dislike of French art expressed in *Pre-Raphaelitism and the Pre-Raphaelite Brotherhood* seems to have been almost pathological, but a letter which he wrote to F. G. Stephens in 1876 gives a reasonably lucid explanation for his dislike of Daubigny: 'I am perfectly unable to see his merit: square flat touches, all equally chopping, whether to represent cloud, distance, vegetation or cattle soon lose their interest.'[37] On the other hand, William Michael Rossetti writing in 1855 was sympathetic to French landscape painting: 'the school is, on the whole, a noble one; which Englishmen, addicted to an opposite principle are far too chary of admitting'.[38] And Dante Gabriel Rossetti, in 1851, was well enough disposed to Théodore Rousseau's painting to suggest that it resembled John Linnell's.[39]

In 1849 Holman Hunt and Rossetti visited Paris, where they saw 'certain paintings of the new Realistic School', which Hunt described as 'coarse and ugly'. This probably referred to Courbet, as did Hunt's ensuing comment, 'naturalism was, in fact, a repudiation, rather than a purgation of art'.[40] However, when William Michael Rossetti visited the *Exposition Universelle* of 1855 in Paris, he wrote that Courbet held in France 'as the apostle of "Realism" a position somewhat analogous to that of the Pre-Raphaelites in

England'. William Michael declared that Courbet 'commands wonder and merits honour', and he praised one painting as 'a glorious snatch of landscape, as real as stone and grass, of which Anthony might be proud'.[41] Nonetheless, William Michael was aware of enough differences between Courbet and the Pre-Raphaelites to make any analogy between them false. One difference was in method: 'the Frenchman is the roughest of the rough, the Englishmen the most exquisite of the elaborated'. While French and English artists were both concerned with naturalism, the English alone sought 'the realisation of the effect through its minutest details'.[42] There was more of a gap between French and English naturalism, however, than could be explained by technique alone. William Michael thought Courbet had only a 'half-grasp' of realism. He was capable, but not thoughtful: 'He sees as far into a millstone as another man – and no further; and is honest enough to paint with a rough and ready freedom, exactly what he sees'. This was not enough. The artist's purpose should be to translate the sentiment of things as well as their appearance. The Pre-Raphaelites had vitality because they had love and reverence, rather than just the 'hail-fellow-well-met' attitude towards nature of Courbet. Hence, after surveying the art of the world, William Michael concluded his review: 'To English Praeraphaelitism – after admiring foreign excellence with no stinted or un-catholic homage – we return in the deliberate conviction that it embodies the highest, truest, and most vitally essential, among the fresh and direct movements of the aera.'[43]

The Pre-Raphaelites did not paint like Courbet, or like the Barbizon artists, not because they were unaware of French art, but because they were convinced that their own path was superior. They may have failed to grasp what was significant about Courbet, and why Courbet's art provided a more substantial basis for future developments than their own, but they were so convinced of their own revolutionary significance that it is understandable that they would not be entirely receptive to the claims of Courbet. To a sympathetically inclined viewer the English paintings could well have looked the most progressive of any works included in the exhibition of 1855. Delacroix's response to the Pre-Raphaelite pictures, and particularly to Holman Hunt's *Strayed Sheep*, has been mentioned.[44] While the landscapes of the Barbizon painters and of Courbet were painted in the studio, *Strayed Sheep* was painted out of doors. Its colours do not have the old-masterly depth of contemporary French painting, but are light and bright, and the shadows are of blues and purples. Its composition is fresher and freer than the usual compositions of mid-century French pictures, and it presents a less traditional view of nature. The Barbizon painters and Courbet were still painting the forest primeval, dark grottoes, and a countryside inhabited by weathered trees and timeless peasants; but Hunt's picture is remarkably free of such imagery. And his colleague Ford Madox Brown had progressed even further in the direction of the modern world by painting landscapes showing the view from his own middle-class suburban window.

In important ways, Pre-Raphaelite landscape paintings have more in common with Impressionism than with French Realism of the 1850s, although they do not seem to have had any actual influence upon the Impressionists. There is no evidence that French artists were aware of the outdoor painting done in England in the 1850s, and there are, of course, as many conspicuous differences as similarities between the English paintings of the 1850s and the later French ones. Henry James wrote a review of the second Impressionist group exhibition in 1876, in which he tried to explain the artists' goals:

> The painter's proper field [they say] is simply the actual, and to give a vivid impression of how a thing happens to look, at a particular moment, is the essence of his mission. This attitude has something in common with that of the English Pre-Raphaelites, twenty years ago, but this little band [of Impressionists] is on all grounds less interesting than the group out of which Millais and Holman Hunt rose into fame.

James declared that none of the Impressionists showed signs of possessing talent, and that, indeed, the Impressionist doctrine seemed incompatible with the existence of talent. He then proceeded to a discussion of the differences between the Impressionists and Pre-Raphaelites:

> But the divergence in method between the English Pre-Raphaelites and this little group is especially striking, and very characteristic of the moral differences of the French and English races. When the English realists 'went in', as the phrase is, for hard truth and stern fact, an irresistible instinct of righteousness caused them to try and purchase forgiveness for their infidelity to the old more or less moral proprieties and conventionalities, by an exquisite, patient, virtuous manipulation – by being above all

things laborious. But the Impressionists, who, I think, are more consistent, abjure virtue altogether, and declare that a subject which has been crudely chosen shall be loosely treated . . . the Englishmen, in a word, were pedants, and the Frenchmen are cynics.[45]

This is as good an explanation as any of the most fundamental difference between Pre-Raphaelitism and Impressionism. It is not the fact that the English paintings are detailed, but it is the moral attitude behind the details, the attempt to make a picture significant in a manner about which the Impressionists no longer cared. There is a compromise, in the theory and in the pictures themselves, between what seems precociously modern and what James called 'an instinct of righteousness'. Ford Madox Brown's diary entries and explanations of his pictures reveal an artist not too weighed down by that instinct, and his landscapes have a wonderfully uncomplicated freshness of vision. Holman Hunt was in some ways a more adventurous artist than Brown, but also a more complex one, whose pictures rarely seem uncomplicated. His memoirs repeatedly assert that the Pre-Raphaelites were not 'realists'.

I think art would have ceased to have the slightest interest for any of us had the object been only to make a representation, elaborate or unelaborate, of a fact in nature. Independently of the conviction that such a system would put out of operation the faculty making man 'like a God', it was apparent that a mere imitator gradually comes to see nature claylike and finite, as it seems when illness brings a cloud before the eyes. Art dominated by this spirit makes us esteem the world as without design or finish, unbalanced, unfitting, and unlovely, not interpreted into beauty as true art makes it.[46]

For Brown, 'pictures must be judged first as pictures', and he was suspicious of any artist 'whose mind was always on the stretch for a moral'.[47] For Hunt, 'One scarcely expressed purpose in our reform, left unsaid by reason of its fundamental necessity, was to make art a hand maid in the cause of justice and truth.'[48] If any artist's mind was always on the stretch for a moral, it was Hunt's. Yet he spent months on end painting directly from nature with the most scrupulous care. Unlike Brown, he seems to have felt no conflict between 'love of the mere look of things' and a quest for philosophical or moral or spiritual content. And he was not alone. In 1862 William Michael Rossetti wrote an explanation of Pre-Raphaelitism in which the movement's essence was reconciliation of seeming opposites:

Praeraphaelitism has arisen to assert that there is no necessary antagonism between the most pictorial conception of a thing and the thing itself; that it is open to the painter, however imaginative, to follow nature in all respects, not only in some, in detail and in all details, not only in generals and in hints for after adaptation; that entire freedom of invention, and every possible latitude of artistic aim and point of view, are compatible with, and may in the main be even aided by, entire adherence to visible matter of fact. This is the gist of Praeraphaelitism, and not the crude notion, so often attributed to it, that mere matter of fact, subserving no artistic purpose, is the be-all and end-all of art.[49]

Some of the most appealing Pre-Raphaelite landscapes are ones in which 'mere matter of fact' appears to have been the be-all and end-all, but for most members of the Pre-Raphaelite circle interest in the look of things was not enough, and they tempered naturalism with other values.

The most central of these other values was Henry James's 'irresistible instinct of righteousness'. James cited the fact that the Pre-Raphaelites were laborious. To painting they brought the Victorian exaltation of hard work. The art demands and receives credit for the sheer labour that went into making it. Along with work came other Victorian virtues: thoroughness, precision, honesty, even chastity. As F. G. Stephens wrote in *The Germ*, the 'simple chastity of nature' was to provide the artist's sole model: 'Let the artist be content to study nature alone, and not dream of elevating any of her works which are alone worthy of representation'.[50]

From the outset, the Pre-Raphaelites were critical of the frivolity of the preceding generation. Art, even in the most humble studies, had to have high moral purpose:

Believe that there is that in the fact of truth, though it be only in the character of a leaf earnestly studied, which may do its share in the great labour of the world: remember that it is by truth alone that the Arts can ever hold the position for which they were intended, as the most powerful instruments, the most gentle guides.[51]

Occasionally, particularly in pictures by Holman Hunt, the high moral purpose of art becomes only too obvious. But relatively few Pre-Raphaelite pictures are such out-and-out sermons as *The Awakening Conscience* or *The Light of the World*. More often in Pre-Raphaelite landscape painting, the high purpose was to convey knowledge about places and about nature. This is, for example, what Ruskin saw as the chief value of Brett's *Val d'Aosta*, and Ruskin's criticism in general was directed to making landscape painting more scientifically informative. As we have seen, Philip Gilbert Hamerton thought that Ruskin had succeeded too well in making art the hand-maiden of science. But science also became the hand-maiden of art. There was a flurry of publications in the 1850s which discussed the application of scientific knowledge to art,[52] and Stephens urged that the artist follow the scientist's example:

> The sciences have become almost exact within the present century. Geology and chemistry are almost reinstituted. The first has been nearly created; the second expanded so widely that it now searches and measures the creation. And how has this been done but by bringing greater knowledge to bear upon a wider range of experiment; by being precise in the search after truth? If this adherence to fact, to experiment and not theory . . . has added so much to the knowledge of man in science; why may it not greatly assist the moral purposes of the arts?[53]

Ford Madox Brown as a slightly older figure remained somewhat detached from this high-minded seriousness. His art does not generally claim to be useful, and it has little of the scientific pretension demanded by Ruskin. However, in Brown's pictures we still feel the urge to exact observation, and in his catalogue of 1865 he gave semi-scientific explanations of certain effects. Like his colleagues, he was studious, industrious, and self-effacing. The artists' values were those of the scientist and the scholar. Henry James was right to call them pedants.

The subjects of Pre-Raphaelite landscape painting remained more or less within the traditional gamut. The two main classes were still topographical views of places of interest, and rustic landscapes, and for most of the variations of these basic categories there was some precedent in earlier English landscape painting. The one new development was the increased importance given by an artist like Brown to his own immediate surroundings, to showing nature as it was experienced by the modern city-dweller. The fact that Brown's views lay outside a suburban back window was not of incidental but of primary significance in his conception; he was not painting nature as much as his own environment. The artist's immediate experience became part of the subject of the picture. Brown and Dyce showed themselves or their families on their holidays, without additional comment. In other Pre-Raphaelite works, if the subject of the picture was not brought into the personal sphere of the artist, we feel the personal experience of the artist projected into the picture as a result of the painter's almost morbidly high degree of involvement. We cannot look at *The Scapegoat*, for example, without thinking of Hunt's heroic labours of painting on the shores of the Dead Sea. The Pre-Raphaelites tried to replace personal expression and invention by scientific accuracy, but the amount of labour given by Hunt or Brett to their pictures makes us as aware of the artists who painted them as if the pictures had been by Cézanne. We admire Brett less for the accuracy of his observation than for the virtuosity of his painting and for the sheer effort made manifest in his pictures.

That there can be no such thing as an absolutely literal view of nature, 'wholly unmodified by the artist's execution',[54] is for us a truism that was not so evident to the Victorians. It is impossible for us not to feel the presence of Brett or Hunt in their pictures; not only, paradoxically, are we the more aware of them because of their very efforts at being self-effacing, but now, in the perspective of time, we can also see how their vision of nature was tempered by the tastes of their day. Their bright colours and crowded compositions are fundamentally Victorian, sharing these qualities with Victorian architecture and the Victorian interiors in which the pictures hung. Although the Pre-Raphaelites may have wanted to be absolutely literal recorders of nature, to most modern viewers their pictures, compared to ones by Constable, or Corot, or Monet, look relatively unnatural and artificial. This is, in part, due to our greater familiarity with Constable and the French artists; we are used to thinking of their art as defining the standards of naturalistic representation, and any divergence appears correspondingly unnatural to us. But even if we were capable of looking at pictures without preconceptions, Pre-Raphaelite paintings would still not look like pictures by Constable. Our artists were keen and industrious observers and recorders, and in their pictures there is an amount of naturalistic observation which we should not discount. Yet in looking at Ford Madox

Brown's landscapes, we have seen that, despite his attempts to record exactly what he saw, his pictures are characterised by bold surface patterns of closely knit details and bright colours. In this one respect, Brown's pictures are similar to those of Rossetti, who shared none of Brown's naturalistic orientation but intended his works to be fanciful and decorative; and almost all Pre-Raphaelite pictures show some tendency to turn into richly articulated two-dimensional patterns which stay on the surface of the canvas. In this respect, they seem to anticipate not the naturalism of the Impressionists but the stylisation of Gauguin and Post-Impressionist art.

The reasons for this relatively abstract aspect of Pre-Raphaelite painting have been discussed: essentially it resulted from the abandonment of most of the traditional space-creating devices of landscape painting, and, particularly, from the insistence upon bright local colours at the expense of tonal modulation. The Pre-Raphaelites were against 'brown foliage, smoky clouds and dark corners' because they considered them artificial. They felt that in avoiding such conventions they were not on the road to abstraction but to realising in paint the exact look of nature. That their pictures should become flat in effect because of the bright colours, and visually confusing because of the weight of detail was not what they intended; it does, however, provide a demonstration of the limits of naturalism in painting. In the seminal consideration of representation, *Art and Illusion*, Ernst Gombrich discussed at length the conflict between traditional schemata of painting and direct observation of nature. He contended that there is no natural vision, no 'innocent eye', but that we learn to see, and that the naturalistic advances of a painter like Constable were made by the progressive modification of inherited schemata. Progress could only be made in the context of respect for tradition. The Pre-Raphaelites, however, had little respect for tradition, and they did believe in the innocent eye.[55] Thus, while they seem by their direct confrontation with nature more radically naturalistic than a Constable, they did not succeed in making their pictures look more natural. They sacrificed too much of what makes a picture work. Constable and the Impressionists approached nature with greater respect for pictorial values than the Pre-Raphaelites, and they succeeded where the Victorian artists failed. In some respects, the Pre-Raphaelites seem conservative, held back by their 'instinct of righteousness', but, stylistically, they were, if anything, too revolutionary. Lingering resistance to Pre-Raphaelitism is not due to the timidity of the revolution, but rather to its extremity, to the movement's too complete abandonment of its artistic heritage. While the French could, and did, build on Constable, the Pre-Raphaelites turned their backs and went their own precarious ways. As Gombrich wrote, illusionist art grew out of a long tradition, and 'it collapsed as soon as this tradition was questioned by those who relied on the innocent eye'.[56] In Pre-Raphaelite landscapes, painted in as immediate a confrontation with nature as was perhaps possible to an educated artist, we see the beginning of the collapse.

The Pre-Raphaelites did not lay 'the foundations of a school of art nobler than the world has seen for three hundred years', as Ruskin had promised in 1851, but they did form a movement which for a few years had immense vitality, and they did paint a number of remarkably ambitious and beautiful pictures. If they failed by the measure of what they set out to do, they are yet failures who have a considerable historical significance. They anticipated the collapse of the illusionist tradition, which prepared the ground for twentieth-century modernism, and, in attempting to rely on their own resources without the aid of sustaining tradition, they seem extremely modern. Turning their backs on the past, Holman Hunt and Ford Madox Brown and their fellow artists chose, almost literally, to re-invent the art of painting in each picture, and, in the pictures we see them feeling their way. Whether they succeeded in finding it or not may perhaps still remain an unresolved critical question, but what is important is the fact that they looked.

CHAPTER ONE

1. William Holman Hunt, *Pre-Raphaelitism and the Pre-Raphaelite Brotherhood*, 2 vols, 1905, I, pp. 131, 140–1, 149–50, 174–6.

2. Ibid., p. 142.

3. *The Works of Dante Gabriel Rossetti*, William Michael Rossetti, ed., 1911, p. 571 ('Exhibition of Modern British Art at the Old Water-Colour Gallery, 1850').

4. William Michael Rossetti, *Fine Art, Chiefly Contemporary: Notices Re-printed, with Revisions*, 1867, p. 189 ('The Exhibition of Mr. Brown's Collected Works', 1865).

5. *Art Journal*, 1849, p. 147.

6. Ibid., p. 171.

7. The relevant volumes of *Modern Painters* are volumes III and IV of *The Works of John Ruskin*, E. T. Cook and Alexander Wedderburn, eds, 39 vols, 1903–12. See also John Steegman, *Consort of Taste: 1830–1870*, 1950, pp. 49–74, and J. R. Hale, *England and the Italian Renaissance*, 1954, pp. 108–26 and 149–68.

8. Lord Lindsay, *Sketches of the History of Christian Art*, 2nd edition, 1885, II, p. 390.

9. T. S. R. Boase, 'The Decoration of the New Palace of Westminster, 1841–1863', *Journal of the Warburg and Courtauld Institutes*, XVII, 1954, pp. 319–24; Keith Andrews, *The Nazarenes: A Brotherhood of German Painters in Rome*, 1964, pp. 84–5; and William Vaughan, *German Romanticism and English Art*, 1979, pp. 177–225.

10. Andrews, *Nazarenes*, pp. 81–2; Vaughan, *German Romanticism*, *passim*; and Marcia Pointon, *William Dyce 1806–1864: A Critical Biography*, 1979, pp. 9–15.

11. Pointon, *Dyce*, pl. 93.

12. *Art Union*, 1839, p. 170. The *Art Union* and the *Art Journal* were the same periodical; the name was changed in 1839.

13. See Ford Madox Hueffer, *Ford Madox Brown: A Record of His Life and Work*, 1896, pp. 44–5; and Kenneth Bendiner, *The Art of Ford Madox Brown*, 1998, pp. 15–16.

14. Hueffer, *Brown*, p. 41 (letter to George Rae, 3 January 1865).

15. Ford Madox Brown, *The Exhibition of Work, and other Paintings*, 1865, p. 16 (quoted in Bendiner, *Brown*, p. 143).

16. Brown, *Exhibition of Work*, p. 4 (Bendiner, *Brown*, p. 133).

17. For a somewhat unsympathetic discussion of these influences, see Hunt, I, pp. 121–6.

18. Hueffer, *Brown*, pp. 50–1.

19. Hunt (I, p. 174) called the composition 'Overbeckian'.

20. Hueffer, *Brown*, pp. 62–6.

21. Hunt, I, p. 125.

22. Brown, *Exhibition of Work*, p. 4 (Bendiner, *Brown*, p. 133).

23. Ibid. (Bendiner, *Brown*, p. 132).

24. Hunt, I, pp. 225–6.

25. Brown, *Exhibition of Work*, p. 16 (Bendiner, *Brown*, p. 143).

26. The notes are transcribed in James Stirling Dyce, 'The Life, Correspondence, and Writings of William Dyce, R. A., 1806–64: Painter, Musician, and Scholar', typescript, Aberdeen Art Gallery. See also Allen Staley, 'William Dyce and Outdoor Naturalism', *Burlington Magazine*, CV, 1963, pp. 470–6.

27. Hunt, I, pp. 206–7, 228–9, and 261.

28. *Works*, XXXVII, pp. 427–8 (letter to Ernest Chesneau, 28 December 1882).

29. Ibid., XII, p. xlv; and John Guille Millais, *The Life and Letters of John Everett Millais*, 2 vols, 1899, I, p. 61.

30. Hunt, I, p. 73.

31. *Works*, III, pp. 635–40.

32. Ibid., XII, p. 339, and III, pp. 623–4.

33. Ibid., III, pp. 149–54.

34. Ibid., p. 163.

35. Ibid., pp. 623–4.

36. Ibid., p. 622.

37. Ibid., IV, pp. 137–8.

38. Ibid., pp. 321–3.

39. Hunt, I, pp. 81–91.

40. Ibid., p. 114.

41. *Art Journal*, 1849, p. 171.

42. Hunt, I, pp. 111–12.

43. Ibid., p. 183 n. 2.

44. Ibid., p. 112.

45. The *Athenaeum* review is quoted ibid., p. 178 n. 1.

46. Hunt, I, p. 173.

47. Ibid., p. 175.

48. Ibid., p. 246.

49. Ibid., pp. 275–7.

50. See the comments of Ford Madox Brown recorded in Hueffer, *Brown*, p. 77; of Dante Gabriel Rossetti in D. G. Rossetti, *Works*, p. 586; and *Art Journal*, 1851, p. 176.

51. Hunt, I, p. 277.

52. [Frederick George Stephens], *William Holman Hunt and His Works: A Memoir of the Artist's Life, with Descriptions of His Pictures*, 1860, pp. 8–9. The pamphlet accompanied the exhibition of Hunt's *Finding of the Saviour in the Temple* (Birmingham Museum and Art Gallery) in April 1860.

53. Ibid., pp. 17–18.

54. *Art Journal*, 1850, p. 176.

55. Ibid., p. 175.

56. Unfortunately we can not be certain if Millais was able to see the Uccello in Oxford in the summer of 1850. According to information kindly provided by Ian Lowe, it was part of a gift from William Fox-Strangways, most of which came to Oxford in March 1850, but some works did not arrive until the following October.

57. *Art Journal*, 1851, pp. 160–1.

58. Hueffer, *Brown*, p. 73.

59. Collins evidently began the picture as an illustration of a poem by Shelley, 'The Sensitive Plant', but changed the subject as his religious convictions changed. See Hunt, I, p. 294. For a thoroughgoing discussion of the painting, see the entry by Malcolm Warner in Tate 1984, pp. 87–8, no. 33. See also Peter Fuller, *Theoria: Art, and the Absence of Grace*, 1988, a book structured around *Convent Thoughts* and Ruskin's praise of the picture in 1851 (quoted below on p. 19), although, as the title implies, it is about much more.

CHAPTER TWO

1. *The Times*, 7 May 1851, p. 8.

2. See Ruskin, *Works*, XII, pp. 319–23 (letter published 13 May), pp. 324–7 (letter published 30 May), and pp. 339–93 (*Pre-Raphaelitism*).

3. John Lewis Bradley, *Ruskin's Letters from Venice 1851–1852*, 1955, p. 262 (letter to his father, 26 April 1852).

4. The watercolour shown by Lewis in 1850, *The Hhareem*, his first Eastern subject to be seen in London and his first exhibited work after a hiatus of many years, caused a sensation and established his reputation as the pre-eminent painter of Eastern subjects. It has disappeared, but a version is in the Victoria and Albert Museum.

5. *Works*, XII, p. 349.

6. Ibid., pp. 353–5.

7. The pamphlet was dedicated to Francis Hawkesworth Fawkes. The other artists discussed were William Henry Hunt, Samuel Prout, John Frederick Lewis, William Mulready, and Edwin Landseer.

8. *Works*, XII, p. li (letter to his father, 21 September 1851).

9. Ibid., p. 361. The comparison of Millais and Turner is discussed below, p. 60.

10. Ibid., p. 385.

11. Ibid., pp. 388–9; and see below, p. 198.

12. Ibid., pp. 357–8.

13. Ibid., III, pp. 599 and 621; XI, pp. 59–60; and see below, p. 55.

14. [William Michael Rossetti], *The P.R.B. Journal: William Michael Rossetti's Diary of the Pre-Raphaelite Brotherhood 1849–1853, Together with other Pre-Raphaelite Documents*, William E. Fredeman, ed., 1975, p. 83 (30 November 1850).

15. Ibid., pp. 92–3 (8–10 May 1851).

16. *Works*, XII, p. 339.

17. *Spectator*, 4 October 1851, p. 956.

18. Hunt, I, p. 257.

19. Millais, I, pp. 116–19.

20. Hunt, II, p. 399.

21. *The Art of William Holman Hunt, O.M., D.C.L.*, Walker Art Gallery, Liverpool, 1907, p. 24, no. 35. See also John Duncan Macmillan, 'Holman Hunt's *Hireling Shepherd*: Some Reflections on a Victorian Pastoral', *Art Bulletin*, LIV, 1972, pp. 187–97; Judith Bronkhurst in Tate 1984, pp. 94–6, no. 39; and Kay Dian Kriz, 'An English Arcadia Reassessed: Holman Hunt's *The Hireling Shepherd* and the Rural Tradition', *Art History*, X, 1987, pp. 475–91.

22. Millais, I, p. 122 (letters from Millais to Mrs Combe, July 1851).

23. Rylands Eng. MS. 1216, f.31.

24. *Fine Art, Chiefly Contemporary*, p. 235.

25. *British Quarterly Review*, XVI, 1852, pp. 215–16.

26. *Athenaeum*, 22 May 1852, p. 581.

27. Stephens, *Hunt*, pp. 19–21.

28. Peter Murray, *Dulwich Picture Gallery: A Handlist*, 1980, no. 185. In the nineteenth century the picture was believed to be by Murillo.

29. Hunt's copy and the version of Dyce's picture which he copied have seemingly disappeared. An engraving of the latter is in *Art Journal*, 1860, p. 296. For other versions of the Dyce see Pointon, *Dyce*, pls 76 and 79.

30. It has been pointed out to me by Kenneth Bendiner that the beer keg and indeed the shepherd's kneeling position also show similarities to analogous details in a *Holy Family* by Titian in the National Gallery, which had been there since 1831 and, hence, was certainly known to Hunt.

31. Hunt, I, p. 49.

32. For *Isabella* see Mulready's *Dispute between Moses and Thornhill* and *Conviction of Thornhill*; for *The Rescue* see *The Fire* (on pp. 43, 278, and 181 in the publication of 1843).

33. Hunt, I, p. 189.

34. For detailed discussion of the precise dates of work on the four paintings, see the entries by Judith Bronkhurst for Hunt and Malcolm Warner for Millais in Tate 1984, pp. 94–9 and 117–19, nos 39–41 and 57.

35. *Athenaeum*, 22 May 1852, p. 581.

36. *Spectator*, 15 May 1852, p. 472.

37. Stephens, *Hunt*, pp. 19–20. Apart from Leonardo, Stephens's references are to Sir Isaac Newton (1642–1727), Sir Humphry Davy (1778–1829), and Sir David Brewster (1781–1868). Newton's experiments with a prism provided the basis for all subsequent light theory. Brewster's primary field of study was the diffraction of light. He published a *Treatise on Optics* in 1831 and a *Memoir of the Life, Writings and Discoveries of Sir Isaac Newton* in 1855. He also invented the kaleidoscope. Davy, a chemist, gave his name to the Davy Lamp, but he did not play an important role in the study of light and optics, and it is not clear why Stephens cited him along with Newton and Brewster.

38. See above, p. 8.

39. Constable, quoted by Charles Robert Leslie in *Memoirs of the Life of John Constable*, first pub. 1843, ed. Jonathan Mayne, 1951, p. 207.

40. Hunt, I, p. 276.

41. Mary Lutyens, *Millais and the Ruskins*, 1967, p. 99 (letter from Millais to Hunt, 20 October 1853).

42. See particularly Hunt, I, pp. 86–8.

43. *Athenaeum*, 22 May 1852, p. 581.

44. See below, p. 108.

45. *Fine Art, Chiefly Contemporary*, p. 211.

46. *The Diary of Ford Madox Brown*, Virginia Surtees, ed., 1981, p. 74.

47. Ibid., p. 76.

48. Hueffer, *Brown*, p. 77.

49. Brown, *Diary*, p. 76.

50. Hunt, II, p. 96.

51. In 1973, in the first edition of this book I speculated that the distant background might have been based on *Southend*, then still lost. The appearance of *Southend* at Sotheby's in 1986 dashed that theory. Nonetheless, it seems likely that the background was painted in the general area, which we know Brown visited in 1858. Following correspondence with L. Helliwell,

Borough Librarian in Southend, Mary Bennett wrote that the view could well be of Canvey Bay from the high ground a little to the East of Hadleigh Castle ('Ford Madox Brown at Southend in 1846: some lost paintings', *Burlington Magazine*, CXV, 1973, p. 78).

52. *Spectator*, 15 May 1852, p. 472.

53. *Art Journal*, 1852, p. 175.

54. Brown, *Exhibition of Work*, pp. 6–7, no. 11 (Bendiner, *Brown*, p. 135).

55. Leslie, *Constable*, p. 49; Graham Reynolds, *The Early Paintings and Drawings of John Constable*, 2 vols, 1996, I, p. 206; and John Gage in *A Decade of English Naturalism: 1810–1820*, Norwich Castle Museum and the Victoria and Albert Museum, 1969, pp. 30 *et passim*.

56. *A Decade of English Naturalism* pp. 18–22. See also John Lewis Roget, *A History of the 'Old Water-Colour' Society*, 2 vols, 1891, I, pp. 383–8.

57. Ford Madox Hueffer, *Ancient Lights and Certain New Reflections: Being the Memoirs of a Young Man*, 1911, p. 207. See also below, pp. 81 and 250.

58. Hunt, I, pp. 253–4 and 261–2.

59. In a letter to Thomas Combe dated 9 May 1851, Millais called Ruskin 'the famous critic' (Millais, I, p. 101).

60. Admiral Sir William James, ed., *The Order of Release: The Story of John Ruskin, Effie Gray and John Everett Millais Told for the First Time in Their Unpublished Letters*, 1948, p. 176 (letter from John James Ruskin to Millais, 4 May 1852).

61. Bradley, *Ruskin's Letters from Venice*, p. 275 (9 May 1852).

62. James, *Order of Release*, p. 176 (5 August 1852).

63. Ruskin, *Works*, XII, p. 161 (in the Addenda to his Edinburgh lectures given in 1853, but not published until 1854).

64. A. P. Oppé, 'Art', in G. M. Young, ed., *Early Victorian England: 1830–1865*, 2 vols, 1934, II, p. 167.

65. Helen Allingham and D. Radford, eds, *William Allingham: A Diary*, 1907, p. 379.

CHAPTER THREE

1. Brown, *Exhibition of Work*, p. 18, no. 42 (Bendiner, *Brown*, p. 145).

2. See above, p. 5.

3. *Exhibition of Work*, p. 4, no. 1 (Bendiner, *Brown*, p. 132).

4. Hunt, I, pp. 225–6; and Hueffer, *Brown*, p. 77 (letter from Brown to Lowes Dickinson, May 1851).

5. Brown, *Diary*, p. 65 (2 July 1849).

6. See Mary Bennett, 'Ford Madox Brown at Southend in 1846: some lost paintings', *Burlington Magazine*, CXV, 1973, pp. 74–8.

7. *Exhibition of Work*, p. 11, no. 23 (Bendiner, *Brown*, p. 139).

8. Hueffer, *Brown*, p. 434.

9. Brown, *Diary*, pp. 46–50 (25 September–9 November 1848).

10. Ibid., p. 82.

11. *Exhibition of Work*, p. 5, no. 5 (Bendiner, *Brown*, p. 133).

12. See Mary Bennett, *Artists of the Pre-Raphaelite Circle: The First Generation: Catalogue of Works in the Walker Art Gallery, Lady Lever Art Gallery and Sudley Art Gallery*, 1988, pp. 25–7 and fig. 15.

13. Reproduced in Martin Hardie, *Water-colour Painting in Britain*, 3 vols, 1966–8, II, pl. 211.

14. He also eliminated two cows (whose *pentimenti* are still visible) and noted the fact in a letter to Thomas Seddon (letter quoted in sale catalogue, Sotheby's, London, 15 December 1970, lot 702).

15. Brown, *Diary*, p. 78.

16. Hunt, II, pp. 96–7.

17. Brown, *Diary*, p. 114.

18. For that history, see the entry by Mary Bennett in Tate 1984, pp. 163–5, no. 88.

19. Brown, *Diary*, p. 192.

20. Brown, *Exhibition of Work*, p. 27 (Bendiner, *Brown*, p. 152).

21. Ibid., p. 31 (Bendiner, *Brown*, p. 155).

22. See above p. 21.

23. *Exhibition of Work*, p. 9, no. 14 (Bendiner, *Brown*, p. 137).

24. *Diary*, p. 152.

25. Ibid., p. 80.

26. *Exhibition of Work*, p. 9 (Bendiner, *Brown*, p. 137).

27. Ruskin, *Works*, XII, p. 334 (letter to *The Times*, 25 May 1854).

28. Robin Ironside and John Gere, *Pre-Raphaelite Painters*, 1948, p. 24n.

29. *Diary*, p. 82. For a more detailed chronology see the entry by Mary Bennett in Tate, 1984, pp. 110–11, no. 51.

30. See Julius Bryant, *Finest Prospects: Three Historic Houses: A Study in London Topography*, The Iveagh Bequest, Kenwood, 1986, pp. 129–31; idem, 'Madox Brown's *English Autumn Afternoon* revisited: Pre-Raphaelitism and the environment', *Apollo*, CXLVI, 1997, pp. 41–3; and Alastair Ian Wright, 'Suburban prospects: vision and possession in Ford Madox Brown's *An English Autumn Afternoon*', in Margaretta Frederick Watson, ed., *Collecting the Pre-Raphaelites: the Anglo-American Enchantment*, 1997, pp. 185–97. Bennett, Bryant, and Wright all identify the spire as belonging to St Anne's in Highgate West Hill, but (according to Pevsner) St Anne's was only built in 1855, and, as Bryant points out, if this identification is correct, Brown compressed the distance between Kenwood and the church. I believe he probably intended the spire

as that of the older St Michael's (built 1830), which is further up Highgate Hill, north of St Anne's and closer to Kenwood.

31. Brown, *Diary*, p. 144 (13 July 1855).
32. *Exhibition of Work*, pp. 7–8, no. 13 (Bendiner, *Brown*, p. 136).
33. Ford Madox Brown, 'The Progress of English Art as not Shown at the Manchester Exhibition', *Magazine of Art*, XI, 1888, p. 122.
34. See above, p. 19.
35. See, for example, Max Friedländer, *Landscape, Portrait, Still-Life: Their Origin and Development*, trans. R. F. C. Hull, 1963, p. 26.
36. See above, p. 5.
37. *Exhibition of Work*, pp. 7–8 (Bendiner, *Brown*, p. 136).
38. See the oil sketch, *The Seeds and Fruits of English Poetry* (Ashmolean Museum, Oxford), reproduced in Tate, 1984, p. 52.
39. *Diary*, p. 84.
40. Ibid., p. 102.
41. Ibid., p. 145.
42. Ibid., p. 93 (21 September 1854).
43. Ibid., p. 96 (3 October 1854).
44. Ibid., p. 88 (1 September 1854).
45. Brown, *Exhibition of Work*, p. 10, no. 18 (Bendiner, *Brown*, p. 138). See also the entry by Mary Bennett in Tate, 1984, p. 122, no. 60. Hendon is located immediately west of Church End, Finchley, where Brown lived from September 1853 to October 1855. Church End is approximately two miles north of Hampstead.
46. Brown, *Diary*, p. 93 (20 September 1854).
47. *Diary*, p. 90 (5 September 1854). In 1865 he wrote that it was painted at Finchley.
48. *Exhibition of Work*, p. 10, no. 19 (Bendiner, *Brown*, p. 138).
49. A. H. Palmer, *The Life and Letters of Samuel Palmer*, 1892, pp. 14 and 17.
50. Brown, *Diary*, pp. 78 and 82.
51. Mary Bennett in Tate, 1984, pp. 178–9, no. 103.
52. *Exhibition of Work*, p. 11, no. 27 (Bendiner, *Brown*, p. 139).
53. See also below pp. 234–7 for a contemporaneous depiction of an analogous subject by William Dyce.
54. Ill., Hardie, *Water-colour Painting*, II, pl. 5.
55. *Exhibition of Work*, p. 21, no. 69 (Bendiner, *Brown*, p. 148).
56. Hueffer, *Brown*, p. 367.
57. See below, pp. 221–3.

CHAPTER FOUR

1. Quoted in Bennett, *Artists of the Pre-Raphaelite Circle*, p. 116, where there is further detail, including identification of the site as the Wylde Farm at North End, Hampstead.
2. M. H. Spielmann, *Millais and His Works*, 1898, p. 71, no. 5.
3. Millais, II, p. 469.
4. Brown *Diary*, p. 87 (30 August 1854).
5. Christie's, London, 20–22 May 1858, lot. 153 (John Miller sale). I am indebted to Mary Bennett for this reference.
6. See the entry by Judith Bronkhurst in Tate, 1984, p. 70, no. 19; and below, pp. 74–6.
7. See Tate, 1984, p. 261, no. 186.
8. *Art Journal*, 1852, p. 173.
9. *Works*, XI, pp. 59–60.
10. Millais, I, p. 162.
11. Quoted by Mary Bennett in *Millais: PRB/PRA*, Royal Academy, London, and Walker Art Gallery, Liverpool, 1967, p. 35, no. 38.
12. Millais, I, p. 175.
13. Ibid., p. 172.
14. See Mary Lutyens, *Millais and the Ruskins*, 1967, pp. 40 and 49–51; and Holman Hunt, undated letter to Edward Lear, John Rylands Library, Manchester.
15. Lutyens, *Millais and the Ruskins*, pp. 97 and 59–104 *passim*.
16. *Works*, XII, p. xxii (letter to Mary Russell Mitford, 17 August 1853).
17. Lutyens, *Millais and the Ruskins*, pp. 64–9.
18. Ibid., p. 75.
19. J. Howard Whitehouse, *Vindication of Ruskin*, 1950, p. 23.
20. *Works*, XII, p. xxiv (letter to Frederick Furnivall, 16 October 1853).
21. Lutyens, *Millais and the Ruskins*, p. 103.
22. *The Diaries of George Price Boyce*, Virginia Surtees, ed., 1980, p. 12.
23. Lutyens, *Millais and the Ruskins*, p. 215.
24. Ibid., pp. 247–8.
25. *Works*, XII, p. xxiv (6 July 1853). Turner's *St Gothard* is a late watercolour, more commonly known as 'The Pass of Faido', painted in 1843 (Thaw Collection, Pierpont Morgan Library, New York); see Andrew Wilton, *J. M. W. Turner: His Art and Life*, 1979, pp. 243 and 484, no. 1538. Much of Chapter II of *Modern Painters* IV (*Works*, VI, pp. 27–47 'Of Turnerian Topography') is about this watercolour.
26. *Works*, XII, p. xxiv.
27. Lutyens, *Millais and the Ruskins*, p. 247 (11 December 1854).
28. *Works*, XII, p. 359. See also above, pp. 19–22.

29. See above, p. 33.
30. *Works*, XII, p. xxiv.
31. Lutyens, *Millais and the Ruskins*, p. 77 (letter to his father, 4 August 1853).
32. Ibid., p. 85 (letter to his father, 18 August 1853).
33. Ibid., p. 94 (8 October 1853).
34. Mary Lutyens, 'Millais's Portrait of Ruskin', *Apollo*, LXXXV, 1967, pp. 246–53, pls 5, 9, and 12; and Mary Lutyens and Malcolm Warner, eds, *Rainy Day at Brig o' Turk: The Highland Sketchbooks of John Everett Millais*, 1983, nos 15, 23, 41, and 42.
35. Mary Lutyens, 'Millais's Portrait of Ruskin', p. 248, pl. 3. This picture has also been ascribed to William Millais.
36. For photographs of the sites of the painting and drawing, see Alastair Grieve, 'Ruskin and Millais at Glenfinlas', *Burlington Magazine*, CXXXVIII, 1996, pp. 228–34.
37. *Works*, XIV, p. 5 (*Academy Notes*, 1855).
38. Ibid., pp. 22 and 56–7.
39. Ibid., p. 23.
40. *Art Journal*, 1857, p. 310.
41. Brown, *Diary*, p. 169 (11 April 1856).
42. See Malcolm Warner, 'John Everett Millais's *Autumn Leaves*: "a picture full of beauty and without subject"', in Leslie Parris, ed., *Pre-Raphaelite Papers*, 1984, pp. 126–42; also the entry by the same author in Tate, 1984, pp. 139–41, no. 74.
43. Brown, *Diary*, p. 168 (11 April 1856)
44. *Works*, XXXIV, pp. 150–1.
45. Ibid., XIV, pp. 66–7.
46. Ibid., III, p. 340.
47. Ibid., XIV, pp. 56–7.
48. Quoted in Hunt, II, p. 113.
49. Millais, I, p. 342 (letter to Effie Millais, 28 April 1859).
50. *Works*, XIV, pp. 106–11. See also below, p. 86.
51. Ibid., pp. 212–16.
52. Quoted in Millais, II, p. 442.
53. Ibid., p. 29.

CHAPTER FIVE

1. Hunt, I, pp. 71–2, where Hunt also describes receiving a commission for a painting of the church in Ewell (private collection; exhibited Tate, 1984, no. 4). Ewell, in Surrey, would in 1851 be where Hunt and Millais painted the backgrounds of *The Hireling Shepherd* and *Ophelia* (see above p. 26).
2. Ibid., p. 114.
3. Ibid., p. 117.
4. See above, p. 11.
5. W. M. Rossetti, *P.R.B. Journal*, p. 12.
6. Boyce, *Diary*, p. 12 (13 March 1854). See Judith Bronkhurst, 'New Light on Holman Hunt', *Burlington Magazine*, CXXIX, 1987, p. 739 and fig. 47.
7. [Mary Bennett], *William Holman Hunt*, Walker Art Gallery, Liverpool, and Victoria and Albert Museum, London, 1969, no. 37.
8. See above, pp. 53–4, and the entry by Judith Bronkhurst in Tate, 1984, p. 70, no. 19.
9. See Robert L. Herbert, *Impressionism: Art, Leisure, and Parisian Society*, 1988, pp. 210–19, pls 211–15.
10. *Works*, XII, pp. 331–2 (*The Times*, 5 May 1854).
11. See below p. 245 and Pl. 203.
12. *Works*, XII, pp. 329–30.
13. See below pp. 209–12.
14. Stephens, *Hunt*, p. 23.
15. *Works*, XXXIII, p. 274.
16. Hunt, I, pp. 48–9.
17. See above, p. 24.
18. For fuller discussion, see Jonathan Ribner, 'Our English Coasts, 1852: William Holman Hunt and Invasion Fear at Midcentury', *Art Journal*, CV, summer 1996, pp. 45–54.
19. Stephens, *Hunt*, pp. 23–4.
20. See the entry by Judith Bronkhurst in Tate, 1984, pp. 106–8, no. 48.
21. L. M. Lamont, ed., *Thomas Armstrong, C. B.: A Memoir*, 1912, p. 6.
22. Eugène Delacroix, *The Journal*, trans. Walter Pach, 1937, p. 46.
23. *Art Journal*, 1855, p. 252.
24. Ibid., 1856, p. 79.
25. Théophile Gautier, *Les Beaux-arts en Europe – 1855*, première série, 1857, pp. 42–3.
26. Robert de la Sizeranne, *English Contemporary Art*, trans. H. M. Poynter, 1898, pp. 76–7. M. Besnard is Albert Besnard (1849–1934).
27. *Works*, XIV, pp. 225–6.
28. Ibid., XXXIII, pp. 272–3.
29. Stephens, *Hunt*, pp. 54–5. See also the entry by Judith Bronkhurst in Tate, 1984, p. 112, no. 52.
30. *Art Journal*, 1855, p. 385.
31. Reprinted in Philip Gilbert Hamerton, *Thoughts about Art*, 1874, pp. 58–9.
32. [John Pollard Seddon], *Memoir and Letters of the Late Thomas Seddon, Artist, By*

His Brother, 1858, pp. 61–2.

33. Hunt, I, p. 447.

34. See Richard Ormond, *Sir Edwin Landseer*, Philadelphia Museum of Art, and Tate Gallery, London, 1981, pp. 170–1, nos 121 and 122. The first person to suggest the dependence of *The Scapegoat* upon Landseer was Derek Hill in *Paintings and Drawings by Sir Edwin Landseer*, Royal Academy, London, 1961, p. xiii.

35. John Rylands Library, Manchester. For a thorough discussion of Hunt's trip to the Dead Sea and his account of it, see Judith Bronkhurst, '"An interesting series of adventures to look back upon": William Holman Hunt's visit to the Dead Sea in November 1854' in Parris, *Pre-Raphaelite Papers*, pp. 111–25.

36. Janet Camp Troxell, ed., *Three Rossettis: Unpublished Letters to and from Dante Gabriel, Christina, William*, 1937, pp. 40–1 (21 March 1855).

37. Letter to Thomas Combe, 31 March 1855 (John Rylands Library, Manchester).

38. Hunt, I, p. 456.

39. *Art Journal*, 1856, p. 170.

40. Brown, *Diary*, p. 174 (19 May 1856).

41. *Works*, XIV, pp. 61–6 and 108.

42. George P. Landow, *'Your Good Influence on Me': The Correspondence of John Ruskin and William Holman Hunt'*, 1977, pp. 29–31. Ruskin's letter is dated 29 April; Hunt's, 4 May 1858.

43. Hunt, I, p. 380 (letter to Millais, 16 March 1854).

44. See the entry by Judith Bronkhurst in Tate, 1984, pp. 269–70, no. 202.

45. The latter is reproduced in Hunt, I, p. 390. The Liverpool watercolour is reproduced in [Bennett], *William Holman Hunt*, pl. 45.

46. [Bennett], *William Holman Hunt*, pl. 44.

47. Hunt, I, p. 380.

48. Ibid., II, p. 42.

49. Troxell, *Three Rossettis*, p. 41 (21 March 1855).

50. See the entry by Judith Bronkhurst in Tate, 1984, pp. 271–2, no. 204.

51. John Rylands Library, Manchester.

52. Christie's, London, 7 March 1862, lots 192–6.

53. Hunt, I, pp. 408–9.

54. Hunt, II, p. 34.

55. *Fine Art, Chiefly Contemporary*, p. 244.

56. Reproduced as 'Sphinx' in Hunt, I, p. 378. The etching, also known as 'The Desolation of Egypt', was published in 1857 in *Etchings for the Art Union*.

57. Hunt, II, p. 47.

58. Reproduced, ibid., II, p. 84.

59. See below, p. 135. For later works showing Egypt, see Judith Bronkhurst, 'William Holman Hunt's visits to Egypt: Passion, prejudice and truth', *Apollo*, CXLVIII, November 1998, pp. 23–9.

60. For two examples, *Asparagus Island* and *Cornish Coast*, see 'William Holman-Hunt, O. M.: Contemporary Notices of His Exhibits in Water Colour', *The Old Water-Colour Society's Club: Thirteenth Annual Volume 1935–1936*, 1936, pls VII and VIII. See also Tate, 1984, pp. 292–3, no. 232 (*Asparagus Island*).

61. Ibid., p. 16.

62. Ibid., p. 14.

63. Hunt, II, p. 256.

64. Camaldoli is a monastery a few miles west of Naples situated on the highest point in the immediate vicinity of the city and commanding a famous view over the Bay of Naples and much of the surrounding countryside.

65. *Old Water-Colour Society's Club*, 1935–6, pp. 18–21.

66. See Martin Butlin and Evelyn Joll, *The Paintings of J. M. W. Turner*, 2 vols, 1977, II, pls 218 and 334.

67. Ruskin, *Works*, XXXIV, p. 169 (*The Three Colours of Pre-Raphaelitism*, 1878), and XXXVII, p. 20 (letter to Charles Eliot Norton, August 1870).

68. *Old Water-Colour Society's Club*, 1935–6, pp. 19–20.

69. Ibid., pp. 18–19.

70. See above, pp. 80–1.

71. *Works*, XXXVII, p. 20.

72. See Hunt, II, facing pp. 352 and 382; and [Bennett], *William Holman Hunt*, pls 88 and 89.

73. Hunt, II, p. 243.

74. And reprinted in the second edition of *Pre-Raphaelitism and the Pre-Raphaelite Brotherhood*, 1913, II, pp. 406–8.

75. Hunt, II, pp. 253–4. See also the entry by Judith Bronkhurst in Tate, 1984, pp. 212–13, no. 134.

76. St Swithin's day is 15 July. According to legend, if it rains on St Swithin's day there will be rain for the next forty days.

CHAPTER SIX

1. John Rylands Library, Manchester. Burchett did not exhibit at the Royal Academy in 1855, but his address was listed in the British Institution catalogue of that year. Collinson remained at 11 Queen's Road through 1858.

2. Ronald Parkinson, *Victoria and Albert Museum: Catalogue of British Oil Paintings 1820–1860*, 1990, p. 13, ill. p. 154.

3. Hunt, I, p. 84.

4. Ibid., p. 237. See also D. G. Rossetti, *Letters*, I, pp. 93–4 (24 and 25 October 1850, from Sevenoaks, Kent, to his mother and to John Lucas Tupper).

5. See Virginia Surtees, *The Paintings and Drawings of Dante Gabriel Rossetti (1828–1882): A Catalogue Raisonné*, 2 vols, 1971, I, pp. 26–32, no. 64, and II, pls 65–7.

6. Brown, *Diary*, p. 106 (12 November 1854).

7. Troxell, *Three Rossettis*, pp. 25–6.

8. Ruskin, *Works*, XXXVI, pp. 225–6.

9. Ibid., V, p. xlix.

10. Boyce, *Diaries*, p. 24 (21 June 1858). See also Surtees, *Rossetti*, I, p. 67, no. 111, and II, pl. 165.

11. Surtees, *Rossetti*, I, p. 92, no. 163, and II, pl. 232; and William Michael Rossetti, *Dante Gabriel Rossetti as Designer and Writer*, 1889, p. 110.

12. *Art Journal*, 1853, p. 88.

13. Quoted in the *Athenaeum*, 6 August 1853, p. 943.

14. See the entry by Malcolm Warner in Tate, 1984, pp. 101–2, no. 43. There is also a comprehensive discussion of the picture in Jason Rosenfeld, 'New Languages of Nature in Victorian England: The Pre-Raphaelite Landscape, Natural History, and Modern Architecture in the 1850s', Ph.D. dissertation, Institute of Fine Arts, New York University, 1999.

15. *British Quarterly Review*, XVI, 1852, p. 213.

16. *Art Journal*, 1852, p. 166.

17. *Athenaeum*, 22 May 1852, p. 582.

18. Hunt, I, pp. 271–2, and II, p. 313. See also Millais, I, p. 133, where it is stated that the picture was never finished.

19. William Bell Scott, *Autobiographical Notes, and Notices of His Artistic and Poetic Circle of Friends, 1830–1882*, W. Minto, ed., 2 vols, 1892, I, p. 285.

20. Robin Ironside and John Gere, *Pre-Raphaelite Painters*, 1948, p. 28. For more recent discussion, see the entries by Leslie Parris in Tate, 1984, pp. 112–15, nos 53 and 54, and Mary Lutyens, 'Walter Howell Deverell' in Parris, *Pre-Raphaelite Papers*, pp. 76–96.

21. Robert Ross, 'April Love: A Note', *Burlington Magazine*, XXVIII, 1916, p. 171. See also Leonard Roberts, *Arthur Hughes: His Life and Works: A Catalogue Raisonné*, 1997, pp. 134–5, no. 29 and pl. 15.

22. H. Allingham and E. B. Williams, eds, *Letters to William Allingham*, 1911, p. 51; also in Roberts, *Hughes*, p. 126, no. 15.

23. *Art Journal*, 1859, p. 170.

24. See Roberts, *Hughes*, pp. 139–40, no. 33, and Martin Postle, '*Home from Sea*: The preliminary landscape study', *Apollo*, CXXXVI, October 1992, pp. 251–5. Postle reproduces a watercolour study showing an almost identical view of the church (private collection), which may have been done by Hughes at the time he was painting the picture's background, but he concludes that the background was not copied from the watercolour.

25. Robin Gibson, 'Arthur Hughes: Arthurian and related subjects of the early 1860s', *Burlington Magazine*, CXII, 1970, pp. 455–6.

26. See Roberts, *Hughes*, pp. 148, no. 45; 153–4, nos 55 and 55.3; and 199, no. 203; pls 27, 35, 36, and 84.

27. William E. Fredeman, *A Pre-Raphaelite Gazette: The Penkill Letters of Arthur Hughes to William Bell Scott and Alice Boyd 1886–97*, 1967, p. 50 (13 January 1893, to Alice Boyd, to whom Hughes sold a version of the picture).

28. Robert Ross, 'Arthur Hughes' (obituary), *Burlington Magazine*, XXVIII, 1916, p. 207.

29. Roberts, *Hughes*, pp. 174–5, no. 101. In a letter to Alexander Munro, Hughes described it as 'a boy's portrait (at a cherry wall)', ibid., p. 284, letter 7 [April 1869].

30. Ironside and Gere, *Pre-Raphaelite Painters*, p. 41.

31. Ruskin, *Works*, XIV, p. 47.

32. Ibid., pp. 60 and 170.

33. D. G. Rossetti *Letters*, I, p. 198 (14 March 1854).

34. See *Le Paysage Anglais des Préraphaélites aux Symbolistes*, Galerie du Luxembourg, Paris, 1974, nos 53, 57, 58, and 62, for a small group of landscapes in watercolour made in Wales, Italy, and Egypt.

35. Ruskin, *Works*, XIV, p. 66.

36. Leslie Parris in Tate, 1984, pp. 136–7, no. 71.

37. *Athenaeum*, 11 September 1886, p. 342.

38. Reproduced in Jeremy Maas, *Victorian Painters*, 1969, p. 227.

39. See Michael Bartram, *The Pre-Raphaelite Camera: Aspects of Victorian Photography*, 1985, pp. 39–40, figs 31 and 32.

40. Ruskin, *Works*, XIV, p. 51; reproduced in *Victorian Painting*, Fine Art Society, London, 1977, no. 24.

41. Susan P. Casteras, *English Pre-Raphaelitism and its Reception in America in the Nineteenth Century*, 1990, p. 64.

42. *Selected Letters of William Michael Rossetti*, Roger W. Peattie, ed., 1990, p. 88, note 4 (letter from A. A. Ruxton to W. M. Rossetti, 20 April 1858).

43. Hunt, I, p. 420.

44. Ruskin, *Works*, XII, p. xxvii. For Paton's friendship with Millais, see Millais, II, pp. 430–9.

45. Ibid., XIV, pp. 155–7.

46. Ibid., pp. 329–31.

47. *Waller Hugh Paton: A Scottish Landscape Painter*, Crawford Art Centre, St

Andrews, and Bourne Fine Art, Edinburgh, 1993 (catalogue by June Baxter), no. 13.

48. Scott Wilcox and Christopher Newall, *Victorian Landscape Watercolors*, Yale Center for British Art, New Haven, 1992, p. 96, no. 32. See also *Fact and Fancy: Drawings and Paintings by Sir Joseph Noël Paton, R.S.A.*, Scottish Arts Council, 1967, nos 18 and 19 (drawings inscribed Inveruglas, dated 25 July and 12–13 August 1857).

49. Scott, *Autobiographical Notes*, II, pp. 35–6.

50. See below, p. 138.

51. See Richard Dorment, *British Painting in the Philadelphia Museum of Art: From the Seventeenth through the Nineteenth Century*, 1986, pp. 368–71.

52. *Autobiographical Notes*, II, p. 44.

53. William Michael Rossetti, ed., *Rossetti Papers 1862 to 1870*, 1903, pp. 393–4 and 441–4.

54. Daphne du Maurier, ed., *The Young George du Maurier: A Selection of His Letters, 1860–1867*, 1951, p. 99.

55. See William S. A. Dale, 'A Portrait by Fred Sandys', *Burlington Magazine*, CVII, 1965, pp. 250–3.

56. Georgiana Burne-Jones, *Memorials of Edward Burne-Jones*, 2 vols, 1904, I, p. 79.

57. Scott, *Autobiographical Notes*, II, pp. 37 and 39.

58. Burne-Jones, *Memorials*, I, pp. 304–5.

59. [John Christian], *Burne-Jones*, Arts Council of Great Britain, 1975, p. 79, nos 246 and 247. See also Christopher Newall, *Victorian Watercolours*, 1987, pl. 26.

60. Burne-Jones, *Memorials*, II, p. 261.

61. Ibid., II, p. 261.

CHAPTER SEVEN

1. *Fine Art, Chiefly Contemporary*, p. 160.

2. For details of Seddon's life see [John Pollard Seddon], *Memoir and Letters of the Late Thomas Seddon, Artist, By His Brother*, 1858. A letter written by Brown in March 1851 (Hueffer, *Brown*, p. 75) implies that Seddon, who was then ill, had been working with Brown for some time.

3. D. G. Rossetti, *Letters*, I, p. 335 (letter to Lowes Dickinson, summer 1858) and Hunt, II, p. 128. For a reproduction see Sotheby's Belgravia sale catalogue, London, 28 November 1972, lot 49.

4. Seddon, p. 7.

5. Ibid., pp. 17–18, and *Spectator*, 18 December 1852, p. 1212.

6. Ibid., p. 21 (1 September 1852).

7. Hunt, I, p. 362.

8. Seddon, p. 36. For their travel arrangements see five letters written by Hunt to Seddon between 15 August and 12 November, 1853, in George P. Landow, *William Holman Hunt's Letters to Thomas Seddon*, 1983, pp. 151–9.

9. Seddon, pp. 32–3 (30 December 1853). The sketch was reproduced in Burton's account of his trip, *Personal Narrative of a Pilgrimage to El Medinah and Meccah*, 2nd edn, 1857, I, facing p. 28, as 'An Arab Shaykh in his Travelling Dress'. For a watercolour version, signed and dated 1854, see *Eastern Encounters: Orientalist Painters of the Nineteenth Century*, Fine Art Society, London, 1978, no. 57. An oil painting, also dated 1854, was sold at Sotheby's Parke-Bernet, New York, 22 May 1985, lot 28. What is evidently a copy of Seddon's original sketch by Edward Lear, dated 23 December 1853, is in the Harvard College Library.

10. See Seddon, pp. 32, 141, and 146. What was presumably the exhibited picture, signed and dated 1856, is illustrated in *Eastern Encounters*, no. 58. A smaller, earlier version, signed and dated 1854, with one rather than two foreground figures, was sold at Sotheby's, London, on 17 June 1986, lot 16, and again on 22 November 1988, lot 28.

11. Seddon, p. 141, and Hunt, I, p. 270. Hunt did attempt to consult Lewis for advice before he and Seddon set off (Landow, *Hunt's Letters to Seddon*, pp. 152 and 154).

12. 'Since Hunt came I have not quite followed your advice, and have done no sketches here' (letter from Seddon at Giza to Brown, quoted in Hueffer, *Brown*, p. 99).

13. Seddon, pp. 52–3.

14. Seddon, pp. 64–5 (27 March 1854).

15. A detail is reproduced in Hunt, I, p. 383.

16. Seddon, p. 85.

17. Ibid., p. 97.

18. Ibid., p. 106.

19. Ibid., p. 111.

20. Hunt, I, pp. 391–5.

21. Brown, *Diary*, p. 117 (16 January 1855).

22. Hunt, I, p. 447.

23. Seddon, p. 131.

24. Brown, *Diary*, p. 117 (16 January 1855).

25. Ibid., p. 171 (23 April 1856).

26. Seddon, p. 134.

27. Ibid., pp. 144–5.

28. Ibid., pp. 133, 135.

29. Ibid., p. 94 (25 June 1854).

30. See above, pp. 49–50.

31. Seddon, p. 92 (10 June 1854).

32. Hunt, II, p. 128, and Landow, *Hunt's Letters to Seddon*, pp. 167–8.

33. Hardie, *Water-colour Painting in Britain*, III, frontispiece (as 'A Halt in the Desert').

34. Seddon, pp. 33–4 and 80.

35. Ibid., p. 144.

36. Holman Hunt, letter to Edward Lear, 31 December 1856 (John Rylands Library, Manchester).

37. Seddon, p. 137 (19 March 1855).

38. *Works*, XIV, p. 465.

39. Ibid., pp. 464–70.

40. Ibid., XII, p. 349.

41. See above, p. 8.

42. See above, p. 86.

43. Letter dated 12 August 1855 (Huntington Library, San Marino). Ruskin's scheme remembered by Hunt must have been proposed prior to Hunt's departure for the East in January 1854. For Lear, see below, pp. 209–12. See also Bronkhurst, 'An interesting series of adventures', pp. 122–3.

44. See above, pp. 84–5 and 87.

45. See below, p. 177.

46. *Athenaeum*, 22 March 1879, p. 386.

CHAPTER EIGHT

1. For Boyce's life see Christopher Newall and Judy Egerton, *George Price Boyce*, Tate Gallery, London, 1987, pp. 9–31 ('Introduction' by Christopher Newall).

2. *The Diaries of George Price Boyce*, Virginia Surtees, ed., 1980, pp. 2–3 (5–27 August 1851).

3. Ibid., p. 24 (21 June 1858), and Newall and Egerton, *Boyce*, p. 12, no. 46.

4. *Diaries*, p. 13 (21 April 1854).

5. Ibid., Appendix, pp. 119–121.

6. Newall and Egerton, *Boyce*, p. 47, no. 13 and pl. 2.

7. *Diaries*, p. 43 (21 November 1865).

8. Ibid., p. 14 (9 December 1854). For the lecture Boyce attended, see Ruskin, *Works*, XII, pp. 499–508.

9. See Newall and Egerton, *Boyce*, pp. 45–6, no. 11.

10. See Newall and Egerton, *Boyce*, p. 50, no. 22. The works at the Royal Academy in 1858 were *At a farm house in Surrey* (no. 216) and *Heath side in Surrey* (no. 539).

11. Newall and Egerton, *Boyce*, pp. 50 and 56, nos 24 and 42, cover illustration and pl. 7.

12. See Newall and Egerton, *Boyce*, p. 54, nos 33 and 34.

13. *Diaries*, p. 34 (14 April 1862).

14. Ibid., pp. 37 and 38 (6 February and 2 June 1863). A nocturnal view in watercolour of Blackfriar's Bridge, possibly the study by moonlight made in June 1863, is in the Tate Gallery.

15. See Newall and Egerton, *Boyce*, p. 53, no. 31, where it is pointed out that the view is from Boyce's earlier lodgings in Buckingham Street, near Hungerford Bridge, where he lived from 1856 to 1862. The original mount of the watercolour is inscribed on the verso: 'From my studio window 15 Buckingham St. Adelphi/GPBoyce'.

16. *Athenaeum*, 18 October 1873, pp. 500–1.

CHAPTER NINE

1. Christopher Newall, *John William Inchbold: Pre-Raphaelite Landscape Artist*, Leeds City Art Galleries, 1993.

2. *Loan Exhibition of Works by G. J. Pinwell, Sam Bough, J. W. Inchbold*, Royal Water-Colour Society Art Club, London, 1888, pp. 7–10.

3. *Spectator*, 19 June 1852, p. 593.

4. D. G. Rossetti, *Letters*, I, p. 285 (to Ford Madox Brown, 10 January 1856), and II, p. 497 (to Brown, ?1864).

5. William Michael Rossetti, ed., *Rossetti Papers 1862 to 1870*, 1903, p. 64. See also *idem*, *Some Reminiscences*, 2 vols, 1906, I, pp. 228–229.

6. *The Swinburne Letters*, Cecil Y. Lang, ed., 6 vols, 1959–62, V, p. 258.

7. See below, pp. 163–5.

8. *Art Journal*, 1853, p. 149.

9. *Works*, III, pp. 177–8.

10. Ibid., V, p. 175.

11. Humphry House, 'Man and Nature: Some Artists' Views', *The Listener*, XXXIX, 1948, p. 615.

12. *Works*, XIV, p. 22 (*Academy Notes*, 1855).

13. *Art Journal*, 1856, p. 168, and Ruskin, *Works*, XIV, pp. 59–60.

14. Diana Holman-Hunt, *My Grandfather, His Wives and Loves*, 1969, p. 128.

15. Ruskin, *Works*, XIV, p. 21.

16. Prior to 1965, the painting was wrongly catalogued as 'Ben Eay, Ross-shire'. As Ian Lowe kindly informed me, the view was correctly identified by Donald Reid on the basis of its topographical accuracy.

17. MS, Yale University Library; quoted in Susan Casteras, 'The 1857–58 Exhibition of English Art in America: Critical Responses to Pre-Raphaelitism', in Linda S. Ferber and William H. Gerdts, *The New Path: Ruskin and the American Pre-Raphaelites*, Brooklyn Museum, 1985, p. 127.

18. Ruskin, *Works*, XIV, p. 38; and see above p. 76.

19. Ibid., XXXVI, pp. 190 and 201.

20. Ruskin, *Works*, XIV, pp. xxiii, 21, 59–60, and VII, p. xxxiii; also *The Diaries of John Ruskin*, 3 vols, Joan Evans and John Howard Whitehouse, eds, 1956–9, II, p. 516.

21. *Works*, III, p. 429.

22. He also tried to get Rossetti to Switzerland; see above pp. 22 and 106.

23. Ibid., XIV, p. xxiii (9 August 1858).

24. *Art Journal*, 1871, facing p. 264.

25. *Works*, XIV, p. 96.

26. See above, p. 141.

27. Newall, *Inchbold*, pp. 54–5, no. 13, and ill. p. 31.

28. W. M. Rossetti, *Rossetti Papers 1862 to 1870*, p. 8 (diary, 11 July 1862). William Bell Scott was also there with them.

29. Philip McEvansoneya, 'The Cosmopolitan Club Exhibition of 1863: the British *salon des refusés*' in Ellen Harding, ed., *Re-framing the Pre-Raphaelites: Historical and Theoretical Essays*, 1996, pp. 27–42.

30. For the others, see Newall, *Inchbold*, p. 55, no. 14 (*From Saint Helena, Venice*), p. 56, no. 17 (*The Redentore, Venice*), and p. 57, no. 20 (*Venice from Lido to Giudecca*), colour pls pp. 32–5.

31. Newall, *Inchbold*, p. 58, no. 25, ill. p. 37.

32. Ibid., pp. 57–9, nos 21–6.

33. W. M. Rossetti, *Rossetti Papers 1862 to 1870*, pp. 438–9 (letter from Inchbold to Rossetti, 10 May 1869).

34. Ibid., pp. 380 and 495.

35. See Newall, *Inchbold*, pp. 21–2, and D. G. Rossetti, *Letters*, II, pp. 684–6.

36. See Newall, *Inchbold*, pp. 63–5, no. 42 and ill. p. 43.

37. *Portfolio*, 1874, p. 180. The article was probably written by Philip Gilbert Hamerton, the editor of *Portfolio*.

38. Ibid., 1876, facing p. 168, and 1879, facing p. 188. Later, in 1885, Inchbold published a set of twenty-one etchings entitled *Mountain and Vale*.

39. Newall, *Inchbold*, pp. 67–8, no. 53.

40. Elihu Vedder, *The Digressions of V.*, 1910, p. 161.

41. W. M. Rossetti, *Rossetti Papers 1862 to 1870*, p. 439.

42. *Some Reminiscences*, I, p. 229.

43. *Letters*, V, p. 258.

CHAPTER TEN

1. Michael Hickox, 'John Brett and Ruskin', *Burlington Magazine*, CXXXVIII, 1996, p. 525 (letter from Ruskin to Brett, 2 May 1863).

2. Brett family. I am indebted to Mrs Joan Mitchell, Mrs C. D. Wales, Patrick Brett, and Michael Hickox for making the artist's diaries, letters, and sketchbooks remaining in the possession of his descendants available to me. I wish particularly to acknowledge the assistance given to me by Michael Hickox, who in his own publications has contributed much to our understanding of Brett.

3. Ruskin, *Works*, XXVI, p. 568 (Introduction to *The Limestone Alps of Savoy*, 1884) and xvii–xli *passim*; and *Works*, V, pp. lvii–lviii (for Stephen) and lv–lxi *passim*. For a more thoroughgoing discussion of the background, and particularly the scientific background, of Brett's painting, see Kenneth Bendiner, 'John Brett's "The Glacier of Rosenlaui"', *Art Journal*, XLIV, Fall 1984, pp. 241–8, and *idem, An Introduction to Victorian Painting*, 1985, pp. 47–63 (chapter devoted to the *Glacier of Rosenlaui*). Bendiner argues that the presence of the large boulders high on a mountain illustrates theories first put forward by the Swiss naturalist and geologist Louis Agassiz in 1837. Agassiz saw the *Glacier of Rosenlaui* in Boston in 1858 and was reported to have given it unqualified praise (letter from A. A. Ruxton to William Michael Rossetti, 20 April 1858, in *Selected Letters of William Michael Rossetti*, Roger W. Peattie, ed., 1990, p. 88, n. 4).

4. *Works*, VI, pp. 365–8.

5. Ibid., pl. 48 and p. 369.

6. Ibid., VII, pp. 360–1.

7. See Derek Patmore, *The Life and Times of Coventry Patmore*, 1949, frontispiece, and facing p. 54.

8. See Sotheby's, London, 4 June 1997, lot 148 (as 'An Alpine Meadow').

9. For a provocative discussion of the relationship of these three works and of social and religious meaning in Brett's picture, see Michael Hickox and Christiana Payne, 'Sermons in Stones: John Brett's *The Stonebreaker* reconsidered', in Ellen Harding, ed., *Re-framing the Pre-Raphaelites*, 1996, pp. 99–114.

10. See Ruskin, *Works*, XII, p. 365 (the pamphlet *Pre-Raphaelitism* of 1851, where Ruskin ascribed Landseer's success to his 'healthy love of Scotch terriers').

11. For more detail, see David Cordingly, '"The Stonebreaker": an examination of the landscape in a painting by John Brett', *Burlington Magazine*, CXXIV, 1982, pp. 141–5; and Mary Bennett, *Artists of the Pre-Raphaelite Circle*, pp. 16–19.

12. *Works*, XIV, pp. 171–2.

13. John Brett, 'Landscape at the National Gallery', *Fortnightly Review*, LVII, 1 April 1895, p. 639.

14. *Works*, XIV, pp. 74–5 and 159.

15. Mary Bennett, 'A Check List of Pre-Raphaelite Pictures Exhibited at Liverpool, and Some of Their Northern Collectors', *Burlington Magazine*, CV, 1963, p. 492.

16. Hickox, 'John Brett and Ruskin', p. 525.

17. *Works*, XIV, pp. xxiii–xxiv (26 August 1858); Ruskin's sketch of the Château St Pierre is reproduced ibid., II, pl. 21.

18. Ibid., VII, p. 361.

19. The book also contains sketches made on the journey of Joseph Couttet, an Alpine guide, who had travelled with Ruskin and was now returning to his home in Chamonix.

20. *Works*, XIV, p. 236 (letter to his father, 26 August 1851).

21. T. S. R. Boase, 'English Artists and the Val d'Aosta', *Journal of the Warburg and Courtauld Institutes*, XIX, 1956, p. 292.

22. For a view in watercolours painted by Brett on 30 July 1858, looking up the Val di Cogne, see Allen Staley, 'Some Water-Colours by John Brett', *Burlington Magazine*, CXV, 1973, p. 89 and fig. 19.

23. See *Turner et les Alpes*, Fondation Pierre Gianadda, Martigny, Switzerland, 1999, nos 42–5. His grandest depiction of the area is the painting *Snow-storm, Avalanche and Inundation – A Scene in the Upper Part of Val d'Aosta* (Art Institute of Chicago), exhibited in 1837.

24. See Fritz Novotny, *Painting and Sculpture in Europe: 1780 to 1880*, 1960, pp. 38–40 and pl. 25.

25. Ibid., p. 112 and 245, n. 3, and pl. 76A. See also Winslow Ames, *Prince Albert and Victorian Taste*, 1968, p. 138.

26. Millais, I, p. 342 (28 April 1859).

27. *Works*, XIV, p. 234.

28. See above, p. 138.

29. *Works*, VII, pls 68, 70, 71, and fig. 87; XXXIV, pl. II. The *July Thunder Cloud* illustration reproduces a detail of a watercolour illustrated in Paul Walton, *Master Drawings by John Ruskin* 2000, pl. 13 (collection of David Thomson).

30. See Hickox, 'John Brett and Ruskin', p. 522.

31. *Works*, XIV, p. 293. 'Woodcutter' seems to be a reference to *The Hedger* (Pl. 141), but Ruskin never mentioned that picture in print.

32. Ibid., XIV, p. 238.

33. Hickox, 'John Brett and Ruskin', p. 524.

34. Quoted by David Cordingly in Tate 1984, p. 183, no. 107 (31 July 1859).

35. See Staley, 'Some Water-Colours by John Brett', pp. 89–90 and fig. 20.

36. Ibid., p. 90 and fig. 23.

37. *Works*, XXXVI, p. 441.

38. See below, pp. 196–7.

39. Hickox, 'John Brett and Ruskin', p. 525.

40. *Works*, III, pp. 623 and 627.

41. Ibid., XXXVII, pp. 212–13 (30 November 1876). For Goodwin, see below, p. 220.

42. Ibid., XXXVI, pp. 493–4.

43. See Mike Hickox, 'The Royal Academy's Rejection of Brett's *Florence*', *Review of the Pre-Raphaelite Society*, III, 1995, pp. 10–16.

44. Du Maurier, *The Young George Du Maurier*, p. 204.

45. *Grand Tour: The Lure of Italy in the Eighteenth Century*, Tate Gallery, London, 1996, p. 134, no. 89.

46. Henry James, *William Wetmore Story and His Friends*, 1903, II, p. 95. See also Giuliana Artom Treves, *The Golden Ring: The Anglo-Florentines, 1847–1862*, trans. Sylvia Sprigge, 1956, pp. 177–93.

47. Wilcox and Newall, *Victorian Landscape Watercolors*, pp. 117–18, no. 54.

48. Ibid., pp. 124 and 128–9, nos 60 and 64.

49. Staley, 'Some Water-Colours by John Brett', p. 93, fig. 22.

50. *Art Journal*, 1871, p. 177.

51. *Three Months on the Scottish Coast: A Series of Sketches and Pictures Painted During the Summer of the Present Year, Accompanied by an Introductory Essay by John Brett*, Fine Art Society, London, 1886.

52. Ibid., p. 10.

53. R. B. Beckett, *John Constable and the Fishers*, 1952, p. 82. Constable was not admired by Brett: 'Constable took so superficial an interest in nature that he never took any pains to study her laws' ('Landscape at the National Gallery', p. 638).

CHAPTER ELEVEN

1. See Mary Bennett, 'A Check List of Pre-Raphaelite Pictures Exhibited at Liverpool, and Some of Their Northern Collectors', *Burlington Magazine*, CV, 1963, pp. 486–95.

2. *Works*, XIV, pp. 327–8.

3. Ibid., pp. 85–7, 233–4, and 239.

4. Julian Treuherz, *Pre-Raphaelite Paintings from Manchester City Art Galleries*, 1993, p. 66, pl. 44.

5. [James Smith], *Two Liverpool Artists: In Memoriam: D. A. Williamson, Born 24th September, 1823, Died 12th February, 1903; W. L. Windus, Born 1823, Died October, 1907*, n.d., p. 18.

6. *Letters*, I, p. 252 (to William Allingham, 11 May 1855).

7. *Works*, pp. 30 and 32.

8. *Art Journal*, 1855, p. 179.

9. *Diary*, pp. 174–5 (19 May 1856).

10. Ibid., p. 190 (27 September 1856).

11. H. C. Marillier, *The Liverpool School of Painters: An Account of the Liverpool Academy, From 1810 to 1867, with Memoirs of the Principal Artists*, 1904, pp. 107–8; and F. G. Stephens, 'William Davis, Landscape Painter, of Liverpool', *Art Journal*, 1884, pp. 326–8.

12. The date on *Bidston Marsh* is difficult to read and is recorded as 1855 by Mary Bennett (Walker Art Gallery, Liverpool, *Merseyside Painters, People & Places: Catalogue of Oil Paintings*, 2 vols, 1978, I, p. 85, no. 1494).

13. Marillier, *The Liverpool School*, pp. 104–5.

14. See above, p. 40.

15. *Works*, XIV, pp. 32–3.

16. *Works*, VI, pp. 30–1.

17. Ibid., VII, p. 233.

18. Stephens, 'Davis', p. 328, and Marillier, *The Liverpool School*, pp. 103–4.

19. Stephens, 'Davis', p. 326.

20. W. M. Rossetti, *Fine Art, Chiefly Contemporary*, p. 160.

21. His death prompted a letter from Inchbold in the *Athenaeum* of 3 May 1873, p. 573, proposing that the Royal Academy create a class of non-member artists such as Davis (and, although unmentioned, Inchbold himself) who would be entitled to exhibit one picture a year at the Academy without fear of rejection.

22. *Works*, XIV, pp. 50–1 and 116.

23. *Letters*, I, p. 344 (to Brown, 25 December 1858).

24. Ruskin, *Works*, VI, p. 211

25. Robert Secor, *John Ruskin and Alfred Hunt: New Letters and the Record of a Friendship*, 1982, pp. 22–3 (16 May [1858]).

26. See above, pp. 179–81.

27. Violet Hunt, 'Alfred W. Hunt, R.W.S. (1830–1896)', *The Old Water-Colour Society's Club: Second Annual Volume: 1924–1925*, 1925, p. 37. Violet Hunt was the artist's daughter.

28. *Works*, XIV, pp. 229–30.

29. See above, pp. 76 and 179.

30. See W. M. Rossetti, *Rossetti Papers 1862 to 1870*, pp. 232–3 (diary, 16 May 1867), and *Notes by Mr. Edmund Gosse on the Pictures and Drawings by Mr. Alfred W. Hunt*, Fine Art Society, London, 1884, pp. 6–7.

31. H. C. Marillier, 'Modern Pictures at Red Heath, Croxley Green', *Art Journal*, 1903, p. 225.

32. Ibid., p. 229; *Notes by Mr. Edmund Gosse*, p. 3; and Virginia Woolf, *Roger Fry: A Biography*, 1940, p. 53.

33. *The Liverpool School*, p. 179.

34. *Fine Art, Chiefly Contemporary*, p. 160.

35. *Works*, XIV, pp. 115, 154, 169, 230 (*Academy Notes*, 1857, 1858, and 1859).

36. *Paintings and Drawings by James Charles, George Sheffield, William Stott, and D. A. Williamson*, City Art Gallery, Manchester, 1912.

CHPATER TWELVE

1. W. M. Rossetti, *P.R.B. Journal*, pp. 26 (19 November 1849), 38 (29 December), and 72 (October 1850).

2. *Spectator*, 19 June 1852, p. 593.

3. *Millais and the Ruskins*, p. 36.

4. See, for example, above, p. 174.

5. The painting is reproduced in Jan Marsh and Pamela Gerrish Nunn, *Women Artists and the Pre-Raphaelite Movement*, 1989, p. 54, pl. 11; Brett and Stephens are quoted on p. 55, the latter from *Spectator*, 5 June 1858, p. 624.

6. Jan Marsh and Pamela Gerrish Nunn, *Pre-Raphaelite Women Artists*, Manchester City Art Galleries, 1997, pp. 106–7, no. 8, ill. p. 22.

7. Ibid., p. 113, no. 18, ill. p. 55.

8. *Letters*, I, p. 163 (to Christina Rossetti, 8 November 1853).

9. Pam Hirsch, *Barbara Leigh Smith Bodichon 1827–1891: Feminist, Artist and Rebel*, 1998, p. 51.

10. Ibid., p. 109 ('Art News from England', *The Crayon*, August 1856, p. 245).

11. Ibid., p. 164 (14 October 1858). The engraving was published in *The Illustrated London News* of 23 October 1858, p. 379, with accompanying text on p. 389.

12. Virginia Surtees, ed., *Sublime and Instructive: Letters from John Ruskin to Louisa, Marchioness of Waterford, Anna Blunden and Ellen Heaton*, 1972, pp. 79–140.

13. Ibid. p. 140 (6 May 1862).

14. *Spectator*, 18 June 1864, p. 710. See also Marsh and Nunn, *Pre-Raphaelite Women Artists*, p. 109, no. 12.

15. Boyce, *Diaries*, pp. 31–2 (4 January 1861).

16. See *Art Journal*, 1859, pp. 110–11, for a lengthy criticism.

17. Ruskin, *Works*, XXXVIII, p. 255, no. 783. See also James Dearden, *Facets of Ruskin*, 1970, pp. 100–1.

18. Wilcox and Newall, *Victorian Landscape Watercolors*, pp. 93–5, no. 30.

19. Vivien Noakes, *Edward Lear: The Life of a Wanderer*, 1968, p. 105.

20. Hunt, I, pp. 328–34. 'Ye Booke of Hunte' has disappeared.

21. Letter dated 19 December 1852 (Huntington Library, San Marino).

22. Letter dated 31 December 1852–1 January 1853 (John Rylands Library, Manchester).

23. Letter dated 11 July 1853 (Huntington Library, San Marino).

24. Seddon, p. 60.

25. See Vivien Noakes, *Edward Lear 1812–1888*, Royal Academy, London, 1985, pp. 149–50, no. 56, ill. p. 41.

26. Ruskin, *Works*, XIV, p. 460 (letter from Ruskin to Smetham, 15 November 1854).

27. Ibid., V, pp. xlvii–xlviii.

28. *Letters of James Smetham*, Sarah Smetham and William Davies, eds, 1891, p. 169. See also Susan P. Casteras, *James Smetham: Artist, Author, Pre-Raphaelite Associate*, 1995, p. 77.

29. *Letters*, p. 68.

30. *Works*, XIV, p. 461 (February 1857).

31. *Letters*, pp. 70–1.

32. Ibid., p. 129.

33. Ibid., pp. 309–10.

34. Ibid., p. 206.

35. *The Literary Works of James Smetham*, William Davies, ed., 1893, p. 130.

36. D. G. Rossetti, *Works*, p. 594.

37. MS Letter, Yale University Library.

38. Ruskin, *Works*, XIX, p. li (letter to his mother, 10 June 1869).

39. Ibid., p. 451.

40. Ruskin, *Works*, X, p. lxiii.

41. See above, p. 138.

42. E. R. and J. Pennell, *The Life of James McNeill Whistler*, 2 vols, 1908, I, p. 270.

43. *Works*, XXXIII, p. 564.

44. For this activity, see ibid., XXX, pp. xxi–lxxv.

45. Burne-Jones, *Memorials*, II, p. 344. See also Mary Lago, ed., *Burne-Jones Talking: His Conversations 1895–1898 Preserved by His Studio Assistant Thomas Rooke*, 1981.

46. Ruskin, *Works*, XXX, p. lxiii.

47. Ibid., XIV, p. 238, and see above, p. 178.

48. Ibid., XXX, pp. lxv–lxix and p. 72.

49. Ibid., XXX, pp. lxxi, 81, and 206.

50. Ibid., p. 178.

51. See *Pre-Raphaelites: Painters and Patrons in the North East*, Laing Art Gallery, Newcastle upon Tyne, 1989, pp. 60–1, no. 12, ill. p. 66.

52. Ibid., p. 57, no. 3.

53. *The Diary of Albert Goodwin, R.W.S. 1883–1927*, 1934, p. 105.

54. See above p. 181.

55. *The Diary of Albert Goodwin*, p. 389.

56. Ibid., p. 105.

57. Ibid., p. 448.

58. *Works*, XIV, p. 161.

59. Alexander Robertson, *Atkinson Grimshaw*, 1988, pp. 29 and 114.

60. Ibid., pp. 110–11, pls 95 and 96. See also Bartram, *The Pre-Raphaelite Camera*, pp. 66–8 and figs 53 and 54.

CHAPTER THIRTEEN

1. See above, pp. 5–6.

2. See Marcia Pointon, *William Dyce 1806–1864: A Critical Biography*, 1979, pp. 10–11, 189, and pl. 43. Pointon's book is now the standard monograph on the artist and includes reproductions of all the works by Dyce mentioned in this chapter. She dates the painting 1827. See also Staley, 'William Dyce and Outdoor Naturalism', p. 470 and fig. 2, where I tentatively and mistakenly tried to identify it as a coast scene exhibited by Dyce in 1832.

3. Pointon (*Dyce*, pp. 161–2, 192 and pl. 84) assigns it a date of *c.* 1851.

4. Mary Bennett (*Artists of the Pre-Raphaelite Circle*, pp. 56–8) relates the picture to Dyce's later more Pre-Raphaelite pictures and argues for a later date. Pointon (*Dyce*, p. 192) dates it *c.* 1855, but in her text (p. 162) places it between 1857 and 1860.

5. Pointon (*Dyce*, pp. 20–1, 189, and pl. 45) dates it much earlier, 1831 or 1832, and uses the title 'Shirrapburn Loch', which she identifies as a local variant for Glen Shirra in Morayshire.

6. *Art Journal*, 1855, p. 173.

7. *Works*, XIV, p. 19. This criticism is noteworthy for Ruskin's early reference to Botticelli, long before his claimed discovery of the artist in 1871. See Gail S. Weinberg, 'Ruskin, Pater, and the rediscovery of Botticelli', *Burlington Magazine*, CXXIX, 1987, pp. 25–7.

8. Dyce, ch. XXXVII (5 May 1857).

9. *Works*, XIV, pp. 98–100.

10. *Art Journal*, 1859, p. 164.

11. Dyce also exhibited the picture at the Liverpool Academy in 1861 without the Keble quotation, but under the title 'And Jesus was led by the Spirit into the Wilderness, and in those days he did eat nothing'.

12. For a contrary view of these works, see Pointon, *Dyce*, pp. 162–5.

13. *Athenaeum*, 11 May 1860, p. 653.

14. Dyce, ch. XXXIX.

15. Ibid.

16. *Art Journal*, 1859, p. 168.

17. Ibid., 1860, p. 165. For more recent discussion see Bartram, *Pre-Raphaelite Camera*, pp. 80–2.

18. Dyce, chs XXIII and XXXIX. Additionally, Bartram (*Pre-Raphaelite Camera*, p. 82) quotes an assertion by the photographer George Washington Wilson that *The Highland Ferryman* was based on a photograph by Wilson.

19. *Art Journal*, 1860, p. 296.

20. Helmut Gernsheim, *Masterpieces of Victorian Photography*, 1951, pl. 21.

21. This watercolour is faintly inscribed 'Oct 57' in the lower right corner. That date would seem to establish that Dyce visited Pegwell Bay prior to October 1858 (the date memorialised in his title for the picture and confirmed in his letter to his brother-in-law cited on p. 232), and that the finished picture is, in fact, as much a recollection of 1857 as of 1858 (see Pointon, *Dyce*, p. 171). I, however, question the reliability of the inscription. Dyce only infrequently signed or dated his works, and no other landscape sketch by him is inscribed in a comparable manner.

22. Marcia Pointon, 'The Representation of Time in Painting: A Study of William Dyce's *Pegwell Bay: A Recollection of October 5th, 1858*', *Art History*, I, 1978, pp. 99–103; and, more briefly, Pointon, *Dyce*, pp. 169–73.

23. *Art Journal*, 1859, p. 168, and *Athenaeum*, 12 May 1860, p. 653.

24. Dyce, ch. XXI. See also Staley, 'William Dyce and Outdoor Naturalism', p. 473.

25. See above, p. 5–6.

26. *Art Journal*, 1857, p. 167.

CHAPTER FOURTEEN

1. Hunt, I, pp. 50–1.

2. *Works*, XIV, p. 195 (*Academy Notes*, 1858).

3. Ibid. pp. 28, 67, 126, 220–1.

4. *Fine Art, Chiefly Contemporary*, p. 125.

5. Richard and Samuel Redgrave, *A Century of Painters of the English School*, Ruthven Todd, ed., 1947, p. 387 (from the edition of 1890; the first edition of 1866 did not mention Creswick, who was then still alive).

6. *Works*, XIV, pp. 13 and 20.

7. Hunt, I, pp. 211–12; and Troxell, *Three Rossettis*, p. 34 (Holman Hunt to Dante Gabriel Rossetti, 29 May 1850).

8. W. M. Rossetti, *Rossetti Papers 1862 to 1870*, pp. 232–3 (diary 16 May 1867).

9. See above, pp. 4–5 and 25–6; also Frederick George Stephens, *Masterpieces of Mulready*, 1867, p. 5; and Stephens, *Hunt*, p. 11.

10. *Art Journal*, 1852, p. 167.

11. Geoffrey Grigson, 'Gordale Scar to the Pre-Raphaelites', *The Listener*, XXXIX, 1948, pp. 24–5.

12. See *John Constable's Correspondence*, R. B. Beckett, ed., III, 1965, pp. 85 and 143; and ibid., IV, 1966, pp. 287–96.

13. F. G. Stephens, 'John Linnell', *Portfolio*, III, 1872, p. 46. For William Henry Hunt see also Ruskin, *Works*, XIV, pp. 373–84.

14. A. H. Palmer, *The Life and Letters of Samuel Palmer*, 1892, p. 15 *et passim*.

15. See above pp. 131, 137, and 173. See also Hunt, I, pp. 270–1.

16. Philip Gilbert Hamerton, *Thoughts about Art*, new edition, revised, 1874, p. 10.

17. Ibid., p. 32.

18. Henry Holiday, *Reminiscences of My Life*, 1914, pp. 45–6.

19. Christopher Newall, *Victorian Watercolours*, 1987, p.60.

20. See above, p. 198.

21. Olivia Rossetti Agresti, *Giovanni Costa: His Life, Work, and Times*, 1904, pp. 212–13. See also Christopher Newall, *The Etruscans: Painters of the Italian Landscape 1850–1900*, Stoke-on-Trent Museum and Art Gallery, 1989.

22. Mrs Russell Barrington, *The Life, Letters and Work of Frederic Leighton*, 2 vols, 1906, I, p. 109, and illustrations facing pp. 69, 116, 200, 202, and 205–7.

23. See Andrews, *Nazarenes*, p. 111, pl. 39b.

24. Barrington, *Leighton*, I, p. 202.

25. See Christopher Newall, 'Leighton and the Art of Landscape' in Stephen Jones et al., *Frederic Leighton 1830–1896*, Royal Academy, London, 1996, pp. 41–54.

26. The similarity of Mason's art to Breton's was noted during his lifetime. See Sidney Colvin, 'English Artists of the Present Day. XXVIII – George Mason, A.R.A.', *Portfolio*, II, 1871, pp. 115–16.

27. John George Marks, *Life and Letters of Frederick Walker, A.R.A.*, 1896, p. 36.

28. Ibid., p. 168.

29. *Works*, XIV, p. 340.

30. Ibid., III, pp. 45 and 191.

31. Ibid., XXIX, pp. 159–60 (*Fors Clavigera: Letters to the Workmen and Labourers of Great Britain*, 79, July 1877).

32. See above, pp. 78, 145–6, and 161.

33. *Athenaeum*, 11 December 1886, p. 790.

34. Brown, *Diary*, p. 132 (12 April 1855); and see above pp. •• and ••.

35. Ibid., p. 116 (12 January 1855).

36. For example, see Ruskin, *Works*, IV, p. 212

37. R. Glynn Grylls, 'The Correspondence of F. G. Stephens', *Time Literary Supplement*, 12 April 1957, p. 232. We should note that 'square flat touches', imitated from the French, would soon become the *lingua franca* of progressive artists everywhere, including the English group associated with the New English Art Club.

38. *Fine Art, Chiefly Contemporary*, p. 116.

39. *Works*, p. 578 ('The Modern Pictures of All Countries at Lichfield House, 1851').

40. Hunt, I, p. 189.

41. *Fine Art, Chiefly Contemporary*, pp. 112–13. In marginal notes in his catalogue of the exhibition (Yale University Library), William Michael characterised another landscape by Courbet as 'Creswicky done broad', which seems apt, but less complimentary.

42. Ibid., p. 100.

43. Ibid., p. 124.

44. See above, p. 80–1.

45. Henry James, *The Painter's Eye: Notes and Essays on the Pictorial Arts*, John L. Sweeney, ed., 1956, pp. 114–15.

46. Hunt, I, p. 150.

47. See above, p. 31.

48. Hunt, I, p. 172.

49. *Fine Art, Chiefly Contemporary*, p. 147.

50. 'The Purpose and Tendency of Early Italian Art', *The Germ*, 2, February 1850, p. 62.

51. Ibid., p. 64.

52. For example, D. T. Ansted, *Scenery, Science, and Art: Being Extracts from the Note-Book of a Geologist and Mining Engineer*, 1854. Ansted, who was professor of geology at King's College, London, also gave lectures, which Ford Madox Brown attended: 'went to Suffolk St to hear professor Anstead tell us that the colour of the air is blue & that of Mist grey etc etc – this they call geology' (*Diary*, p. 27 [31 January 1848]). The *Art Journal* published several series devoted to the application of science to art. One was 'The Natural Philosophy of Art' by John Sweetlove, the purpose of which was to explain 'the laws of those phenomena in nature which have an immediate connexion with art, especially painting, and with which the artist must be acquainted in order to make a truthful representation of nature.' The writer began by declaring, 'A moment's consideration of the objects and means of art will show how much it resembles the more strictly experimental sciences in relation to both nature and the human mind' (*Art Journal*, 1852, p. 6). See also Marcia Pointon, 'Geology and landscape painting in nineteenth-century England', in L. J. Jordanova and Roy S. Porter, eds, *Images of the Earth: Essays in the History of the Environment Sciences*, 1979, pp. 84–116.

53. 'The Purpose and Tendency of Early Italian Art', p. 62.

54. As Ruskin claimed about Seddon (with the modification 'as far as art can do'); see above, p. 138.

55. See above, p. 4, and Hunt, I, p. 125, where he refers to 'a child-like reversion from existing schools to Nature herself'. The concept of the 'innocent eye' was basic to Ruskin (see *Works*, III, pp. 140–8, and XV, p. 27), and Ruskin's arguments provided Gombrich's point of departure (*Art and Illusion: A Study in the Psychology of Pictorial Representation*, 1960, pp. 14 and 296–7).

56. *Art and Illusion*, p. 313.

ANDREWS, KEITH, *The Nazarenes: A Brotherhood of German Painters in Rome*, 1964.

BARRINGER, TIM, *Reading the Pre-Raphaelites*, 1998.

BARTRAM, MICHAEL, *The Pre-Raphaelite Camera: Aspects of Victorian Photography*, 1985.

BENDINER, KENNETH, 'John Brett's "The Glacier of Rosenlaui"', *Art Journal*, XLIV, Fall 1984, pp. 241–8.

BENDINER, KENNETH, *An Introduction to Victorian Painting*, 1985.

BENDINER, KENNETH, *The Art of Ford Madox Brown*, 1998.

BENNETT, MARY, 'A Check List of Pre-Raphaelite Pictures Exhibited at Liverpool, and Some of Their Northern Collectors', *Burlington Magazine*, CV, 1963, pp. 436–95.

[BENNETT, MARY], *Ford Madox Brown: 1821–1893* (exhibition catalogue), Walker Art Gallery, Liverpool, 1964.

[BENNETT, MARY], *PRB: Millais: PRA* (exhibition catalogue), Walker Art Gallery, Liverpool, and Royal Academy, London, 1967.

[BENNETT, MARY], *William Holman Hunt* (exhibition catalogue), Walker Art Gallery, Liverpool, and Victoria and Albert Museum, London, 1969.

[BENNETT, MARY], Walker Art Gallery, Liverpool, *Merseyside Painters, People & Places: Catalogue of Oil Paintings*, 2 vols, 1978.

BENNETT, MARY, *Artists of the Pre-Raphaelite Circle: The First Generation: Catalogue of Works in the Walker Art Gallery, Lady Lever Art Gallery and Sudley Art Gallery*, 1988.

The Diaries of George Price Boyce, Virginia Surtees, ed., 1980.

BRADLEY, JOHN LEWIS, *Ruskin's Letters from Venice: 1851–1852*, 1955.

Three Months on the Scottish Coast: A Series of Sketches and Pictures Painted During the Summer of the Present Year, Accompanied by an Introductory Essay by John Brett (exhibition catalogue), Fine Art Society, London, 1886.

BRETT, JOHN, 'Landscape at the National Gallery', *Fortnightly Review*, LVII, 1 April 1895, pp. 623–39.

BRONKHURST, JUDITH, '"An interesting series of adventures to look back upon": William Holman Hunt's visit to the Dead Sea in November 1854', in Leslie Parris, ed., *Pre-Raphaelite Papers*, 1984, pp. 111–25.

The Diary of Ford Madox Brown, Virginia Surtees, ed., 1981.

The Exhibition of Work, and other Paintings, by Ford Madox Brown, at the Gallery, 191, Piccadilly (exhibition catalogue), 1865.

BURNE-JONES, GEORGIANA, *Memorials of Edward Burne-Jones*, 2 vols, 1904.

CASTERAS, SUSAN, *English Pre-Raphaelitism and its Reception in America in the Nineteenth Century*, 1990.

CASTERAS, SUSAN, *James Smetham: Artist, Author, Pre-Raphaelite Associate*, 1995.

CORDINGLY, DAVID, '"The Stonebreaker": an examination of the landscape in a painting by John Brett', *Burlington Magazine*, CXXIV, 1982, pp. 141–5.

DAFFORNE, JAMES, 'British Artists: Their Style and Character: No. LI – William Dyce, R.A.', *Art Journal*, 1860, pp. 293–6.

DYCE, JAMES STIRLING, 'The Life, Correspondence, and Writings of William Dyce, R.A., 1806–64: Painter, Musician, and Scholar', unpublished typescript in the Aberdeen Art Gallery.

FERBER, LINDA S., and GERDTS, WILLIAM H., *The New Path: Ruskin and the American Pre-Raphaelites* (exhibition catalogue), The Brooklyn Museum, 1985.

[GAGE, JOHN], *A Decade of English Naturalism: 1810–1820* (exhibition catalogue), Norwich Castle Museum and Victoria and Albert Museum, London, 1969.

GIBSON, ROBIN, 'Arthur Hughes: Arthurian and related subjects of the early 1860s', *Burlington Magazine*, CXII, 1970, pp. 451–6.

The Diary of Albert Goodwin, R.W.S. 1883–1927, privately printed, 1934.

Notes by Mr. Edmund Gosse on the Pictures and Drawings by Mr. Alfred W. Hunt (exhibition catalogue), Fine Art Society, London, 1884.

GRIEVE, ALASTAIR, 'Ruskin and Millais at Glenfinlas', *Burlington Magazine*, CXXXVIII, 1996, pp. 228–34.

GRIGSON, GEOFFREY, 'Gordale Scar to the Pre-Raphaelites', *The Listener*, XXXIX, 1948, pp. 24–5.

HAMERTON, PHILIP GILBERT, *Thoughts about Art*, new edition, revised, 1874.

HARDIE, MARTIN, *Water-colour Painting in Britain*, 3 vols, 1966–8.

HELENIAK, KATHRYN MOORE, *William Mulready*, 1980.

HICKOX, MICHAEL, 'John Brett's The Stonebreaker', *The Review of the Pre-Raphaelite Society*, III, Spring 1995, pp. 1–9.

HICKOX, MICHAEL, 'The Royal Academy's Rejection of Brett's Florence', *The Review of the Pre-Raphaelite Society*, III, Spring 1995, pp. 10–16.

HICKOX, MICHAEL, 'John Brett and Ruskin', *Burlington Magazine*, CXXXVIII, 1996, pp. 521–5.

HICKOX, MICHAEL, and PAYNE, CHRISTIANA, 'Sermons in stones: John Brett's The Stonebreaker reconsidered', in Ellen Harding, ed., *Re-framing the Pre-Raphaelites: Historical and Theoretical Essays*, 1996, pp. 99–114.

HOLMAN-HUNT, DIANA, *My Grandfather, His Wives and Loves*, 1969.

HUEFFER, FORD MADOX, *Ford Madox Brown: A Record of His Life and Work*, 1896.

HUNT, WILLIAM HOLMAN, *Pre-Raphaelitism and the Pre-Raphaelite Brotherhood*, 2 vols, 1905.

'William Holman-Hunt, O. M. (1827–1910): Contemporary Notices of His Exhibits in Water Colour', *The Old Water-Colour Society's Club: Thirteenth Annual Volume: 1935–1936*, 1936, pp. 12–36.

IRONSIDE, ROBIN, and GERE, JOHN, *Pre-Raphaelite Painters*, 1948.

JAMES, ADMIRAL SIR WILLIAM, *The Order of Release: the Story of John Ruskin, Effie Gray and John Everett Millais Told for the First Time in Their Unpublished Letters*, 1948.

LANDOW, GEORGE P. *'Your Good Influence on Me': The Correspondence of John Ruskin and William Holman Hunt*, 1977 (reprinted from the *Bulletin of the John Rylands University Library of Manchester*, LIX, nos 1 and 2, Autumn 1976 and Spring 1977).

LANDOW, GEORGE P., *William Holman Hunt's Letters to Thomas Seddon*, 1983 (reprinted from the *Bulletin of the John Rylands University Library of Manchester*, LXVI, no. 1, Autumn 1983).

LESLIE, CHARLES ROBERT, *Memoirs of the Life of John Constable*, Jonathan Mayne, ed., 1951 (first published 1843).

LUTYENS, MARY, *Millais and the Ruskins*, 1967.

GALERIE DU LUXEMBOURG, PARIS, *Le Paysage Anglais des Préraphaélites aux Symbolistes* (exhibition catalogue), 1974.

MARILLIER, H. C., *The Liverpool School of Painters: An Account of the Liverpool Academy from 1810 to 1867. With Memoirs of the Principal Artists*, 1904.

MARSH, JAN, and NUNN, PAMELA GERRISH, *Women Artists and the Pre-Raphaelite Movement*, 1989.

MARSH, JAN, and NUNN, PAMELA GERRISH, *Pre-Raphaelite Women Artists* (exhibition catalogue), Manchester City Art Galleries, 1997.

MILLAIS, JOHN GUILLE, *The Life and Letters of Sir John Everett Millais*. 2 vols, 1899.

NEWALL, CHRISTOPHER, *Victorian Watercolours*, 1987.

NEWALL, CHRISTOPHER, *The Etruscans: Painters of the Italian Landscape 1850–1900* (exhibition catalogue), Stoke-on-Trent Museum and Art Gallery, 1989.

NEWALL, CHRISTOPHER, *John William Inchbold: Pre-Raphaelite Landscape Artist* (exhibition catalogue), Leeds City Art Galleries, 1993.

NEWALL, CHRISTOPHER, and EGERTON, JUDY, *George Price Boyce* (exhibition catalogue), Tate Gallery, London, 1987.

NOAKES, VIVIEN, *Edward Lear: The Life of a Wanderer*, 1968.

NOAKES, VIVIEN, *Edward Lear 1812–1888* (exhibition catalogue), Royal Academy, London, 1985.

NUNN, PAMELA GERRISH, *Victorian Women Artists*, 1987.

PARRIS, LESLIE, *Landscape in Britain c. 1750–1850* (exhibition catalogue), Tate Gallery, London, 1973.

PARRIS, LESLIE, ed., *Pre-Raphaelite Papers*, 1984.

POINTON, MARCIA, 'The Representation of Time in Painting: A Study of William Dyce's *Pegwell Bay: A Recollection of October 5th, 1858*', *Art History*, I, 1978, pp. 99–103.

POINTON, MARCIA, *William Dyce 1806–1864: A Critical Biography*, 1979.

ROBERTS, LEONARD, *Arthur Hughes: His Life and Works: A Catalogue Raisonné: with a Biographical Introduction by Stephen Wildman*, 1997.

ROBERTSON, ALEXANDER, *Atkinson Grimshaw*, 1988.

ROSENFELD, JASON, 'New Languages of Nature in Victorian England: The Pre-Raphaelite Landscape, Natural History, and Modern Architecture in the 1850s', Ph.D. dissertation, Institute of Fine Arts, New York University, 1999.

Letters of Dante Gabriel Rossetti, Oswald Doughty and John Robert Wahl, eds, 4 vols, 1965–7.

The Works of Dante Gabriel Rossetti, William Michael Rossetti, ed., 1911.

ROSSETTI, WILLIAM MICHAEL, *Fine Art, Chiefly Contemporary: Notices Re-printed, with Revisions*, 1867.

ROSSETTI, WILLIAM MICHAEL, ed., *Rossetti Papers 1862 to 1870*, 1903.

ROSSETTI, WILLIAM MICHAEL, *Some Reminiscences*, 2 vols, 1906.

The P.R.B. Journal: William Michael Rossetti's Diary of the Pre-Raphaelite Brotherhood 1849–1853, Together with other Pre-Raphaelite Documents, William E. Fredeman, ed., 1975.

Selected Letters of William Michael Rossetti, Roger W. Peattie, ed., 1990.

The Works of John Ruskin, E. T. Cook and Alexander Wedderburn, eds, 39 vols, 1903–12.

SCOTT, WILLIAM BELL, *Autobiographical Notes, and Notices of His Artistic and Poetic Circle of Friends, 1830–1882*, W. Minto, ed., 2 vols, 1892.

[SEDDON, JOHN POLLARD], *Memoir and Letters of the Late Thomas Seddon, Artist, By His Brother*, 1858.

Letters of James Smetham, with an Introductory Memoir, Sarah Smetham and William Davies, eds, 1891.

[SMITH, JAMES], *Two Liverpool Artists: In Memoriam: D. A. Williamson, Born 24th September, 1823, Died 12th February, 1903; W. L. Windus, Born 1823, Died October, 1907*, privately printed, n.d.

STALEY, ALLEN, 'William Dyce and Outdoor Naturalism', *Burlington Magazine*, CV, 1963, pp. 470–6.

STALEY, ALLEN, 'Some Water-Colours by John Brett', *Burlington Magazine*, CXV, 1973, pp. 86–93.

[STEPHENS, FREDERICK GEORGE], *William Holman Hunt and His Works: A Memoir of the Artist's Life, with Descriptions of His Pictures*, 1860.

STEPHENS, FREDERICK GEORGE, 'William Davis, Landscape Painter, of Liverpool', *Art Journal*, 1884, pp. 325–8.

The Swinburne Letters, Cecil Y. Lang, ed., 6 vols, 1959–62.

TATE GALLERY, LONDON, *The Pre-Raphaelites* (exhibition catalogue), 1984.

TREUHERZ, JULIAN, *Pre-Raphaelite Paintings from Manchester City Art Galleries*, 2nd edition, 1993.

TROXELL, JANET CAMP, ed., *Three Rossettis: Unpublished Letters to and from Dante Gabriel, Christina, William*, 1937.

VAUGHAN, WILLIAM, *German Romanticism and English Art*, 1979.

WARNER, MALCOLM, 'John Everett Millais's "Autumn Leaves": a picture full of beauty and without subject', in Leslie Parris, ed., *Pre-Raphaelite Papers*, 1984, pp. 126–42.

WILCOX, SCOTT, and NEWALL, CHRISTOPHER, *Victorian Landscape Watercolors* (exhibition catalogue), Yale Center for British Art, New Haven, 1992.

WRIGHT, ALASTAIR IAN, 'Suburban prospects: vision and possession in Ford Madox Brown's *An English Autumn Afternoon*', in Margaretta Frederick Watson, ed., *Collecting the Pre-Raphaelites: the Anglo-American Enchantment*, 1997, pp. 185–97.

While every effort has been made to trace copyright holders, any further information on their identity would be welcome. In most cases the illustrations have been made from the photographs or transparencies provided by the owners or custodians of the works. Those for which further credit is due are:

Aberdeen Art Gallery and Museums 190, 194; Art Gallery of New South Wales, Sydney 1; © The Ashmolean Museum, Oxford 5, 9, 38, 65, 71, 72, 82, 103, 106, 108, 113, 121, 125, 157, 159, 175, 179, 201; © The Ashmolean Museum, Oxford/The Bridgeman Art Library 14; Birmingham Museums & Art Gallery 6, 13, 33, 83, 96, 98; Birmingham Museums & Art Gallery/The Bridgeman Art Library 23 and back cover 28, 40, 41, 60, 81, 85; The Bridgeman Art Library 4, 141; © The British Museum 186; Cecil Higgins Art Gallery, Bedford/The Bridgeman Art Library 112; Christie's Images 206; Christopher Wood Gallery, London/The Bridgeman Art Library 184; Delaware Art Museum, Samuel and Mary R. Bancroft Memorial 27, 37; The Fine Art Society, London 127; The Fine Art Society, London/The Bridgeman Art Library 102; © Fitzwilliam Museum, University of Cambridge 51, 137; Fitzwilliam Museum, University of Cambridge/The Bridgeman Art Library 111, 123; The Forbes Magazine Collection, New York/Bridgeman Art Library 107; Glasgow Art Gallery and Museum 189; Glasgow Art Gallery and Museum/The Bridgeman Art Library 89; Guildhall Art Gallery, Corporation of London/The Bridgeman Art Library 8, 86, 198; Harris Museum and Art Gallery, Preston/The Bridgeman Art Library 57, 105; Courtesy of the Fogg Art Museum, Harvard University Art Museums, Gift of Samuel Sachs © President and Fellows, Harvard College, Harvard University Art Museums 170; Indianapolis Museum of Art, James E. Roberts Fund 143; Keble College, Oxford/The Bridgeman Art Library 50; Lady Lever Art Gallery, Port Sunlight 18, 43, 44, 55, 204; Laing Art Gallery, Newcastle-upon-Tyne 182; Leeds Museums and Galleries 129, 183; Leeds Museums and Galleries/The Bridgeman Art Library 120; Lyman Allyn Art Museum, Connecticut 110; The Makins Collection/The Bridgeman Art Library 7, 35, 47; © Manchester City Art Galleries 11, 21, 22, 30, 42, 75, 80, 88, 191; Courtesy, Museum of Fine Arts, Boston © 2000/All Rights Reserved 87; The Museo de Arte de Ponce, The Luis A. Ferré Foundation, Inc. Ponce, Puerto Rico 101; National Gallery of Canada, Ottawa. Gift of Mrs H.A. Bulwer, Vancouver 99; National Gallery of Scotland, Edinburgh 92, 95, 185, 192; National Portrait Gallery, London 36; National Museum of Wales, Cardiff 15; The National Trust 100, 91; Northampton Museums and Art Gallery 119; Philadelphia Museum of Art: Purchased: The John H. McFadden, Jr. Fund 94; Sheffield Galleries and Museums Trust/The Bridgeman Art Library 146; Shipley Art Gallery, Gateshead 132; © Society of Antiquities, London 134; Sotheby's Picture Library 68, 135; © The Tate Gallery, London 10, 24, 25, 26, 31, 48, 52, 53, 73, 78, 104, 114, 116, 124, 131, 132, 133, 138, 142, 147, 173, 196, 205; Toledo Museum of Art, Purchased with funds from the Libbey Endowment, Gift of Edward Drummond Libbey 172; Victoria & Albert Museum, London, Courtesy of the Trustees of the V&A 79, 126, 199, 200, 202; Victoria & Albert Museum, London/ The Bridgeman Art Library 12, 67, 136; Walker Art Gallery, Liverpool 29, 34, 139, 148, 150, 151, 152, 158, 161, 162, 163, 171, 174, 188; The Whitworth Art Gallery, University of Manchester 58, 59, 61, 62, 66, 145, 169; William Morris Gallery 19; Williamson Art Gallery & Museum, Birkenhead 164; Yale Center for British Art, Paul Mellon Collection 74, 93, 118, 165.